PATRONS AND PATRIOTISM

v. of Chi 4.60

PATRONS
AND PATRIOTISM

THE ENCOURAGEMENT
OF THE FINE ARTS
IN THE UNITED STATES
1790–1860

LILLIAN B. MILLER

THE UNIVERSITY OF CHICAGO PRESS • CHICAGO & LONDON

THE UNIVERSITY OF CHICAGO PRESS, CHICAGO 60637
THE UNIVERSITY OF CHICAGO PRESS, LTD., LONDON
© 1966 by The University of Chicago
All rights reserved
Published 1966
Third impression 1974
Printed in the United States of America
ISBN: 0-226-52772-7 (clothbound); 0-226-52773-5 (paperbound)
Library of Congress Catalog Card Number: 66-13880

FOR MY PARENTS

The influence of the plastic arts on the social condition of man is felt and appreciated in proportion to the encouragement they receive from the hands of the community at large. If they are fostered with liberal affection in their infancy, they, in their full maturity, return with tenfold interest the care bestowed on them in their youth.

A. S. WAUGH in *Western Journal and Civilian,* 1848

PREFACE

NATIONAL CULTURAL ATTITUDES and the inadequacy of the nation's artistic achievements have created in many Americans, at various times in their history, feelings of guilt and inferiority. Such critical introspection has usually accompanied a resurgence of nationalism, when as a result of internal or external pressures, Americans have felt the need to reassert the value of their institutions and national ideals. The years following World War II, for example, have witnessed an intense—even anxious—concern on the part of the people of the United States over the quality of the nation's cultural life. Throughout the country, groups of a most varied kind have sponsored art exhibitions and shows in their desire to advance the cause of art and to make it accessible to more and more people. Art critics, patrons, and artists, voicing the fears and hopes of Americans for art in this country, have been granted unprecedented exposure in print and at conferences. From 1946 on, there have been repeated calls for congressional action to commit the government to a program for the encouragement of the arts in order to promote the "nation's prestige and general welfare"; the National Foundation on the Arts and Humanities Act of 1965 represents, in fact, the fruition of these efforts. "A high civilization," the Declaration of Purpose of the Act of 1965 reads, "must not limit its efforts to science and technology alone, but must give full value and support to the other great branches of man's scholarly and cultural activity." Even more cogently the argument continues, in the battle of ideologies in non-committed areas, "world-wide respect and admiration for the Nation's high qualities as a leader in the realm of ideas and of the spirit" are matters of national significance. "If we are to be among the leaders of

the world," wrote President Kennedy in February, 1962, ". . . this sector of our national life cannot be neglected or treated with indifference."

The American sense of inferiority in the arts, growing out of the conviction that the nation has dedicated itself to materialistic goals, is part of a tradition that began with the genesis of the country. The United States had no sooner gained independence than Americans began to urge the encouragement of a national art to prove to the world that a republic was capable of cultural achievements. Inferiority in the arts at that time was a condition that deserved attention, but it was a condition more easily justified then because of the youthfulness of the nation and the prevailing sense of national potentiality. As America's potentiality came to be realized in its enormous material achievements, American nationalism grew apace, despite the disunionist forces; especially in the northeast and west, nationalism gave strength and direction to the movement to encourage native art. Wealth, a dynamic economy, an intermingling of peoples and cultures, all contributed to the power of the nationalist psychology, which, in turn, exerted a profound effect on American art life. Moreover, Americans entertained a commonly held definition of art's values which gave the arts a clear usefulness in social and national development that was attractive to a functionally oriented society.

This study is designed to examine the way in which Americans of this earlier generation—members of the educated middle and upper classes especially—defined art with respect to its mission and how they justified its promotion, and to determine the extent of their achievement in establishing art in their communities through public or private institutions. The study is limited to the formalized arts of painting and sculpture, as they developed during the Renaissance in Europe, which were characterized as the Fine Arts in contrast to the practical arts. The folk arts and the so-called vernacular arts, whatever their interest may be today to social and art historians seeking to discover an indigenous artistic expression, were not regarded as ART during the first half of the nineteenth century, and so did not receive the attention of self-conscious nationalists and art patrons.

By the outbreak of the Civil War, the movement to encourage a native art appeared to have lost its force. Much had been accomplished for art by nationalistically minded individuals. After the war a new generation took over economic and cultural leadership and built

on the foundations laid by the earlier nationalists, but for different reasons and from different motivations. Theirs, therefore, constitutes a separate story.

Although taste in art during this period was affected by sentiments of American nationalism and from that point of view deserves discussion, no attempt has been made in this study to evaluate the art created during these years in purely aesthetic terms. Tastes in art change as individual and social needs change and make new or different demands on artists. Controversies regarding the merits or shortcomings of painters and of paintings wrought for another generation's requirements are not therefore pertinent here; essentially, what this study has tried to do is to treat art as a factor in social and cultural development—in William Constable's words—as "one element in a complex mass of activities which may influence it or in turn be influenced by it, and in terms of which it can alone be fully understood."

The choice of material for the section dealing with art and the federal government should be explained. There has been no intention to present here a definitive and complete history of government patronage of artists during this period. At various times, commissions for portraits and busts were voted by Congress; most of these are discussed in two important sources: *Documentary History of the Capitol* (Washington, D.C., 1904) and Charles E. Fairman, *Art and Artists of the Capitol* (Washington, 1927). The commissions or incidents chosen for examination were selected either because they are most representative of congressional and governmental attitudes at that time, or because they reveal national tastes and social values. For similar reasons, this study does not include state and municipal patronage of artists, primarily because such patronage was expressed in the form of commissions for portraits or busts of contemporary or historical personages and in no way reflected a policy of art patronage.

I am grateful to the American Council of Learned Societies for the generous two-year fellowship which facilitated the planning of the book and some of its research. I am glad to be able to acknowledge here my obligation to Jacques Barzun, Henry Steele Commager, Robert A. Cross, James M. Fitch, Nathan Miller, Lionel Trilling, and the late Francis Henry Taylor for their generous aid and suggestions. I owe a very large debt of gratitude to Richard Hofstadter

for his unstinted help and encouragement. I am also indebted to the numerous libraries that are listed before the bibliography, and to the museums and institutions whose helpful personnel eased the task of obtaining the illustrations.

L. B. M.

CONTENTS

ILLUSTRATIONS

APOLOGIA FOR THE ARTS

A Republican Government is the appropri-
ate soil for the cultivation [of the Fine Arts].

DeWitt Clinton, 1816

In 1791 and 1792 there appeared in the *American Museum or Universal Magazine* a series of letters to a young lady of gentility offering advice on the "proper studies for females." "Politics, philosophy, mathematics or metaphysics," she was cautioned, were not her province. "Machiavel, Newton, Euclid, Malebranche or Locke would lie with a very ill grace in your closets." Rather, "taste and imagination" were the faculties that should be encouraged: "they do not require so much time, abstraction, or comprehensiveness of mind; they bring no wrinkles, and they give a polish to your manners, and such a liberal expansion to your understanding, as every rational creature should endeavor to attain." By "taste" this young lady's mentor implied "connoisseurship"—"knowledge which is not injudicious"—and by "imagination," the ability to survey an elegant pile of building, the designs of a Palladio, the landscape of a Claude Lorrain, the portraits of a Titian, or the *Transfiguration* of a Raphael, with "uncommon rapture," and to "entertain herself for hours" with a "ruin or a castle in which the unskilful can see nothing but deformity or the corrosions of time." [1]

Undoubtedly, these articles had first appeared in an English journal, for the advice was quite unsuited to the requirements and opportunities of a young American lady of the time. Where in this essentially provincial and rural society, with a small and scattered population and a land still largely uncultivated, was she to go to study a landscape by Claude or to meditate on the ruins of a castle? Throughout the first half of the nineteenth century, forests rather than ruins were the impressive feature of the American landscape. Here were no ancient buildings, monuments, or cathedrals to mark the passage of civilization, but, as Emerson put it, "nature sleeping, overgrowing, almost conscious, too much by half for man in the picture, and so giving a certain *tristesse* like the rank vegetation of swamps and forests seen at night." [2]

Yet the fact that the editor of the journal should have judged such an article appropriate for publication in 1791 suggests that by that date there existed a leisure class in the United States with wealth and education enough to benefit from such advice. It suggests that the

state of American society and economy had, in the opinion of some contemporaries, matured to the point where the development of an interest in the fine arts was feasible and, in fact, desirable.

What was the state of American society in 1791 that influenced the editor of the *American Museum* to believe that the country now could begin to cultivate the arts? Had Americans by the turn of the century an economy and cultural life sufficiently advanced and dynamic enough to sustain and encourage the growth of native art? For a vigorous art life presumed a base of more than average wealth in the possession of a sufficiently large segment of the population to assure artists and art institutions a steady and continuous support; it also presumed the existence of an active interest in art, together with guiding traditions and techniques which could be absorbed and developed by succeeding generations of artists.

Colonial Americans, especially those in the northeast, possessed a "mediocrity" of wealth, tied up for the most part in lands and goods not readily available for luxuries. Besides being handicapped by the shortage of liquid capital, middle-class landowners were often isolated from each other and from the centers of social living, and facilities for communication were slow and cumbersome. The rural society of eighteenth-century America could not effectively support the crafts, as Carl Bridenbaugh has pointed out, and the development of crafts was often a necessary preliminary for the growth of the finer arts, creating an interest in them while at the same time conveying or continuing knowledge of the techniques and "mysteries" in their practice.[3]

The homes of farmers and rural Americans in the colonial period were not devoid of decoration; they often displayed carvings and wall hangings turned out by members of the family that indicate at least a yearning for elegance and pictorial beauty along with artistic inventiveness. Once experience with works of art of a more professional order could be obtained, it was likely that this interest might be developed into more purposeful artistic activities. Rural southerners who were also members of the planter aristocracy in Virginia and seaboard Carolina—the Byrds, the Carters, the Claibornes, the Lees, and others like them—enjoyed more professional works of art in their homes. Amidst splendid gold and silver plate, silk and damask draperies, fine china, carpets, and imported furniture could be found prints and portraits, some of which were painted in England and some the work of native itinerant limners.[4]

Despite this interest in display, artists did not flourish in the colonial South except in Charleston. The rural area encouraged, in the first place, itinerancy and anonymity. More important, southern interest in art was inspired primarily by the desire to imitate English ways, and little interest was demonstrated in the theoretical or social or aesthetic value of art as an aspect of culture. Equally important was the fact that the southern aristocratic tradition developed by these colonial planters precluded professionalism in the arts among members of their own class and relegated this kind of activity to the middle classes. The southern gentleman might amuse himself with drawing, water-color painting, and architecture in an amateur way, but the professional practice of painting or sculpting was not considered suitable for a member of his class.

The arts and crafts flourished in the colonial cities—Boston, New York, Philadelphia, and Charleston—those "little oases of culture and taste" that grew up along the Atlantic seaboard. Here were found libraries, schools, colleges, bookstores, and whatever collections of paintings merchants, artists, and government officials had assembled. Moreover, the colonial towns provided an opportunity for small shopkeepers, craftsmen who had attained a degree of specialization and skill in their crafts, and professional men to accumulate fortunes large enough to enable them to pass into the ranks of upper-class society. While imitating the pastimes of the aristocracy at home and in England by collecting prints and engravings imported from London, and especially by extending commissions to portrait painters, these individuals at the same time broadened the base of potential support for art.[5]

The War for Independence and the demands of postwar readjustment only accelerated the process of urbanization that had been in motion for almost a century. New York, Boston, Philadelphia, Charleston, and Baltimore continued to develop as centers where men of business abilities who had accumulated capital during the war congregated in order to invest in profitable ventures. Banks, commerce, and transportation companies sought investment capital, and men of business acumen found in these new corporate activities an outlet for their surplus funds as well as for their spirit of enterprise. The expansion of business during the last years of the eighteenth century produced an acute consciousness of economic growth that permeated all areas of life. Certainly, English and European artists quickly sensed the potentiality here of patronage easily won and

wealth easily obtained, for between 1777 and 1799 the more impor-
tant cities of the eastern seaboard were visited by a constantly
increasing stream of foreign as well as native painters. In New York,
for instance, between 1726 and 1776, only eight painters advertised
their talents, and most of these did not remain in the city for any
length of time; between 1777 and 1799, thirty-four painters at one
time or other set up their easels in that city. Similarly, in Boston,
Philadelphia, Charleston, and Baltimore, the number of artists and
drawing schools increased threefold after independence was achieved.
Even American artists resident abroad now found it worthwhile to
return home to practice their craft; in 1786, after twelve years abroad,
Ralph Earl returned to Connecticut from England to paint portraits
of Connecticut's great men, and John Trumbull returned to New
York City from England in 1789. As artists began to secure more
patronage and respectability in the new American society, and as
knowledge of the fame and success of such native-born artists as
Benjamin West and John Singleton Copley spread through the
northeastern states especially, the profession of painter took on added
attractions, tempting into its practice many who might otherwise have
not pursued it. By 1800 it was possible for a competent portraitist like
John Wesley Jarvis to set up a studio in New York City and enjoy an
attractive income from painting portraits of New York's upper
income groups.[6]

When the Marquis de Chastellux, who was accustomed to "the
luxury of musick and the fine arts, and to their enjoyment in the two
capitals of France and England," traveled through the United States
in the 1780's, he found little to comfort his soul. During the years that
followed his visit, however, there was a burst of artistic activity, and
in almost all of the major cities, academies of art or museums of
various kinds were being established. Most of these institutions were
small-scale ventures of artists who found such enterprises necessary to
augment their uncertain incomes. They were followed a few decades
later by more formal organizations for the encouragement of the fine
arts; and although these suffered, along with artists, from the tensions
and economic disruptions occasioned by the War of 1812, some
remained strong enough to ride out the storm.[7]

The Napoleonic wars brought large profits to American merchants
and farmers because of the devastation of European agriculture and
the interruptions in the European carrying trade caused by English

and French maritime policies. Despite temporary periods of distress, American merchants, especially in the North, continued to accumulate fortunes and to acquire surplus capital, which, after the cessation of hostilities, they were eager to plow back into old enterprises or to invest in new ones. This group was also prepared to participate more actively in cultural affairs. Given, then, a condition of economic growth and the promise of increasing fortunes, together with the simultaneous development of an interest in art, it seems reasonable to assume that the fine arts would eventually have found a home in the United States. The process was hastened, however, by the intense nationalism that pervaded American thought and life during the first half of the nineteenth century and by the fact that the philosophical traditions of the British eighteenth-century Enlightenment endowed the fine arts with a social and national value that helped to justify the nationalist cause.[8]

CHAPTER ONE

THE NATIONALIST APOLOGIA

NATIONALISM STIMULATED THE AMERICAN EFFORT to develop a native culture during the years following the achievement of independence. War had tested the capacity of Americans to survive as a nation, and whatever misgivings individuals may have had about their countrymen's ability to meet the problems presented by their new status, Americans generally had no doubt that the future was theirs. It had been no small task to array their meager forces against the tremendous power of Great Britain, and the unity with which they emerged from the conflict, the unique political and social system which they developed, gave Americans a sense of superiority over what they considered "decadent" Europeans and declining European institutions. Now they looked westward for inspiration and found it in the promise of the seemingly limitless stretch of land extending beyond the Allegheny Mountains. "The proudest empire in Europe," exulted the New York patrician Gouverneur Morris in 1801, as he stood on the shores of Lake Erie and gazed westward, "is but a bauble compared to what America will be, *must* be, in the course of two centuries, perhaps one. . . ." [1]

The nationalist psychology had begun to permeate American life and thought even before the Revolutionary War, as the colonists increasingly regarded themselves as Americans rather than transplanted Europeans. But if Independence crystallized and articulated psychological forces that had been gathering strength slowly during the one hundred and fifty years of the American experience, it also presented Americans with a greater and more immediate sense of their responsibility for the moral tone of their country, for its cultural achievements as well as its political well-being and economic success. Whatever sensitivity colonial Americans may have had about their

crudity as a society, whatever desires they may have experienced for recapturing here in the wilderness the refinements of European culture and art were intensified by their involvement, once independent, in nation-building and by the realization that to a large extent they were working out their country's destiny before the eyes of the whole world. The achievement of political independence and the progress they were making in economic development only made Americans more self-conscious about what appeared to be their cultural inferiority.

Cultural nationalism found its spokesmen almost immediately after the Peace of Paris, when educational reformers sought to recast American thought into a distinctly "American mold" by rewriting textbooks and reforming educational institutions. Associations for the advancement of art, science, and letters were also the immediate result of the post-revolutionary wave of nationalistic feeling. Despite the fact that these efforts to establish a native culture weakened under the impact of the circumstances leading up to the War of 1812, the close of the war brought all groups and sections together again, and, in Albert Gallatin's opinion, "renewed and reinstated the national feelings and character which the Revolution had given. . . . The people have now more general objects of attachment with which their pride and political opinions are connected. They are more Americans. They feel and act more as a nation. . . ." [2]

Following the Peace of Ghent a much more rampant nationalism emerged, pervading all areas of the country's life. Behind the nationalistic emotions of Americans lay the felt necessity for economic and cultural independence from England. The uniqueness of the American character, it was argued, would emerge only if Americans "cut the umbilical cord" that stretched "three thousand miles across the Atlantic"; only then would the country see "pencils and chisels . . . ready to echo in colour and marble every noble cry of the American voice." To achieve such independence, nationalists sought to develop a strong economy and a native culture. Economic nationalists pressed for a protective tariff and internal improvements—roads and canals built and paid for by the national government, while cultural nationalists advocated patronage and encouragement of the arts by government, communities, and individuals. Both groups saw in such measures the achievement of a greater freedom from the former mother country and a bulwark against the national dismemberment

that so many Americans feared when they contemplated the vast and unsettled West. "We are great and rapidly—I was about to say fearfully—growing," said John C. Calhoun in 1817. "This is our pride and our danger; our weakness and our strength. . . ." [3]

Because a program aimed at realizing economic self-sufficiency usually included as its justification the stimulation it would give to the growth of a native art life, economic nationalists were often at the same time cultural nationalists. Alexander Everett, for example, Boston lawyer, politician, diplomat, editor, and writer, believed that economic growth and activity provided the most exciting environment for the "successful cultivation of the elegant arts." "The Muses," wrote Everett, "are not a set of sentimental fine ladies who are frightened at the free and open face of real life"; no contradiction existed between a life devoted to art and one devoted to "Politics, commerce and manufactures—the bustle of business." In all these areas, strength would be achieved through the application of nationalistic principles to economic life. Canal Commissioner DeWitt Clinton of New York was a vocal and eloquent advocate of government-sponsored canals, but he also gave his time and energies to organizations like the American Academy of Fine Arts and similar groups designed to further learning and the arts and sciences. Whether or not Clinton's interest in cultural matters was that of a dilettante, as many of his contemporaries and later biographers claim, it is pertinent to note that the New Yorker justified state-sponsored canals with the argument that the revenue derived from their operation might be used "in encouraging the arts and sciences; in patronizing the operations of industry; in fostering the inventions of genius, and in diffusing the blessings of knowledge." Others who were interested in forwarding measures for the economic and cultural development of the country did so because they saw an intimate connection between culture, economic strength, and political freedom. [4]

Many Americans found it particularly painful to have their institutions attacked by visiting Europeans who found America wanting especially in those achievements of the mind and spirit that contributed, so it was believed, to the greatness of national character. They were troubled when travelers commented on the "paradox" that a "civilized, peaceful, free, industrious and opulent" country, whose inhabitants had "sprung from one of the most enlightened nations of the globe," should be so lacking in artistic achievements. A sympa-

thetic traveler like the French writer Brissot de Warville might blame the dearth of art in the United States on the fact that although the nation was rich there was "little in the way of surplus" wealth here, for "riches [were] equally divided." Other travelers who arrived in the United States after Brissot were not as kind. "American materialism," "vile cupidity," and stern utilitarianism, most of these observers believed, rendered Americans incapable of appreciating the "agreeable" arts; and the fact that abstract knowledge or Ideal Beauty commanded no value in the American market place prevented any successful developments in the creation of a national art. America, wrote the English visitor Francis Hall in 1818, might expect a "brilliant success in whatever relates to the useful sciences, in mechanical inventions, and all the arts by which her immense territory and active population may be most advantageously employed; but the ideal world is not included in her domain. . . ." A year later, Henry B. Fearon, his countryman, analyzed the American mind as not receptive to "an enjoyment of the more noble productions of art or the higher walks of mental cultivation." "In the four quarters of the globe," commented the *Edinburgh Review* in 1820, "who reads an American book? or goes to an American play? or looks at an American picture or statue?" Thus, while Americans vaunted their country's superiority over "decadent" Europe, they sensed an inferiority in areas where they were particularly vulnerable; and while they boasted abroad of their countrymen's cultural achievements, at home they urged the development of a native culture that would prove to the world the advantages of the American system.[5]

The fine arts in particular profited from this wave of nationalistic feeling, since achievements in the other cultural areas—literature, education, music—were, in these early years, still largely matters of hope. In the fine arts, however, Americans could bolster their faith in their countrymen's inherent genius by citing a record of considerable accomplishment. The careers of Benjamin West, John Singleton Copley, Gilbert Stuart, John Trumbull, and Washington Allston, as well as those of many lesser lights, demonstrated that "American genius" had flourished without any encouragement from the environment—indeed, despite the environment. As early as 1787 Americans cited the success of West, Copley, and Trumbull as proof of their country's special talent in painting. In 1795, John Quincy Adams told a French official that although there was not much taste for music in

America, "American genius was very much addicted to painting, and we had produced in that art some of the greatest masters of the age." The fact that America had produced these great artists indicated beyond doubt to a writer for the *Literary Magazine and American Register* that Americans were "highly disposed to the enjoyment of the sublime art in which those men are justly so famous." "We have a great natural turn for [the fine arts]," wrote John Lowell to his son Francis, who was in Edinburgh during the war years; and he assured his son that merely the mention of West, Copley, Stuart, Trumbull, and Allston would "convince any liberal foreigner that the Fine Arts do not refuse us their aid, and we only want European capital to give them encouragement." A few years later, in 1814, Samuel F. B. Morse, after surveying the condition of art in England, wrote in a similar vein to his parents that "the palm of painting still rests with America, and is, in all probability, destined to remain with us. All the country needs is taste . . . and a little more *wealth*." "With no public, and but little private, patronage," wrote an essayist in the *Analectic Magazine* in 1815, the fact that "the nation should have produced a continual and uninterrupted succession of painters of great merit" could only be accounted for by allowing the existence of some organic cause or natural propensity of genius." DeWitt Clinton noted too, in 1816, that "both abroad and at home, our country-men . . . have exhibited powers of genius and taste which have commanded not only applause, but admiration." [6]

Despite their pride in the talent of American artists, some Americans were conscious of a widespread lack of interest in the fine arts and felt the necessity of apologizing for it. The most common excuse offered was the youthfulness of the nation. "All things have their season," wrote Benjamin Franklin, "and with young countries as with young men, you must curb their fancy to strengthen their judgment. . . . To America, one schoolmaster is worth a dozen poets, and the invention of a machine or the improvement of an implement is of more importance than a masterpiece of Raphael. . . ." Franklin was not opposed to the cultivation of the arts in due time. "Poetry, painting, music (and the stage as their embodiment)," he went on to say, were "necessary and proper gratifications of a refined society." If he objected to the encouragement of the arts during this early period of national development, he did so because of his fear that the people might develop expensive tastes before they possessed the means of

satisfying them. The *Literary Magazine and American Register* elaborated on the same theme; it noted that "a people must secure a provision of absolute necessities before they think of convenience, and must enjoy conveniences before they indulge in the agreeable arts of life." The fine arts were the "refinements of ancient, sometimes declining empire," Charles Ingersoll aggressively explained, and therefore they were not to be expected in a growing and vigorous nation. In reviewing Ingersoll's book, however, Jared Sparks modified the author's conclusions. "When we grow older, and have more leisure, more wants, and more wealth," the historian wrote, "we can afford to indulge in luxuries"; then America would be able to "spare a portion of the effective talent of our community to provide delicacies," and then would "the American soil . . . be found not less fertile in the products of fancy and taste than it now is in the fruits of practical invention and wise maxims of political science." [7]

Other Americans saw no reason at all for the country to cultivate the arts. Indulgence in the arts, many believed, weakened the moral strength of the nation and corrupted the society that nourished them. The arts, John Adams wrote in one of his more critical moments, had been from the dawn of history the product of despotism and superstition and so should be avoided by the new republic. Morality aside, the patronage of the fine arts, some thought, weakened the capacity of the young country to achieve a measure of economic stability; more important than art was the practice of austerity. In fact, during times of depression, the prevailing economic difficulties were often ascribed to a "reckless" extension of business that occurred because Americans had developed a "supreme contempt for the plain and republican habits" of their ancestors, while seeking to outvie each other in their dress and in their attention to such luxuries as the fine arts, music, and dancing.[8]

Nationalists were prepared to counter such arguments. Defenders of a national culture found it shameful to be considered without artistic pretensions; it was a blot on the nation's honor and an insult to the character of its people. The arts were only as corrupt as the society that influenced them, they answered; the morality of a people determines the purity of the arts they practice. Although the fine arts have "too often [been] perverted to the service of licentiousness and vice," they could be "rendered a powerful auxiliary to virtue and religion." The anonymous writer in the *South Carolina Weekly*

Museum who argued in this fashion elaborated on his theme at length. "If lascivious paintings and statues, with impure poems, have by their fascinating influence tended greatly to the corruption of morals and the promotion of infidelity," he concluded, "must not the charms of piety, benevolence, gratitude, sympathy, friendship, and the other virtues . . . become irresistible when joined with those charms of sight which so delight the imagination?" As for the lack of economic means with which to patronize art, Americans, it was claimed, were wealthy enough to buy contemporary art, the works of "living genius," if not the celebrated works of European Old Masters; such encouragement, in fact, was all that was required in this country "to enable [American artists] to rival the *chef-d'oeuvres* of the old world." That Americans were without experience in the arts and therefore without taste was an argument contemptuously dismissed; "taste can only be nourished by the sight of the objects which call it into action." Such individuals who defended encouraging the arts in this way believed, like the contributor to the *North American Review*, that "commerce, manufactures, all that is profitable, all that is mechanical, and all that is sensual," would take care of itself in this country, but that the "rock on which the glory of America may split, [was] that everything is calling her with Syren songs to a physical, inelegant, immature, unsanctified, Carthaginian, perishable prosperity"; to avoid such an undesirable fate, it was absolutely essential that the fine arts be encouraged.[9]

—2—

Undoubtedly many considerations, such as community prestige, political advantage, emotional or psychological factors, prompted Americans during the early years of the Republic to develop an interest in advancing their country's intellectual and artistic life. Certainly, the Puritan conception of wealth, which encouraged acquisitiveness only on condition that a certain proportion of the individual's accumulation be devoted to social or civic causes, prepared the minds and hearts of many Americans for the idea that it was their obligation to encourage American culture generally. With respect to the fine arts specifically, however, one of the more important influences that acted on educated Americans during these years was the heritage of ideas derived from the eighteenth-century Enlightenment.[10]

Americans who read eighteenth-century philosophy absorbed and were influenced by the prevailing pattern of thought which held that the mind owed everything to environment, that Nature shaped human nature and human institutions, and that man by his Reason could bring these institutions into harmony with the natural order. "Men are like plants," wrote Crèvecoeur; ". . . we are nothing but what we derive from the air we breathe, the climate we inhabit, the government we obey, the system of religion we profess, and the mode of our employment." Writers like Hutcheson, Shaftesbury, and Lord Kames extended such ideas to the realm of aesthetics and taste in order to meet the political and social problems of eighteenth-century England, for they perceived or rationalized a relationship between an environment in which Taste was encouraged and political and social reform. As the government, so the Taste, wrote Shaftesbury; "nothing is so improving . . . so congenial to the liberal arts, as that reigning liberty . . . of a people." A taste for the fine arts, Lord Kames pointed out, went "hand in hand with the moral sense, to which indeed it is nearly allied." Political liberty and the morality of a people were both related to the development of Taste, and Kames and his fellow philosophers, therefore, considered it necessary that members of the upper classes interest themselves in the arts, sciences, and literature in order to influence and shape the tastes of the masses. "Those who depend for food on bodily labor are totally devoid of Taste," Kames observed; the standard could only be maintained by individuals of education, reflection, and experience. Thus, in England, the ideas of the Enlightenment became a philosophy of behavior for the upper classes, establishing an aristocratic responsibility for the political, moral, intellectual, and cultural well-being of the nation.[11]

The influences of the Enlightenment, once felt in this country, worked rapidly on American life. Its early manifestations appeared in the middle of the eighteenth century with the expansion of educational facilities of all kinds—libraries, schools, the press. These, in turn, made possible a continued circulation of the ideas of the Enlightenment and constantly widened the area in which they exerted influence. When a new middle class entered into the economic circles of the old colonial aristocracy after the Revolution, its members quickly absorbed and imitated the aristocratic pattern of behavior established by men influenced by Enlightenment thought. Under the impact of these ideas, Americans of established social and

economic positions in their communities, whose ranks included merchants, doctors, lawyers, statesmen, and ministers, became convinced that it was their duty to forward the progress of their country and to improve their fellow men. Edward Everett, a Boston Brahmin, defined this sense of cultural responsibility in 1824 when, in language reminiscent of Kames, he called on American scholars "to exert our powers, to employ our time, and consecrate our labors for the honor and service of our native land. . . . It is by the intellect of the country that the mighty mass is to be inspired." [12]

In this spirit, enlightened gentlemen founded eleemosynary institutions and reformed those already in existence; they organized scientific societies and museums and interested themselves in the natural history of their country; they formed literary groups and dabbled in the writing of polite literature. Drawing was a necessary accomplishment of the enlightened gentleman, and together with the study of Taste became an important part of his education. [13]

Americans owed more to British eighteenth-century philosophy than merely a pattern of behavior that they could follow; they also acquired an aesthetic, which, in the absence of any extended experience with painting and sculpture at home, strengthened their arguments in behalf of encouraging the arts. "An intellectual milieu," Robert Streeter has pointed out, "as well as Anglophobia and pride in the republic, was instrumental in shaping the views of some of the most zealous nationalists. . . ." Streeter, however, found the critical writings of the French and German schools—Montesquieu, the Schlegels, and Mme de Stael—of importance in their influence on American literature. There is no question that young American students like George Ticknor, Edward Everett, and George Bancroft, who attended German universities after the War of 1812, did find the literary doctrines of these writers attractive and in particular were drawn to the "new criticism" as argued by A. W. and Frederick Schlegel. They were especially impressed by the assertion that the beautiful and grand can be understood only through an awareness of the cultural differences and peculiarities of nations and historical epochs. When Edward Everett, for example, returned to the United States and found himself in 1824 expounding on "The Circumstances Favorable to the Progress of Literature in America", he argued from the premise of the French and German critics that there existed national differences in taste resulting from a combination of unique political, social, climatic, and topographical circumstances. Other

cultural nationalists of Everett's generation—Gulian C. Verplanck, Charles J. Ingersoll, William Cullen Bryant, and William Ellery Channing—all emphasized the influence of the native environment on traits of national character, attitudes, values, and intellectual achievements.[14]

Yet, with respect to the fine arts, Americans who reached their maturity between 1790 and 1830 still clung to British neoclassicism as an aesthetic ideal, accepting from the continental writers only selected emphases and ignoring their repudiation of classical standards of taste based on universal rules, applicable to all nations at all times. The full impact of the new criticism was actually to come to the United States later, when the romantic writers of Emerson's generation would eagerly accept all the implications of the German emphasis on spontaneity and nature and reject neoclassicism clearly and specifically. The earlier generation of American nationalists straddled the issue and found in a combination consisting essentially of the neoclassicism of Sir Joshua Reynolds and the associationism of Archibald Alison a synthesis that justified the national encouragement of art.

The works of Sir Joshua, especially the *Discourses* and the *Autobiography*, were as widely read in this country as in his own. Although portraits by Reynolds were highly prized possessions of only a few American collectors, almost every private library that contained works on the fine arts included the artist's writings. When an editor wished to fill a corner of his magazine with an uplifting quotation from a classical source, lines from Reynolds' essays were a common choice, and these often stimulated further enthusiastic comments from the editor.[15] Similarly, Alison's *Essays on Taste* circulated widely in American cities after 1815 and came to be considered a textbook for artists as well as for educated gentlemen. In 1825, for instance, a young aspiring artist wrote to his patron, Philip Schuyler, that he was perfecting his art not only by practicing drawing but also by "cultivating his mind" with such works as Alison's *On Taste*, Stuart's *Philosophy of the Human Mind*, and a *Greek Mythology*. As late as 1874, Thorstein Veblen read a version of Alison's work as the prescribed text in aesthetics at Carleton College, and no doubt many other students in the United States between 1815 and 1900 derived their ideas about art directly or indirectly from the same source.[16]

Eighteenth-century neoclassicism as expressed in the writings of Sir

Joshua posited as the end of art, and of all human activity, the ethical
enlargement of the individual character; and it considered man's
reason capable of gaining an insight into ideal nature and of under-
standing it in terms of the moral ends which it embodied. Moral
excellence and physical perfection, both of which constituted the
"Ideal" according to Reynolds, became man's primary guide to an
evaluation of the beautiful; in turn, the more moral and intellectual
art became, the greater usefulness and respectability it achieved.
Artists, therefore, had moral responsibilities, and Reynolds cautioned
them that only so long as they contributed to "the general purpose
and perfection of society" would they deserve encouragement.
Classicism restricted the artist in one other respect, for it saw in the
Greek achievement and in the painting of the past—especially that of
the sixteenth and seventeenth centuries—the most successful realiza-
tion of the Ideal. Modern artists, then, had to study and emulate
Greek sculpture and the canvases of the Old Masters if they were to
achieve similar success.[17]

Neoclassicism affected patrons too, not only by establishing stand-
ards of taste for comparison, but by making it virtuous to encourage
art. Reynolds, wrote an American essayist in the *Analectic*, "so justly
and wisely and eloquently taught that the great object of all the
pleasures of cultivated taste is to disentangle the mind from appetite
and to teach it to look for its pleasures in intellectual gratification, till
at length that freedom from the thralldom of sense, which began in
taste, may, as it is exalted and refined, conclude in virtue." [18]

The aesthetic ideas of Archibald Alison were influenced by the
philosophy of associationism, the basis for which may be found in
British empirical psychology. British empiricism rejected the classical
standard of ideal nature, or the universal, and emphasized instead the
idea that knowledge was derived from the particular and the sensa-
tional. As it permeated aesthetic and critical doctrine of the latter half
of the eighteenth century, this psychology developed a view of man's
nature as a "bundle of habits" formed on the basis of repeated
experience or association of ideas. In its simplest form this meant that
similar ideas, or ideas that have repeatedly occurred simultaneously or
in succession, automatically produce a particular train of thought.
Thus, an individual's associations with particular scenery, or books, or
songs, make him react emotionally when they are recalled to him
through a painting or a poem or a musical composition; the painting,

poem, or music then appears to him as "sublime" or "beautiful" depending upon the intensity of his associations. In Alison's opinion, the individual's strongest associations were those that sprang from his own country's scenery, customs, traditions, and history: "National associations . . . [increase] the emotions of sublimity and beauty as they very obviously increase the number of images presented to the mind." [19]

Associationist psychology, which connected man integrally with what he saw, heard, and felt, established an intimate connection between man's environment and his emotions; it therefore described the American experience with greater accuracy than did classical doctrine, which tended to separate man from his physical surroundings and place him outside the "frame of Nature." Just as Wordsworth, influenced by the associationist explanation of the nature of man's experiences, turned away from classicism and related man to his external environment, so many Americans, before and after Wordsworth's influence was felt in this country, turned to associationist aesthetics for a definition of art and nature and man's relation to both. Yet, although classicism and associationism were contradictory in their emphases—one positing a priori principles as the source of knowledge, while the other posited empirical experience or sensationalism—they were in agreement with respect to the goals and influences of art. Both emphasized the moral and intellectual value of the fine arts: the classicist Reynolds, for example, presaged the associationist belief that constant exposure to the great masterpieces of art would favorably affect the whole mental development and behavior of the observer as well as his artistic taste, while Alison agreed with Reynolds that the fine arts served "to exalt the human mind from corporeal to intellectual pursuits." [20]

American intellectuals were highly receptive to these concepts. In 1816, DeWitt Clinton, a classicist in taste and aesthetic principle, reflected the influence of the associationists' emphasis on the derivation of ideas from sense perceptions and the effect of national associations on art; "the inventive powers," said Clinton,

act upon those images which have been collected by observations and deposited in the storehouse of memory—and which refer not only to the world of sense without us, but to the world of thought within us. But as almost all our ideas are derived in

the first instance from sensation—and as the imitative arts rely for their field of operations upon the material world, it must be obvious that the imagination of the artist must derive its forms and receive its complexions from the country in which he was born and in which he resides.[21]

Two years later, another cultural nationalist, John Knapp, writing in the *North American Review*, showed his familiarity with associationist doctrine when he asserted:

If we take any glory in our country's being beautiful and sublime and picturesque, we must approve the work which reminds us of its scenery. . . . If men's minds are influenced by the scenes in which they are conversant, Americans can scarcely be denied acclaim to be inspired with some peculiar moral graces by their grand and lovely landscapes. But, moreover, it is beneficial to connect our best intellectual associations with places in our own land.[22]

Under the influence, then, of the Enlightenment and eighteenth-century European and British philosophy, American nationalists during the first decades of the nineteenth century developed an apologia for the fine arts that became a justification for the encouragement of a native artistic and intellectual life.[23]

—3—

The fine arts, American writers argued, provided a source of "rational enjoyment" for men of wealth who might otherwise dispose of their fortunes in "the extravagance of gambling, horseracing, betting &c: habits too readily borrowed from the luxury of old countries; degrading to the morals of youth, and at once ruinous to their health and fortune." The encouragement of a national taste for the fine arts would improve the pastimes of the entire nation and offer an intellectual, refined, and gentle way of satisfying people's desire for amusements. "Public amusements are and must be a part of the system of civilized life," wrote the Boston merchant Samuel A. Eliot in 1829, "and the character and condition of a country cannot fail to be much affected by the nature of them." Society must have its luxuries, and surely, Eliot thought, the fine arts were better than the "gross luxuries" of "corporeal indulgences." The "healthful" and

"innocent" pleasures afforded by "galleries of paintings and sculpture" were preferable to the "odious scenes of dissipation" provided by "bull-baiting, bear-baiting, and prize rings." [24]

The fine arts were considered capable of "counteracting the overworked, anxious character of [the] community"; they provided a distraction from the pressures of material interests, encouraged "reflection," disposed one to "tranquillity," and thus produced an "agreeable melancholy . . . suited to love and friendship." The development of a superior taste added to knowledge and enriched the imagination "with a thousand agreeable images" that provided constant pleasure for the mind. More important, by increasing knowledge, the fine arts improved an individual's judgment—of men as well as the productions of art. They enabled him to form more just notions of life and to lose that "delicacy of passion" which is affected by the "frivolous" and is so "incommodious." In addition to improving a man's judgment, the fine arts also exerted a favorable influence on character generally by rendering the "soul more susceptible of whatever is noble and good." Individual awareness of the "noble simplicity" that "reigns throughout all the works of the Creator" increased as a result of exposure to the fine arts; the arts became, in fact, a school of virtue and morality. Through the development of a sense of beauty, the individual came to recognize that "order" which "facilitates the perception of the whole" and "would guide him to a knowledge of the rules of truth." Taste "excited" the individual to become "more familiar with nature, to carry his researches farther"; and this knowledge of nature and insight into the order that nature presented was, so the argument ran, "highly instrumental in the formation and preservation of manners." [25]

The moral and educative characteristics attributed to art provided an effective answer to assertions that art would weaken the moral fibre of the nation because of its emphasis on the sensuous. The arts, DeWitt Clinton argued, "marked with an unerring hand" the boundary between "barbarism and refinement." By stressing the single idea that the "cultivation of the liberal arts will not allow men to relapse into ferocity," William Tudor, Boston merchant, diplomat, and amateur essayist, easily generalized the argument to include the elevation of the nation as a whole as well as of its individual citizens. The tendency of the arts, wrote Tudor, is to "purify, adorn and elevate every country where they are cherished." When they are

encouraged by the nation, Tudor believed, they are capable of conveying ideas directly and powerfully. His fellow Bostonian, Franklin B. Dexter—lawyer, amateur painter, and collector—took up the argument; the arts, wrote Dexter, "act immediately on the character of a People, as well as of Individual Man; they are addressed to the whole mass of society." They become, in the words of a writer in the *Analectic*, "the instruments of public morality." [26]

The profits that a development of taste in the fine arts would bring to the nation were not confined to the intellectual or moral kind. Dexter thought that a community interest in the fine arts would provide "a livelihood" as well as a "consideration in society" for individuals who wished to labor with their minds; it would open "a new . . . field of profitable intellectual industry." The fine arts could also become "very abundant sources of national and individual wealth" because of their influence upon manufactures, wrote Tench Coxe in a Treasury Report of 1814. Coxe pointed out the specific ways in which the fine arts, particularly architecture, painting, and sculpture, had already benefited manufactures in this country, especially the productions of "alabaster, marble, clay, plaster and metals, and of wool, linen, cotton and leather." Writers urging the cultivation of the fine arts repeated this theme often, in the undoubted expectation that such an argument would appeal directly to the American business mind. So, in 1816, Tudor, writing in the *North American Review*, discussed the idea that the influence of the fine arts could be felt in many industries, and contributors of articles to the *Analectic* also emphasized the relationship between improvement in manufactures and proficiency in the arts of design. It is not surprising that this argument was stressed during the years following the War of 1812, when American manufacturers were finding it extremely difficult to meet the competition provided by the industrially advanced English economy. [27]

Nationalists who genuinely feared that long distances and a disparate population threatened the unity of the country argued that the fine arts would re-enforce the citizens' feelings of loyalty "by preserving and multiplying the images of the truly great of the nation" and "by immortalizing deeds of patriotism and heroism." "The sculptured tomb which protects the ashes," wrote Tudor, "the simple engraving which on the walls of every parlour delineates the actions of patriotism or humanity, have been found among all nations

to be one of the incentives, one of the sweetest rewards to genius and virtue." The arts, in fine, because they "excite labor, produce riches, enlarge the sphere of innocent amusements, increase the stock of harmless pleasures, expand our intellectual powers, improve our moral faculties, stimulate to illustrious deeds, enhance the charms of virtue, diffuse the glories of heroism, augment the public wealth, and extend the national reputation," demanded the aid and attention of the nation; where they flourished, they conferred on the nation "a rank and distinction in the annals of mankind, the most honorable and the most durable that can be attained." [28]

THE APOLOGIA CONTINUED: EMERSON, RUSKIN, NORTON

COMMUNITY LEADERS WHO TOOK PRIDE in being "guardians of a great tradition" gave the initial impetus to the movement for the encouragement of the fine arts in the United States. The cause was further taken up by the succeeding generation of Romantics, who despite their hostility to the classical ideas held by their fathers, yet found, as Perry Miller has pointed out, in the eighteenth-century "doctrine and . . . practice of the beautiful," a language which they could use to express their revolt. Many voices were heard in the mid-nineteenth century justifying the encouragement of art. Especially articulate were the Transcendentalists in New England, the spokesmen for the Art Unions, and the editors and publishers of the women's and literary magazines that flourished in great profusion during these years. Above the general melee, the dominant tones that emerged to define the meaning of the cause were those of the American essayist and lecturer, Ralph Waldo Emerson, the English art critic, John Ruskin, and the first American professor of the history of the fine arts, Charles Eliot Norton.[1]

— I —

Ralph Waldo Emerson was probably the most forceful apologist for art that nineteenth-century America produced. The Concord philosopher had derived his sense of responsibility for the cultural level of his community in large measure from his father, the Reverend William Emerson, who, along with other Bostonians "conscious of their rank," had undertaken at the beginning of the century the task of planning for "a future city notable for letters, arts, and sciences." While rejecting his father's social conservatism, Emerson remained

dedicated to the ideals of the Enlightenment which had given meaning to his father's efforts. Emerson also retained the ministerial zeal of his father, an enthusiasm that burst forth in a grand effort to convert his fellow Americans to a religion of culture.[2]

Toward the actual arts of painting and sculpture Emerson reacted as a creature of his time; he viewed them primarily from a literary point of view, as the artist's expression of his moral insight, rather than from any passionate concern with the intrinsic, formal qualities of art. He had come to the fine arts from history, and despite further, more intimate experiences with painting and sculpture in Europe as well as at home, he persisted in regarding these as an expression of historical development. In fact, art's "highest value" was "*as history.*" Throughout all his speeches and writings, when the fine arts were his subject, he maintained the belief that art was simply a different mode of expressing historical, poetical, or philosophical ideas. "The artists, the orators, and the leaders of society" were all engaged in the same task, wrote Emerson: "to give an all-excluding fulness to the object, the thought, the word they alight upon and to make that for the time the deputy of the world." Like religion and education, art aimed at "the practical and moral," which for Emerson was the restoration of "the simplest states of mind," or the conscience. Moreover, Emerson believed that the fine arts sprang from indigenous sources, as did the other practical arts that man pursued. "Beauty," he wrote in his essay "Art," "must come back to the useful arts, and the distinction between the Fine and useful arts be forgotten." Such beauty would "not come at the call of a Legislature nor will it repeat in England or America its history in Greece. It will come, as always, unannounced, and spring up between the feet of brave and earnest men." [3]

Emerson's message included both an indictment of American culture and a vision of its potential achievements. "We have listened too long to the courtly muses of Europe," he proclaimed in 1836. The time had come to domesticate culture. America had yet "no genius . . . with tyrannous eye, which knew the value of our incomparable materials." "America is a poem" unsung: "our logrolling, our stumps, and their politics, our fisheries, our Negroes and Indians, our boats and our repudiations . . . the northern trade, the southern planting, the western clearing, Oregon and Texas"—all were worthy subjects for artists' pens and brushes. An art that embodied such material and conveyed the essential ideas of the American nationality

was, in Emerson's view, an art eminently worthy of encouragement.[4]

The scholar, according to Emerson—and by the scholar he meant all men involved in thinking and creating—was the "delegated intellect" of the community and was sent into the world "as a leader to lead." In this way Emerson glorified the position of the poet, the thinker, the literary man, and the artist as valuable, respectable, and, indeed, necessary citizens of the national community. The artist was a man in whom the love of beauty existed "in such excess" that "not content with admiring," he sought to "embody it in new forms." By doing so he made the beauty of nature accessible to all who were capable of responding to it; and this meant, potentially, every man, "for all men have the thoughts whereof the universe is the celebration." While exalting the artist, Emerson justified his position in a democracy, for he widened the social base of art and proclaimed it possible for all men, not just an intellectual elite, to open their minds and "souls" to the message of the artist. Moreover, Emerson's aesthetic was also one for a democracy. "Pictures," he advised, "must not be too picturesque. Nothing astonishes men so much as common-sense and plain dealing. All great actions have been simple and all great pictures are." Such pictures could be understood and appreciated by all who had "eyes capable of being touched by simplicity and lofty emotions." "The knowledge of the picture-dealers," Emerson went on, "has its value, but listen not to their criticism when your heart has been touched by genius. It was not painted for them, it was painted for you. . . ." What could be more effective than such advice to a democracy just beginning to feel its power during the age of Jackson! [5]

The force of Emerson's message cannot be completely understood by the mere citation of specific phrases he used. Almost every speech, every essay, every article or book is permeated by his special pleading for the cause of art and by his philosophical idealism that saw art as the final expression of the whole man and "an abstract or epitome of the world." This message was carried to Americans wherever Emerson went to lecture, whether in Providence, Rhode Island, or Freeport, Illinois. At a time when the public speaker provided Americans in all areas of the country, from the sparsely settled rural regions to the more heavily populated cities and towns, with one of their important sources of new ideas, Emerson's lectures exerted an influence of an incalculable extent. George P. Bradford has said that

Emerson's lectures at the Masonic Temple in Boston "constituted an era in the social and literary history" of that city, "as well as in the life and culture of many individuals. . . . To his hearers they seemed to open a new world. . . ." "Earnest people in the common walks of life, who loved to sweeten their unromantic lives with such entertainment," filled bitterly cold halls to listen with emotions bordering on awe and reverence to the slightly nasal, low, diffident tones of this Yankee scholar. An occasional American might walk out of Emerson's lectures because of the obscurity of their content and the soberness of his delivery—what the people wanted was "a hearty laugh"; but more stayed than left, impressed with the importance of his message. Emerson's lectures encouraged the circulation of his writings. Magazines like the *Crayon* and the *Cosmopolitan Art Journal*, along with local newspapers, regularly printed excerpts from his speeches and writings, so that by 1860 Emerson's belief that the fine arts possessed value for a democracy and that an American art expressing native themes was essential for the full realization of nationality had effectively pervaded many areas of the United States and the minds of many Americans.[6]

—2—

Another prophet of the mid-century whose work helped to further an interest in the fine arts in the United States was the English critic, John Ruskin. Ruskin's first volume of *Modern Painters* appeared in an American edition in 1850, three years after its English publication, but many Americans had read it even before the official American edition appeared. In fact, a review of *Modern Painters* by Franklin B. Dexter appeared in the *North American Review* in January, 1848; and in June, 1848, Emerson noted in his Journal that he was becoming interested in the landscapes of Turner under Ruskin's tutelage. The initial reception given to Ruskin's book was "as to one of the sensation-books of the time, and fell upon the public opinion of the day like a thunderbolt from a clear sky." Some Americans, especially members of the older generation of classicists—"most of the reverent and conservative minds"—disapproved of the writer's rejection of the Old Masters; while others, especially those of Emerson's romantic generation—"most of the enthusiastic, the radical, and earnest"—found in Ruskin a spokesman for their own "modernism."[7]

Many of Ruskin's ideas had been current during the half-century

preceding the appearance of his book; in one form or another they had been expressed by the eighteenth- and early nineteenth-century aestheticians who had influenced early American thought—Burke, Reynolds, Stewart, Fuseli, and Alison, among others. To these writers Ruskin owed some of his ideas, but he reinterpreted them to satisfy his individual viewpoint, infused them with his sense of religious morality, and poured them out with an "impetuous enthusiasm" that appealed to many Americans.[8]

The reasons for Ruskin's popularity in the United States are not difficult to discover. In the first place, many Americans were easily convinced by Ruskin that modern artists were superior to the Old Masters, for in their rebellion against the ideas and claims of classicism they were eager to discard the painters whom the classicists so highly valued. Emerson had already spoken out against the "worship of the past" and had called the attention of his fellow Americans to the work of their contemporaries. More important, Americans found no difficulty in rejecting the Old Masters since most of them had never seen a genuine old painting. The few good old paintings that did arrive in this country were for the most part in private collections and were only occasionally on public view when lent to exhibitions. Many of the Old Masters that were presented to the American people as examples of fine art were copies or "spurious" reproductions; and when a genuine masterpiece did make its appearance, often the sooty accumulations of the years obscured whatever merits it may have possessed as a work of art. Americans were thus, as Dexter put it, "not too willing admirers of antiquity," and when it came to considering the supremacy of the Old Masters, they harbored "a rebellious doubt." Dexter felt that Ruskin, by rejecting these painters, was flattering the "notion of the unlearned" who, without having seen such works of art condemned them, and he accused Ruskin of doing art a gross disservice thereby. The Bostonian's was a minority voice, however, the last protest of dying classicism in this country. After him, American writers and readers and artists alike were joined in their appreciation for this new prophet of art, whose views, in one writer's opinion, exercised the highest influence "in the buildings and paintings of the day."[9]

Besides appealing to the desire of Americans to find fault with works produced in Europe under different and, in their opinion, "inferior" social systems, Ruskin's general attitude toward art found

ready favor here. For Ruskin, like his contemporary Americans, viewed art in moral terms and emphasized the message of the artist in the belief that what was represented was of as much importance as the manner of representation. When, in *The Seven Lamps of Architecture* (1849) and *The Stones of Venice* (1851–53), Ruskin underlined the intimate relationship that he believed existed between art and national morality—the idea that art reflected a nation's character and highest moral aspirations—he was effectively reinforcing an attitude that had prevailed in this country for the previous half-century.

Ruskin's moral justification of art went further than that of the eighteenth-century philosophers; the morality involved in his attitude toward art did not result from the perfection of reason and the development of an insight into nature, but came as a revelation from God. Ruskin voiced his claims and demands for art in terms of the Bible and religion, and these were familiar and arousing sources to most Americans habituated to thinking of life in spiritual terms. To the rational Boston jurist, Franklin Dexter, who calmly sought the Ideal in art through the exercise of the intellect in classical fashion, Ruskin's dogmatic assertions that landscape painting must teach a "holy lesson," "penetrate . . . that which was hidden," make the observer feel "the wonder . . . the power . . . the glory of the universe," and lift his thoughts "to the throne of the Deity" were "singular opinions" and not to be considered seriously. To younger critics, however, warmed by the fires of Transcendentalism, Ruskin's "deep religious warmth," which dealt with art "as if he had been studying her mysteries among the shadows of another world and in a holier atmosphere," promised a new era when art "in its true mission" —that is, united with morality and virtue—"will purify the intellect from the dross of worldly aspirations." In America there were two extremes, wrote C. C. Everett in 1857: one was a "materialism which tends to check the development of our higher nature," and the other, "a spiritualism which would cast aside all outward form." What Ruskin provided, according to this writer, was "the mediation of beauty" that "blended" the two forces, refining the one while giving substance to the other.[10]

—3—

Cultural nationalism, the philosophy of the Enlightenment, the democratization and nationalization of art as enunciated by Emerson,

and the philosophy of the religious morality of art as set forth by Ruskin endowed the fine arts with a value that justified their encouragement by Americans of the mid-nineteenth century. The coalescence of these attitudes and beliefs is most clearly seen in the person and mind of Charles Eliot Norton, who, as teacher and writer, carried this mission of art (as defined before the outbreak of the Civil War) into the postwar period and thereby provided a transition to postwar ideology and developments in the field of art.[11]

Charles Eliot Norton, born in Boston into the intellectual world of the ministerial Nortons and the wealthy Eliots, was a typical descendant of the Enlightenment. In him were combined the learning and culture of his Puritan forebears and the business conservatism and sense of *noblesse oblige* that accompanied inherited wealth. Norton's strong sense of aristocracy was mitigated by an equally strong sense of responsibility for the cultural and intellectual well-being of his community. Though deeply engaged in business activities, he maintained an active interest in educational reform. He founded and taught at an evening school for workers and labored in behalf of the New England School of Design for Women as well as for the Unitarian Sunday School. Humanitarianism and evident business capacity resulted in the successful establishment of his "model" lodging-house development in Boston, designed as a pilot project to point the way for slum clearance. Norton's sense of community responsibility also entered into his art criticism and instruction, which were guided and motivated by the prevalent belief that the art of a country reflected its moral climate and grew in greatness as the morality of a people increased.

In his early years, Norton was optimistic about America's future in the fine arts and shared Emerson's faith in the artistic potentialities of the nation. "We shall see nobler pictures than Titian or Raphael ever painted or dreamed of," he wrote in 1855 to William J. Stillman, co-editor of the *Crayon*, "because given equal powers of coloring and drawing . . . we shall have pictures painted by men whose imaginations are refined, whose conceptions are ennobled by their sense of the moral relations of their Art, and of the responsibilities under which they work." A few years later, shortly before the outbreak of the Civil War, Norton wrote a series of articles for the newly founded *Atlantic Monthly*, in which he expressed a much less hopeful feeling about the future course of cultural development in America.

Now America appeared to him as a land "barren and naked," possessing "neither the taste nor the capacity for any noble works of art." Norton went on to urge Americans to turn to pursuits not associated with "instant return of tangible profit" and to develop interests that would, instead, bring them into "the freer, tranquiller, and more spacious world of noble and everlasting thought." Believing that America lacked a "supply of those men who . . . do the higher and more lasting constructive work of civilization," he insisted, in a vein reminiscent of Emerson, that America needed scholars of her own; how long, he asked, would the country continue to rely on "the thinkers and scholars of other lands?" [12]

Norton's reviews in the *Atlantic* reached the homes of more than forty thousand subscribers and were read by many more readers. After the Civil War his attempts to influence American opinion in matters of art and behavior were channeled into his teaching activities at Harvard University, where he tried to inspire his students "with love of things that make life beautiful and generous." He also continued to fill the pages of the *North American Review*, the *Nation*, *Scribner's*, and other journals with articles deploring America's mediocrity in the arts, her spiritual barrenness, and her stultifying conformity.[13]

Norton's increasingly pessimistic views about the possibilities of American cultural life following the war belong to another chapter of American intellectual history. What is important here is the continuity he provides to a tradition of American thought that was born out of the peculiar social and economic nature of American life. The possibility that economic prosperity might turn Americans to gross materialism and the fear that democracy meant inevitably a vulgarization of culture lay at the heart of the cultural nationalists' plea for the encouragement of art in this country. What the country needed, said its critics—William Tudor, Franklin B. Dexter, William Emerson, Ralph Waldo Emerson, and Charles Eliot Norton, among many others—was an educated elite who would raise American intellectual and moral standards by encouraging all efforts to foster art, artists, and the development of taste. An industrial society could avert complete degradation only through art, and the single force that could "raise to a divine use the railroad, the insurance office, the joint-stock company," as well as "the moral nature" of the individual worker, was a sense of beauty. That Emerson's and Norton's message

was also Ruskin's simply added to the effectiveness of the British critic's writings, for he thus reinforced a long felt belief.[14]

Norton's opinion that America was still wanting in cultural resources in 1860 seems an exaggeration since the preceding decades had not been without their achievement in the arts. As a result of the urgings of the early cultural nationalists, Americans were making progress in establishing the fine arts on a more secure and permanent foundation. The mid-century, in fact, witnessed a great flowering of art in America as patronage was extended to many more artists than ever before for paintings and sculpture on all levels of art and in all genres. In most of the major cities, attempts were made to found art institutions and to hold art exhibitions, efforts which were usually justified by the argument that America needed the refining influence of art if it were to escape the effects of materialism. If the kind of art that "flourished" in this country during the mid-century did not meet with the approval of Norton, whose course in art history never extended beyond 1600, it nevertheless did provide something of an impetus to the eventual development of a cultural situation more compatible with his European-inspired dreams. For what Norton and other nineteenth-century critics of American culture accomplished was to force on the consciousness of the American people a sense of their cultural shortcomings and a belief in the redemptive value of art. These were lessons that had to be learned before the goal that the critics aimed for could be fully realized.[15]

War and *Peace* (marble), by Luigi Persico (1791–1860). Reproduction from the original by Carl Schmitz. East Central Portico, main entrance, United States Capitol. Courtesy Library of Congress.

These statues were commissioned by President John Quincy Adams, one of the many government officials who admired Persico. What appeared foreign in their treatment aroused unfavorable criticism. In 1886 Ben Perley Poore noted that War was "a stalwart gymnast with a profuse development of muscles . . . while Peace is a matronly dame, somewhat advanced in life and heavy in flesh, who carries an olive branch as if she desired to use it to keep off flies."

Declaration of Independence, by John Trumbull (1756–1843). Rotunda, United States Capitol. Courtesy Library of Congress.

Trumbull's commission to paint four panels for the Rotunda was the first offered an American artist by the government; the results were among the most criticized works of the day. John Quincy Adams, a skeptic about American art generally, noted in his diary in 1817 that he was not disappointed in the *Declaration* "because my expectations were very low; but the picture is immeasurably below the dignity of the subject. It may be said of Trumbull's talent as the Spaniards say of heroes who were brave on a certain day: he has painted good pictures."

The Resignation of George Washington, by John Trumbull. Rotunda, United States Capitol. Courtesy Library of Congress.

The Resignation of George Washington also created consternation; Congressman Holmes of Maine claimed he would not give thirty-two cents for the series of paintings, never mind thirty-two thousand dollars. "The event," he insisted in 1825, "was one of the most sublime incidents that ever took place in the country. But what do you see . . . Why, a man looking like a little ensign, with a roll of paper in his hand, like an old newspaper, appearing as if he was saying, 'Here, take it—I don't want to give it up.'"

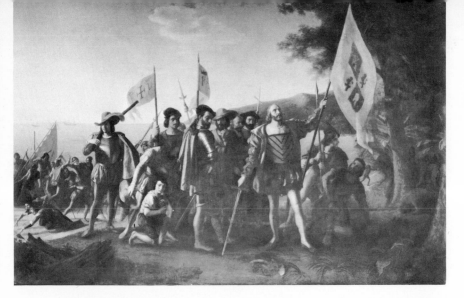

The Landing of Columbus, by John Vanderlyn (1776–1852). Rotunda, United States Capitol. Courtesy Library of Congress.

Vanderlyn's painting for the Rotunda came as the climax to a long career devoted to seeking government commissions and to complaining about not being appreciated. Finished in Paris, the painting did not delight all Americans, although the *New York Journal of Commerce* relished its patriotic content and declared it "a proud triumph to American Art and genius. The first impression made upon us was that the sky, water, and whole scenery were *American*. . . ."

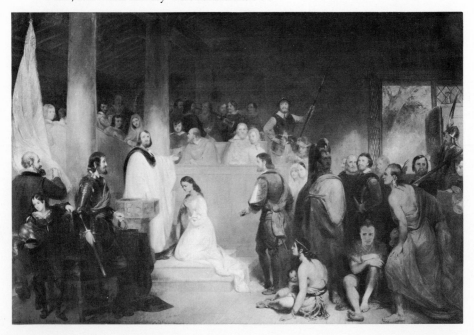

The Baptism of Pocahontas, by John Chapman (1808–1889). Rotunda, United States Capitol. Courtesy Library of Congress.

Chapman's Rotunda painting also aroused complaints among Americans that "we had not an artist to whom we could trust an order for a picture that would do credit to the Capitol." The ridicule it excited made many congressmen even more unwilling to extend government patronage to artists.

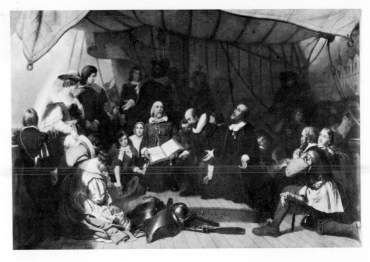

The Embarcation of the Pilgrims, by Robert W. Weir (1803–1889). Rotunda, United States Capitol. Courtesy Library of Congress.

Weir's *Embarcation* was more hospitably received than the other Rotunda paintings, but even he found it necessary to defend his characters' "gay" dress. "I try to tell in the picture, in an instant of time," he wrote to Congressman Verplanck in 1843, "all I know of the individuals and the situation in life which they left, to show the sacrifice which they made and heighten the moral character of the scene."

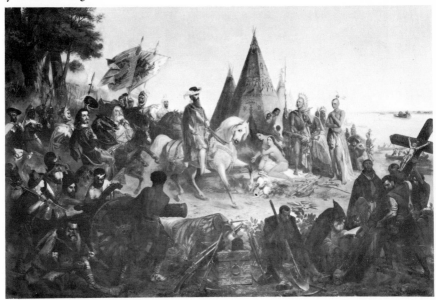

De Soto Discovering the Mississippi, by William H. Powell (1823–1879). Rotunda, United States Capitol. Courtesy Library of Congress.

When Inman died before completing his painting for the Rotunda, the commission to fill the vacant panel was given to William H. Powell, much to the regret of friends of Samuel F. B. Morse who hoped that the aging artist would be granted the honor. Powell was recommended for the job as a westerner who could thus increase the national representation of the Rotunda collection; his paintings, however, received as severe criticism as the others. "We do not know just what it was that Mr. Powell set out to paint," wrote F. C. Adams in 1871, "but we do know that he succeeded in giving the government a picture in which fancy is in excess of historical truth."

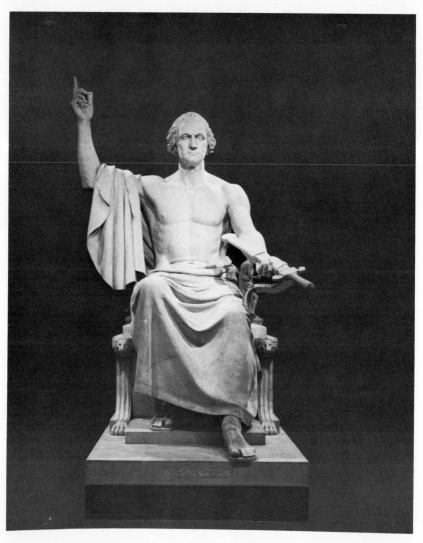

George Washington (marble), by Horatio Greenough (1805–1852). Growth of the United States Halls, Museum of History and Technology, Smithsonian Institution. Courtesy Smithsonian Institution.

Greenough's statue was as hotly defended as it was criticized. The classicist Edward Everett found it "truly sublime . . . of colossal grandeur. . . . In the reversed sword the design of the artist was of course to indicate the ascendancy of the civic and humane over the military virtues, which distinguished the whole career of Washington and which form the great glory of his character."

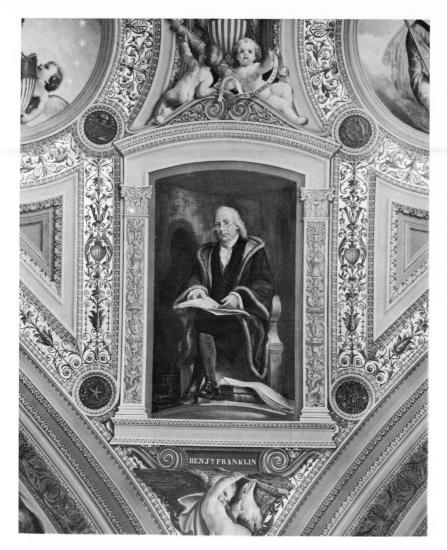

Benjamin Franklin (fresco), by Constantino Brumidi (1805–1880). President's Room, United States Capitol Extension. Courtesy Library of Congress.

Brumidi's frescoes in the Capitol Extension infuriated American artists and congressmen alike, who raged at what they considered foreign "gew-gaws" and ornamentation so contrary to republican simplicity. "Gazing," wrote Mrs. Ames in 1876, "I feel an indescribable desire to pluck a few of Signor Brumidi's red legged babies and pug nosed cupids from their precarious perches on the lofty ceilings, to commit them to nurses or to anybody who will smooth out their rumpled little legs and make them look more comfortable."

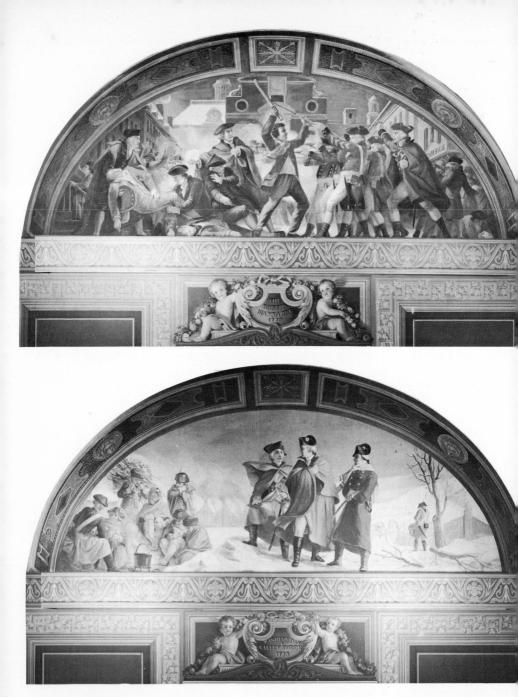

The Boston Massacre (fresco), by Constantino Brumidi. Senate Appropriations Committee Room, United States Capitol Extension. Courtesy Library of Congress. *Washington at Valley Forge* (fresco), by Constantino Brumidi. Senate Appropriations Committee Room, United States Capitol Extension. Courtesy Library of Congress.

The lack of nationality in Brumidi's paintings became a matter of criticism. "To do justice by American subjects, the artist should be baptized in the spirit of its nationality," insisted the United States Art Commission in 1859. But Brumidi's rooms were "so foreign in treatment, so overlaid and subordinated by symbols and impertinent ornaments, that we hardly recognize them."

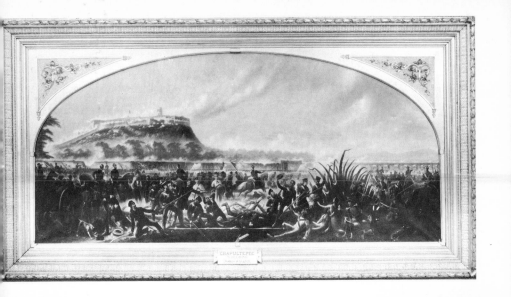

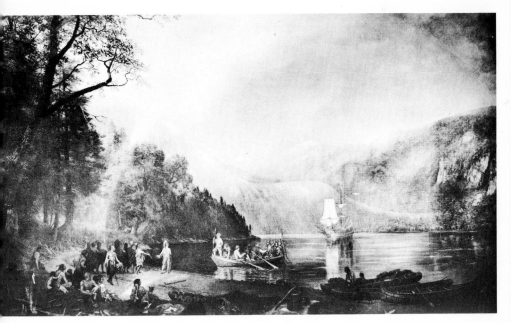

The Battle of Chapultepec, by James Walker (1819–1889). United States Capitol (in storage). Courtesy Library of Congress.
Discovery of the Hudson River, by Albert Bierstadt (1830–1902). United States Capitol. Courtesy Library of Congress.

After the uproar about hiring foreign artists to decorate the Capitol Extensions had died down, it was thought the better part of wisdom to offer the remaining panels to American artists. These paintings by Walker and Bierstadt were the result, but they too did not please the American public, despite their nationality. "Mr. Walker had genuine love for art," wrote F. C. Adams in 1871, "but his ability did not rise equal to the production of a large picture suitable for the Capitol."

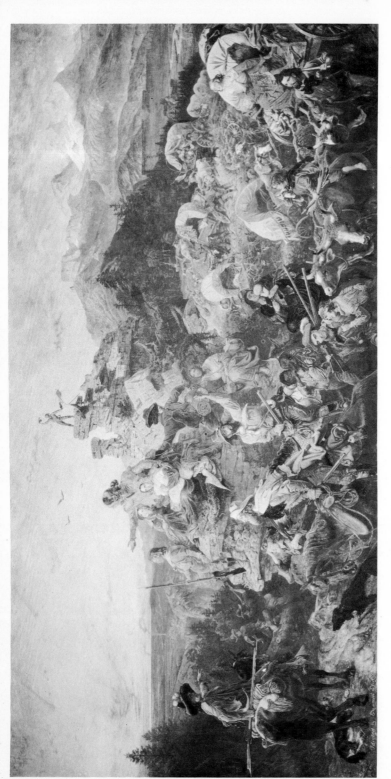

Westward, the Course of Empire Takes Its Way, by Emmanuel Leutze (1816–1868). West Stairway leading to Gallery of House of Representatives, United States Capitol. Courtesy Library of Congress.

Leutze's commission to do a painting for the Capitol Extension was urged by some congressmen who believed that the German-born and -trained artist was the best in the historical field. His painting was thought to be "strongly American in its character" and to express "the various features of the country in the far west, and the settlers who open it up to civilization." Unfortunately, the kind of paint used and the dampness of the wall resulted in fading colors

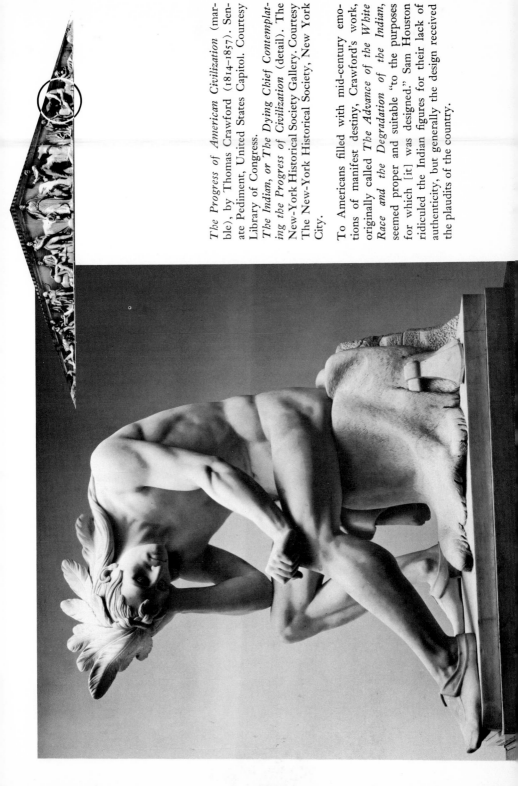

The Progress of American Civilization (marble), by Thomas Crawford (1814–1857). Senate Pediment, United States Capitol. Courtesy Library of Congress.

The Indian, or The Dying Chief Contemplating the Progress of Civilization (detail). The New-York Historical Society Gallery, Courtesy The New-York Historical Society, New York City.

To Americans filled with mid-century emotions of manifest destiny, Crawford's work, originally called *The Advance of the White Race and the Degradation of the Indian*, seemed proper and suitable "to the purposes for which [it] was designed." Sam Houston ridiculed the Indian figures for their lack of authenticity, but generally the design received the plaudits of the country.

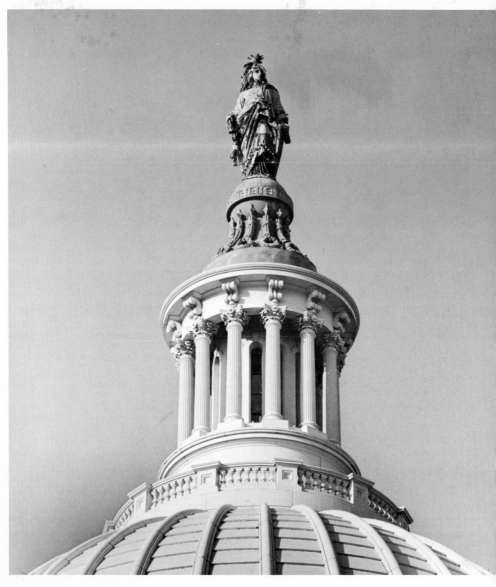

Statue of Freedom [*Liberty*], by Thomas Crawford. Capitol Dome, United States Capitol. Courtesy Library of Congress.

Armed Freedom, as the statue was originally called, received help from Jefferson Davis, who suggested the visored helmet. Some congressmen opposed all ornamentation for the Capitol Extensions, and took issue also with this "mythological" conception of Liberty. Sam Houston believed it represented "some unfortunate lady that had fallen into great bodily agony and infelicity of feeling."

PART II

ART AND THE FEDERAL GOVERNMENT

. . . we have learned to vote columns to the
tune of hundreds of thousands, while stat-
ues seem to us useless luxuries.

HORATIO GREENOUGH, 1844

IT WAS A MATTER OF COURSE that Americans who were seeking to encourage the development of a native art should look to the national government for assistance. The colonial governments, to a large extent, had established a precedent for state aid to arts and letters by founding and contributing to the support of colleges and learned societies and by encouraging town-supported schools. Although these institutions suffered during the War for Independence, the idea embodied in the first Constitution of Massachusetts persisted that "Legislatures and Magistrates were obliged to cherish the interests of literature and the sciences, and all seminaries . . . to encourage private societies and public institutions . . . for the promotion of agriculture, arts, sciences, commerce, trades, manufactures, and a natural history of the country. . . ." Cultural nationalists entertained the possibility of state and municipal aid to cultural institutions, but because of their concern with the nation as a whole, they more often looked to the national government for a program that would advance their cause.[1]

The early presidents continued the tradition set by the colonial and state governments. In 1789, George Washington considered the possibility of urging congressmen to use their "best endeavours to improve the education and manners of a people; to accelerate the progress of art and science; to patronize works of Genius, to confer rewards for inventions of utility, and to cherish institutions favorable to humanity." Without actually making such a specific recommendation to the legislators, he nevertheless frequently urged Congress to consider the possibility of a national university and military and naval academies, which, he believed, would help produce "a flourishing state of the arts and sciences" so essential for the "national prosperity and reputation." Despite occasional constitutional scruples, John Adams, Jefferson, Madison, Monroe, and John Quincy Adams all urged the establishment of national cultural institutions and the extension of the fostering hand of government to the arts and sciences, along with internal improvements and aid to commerce and manufacturing. These political leaders, influenced by lingering traditions of mercantilism, believed generally that it was the obligation of

government, as John Quincy Adams declared, to plan "for the progressive improvement of the condition of the governed," since "moral, political, and intellectual improvement are duties assigned . . . to social no less than to individual man." [2]

During the early years of the Republic the persistence of this tradition often meant that any project that seemed too large for individual enterprise to cope with would be proposed as a function of government. These projects were urged largely for nationalistic reasons: roads and canals, for instance, were considered necessary to bind together all sections of the country into an interdependent economy; similarly, a national university was expected to establish "a uniform system of education among citizens," to lessen sectional "jealousy and prejudice," and to multiply "features of a national character." An underdeveloped economy required protection in the form of tariffs, and an underdeveloped culture, protection in the form of copyright laws and in the patronage by the government of the arts and sciences. DeWitt Clinton recognized this function of government when he declared that "in the progress of a civilized and enlightened community, all the professions, whether liberal or mechanical . . . must be filled up; and it is the duty of a patriotic Government to encourage all, by dispensing its beneficence like the dew of heaven. . . ." [3]

Knowledge of traditional European practices bolstered the movement for government support of cultural enterprises. Despite their inclination to sever all ties with Europe, cultural nationalists were not willing to abandon European methods of achieving the ends they so earnestly desired. Many of them had been educated in, or were familiar with, European institutions, and they were aware that the fine arts in England, France, Italy, and Russia had received their greatest encouragement from the ruling heads of those countries. They insisted, however, that a popular government was equally capable of performing this service. A republic, declared Edward Everett in 1824, was not "destitute either of the means or the disposition to exercise a liberal patronage." To prove his point he referred to an ancient precedent that most Americans of his generation regarded as an unassailable argument: "No government, as a government, ever did more for the fine arts than that of Athens." [4]

Like Everett, the painter William Dunlap scorned the European style of aristocratic patronage of artists but approved the practice of

European governments in supporting the fine arts, especially the theater. Noting that French and German theaters flourished under government auspices, Dunlap proposed that the states establish their own theaters in order to eliminate the profit motive from theatrical enterprises and thus improve the quality of both the plays performed and the performances themselves. By such encouragement, all the arts —music, design, literature—would benefit.

Thomas Cole, foremost of the landscape painters of the Hudson River School, also looked to the Greek republics of antiquity for an example of the kind of patronage he desired for his country. "Art," the painter wrote, "wants a patronage of a more ample nature" than what was offered in America. In Greece, the "glory and fortune of a great painter did not depend as now on the caprice of individuals; he was the property of the Nation. He was employed by his country and by cities, and his rewards were considered as a just portion of the national expenditure. . . . Such will be the system in our country," he hopefully added, "when the people become fully instructed and made sensible of the moral and commercial influence of Art." [5]

Most of Cole's contemporaries shared his hope. John Trumbull, venerable soldier and artist of the Revolution, wished to "adorn the Capitol with Pictures which shall perpetuate the great Events and the glories of the Revolution, as the Ducal Palace of Venice and the Rath House [*Raaduis*] at Amsterdam, by the Talents of the Great Painters of the Day have commemorated [the glories] of these Republics." Trumbull had printed and distributed among legislators a scheme for systematic government patronage of the arts. Here he suggested that the federal government commission artists to paint pictures to commemorate political, naval, or military events of great importance, as these occurred; copies and engravings of the paintings would be distributed to "national servants," foreigners of distinction, and embassies and consulates of the United States all over the world. From the funds collected by the sale of engravings of these national paintings, the cost of the entire project would be defrayed. "So," Trumbull concluded, "it appears that with very little expense beyond the mere PATRONAGE OF GOVERNMENT, the fine arts may be stimulated and encouraged, the national edifices decorated, authentic monuments of national history preserved, elegant and attractive rewards bestowed on the meritorious servants of the public, and the national glory essentially advanced." [6]

Samuel F. B. Morse, founder and first President of the National Academy of Design in New York, proposed that the Library Committee of Congress award commissions for historical paintings in the Rotunda of the Capitol that would "collect the variety of talent which exists in this country" and stimulate the energies of genius. The portrait artist and historical painter, John Vanderlyn, for decades attempted to "make interest with the Government for a National Establishment or Gallery of Pictures," which he, of course, hoped to supervise. Horatio Greenough, John Frazee, Hiram Powers, Robert Weir, Henry Inman, Rembrandt Peale, among many other artists, actively pressed for governmental participation in the arts and looked to the government for commissions whenever such possibilities arose.[7]

The country was not ready, however, for any kind of extended plan of governmental patronage of the fine arts. Most of the individuals who sought such aid were from the northeastern section of the country, and they had to contend especially with the opposition of jealous westerners from "those enormous swamps of semi-culture" who pleaded economy or preferred projects more essential to the development of their section. During the first half of the nineteenth century Congress faced complicated economic and political problems that accompanied incipient industrialism in the North and the accumulation of immense territories in the West. Banking, the sale of public lands, the tariff, internal improvements, slavery in the territories, and states' rights overweighed all other issues that came up for congressional consideration during these years. All questions involving the participation of government, besides becoming entangled in normal political maneuverings between parties and men, eventually became complicated by the controversy between North and South, between free and slave interests, between philosophies of national power and states' rights. Under such circumstances, it would have been impossible to come to any agreement about a national program for the fine arts even if such a program had been presented.[8]

Patronage of the fine arts by the federal government was extended in response to specific needs. The first occasion came with the building of the Capitol, since a new government building required decoration and embellishment if it was to represent the dignity and pride of the nation. When British troops put the torch to the half-completed Capitol during the War of 1812, the necessary rebuilding

following the peace provided a second opportunity for artistic patronage by the government. A third, large, opportunity occurred in 1850 with the planning and construction of the Capitol Extension. Each of these occasions stirred the hopes of artists and others interested in promoting art that out of the specific need for ornamentation two things in particular would develop: a governmental policy with respect to encouraging the arts and a diffusion of taste for the arts among the citizens. Their hopes were doomed to disappointment, as were those of the various congressmen and artists, who, with the same ends in view, throughout the half century attempted to obtain commissions from the national government for works of art. Sometimes commissions were granted, sometimes not; but in no instance did such individual successes or failures lead to any over-all plan or program of government aid to the arts. In fact, so great was the government's desire to avoid the impression that it was entering the field of art that when commissions were granted they were frequently accompanied by an express denial that the government was thereby becoming a "patron of the Fine Arts." Whether or not this kind of haphazard commissioning was good for the arts, it did have an effect on the course of development that American art took during these years. The fact that the art produced for the government generally gave little satisfaction also resulted in a growing antagonism among congressmen towards such projects and a prejudice against government sponsorship of the arts that was never wholly eradicated.[9]

CHAPTER THREE

BUILDING THE CAPITOL

In 1800 THE CITY OF WASHINGTON in the District of Columbia was made
the seat of the federal government, and immediately men's thoughts
turned to the problem of building a Capitol to serve the young
Republic's needs.[1] "The magnificence of a free people," said DeWitt
Clinton, "ought always to be seen in their halls of justice, in their
edifices of learning, and in their temples of religion." It was even
more important that the Capitol reflect the spirit of the new nation.
The building, in the words of the Commissioners of Public Buildings
and Grounds of the City of Washington and the District of Colum-
bia, must "exhibit a grandure [sic] of conception, a Republican
simplicity, and that true Elegance of proportion which corresponds to
a tempered Freedom. . . ." A skilled architect was, therefore, a
necessity; but artists were also needed to ornament and decorate this
important national building.[2]

In 1793 the amateur architect William Thornton was appointed the
first Architect of the Capitol, a position which he held until 1802.
Thornton's design for the exterior of the building was retained in part
by his successor, the English-born Benjamin Henry Latrobe, who
had been called to Washington by President Jefferson in 1803 to
bring some order out of the confusion of plans that had been drawn
for the building. Both Latrobe and President Jefferson were familiar
with many of the great buildings in Europe and in their plans for the
interior of the building they included sculptural decorations for the
Hall of the House of Representatives. Native professional sculptors
were few, however, and none of these, in Jefferson's opinion, had the
requisite skill or experience for the task at hand. For this reason
Jefferson had recommended the French artist Jean-Antoine Houdon
to the State of Virginia when, in 1784, it proposed to commission a

statue of Washington; and for a similar job, he later recommended the Italian sculptor Canova to the Governor of North Carolina. For the sculptural work on the Capitol, then, Jefferson turned to an Italian friend and correspondent, the physician Philip Mazzei, and on his recommendation brought two Italian artists, Giuseppe Franzoni and Giovanni Andrei, to the United States at the government's expense.[3]

Of "good temper and good morals," as well as possessing "talent in their art," these sculptors were put to work carving Corinthian capitals and designing and executing colossal eagles. Latrobe had no illusions about the abilities of the sculptors; Franzoni and Andrei were, he believed, "the only sculptors in America" and therefore the only talent available: they would not *"disgrace"* us, but they were certainly not the equal of Canova or Thorwaldsen or Flaxman. Latrobe valued the work of the two men because he believed that sculpture was essential to the effect of his architecture; beyond this he hoped that their presence and their work would give "a taste of art to our citizens of which . . . very few have the most distant apprehension." As he later put it, "if a conviction can be wrought and diffused throughout the Nation that the fine arts may indeed be pressed into the service of arbitrary power . . . yet that their home is in the bosom of a republic, then, indeed, the days of Greece may be revived in the woods of America. . . ."[4]

What these Italian sculptors actually accomplished in the way of providing sculpture for the Republic is not completely clear, because much of their work and most of the documents that might cast light on it were burnt when the British troops set fire to the Capitol in 1314. Andrei's work seems to have been almost completely in decorative sculpture. Franzoni, a statuary sculptor, carved two colossal eagles, one for the frieze of the entablature of the Hall of Representatives and one for the gate of the Navy Yard. Since Franzoni was more familiar with the "Italian, or Roman, or Greek" variety of eagle, Latrobe solicited the aid of Charles Willson Peale, the artist and museum-keeper of Philadelphia, for a drawing of an American bald eagle, in order to avoid "any glaring impropriety of character" which would be "immediately detected by our Western members." Franzoni also carved a group of female figures representing Agriculture, Commerce, Art, and Science, and a statue of Liberty that also had to be "Americanized" by the architect. The Italian

would have presented Liberty with "a club or shelalah" in one hand, or with "doves nestling in a helmet"; but Latrobe, more sensitive to the temper and tastes of his adopted countrymen, and especially of congressmen, had the figure carved "with an Eagle by her side, her right hand presenting the Constitution and in the left a Liberty cap. Her feet rested on a reversed crown and symbols of monarchy and oppression." This estimate of what would appeal to American legislators undoubtedly influenced Latrobe's design of the "corncob capitals," executed by Franzoni in 1809, which won "more applause from the members of Congress than all the works of magnitude or difficulty that surround them" and which were admired by Americans and foreigners alike, who found them, as did Mrs. Trollope, "truly American." [5]

The necessity that Latrobe faced of avoiding "Italian frippery" in the work of the two sculptors indicates how nationalism affected artistic taste very early in the century. Close adherence to natural forms—as in the eagles, the corncob capitals, and, later, the tobacco capitals—and easily intelligible symbolism—or what was considered "simplicity in symbolism"—were the two most important aesthetic qualities assumed to be "American." After the War of 1812, as sentiments of nationalism increased, "Americanism" in art became more specifically defined as well as demanded; but no matter how intricate the definition became, these two qualities of "Americanism" remained constant within it.[6]

Except for some awkwardness in communicating in a foreign tongue and some slight misunderstandings in connection with their compensation, the foreign sculptors experienced little difficulty with the government of the United States. The weight of congressional approval or disapproval fell instead on the architect Latrobe, who was burdened also with problems of labor, economy, progress of the project, and the aesthetic and functional fitness of the plans. From the very beginning of his employment by the government, Latrobe suffered from the difficulty of obtaining an adequate labor force, since the prevailing labor shortage and the seasonal nature of the employment made the hiring of a trained crew difficult. Building materials of the fine quality that he insisted on were also difficult to find, and the search for good stone quarries, as well as the business negotiations involved, often caused long delays—much to the irritation of an impatient Congress. Latrobe's position was also rendered unpleasant by the enmity of the architect, William Thornton, who

bitterly opposed anyone else working on the Capitol which he had begun; political attacks from the Washington *Federalist*, since Latrobe was in politics a Republican and the appointee of a Republican President, also added to the architect's difficulties.[7]

Congressional concern for economy was the greatest burden that Latrobe had to bear, especially since in the unfortunate year of 1807–8 the architect had inadvertently overspent his appropriation. Both President Jefferson and Latrobe conceived of the Capitol as "a building that should . . . stand out as a superb visible expression of the ideals of a country dedicated to liberty." This meant richness of decoration. Jefferson's administration, however, had pledged frugality in government; and politics, together with the realization that war with Great Britain was probable, dictated that the costs of the building should not be so high that they would be regarded by either congressmen or their constituents as excessive. When Jefferson, therefore, insisted that the Capitol include "rich Corinthian capitals, based on those of the Choragic monument of Lysicrates in Athens," Latrobe replied that he could not understand "how economy and anything like an exact imitation can be united—for it's a most complicated piece of sculpture." Similarly, in order to achieve a rich decorative effect, Latrobe commissioned the Philadelphian George Bridport to decorate the ceiling of the Hall of the House of Representatives at a cost, "all expense included," of $3,500. Latrobe suspected that members of Congress would, despite the low cost, think the finished product "too fine," and was certain that "Mr. Randolph would abuse it." In "economy" years, such as 1808, Latrobe was forced to limit his artistic projects; and in 1811 the impending war caused an economy-oriented Congress to stop all construction on the building.[8]

When the British, under the command of Admiral Cockburn, captured the city of Washington on August 24, 1814, the officer who was ordered to set fire to "this harbor of Yankee democracy" is reported to have made the comment that "it was a pity to burn anything so beautiful." Latrobe's achievement had been a great one: possessing the sympathy and aid of a President of taste and education in the fine arts, he had, notwithstanding the economies imposed by the exigencies of the times, created what his biographer has called "undoubtedly the most beautiful legislative chamber in the western world."[9]

After the war Latrobe was called to rebuild the Capitol, and in its

way the commission was a vindication of his earlier efforts, which had been subjected to so much criticism. However, he continued to encounter the same difficulties that he had experienced during the earlier years, for congressional ideas of economy and the necessity for speedy construction had not changed. Congress, too, was still suspicious of Latrobe's "extravagances," and this suspicion was increased when it was revealed that his expenditures had exceeded his estimates by $500,000—confirming in the minds of congressmen and the President as well Latrobe's reputation, deserved or not, for impracticality.[10] Persisting, too, were labor problems and the difficulty of procuring fine materials nearby; but probably the most cogent factor behind Latrobe's final resignation was the fact that with the establishment of the office of Commissioner of Public Buildings, a division of authority took place in which Latrobe played the lesser role. Added to the unpleasantness of having to work with an unsympathetic President, James Monroe, who seemed cold to all considerations other than the rapid completion of the building, was a constant stream of abuse from personal enemies. In 1817 Latrobe's position was rendered so uncomfortable that he reluctantly resigned. The architect's "great fault," in William Lee's opinion, lay "in being poor." Lee went on to say that

> Every carpenter and mason thinks he knows more than Latrobe, and such men have got on so fast last year with the President's House (a mere lathing and plastering job) that they have the audacity to think they ought to have the finishing of the Capitol, a thing they are totally unfit for.[11]

. When Charles Bulfinch, the Boston architect, was offered the opportunity to take over Latrobe's position in 1817, the commission as tendered to him by Colonel Samuel Lane, the Commissioner of Public Buildings, indicated clearly that the new architect's appointment was to be "entirely at [the Commissioner's] disposal" and that therefore "the architect must be responsible to him." Neither Congress, the President, nor the Commissioner was willing to risk again the possibility of a divided authority; and because of the prevalent distrust of professionals, it was inevitable that in the future the architect would occupy an inferior position.[12]

CHAPTER FOUR

PAINTINGS AND POLITICS

JOHN TRUMBULL RETURNED to the United States in 1816 from sojourns in Paris and London, filled with hopes of achieving national glory and of recouping his waning fortunes and reputation by means of a "great but long-suspended project of national paintings of subjects from the Revolution." For nearly two years Trumbull labored to secure the desired commission from Congress. Studies in miniature of his proposed paintings, which included authentic portraits of the men who had signed the Declaration of Independence or had fought in the Revolution, confronted congressmen from their exhibition place in the Hall of the House of Representatives; and "influential" friends in and outside of Congress, "zealous to see [his] plan executed in its full extent," worked in Trumbull's behalf, presumably by enlisting the support of hesitant congressmen.[1]

These were years when party affiliation counted little, personal relations more. Republicanism had all but swallowed Federalism, and as the years passed it began, in fact, to resemble Federalism more and more. In the Senate, James Barbour of Virginia introduced the Joint Resolution that proposed to commission Trumbull to "compose and execute four paintings of the principal events of the Revolution, to be placed in the Capitol"; while northern Federalists like Timothy Pitkin of Connecticut (Trumbull's home state) and Rufus King and Christopher Gore of New York enthusiastically aided Trumbull in his attempt to obtain government patronage. In the House, Republicans John C. Calhoun of South Carolina and John Randolph of Virginia served with Federalist Joseph Hopkinson of Pennsylvania on the committee whose report eloquently supported Trumbull's appeal. Strong feelings of nationalism undoubtedly contributed much toward securing the final passage of the resolution; yet it did not pass without

debate, and the expressions of opinion by congressmen on the subject were, indeed, as the Reporter of the *Debates and Proceedings* noted, "interesting, amusing, and instructive." [2]

All members participating in the debate acknowledged the talents, of the artist and the "excellence" of his paintings. Some northerners doubted, however, that it was "just or proper for the Government of the United States to become a patron of the fine arts." Economic and moral reasons were given for opposing the commission: until the government had paid its debts and fulfilled all of its "pecuniary obligations" arising out of the past two wars, it had no right to become a patron of the arts; and since paintings and statuary had had "no perceptible effect in preserving the liberty and independence of those nations" where they had flourished, they undoubtedly would not contribute to the preservation of the rights and liberties of this nation. Those who favored the commission felt that the government had "performed its obligations as far as it could, had paid its debts, had been just, and might, therefore, be generous"; that the expense was small considered in terms of similar decorations of less importance; and that the "moral effect" of these paintings, "independent of their intrinsic worth," would be of great value, "serving to recall to the attention of future legislators, the events and principles of the Revolution, and to impel them to an imitation of the virtues of the men of those days." [3]

The resolution commissioning Trumbull's four paintings passed both houses with little difficulty, and its passage was viewed enthusiastically and optimistically by those who saw in it the beginning of a governmental policy favorable to the arts. The *Albany Daily Advertiser*, for instance, was "extremely gratified" with the commission and especially pleased "to find the patronage of the government extended to the encouragement of the arts which refine and adorn society," and not "wasted on objects of neither intellectual nor moral worth." In the same vein, the *Analectic Magazine* found Trumbull's commission "pleasing evidence of attention prevailing in favour of this department of excellence." [4]

Trumbull's paintings were hardly exhibited, however, before expressions of discontent could be heard. Artists like William Dunlap and John Vanderlyn, who were anxious to receive government commissions themselves, were bitterly critical of the old artist and his paintings. Congressmen felt "abominably taken in" when they

learned that Trumbull was exhibiting his paintings for profit before setting them up permanently in the Capitol. Moreover, some congressmen were keenly disappointed in the paintings as works of art. *The Resignation of George Washington*, for instance, the last painting in the series, was called by Senator Holmes of Maine "a piece of the most solemn daubing he ever saw."

> The event was one of the most sublime incidents that ever took place in this country. But what do you see in this picture? Why, a man looking like a little ensign, with a roll of paper in his hand, like an old newspaper, appearing as if he was saying, "Here, take it . . . I don't want to give it up." [5]

Three years later, in 1828, Representative John Randolph, a member of the committee that had originally recommended Trumbull's commission, protested as "a man of taste" against "the whole of these paintings." Randolph declared that he "hardly ever passed through that avenue [the Rotunda] to this Hall . . . without feeling ashamed of the state of the Arts in this country; and, as the pieces of the great masters of the Arts have, among the *cognoscenti*, acquired a sort of *nom de guerre*, so ought, in his opinion, the picture of the Declaration of Independence to be called the *Shin-piece*, for surely never was there before such a collection of legs submitted to the eyes of man." [6]

Some historians attributed the defeat of any further attempt to extend government patronage to American artists to "the prejudice excited against [Trumbull's] pictures." Certainly, dissatisfaction among some congressmen did discourage them for a time from voting funds for art commissions, but Trumbull had many defenders who found great merit in his work and were not at all disappointed with his paintings. Congressional ideas of economy and developing political animosities offer more realistic explanations for Congress' refusal to vote large-scale commissions to American painters during the two decades following the award to Trumbull. Charles Bulfinch, who followed Latrobe as the Capitol's architect, testified to the economy-mindedness of Congress when he wrote in 1820, "Congress . . . seems . . . determined now to make great efforts at retrenchment, to curtail all the establishments, as much as they will possibly bear." Bulfinch also noted "the carping and caviling [*sic*]" of congressmen towards the measures of the administration, and "the jealousy, almost

approaching to hostility with which every measure of administration is viewed and commented upon, even now when the majority are fast friends with the executive." [7]

The reaction of some congressmen to the speech of Representative Cushman of Maine in 1824 illustrates what the cause of government art had to contend with from frugal legislators during these years. Mr. Cushman defended the policy of ornamenting the Capitol with works of art; of all governments, "a republic," he believed, "ought to appear with sober pomp and modest splendor." The congressman also appreciated the achievements of art: ". . . I have no sympathies," he insisted, "in common with those politicians . . . whose policy, whatever be their motives, tends to replunge the civilized world into the depths of Gothic ignorance and grossness. . . . The genuine patriot . . . will feel the generous ardor, the noble enthusiasm of the poet who paints for eternity." Mr. McArthur of Ohio, however, testily disagreed; calling himself a "backwoodsman, brought up in tents and camps," he regarded the money expended to make the Capitol magnificent as "in a great measure, money thrown away." McArthur found an ally in Mr. Kremer of western Pennsylvania, who went even farther and called the Hall of the House of Representatives "a monument of pride and extravagance, and not of old Republican principles. . . ." Mr. Kremer warned Congress that "before we set about making monuments of 'simple grandeur,' we had better be sure that we have the money to make them in our pockets." [8]

With such concern about the need for economy gaining importance in Congress, and with the disappearance of the "good feeling" that had eased the passage of Trumbull's commission, it became increasingly difficult for Congress to come to any agreement even about the paintings for the vacant Rotunda panels. The prevailing political hostilities were reflected in a debate that took place in 1828, an election year, when Andrew Jackson, "the hero of New Orleans," was a leading contender for the presidency. A resolution introduced into the House called for the employment of Washington Allston, the country's most prominent artist, to fill a panel in the Rotunda with a painting of the Battle of New Orleans. There had been earlier attempts to fill the four vacant panels, but the previous resolutions had been tentative in nature, designed "to inquire into the expediency of offering a suitable premium" for designs, rather than explicitly designating an artist and a subject for the specific job. The resolution

of 1828 was patently a political act. If it had succeeded it would have been considered, according to one observer, "a sign of the times," and would have been of great psychological aid to Jackson's candidacy. The motion was introduced by James A. Hamilton, Jr., of South Carolina, a staunch Jackson follower who had become powerful in South Carolina politics after serving two terms in Congress. Hamilton worded his resolution to trap Edward Everett, Chairman of the Library Committee and an "Adams-man" from Massachusetts, into aiding its passage. First, Hamilton made complimentary references to Everett's own committee report of the previous session, which had recommended the engagement of "such artist or artists as Congress should deem competent" to complete the decorations "under the proper directions as to the choice of subjects." Then Hamilton went on to specify Allston as the artist—a South Carolinian by birth, a Bostonian by choice of residence, "the very best [artist] the country has produced," and incidentally, the one artist for whom Everett was eager to secure a commission.[9]

Hamilton's speech was lengthy. "Without professing to be a connoisseur," he nevertheless could appreciate the policy of using "the delightful art of painting" to embellish the national building. The natural setting of the Battle of New Orleans, the heroism and valor displayed, were both highly suitable for the canvas, and Allston, "now engaged . . . under the patronage of a city no less distinguished for its refinement and taste than by its literature and science," was surely "one of the first, if not the very first, living artist our country has produced." Having "puffed his blast," Hamilton confided his resolution to "the judgment and patriotism of his honorable friend from Massachusetts," Edward Everett, and to the other gentlemen on the Library Committee.[10]

The smoke that followed Hamilton's blast was thick. The easiest way to kill the resolution, without appearing to be against either art or Jackson, was to suffocate it with amendments, or to so entangle it that it could not be passed, and this the Adams party proceeded to do. Mr. Ingersoll of Connecticut moved to strike out the name of Allston and substitute some "suitable artist," for his choice would be John Trumbull, native of his own state, whose pride and fame had been hurt by the unjust criticisms of his Rotunda paintings. Mr. Dwight of Massachusetts, "while he did not refuse to do homage to the great and acknowledged merit of Mr. Allston," proposed that the resolution be

changed to "embrace the battles of Bunker Hill, Monmouth, Prince-ton, and the attack on Quebec." Mr. Kremer of Pennsylvania, wishing to be "fair," maliciously moved the "small" amendment that another painting be placed alongside the one proposed, this one to represent the meeting of the Hartford Convention, which had been in full session at the time the battle was being fought and which reflected the anti-war sentiments of some New England businessmen. Edward Everett, whose Library Committee report had laid the basis for Hamilton's proposal, preferred to enlarge the terms of the resolution to include all the vacant panels of the Rotunda; Storrs of Buffalo pleaded the cause of our naval victories as "entitled to some notice," and there the debate stopped until the next day, when it was resumed as a first order of business. The merits of the various subjects proposed were discussed and argued, and finally, the amendments containing these resolutions were voted down. Congressmen who felt that is was improper to use government money to pay for paint-ings, or who had particular interests to press, took this opportu-nity to display their oratorical talents. It was at this point that John Randolph vented his spleen against poor Colonel Trumbull's *Declara-tion of Independence.* Finally, Tristram Burges of Rhode Island, Ichabod Bartlett of New Hampshire, and William McCoy of Vir-ginia spoke out against the entire practice of the government's commissioning paintings. There were other means of commemorating acts of valor; the government might reward its soldiers with pensions, Burges suggested—a proposal to be expected from a congressman who had been active in presenting to Congress petitions from disabled war veterans. McCoy thought that books, or testimonials of thanks accompanied by gold medals, would accomplish the purpose of the resolution. The sample of the fine arts in the Rotunda had brought the country "more plague than profits," McCoy concluded, "and if the fine arts cannot thrive in this country without getting up Govern-ment jobs, why I say, let them fall." As to the "moral effect" of such paintings, added P. P. Barbour of Virginia, "so long as the high spirit of liberty which now animates this nation shall prevail, it wants nothing to preserve it; and when it shall once have passed away, nothing that the arts can do will ever restore it. . . ." [11]

Thus ended the debate, as it had begun, "in smoke," Richard Dana commented to Verplanck. "The object of the members on both sides," concluded the British observer Captain Hall, "seems to be

merely to thwart by every means, the wishes of their political antagonists, and to wear one another out by perservering opposition." "I suppose," Dana had added in his letter to Verplanck, "all H.'s talk about Allston and the canvass, was nothing more nor less than *canvassing* for President." Another correspondent of Verplanck's agreed: "the Resolution of Hamilton respecting the Painting," he wrote, "savoured too much of vulgar electioneering. It had better not have been proposed." [12]

Friends of Washington Allston, disappointed that partisan politics had prevented Congress from voting him a commission, rallied to press his cause again. One of his supporters in Congress was Gulian C. Verplanck of New York, who served on the Buildings Committee during the 1830's. Verplanck urged the diffident Allston to find a subject that would be suitable for one of the panels. "To scripture," wrote Verplanck, "I fear we cannot go in the present state of public opinion & taste, but does our ante-revolutionary history present no subject?" Verplanck suggested the Landing of the Pilgrims as a possibility, but was willing to give the hesitant artist an almost unrestricted choice, limiting him only to American history, "in which Columbus would of course be included." Other members of the committee, Leonard Jarvis of Maine and Colonel Drayton of South Carolina, were as enthusiastic as Verplanck for the employment of Allston, but the pressure of congressional business that year crowded out the committee's bill for the improvement of public buildings and the matter had to be put off until 1834. [13]

Other artists and their friends were doomed to suffer disappointment at the hands of an economical and unsympathetic Congress as well. One of these was Samuel F. B. Morse, who had begun his study of art early in the century and who, by the 1830's, realized that his powers as an artist were waning while younger men were crowding him on all sides. Morse had friends in Congress too, and in 1832 he took the occasion to write to Verplanck from Paris, ostensibly to offer the government two paintings by Rubens that some French ladies wished to sell to the United States, to form the nucleus of a national gallery. Morse's real intention, however, was to plead his own cause. He had, he confessed, little enthusiasm for the kind of government patronage he was now suggesting; rather, he would have the government devote whatever funds it had for the purpose of encouraging art to "living" and "native" talent, and, of course, to his

own talent. "I have too long lived in the hope of doing something for the Capitol," Morse wrote. "I have studied and travelled to prepare myself." Morse's hopes went unfulfilled, and he soon turned his attention to enlisting government support for his telegraph rather than for his art.[14]

On January 24, 1834, Henry A. Wise of Virginia introduced a resolution in the House of Representatives instructing the Committee on Public Buildings "to inquire into the propriety and expediency of employing American artists to execute four national paintings appropriate to fill the vacant niches in the rotunda of the Capitol, corresponding to those executed by Trumbull." The Resolution went through the routine established by the House, being at first entrusted to the Committee on Public Buildings. This committee reported on February 11 a Joint Resolution similar to Wise's, but it was not until December 15 that the bill received its third reading. At that time, a "somewhat inconsiderate" amendment introduced by John Quincy Adams provoked a heated debate. Doubting that four native artists could be found "of eminence in the profession so transcendent as to ensure the performance of four masterpieces," Adams proposed to strike out the word "four" and leave it to the discretion of the committee to employ one or more artists for the job of painting four panels. If four or more artists were employed, Adams feared that the result would be "very indifferent work, unfit to be exhibited to the world."[15]

Three members of the reporting committee—Jarvis, Wise, and Aaron Ward of New York—rose to the defense of American artists. Jarvis believed that it was desirable to prevent "such a monopoly as produced the paintings already in the Rotundo" and was certain that there would be no difficulty in finding four competent artists in this country; the problem would be "in selecting from the multitude in the galaxy." Wise was "proud" to declare that the country was "richer now in native talents in the fine arts than any country on the globe." "Though the fine arts are not encouraged here, they are indigenous to the country": Sully, Chapman, Allston, Greenough, Morse, Weir, Peale, Leslie, and others, could produce works that would never "discredit the Capitol of the nation," Ward declared, and he agreed with Wise that by enlarging the field of selection Congress would be developing "as much native talent as possible" and

would be giving young artists "an opportunity to distinguish themselves." [16]

Adams' amendment received help from an unexpected source when Tristram Burges, the congressman from Rhode Island, came to its support. In the past, Burges had demonstrated such bitterness towards the former President that he opposed him on almost all measures; his animosity toward Adams had not lessened, but he disdained art more. He was especially contemptuous of Wise's claim for the superiority of American art and artists. Wise, answering "with more passion than wit," expressed "astonishment" that Burges could question the presence of native talent in this country in the fine arts.

> In *this* country, sir? It is not only the richest in the fine arts now, but is the richest country in the world, sir, in *historical events* for the pencil of the painter! . . . Every state in the Union has events to be painted—even the little state of Rhode Island has a *great man* to be painted! [17]

But, Wise went on, this was not Burges' meaning; what Burges seemed to fear was a second attempt to glorify an event of the President's [Jackson's] life, and Wise assured Burges that nobody "in good taste" would choose a subject of so recent an event, but would rather go back in time to events "magnified and mystified by antiquity." As for Burges' suggestion that artists be requested to produce their paintings so that the "public," as represented by the members of the House, could select "such as are most worthy of selection," Wise had only contempt at the man's ignorance of how artists felt and the way they worked: "they [artists] can never be brought by necessity to hazard fortune and fame upon a painting to be offered to this government—to be undervalued—criticized by every pretender who knows not foreshortening from coloring—and then to be rejected, perhaps, as unworthy." Finally, Wise referred to Burges' fear that theories of "democracy" or "agrarianism" would be applied to the choice of a painter so as to avoid the "cry of monopoly." What did Burges mean, asked Wise, by an "aristocratic painting"? The decision to commission four artists was made to see "who is really the greatest of the corps." "It is not to pull down the best to the common level, but to ascertain whether the favoritism of private patronage may not have distinguished some one undeservedly

above the others." And Wise concluded with the expected national-
istic peroration:

> There is something national in making the trial. . . . We have
> frequently employed foreign artists . . . at great expense, and I
> now desire very much to see if America cannot bestow her
> favors and lawful patronage in such a manner on American
> artists as to nurture the finer art, to illustrate, in their turn, the
> arms, civic virtues, and the glorious deeds of this illustrious
> nation.[18]

Suddenly the debate took a personal turn, as Burges in reply
impugned Wise's political integrity, accusing him of being among
those who "were at times to be found in the rear, supporting the
President and at other times in front, harassing and attacking him."
Wise accused Burges of constitutional weakness, "as well as weakness
of old age," and had to be stopped by the Speaker before he could
accuse him of greater evils. On this note of ill temper, the debate
ended as the House adjourned.[19]

The initial introduction of the resolution in January had already
given rise to a flurry of interest among artists who hoped to secure
one of the four commissions when Congress should finally get around
to passing it. In fact, as soon as the resolution was reported to Jarvis,
the chairman of the Committee on Public Buildings, "recommenda-
tory letters" began to "pour" in upon him, and he appealed to his
fellow congressman from New York, Gulian C. Verplanck, for help
in investigating the qualifications of the many painters who sought
employment. Artists also wrote to Verplanck asking his intervention
in their behalf. Henry Inman, who had once before received Ver-
planck's aid, now asked him again for his "friendly remembrance";
and Robert Weir, more self-conscious about soliciting favors for
himself, used an intermediary, George P. Morris, editor of the *New
York Mirror*, to intervene in his behalf. Weir believed that Verplanck
was "hard at work" already, attempting to secure a commission for
him, but he did not hesitate to press this gentle reminder on the
harried congressman. Even the landscape painter Thomas Cole en-
tered the lists, despite the fact that the commissions were intended for
"historical" paintings. In his letter to Edward Everett, Chairman of
the Library Committee, which often handled these assignments, Cole

indicated that he had just returned from Europe where his studies had been "in great measure" in history. Although his historical pictures were few and "executed under great disadvantage," the artist trusted that "from them might be augured much higher excellence when [his] field and facilities . . . shall be extended. . . ." The Boston lawyer and art patron, Franklin B. Dexter, urged Cole's application also because he felt that Cole would "do more credit to the country than any other man except Allston or Vanderlyn." Like other aristocrats of taste, Dexter could not refrain from adding that he hoped "members of Congress who have had no opportunity of seeing good pictures will not undertake from personal predilection to overwhelm those who know better in this matter. I dread to think who are selected for these works," confessed Dexter, "I have the horrible intimation of what might be expected." [20]

John G. Chapman had been kept informed of the progress of the resolution by Wise, and his anxiety to receive one of the commissions was all consuming. For years, the possibility of such an assignment had, he wrote, "cheered the loneliness of an arduous routine of study in a foreign land and cast a glow over the coldest neglect that has sometimes been my lot to feel since my return." Incapable of "electioneering" for himself, he left it up to Wise and his "southern friends" whose "countenance" would be "grateful to his pride." John Vanderlyn also actively petitioned for one of the government commissions. Vanderlyn, in fact, had been lobbying for his own interests ever since 1825, when he began his frequent visits to Washington to paint the portraits of public men. In 1832, for instance, he undertook a portrait of Vice-President Calhoun, who had by this time come to public disagreement with the Jackson administration, "for the purpose of courting favor with the Anti-administration party." Vanderlyn possessed a generous friend in the artist Washington Allston, and it was partly through Allston's intercession and recommendation that Congress had been persuaded to vote Vanderlyn a commission in 1832 to paint a copy of Stuart's *Washington*. Leonard Jarvis had also aided Vanderlyn in his dealings with Congress; and especially after the successful completion of the Washington portrait, for which Vanderlyn received an extra compensation of $1500 over and above the original $1000 voted, it became almost a foregone conclusion that he would receive one of the four commissions to decorate the

Rotunda. It was also generally acknowledged that Allston, because of the esteem in which his work was held, was entitled to at least two of the four commissions, if not the entire set.[21]

Before leaving his post in 1830, the architect Bulfinch had pointed out in all his yearly reports the necessity of filling the vacant panels with paintings "conformable to the others on great national subjects." By 1836, members of both houses of Congress regarded the four vacant panels as a shameful impropriety that demanded immediate action. Therefore, there was little debate on the question when finally the House Committee on the Library introduced a Joint Resolution authorizing the full committee to "contract with one or more American artists" for the purpose of decorating the Rotunda; the bill, hardly opposed, passed both the House and the Senate, and from then on, the Joint Committee on the Library took over the matter.[22]

Within the committee, the members agreed that Allston should be offered two of the panels, while the two that remained should go to two of the four artists who had so anxiously solicited them—Vanderlyn, Weir, Inman, and Chapman—on the basis of the best design submitted. Allston, completely preoccupied with his large, ill-fated painting, *Belshazzar's Feast*, and fearful of undertaking another such large project, refused the commission despite its liberal terms—the only restriction placed on the artist was that the choice of subject illustrate some event "civil or military, of sufficient importance to be the subject of a national picture, in the history of the discovery or settlement of the Colonies . . . or the separation of the colonies from the mother country, or of the United States prior to the adoption of the federal constitution." After Allston's refusal, the committee offered the commissions to the four other painters, on the assumption that

> we ought to get the best artists that the Resolution, under which
> we acted permitted; and that if the paintings should not turn out
> chefs d'oeuvre, it would only prove that our artists are not as
> good as some in other countries; a fact which all admit.[23]

As work on the paintings progressed, rumors flew that the commissioned artists were not being entirely honest in fulfilling their assignments. For instance, Vanderlyn let it be known that Inman, who had been making little progress on his painting, had employed a

young artist from Charleston to paint the picture from his sketch for two thousand dollars and that Inman proposed only to retouch the finished product. This arrangement, Vanderlyn said, was giving Inman an opportunity to maintain his lucrative business of portrait painting while enjoying the government's money. Whatever the facts of the case, Inman died before completing the painting, having received $6000 in advance payments for it. Inman's friend, Samuel F. B. Morse, offered to finish the picture for the balance of $4,000 still due, but Congress seemed reluctant to accept his offer, perhaps because by this time the other paintings had made their disappointing appearance and most Congressmen were convinced that American art —if the paintings they commissioned were representative—was a failure.[24]

While spreading the rumor of Inman's lack of respect for the government's commission, Vanderlyn himself was similarly accused. It was said that having found his powers as a painter waning, he had hired in Paris, where he had gone to complete the work on the painting, a young man to finish the picture from his design. However little truth there may have been in both these rumors, what is clear is that the reaction to the three completed paintings was mostly adverse. A few critics were enthusiastic. Vanderlyn's work, asserted the *New York Journal of Commerce*, was "a proud triumph to American art and genius. The first impression made upon our mind was that the sky, water, and whole scenery were American. . . ." Generally, however, more disappointment than pleasure was expressed, and again Congress was accused of "extravagance" in spending the people's money on such "trash." [25]

CHAPTER FIVE

SCULPTURE, POLITICS, AND THE TASTE OF POLITICIANS

MONUMENTAL SCULPTURE did not find favor among legislators any more than painting did as providing a proper field for governmental activity. If there was relatively less opposition voiced by congressmen to the commissioning of sculptural works, it was because so much of the sculpture needed for the Capitol was included in the architects' plans and was paid for out of general appropriations made to carry on the building and decorating of the edifice. Latrobe's plans, for instance, included considerable statuary in the form of figures symbolizing the original thirteen states; these were intended to serve as supports for one of the Senate galleries. Bulfinch, too, included sculptural decoration and statues in his plans.[1]

For sculptors, the opportunity to work for the government presented a desirable situation from which they hoped to obtain not only profitable commissions, but even more important, reputation and prestige among Americans of official position, rank, or wealth. And so, as the Capitol lay in its half-finished state during the 1820's and 1830's, sculptors—especially foreigners—flocked to Washington to flatter or cajole influential legislators in the hope of sharing in the glory and wealth of the new Republic.[2]

Of the foreign artists who received commissions from Congress during the early years of the nineteenth century—Capellano, Caracci, Causici, Gevelot, and Persico—Persico was considered the most competent; at least, he had an impressive number of political friends, including President John Quincy Adams and various members of the House of Representatives. Persico's friendship with Adams began when the President, dissatisfied with the designs presented by thirty or more persons for the decoration of the pediment of the eastern

portico of the Capitol, made up his own design and gave it to Persico to execute. Adams' taste did not run to "triumphal cars and emblems of victory, and . . . allusions to heathen mythology"; rather, he thought that the "duties of the Nation or its Legislators should be expressed in an obvious and intelligible manner." In one of his last official acts as President, Adams signed the contract authorizing Persico to execute "emblematical" statues of "War and Peace" for the front stairs of the Capitol. The choice of the subject had been left to the President, as James Buchanan of Pennsylvania explained, in order to avoid the "three hundred opinions" that would have been expressed had the decision been left to the three hundred members of the House of Representatives. In this case Adams merely approved the subject that the sculptor suggested; the resulting colossal statues were in the conventional classical style as understood and practiced by second-rate Italian sculptors of the period—that is, copied, with some changes, usually for the worse, from the statues of Mars and Minerva at Rome. In the words of a contemporary, War was represented by a "stalwart gymnast with a profuse development of muscles and a benign expression of countenance, partially encased in Roman armor, while Peace is a matronly dame, somewhat advanced in life and heavy in flesh, who carries an olive branch as if she desired to use it to keep off flies." [3]

One of the more important government commissions for sculptural work was given to Horatio Greenough in 1832, for a colossal statue of Washington. Throughout the early years of the country's national life, from 1783 on, resolutions had been periodically introduced into Congress, proposing such monuments to memorialize the life and deeds of the first President. "Every wise nation," Representative Buchanan remarked in Congress in 1823, "has paid honours to the memory of the men who have been the saviours of their country"; it was appropriate for the United States to do the same. Nevertheless, the opposition was adamant: the practice of erecting monuments to leaders, it was held, had originated "before the lights of reason had penetrated the darkness of society." This country needed no monument to remind it of Washington's life—"he has a monument . . . in the heart of every American . . . and let it be our peculiar pride to enshrine him there alone." "Yes, sir," insisted Representative Cary of Georgia, "we will keep Washington's monument in our bosoms. We will commit it to no perishable stone. . . ." [4]

A biography of Washington that would be distributed among the poor and sold to the rich was preferable, some congressmen believed, to still another statue that would be seen only by members of Congress and people who had business to transact in Washington. A publication of this kind that could be read in "the pine hills in North Carolina . . . the Western forests, and every portion of this Union" would serve the national interest far more effectively than "pictures and portraits in the Capitol." [5]

Congress continued to oppose measures designed to memorialize Washington; when another resolution was introduced in favor of installing three copies of Capellano's bust of the first President in various public buildings, the answer came back from the Committee on Public Buildings, who had charge of such resolutions, that "however laudable it may be in the Government to cherish a disposition friendly to the fine arts . . . or politic to adorn our public halls or libraries with the likenesses of departed sages or heroes," it was "inexpedient" to buy the busts "at this time." [6]

By the 1830's, congressional pressures mounted in favor of erecting a monument commemorating Washington's "virtues and services"; the time was ripe—1832 marked the centennial of Washington's birth, and appropriate measures of honor would have to be taken. Over a period of years, Leonard Jarvis, Chairman of the Committee on Public Buildings and a former classmate of Washington Allston at Harvard, had found it pleasant to consult with the artist on all kinds of matters pertaining to art, from buying a collection of paintings for the President's house to the choice of an artist to paint Washington's portrait. Therefore, when Allston proposed to Jarvis that the government commission the young sculptor Horatio Greenough to do a statue of Washington, Jarvis was receptive to the suggestion. Allston had also written to Daniel Webster about Greenough, and at the same time, James Fenimore Cooper was exerting his influence in the sculptor's behalf. Gulian C. Verplanck of the Library Committee was also a friend of Allston's, and so, "in consequence of the high praise" Allston had bestowed upon Greenough, Verplanck and Jarvis together moved the resolution in Congress that a commission be given to the sculptor. Greenough's employment was urged in preference to a foreigner; as a "native citizen capable of producing a work of distinguished excellence," and as an artist who had "no rival among his countrymen," Greenough was, in fact, the logical choice for the

work. The committee felt that "there was nothing invidious about introducing his name into the resolution," since "no other American sculptor had yet appeared who was fit to be entrusted with the execution of Washington's statue." With little opposition the resolution was passed. Later resolutions fixed the amount of payment at $20,000 and provided for payment of the transportation costs of the statue from Florence, where Greenough had his studio, to the United States.[7]

Except for limiting the artist to the features of Washington as they were represented in Houdon's bust, the commission was a liberal one. The sculptor was left free to make of the statue whatever he wished, adding any "animation" to the face that the "action of the figure" required. The liberal spirit that pervaded Congress when it passed the resolution vanished, however, when the statue finally arrived in 1841. Most congressmen, as well as Americans generally, were shocked by Greenough's conception of Washington half clothed, with one arm raised, looking as Charles Bulfinch observed, as if he were "entering or leaving a bath." [8]

As early as 1834, when Greenough's design had arrived in Washington, the committee in charge had become apprehensive. Leonard Jarvis, who felt personally involved in Greenough's success, became especially alarmed and wrote to Allston on May 15 of that year asking him to come to Washington at the expense of the government "to pass judgment" on the design. "I am very solicitous for your opinion," Jarvis wrote,

> . . . for I doubt whether Greenough has not made a mistake in his conception of what it ought to be & as the project was of my own creation & as the selection of the artist was also at my suggestion which was occasioned by your commendation, I feel deeply interested that the design as well as the execution should give general satisfaction.[9]

When Allston demurred at coming, pleading ill health, Jarvis replied detailing his objections at greater length. "Greenough's design does not satisfy me," he wrote.

> He has undertaken to *idealise* Washington and to make an emblematical statue. It is not *our* Washington that he has represented. He has evidently taken the idea of his statue from that of Jupiter. . . . The parts are well balanced and as a work

of art the design is worthy of praise. But I object to the absence of drapery on the upper part of the figure and I should have been better pleased if the arm had some more easy and usual action. I dislike anything theatric & the more perfect the repose that could have been given to this design the better I should have been pleased with it.[10]

Allston agreed with Jarvis and reported that both the Danas, father and son, were also struck with the "inappropriateness of the raised arm and the idealizing of Washington." Judiciously, however, Allston was unwilling to "dictate to the artist"; he was ready to admit two schools of thought about the problem of clothing statues, "since the opinion of the world, that is, of competent judges in it, is divided on that point." He assured Jarvis that Greenough was an artist "of no common order . . . a well grounded scholar in his art," and he declared that he was confident the sculptor would produce a statue that would "do honor to the country." [11]

Greenough's statue and the controversy it created precipitated one of the first large-scale discussions of taste in art that took place in this country. The nudity of the statue and the symbolism of its conception were either hotly defended as necessary to the image of Washington that Greenough wished to convey—the image of "a truly great man in whom statesmanship and generalship were subordinate to nobleness of mind and moral power"—or they were mercilessly ridiculed. The statue, wrote Philip Hone of New York, "looks like a great Herculean warrior—like *Venus of the bath* . . . undressed with a huge napkin lying in his lap and covering his lower extremities, and he, preparing to perform his ablutions, is in the act of consigning his sword to the care of the attendant." In a similar vein, a joke circulated around the capital during later years to the effect that the statue represented Washington reaching out his hand for his clothes, which were on exhibition in a case at the Patent Office. The "naked statue" was scornfully attacked in 1842 by Congressman Henry Wise of Virginia, who, despite John G. Chapman's recommendation of Greenough, was ever ready to throw the weight of his wit against a New Englander. Wise told the story of a gentleman from Maryland, who, having heard "so much said of the statue, mounted his horse and rode a long distance purposely to look at it." But after gazing at the statue for a few seconds, this gentleman "turned from it, as he said the father of his country would do, who

was the most modest of men." Mr. Wise's final suggestion before taking his seat was that the head of the statue be preserved and the body thrown into the Potomac, "to hide it from the eyes of the world, lest the world should think that that was the people's conception of their nation's founder." [12]

Less severe than Wise, Senator Thomas Hart Benton from Missouri nevertheless was in agreement with the representative. Benton informed Greenough at a dinner party that he could not "reconcile his taste to the nudity of the body," but the head of the statue "had often enchained him for half an hour together." [13]

Dissatisfaction with the statue continued as time passed by. In 1852, when the Senate debated a proposal to purchase George Catlin's Indian collection—a subject seemingly removed from Greenough's statue—Senator John Parker Hale of New Hampshire asked the Library Committee "to inquire into the expediency of removing that thing in the east yard called 'Greenough's Washington.'" The following year, Captain Meigs, Superintendent of the Capitol Extension, writing to Thomas Crawford on the subject of a design for pediments for the south and north wings of the new extensions, declared that Americans did not "appreciate too refined and intricate allegorical representations, and while the naked Washington of Greenough is the theme of admiration to the few scholars, it is unsparingly denounced by the less refined multitude. . . ." [14]

If the nudity and ideality of the statue offended the taste of the majority, there were still many who found it an inspiring work of art. Greenough reported to his brother that a Mr. Arnold told him that when he first saw the statue he thought it "outré"; the second time, he was "not shocked at all"; and after that, he "began to like it" and went on liking it "better and better." Edward Everett, Whig governor of Massachusetts, diplomat, congressman, and connoisseur of the arts, regarded the statue as "one of the greatest works of sculpture of modern times." His brother Alexander called the work "truly sublime": the "antique drapery, the more youthful air of the face . . . increase very much the moral impression, and . . . are positive merits of high importance." Charles Sumner, Whig patrician and senator from Massachusetts, "felt" and "was moved by" the statue, and so was the aristocratic editor of a Baltimore newspaper, George Henry Calvert, who discounted his countrymen's preference for a Washington in full dress and approved of the artist's refusal to

stoop to "uncultivated tastes" in order to popularize his art. "By presenting [the statue] to the general gaze in its severe simplicity, and thus, through grandeur and beauty of form, lifting the beholder up into the ideal region of art," Greenough would eventually make his art popular. Gouverneur Kemble, art collector and iron manufacturer of New York, "a gentleman of taste" in Everett's opinion, praised the statue as "one of the noblest works of modern times in power and effect, second only to the Moses of Michael Angelo." Mrs. Mary Clemmer Ames summed up the situation in 1876 when she called the statue the "grandest and most-criticized work of art about the Capitol." "It is impossible for [the American] to reconcile a Jupiter in sandals with the stately George Washington in knee-breeches and buckled shoes," wrote Mrs. Ames. "The spirit of the statue, which is ideal, militates against the spirit of the land, which is utilitarian if not commonplace." [15]

Visitors to this country considered Greenough's statue a touchstone for evaluating American taste. Most agreed with Thomas Colley Grattan, the British consul in Boston, that the lack of appreciation among Americans for Greenough's work indicated that Americans "imperfectly" understood the fine arts and were especially ignorant of the art of sculpture. Greenough, however, held out hope for his countrymen. In a memorial to Congress, asking that the statue be placed under suitable protection to prevent its being disfigured by the elements as well as by visiting pranksters, the sculptor took the opportunity to answer some of the objections the work had encountered. He pointed out that throughout history—"both in ancient and modern times"—sculptors had conceived of their heroes in undressed form. "The dresses of their several epochs were neglected," he wrote, "because their object was to show, not the attire, but the man . . . the grand type of the human race. . . ." Greenough expressed the hope that this would continue to be the style of art in the Republic, which stood, he explained, "upon a broader basis of human nature," and more fairly represented "the general human will" than did the aristocratic governments of Europe and especially of England. Art in a republic, Greenough believed, must "make that choice of style in sculpture, adopt those views of its nature and uses, which are most in harmony with the highest and truest . . . philosophy of art." Neither a despotic court nor an aristocracy could force an artist in this country "to pay homage in marble and bronze to the ephemeral

legislation of the tailor and the haberdasher," wrote Greenough; instead, the classical style he had adopted for his Washington was the most suitable for the American system of government. In the future, Greenough was convinced, the "prejudice" in the country against "naked statuary" would decline before the "efforts of high art," so that his successors in the art would be "enabled to show that the inspired writer meant not merely the face, when he declared that God had made men after his own image." [16]

CHAPTER SIX

DECORATIONS FOR THE CAPITOL EXTENSION

On June 3, 1830, Charles Bulfinch, architect of the Capitol since 1818, regretful at parting with friends and the place that contained "memorials" of himself, left Washington, his work for the federal government having ended with the termination of the office he held and the completion of the Capitol building. After Bulfinch's departure, the Capitol became the responsibility of the Commissioner of Public Buildings, and except for the occasional employment of a temporary architect for special tasks, no permanent architect for the Capitol was appointed until 1851, when Thomas U. Walter undertook the planning and supervising of the Capitol Extension.[1]

Bulfinch's achievements, despite the fact that he worked from his predecessor's plans, were respectable. When Latrobe resigned he left an unfinished pile of stone still showing the ravages of the fire that had been set by the British troops four years earlier. Bulfinch, a modest man with none of the arrogance often associated with artists of achievement, was content "to follow in a prescribed path" and receive "no credit for invention." He found Latrobe's plans "beautifully executed," with the design "in the boldest stile"; but he also found sufficient fault in the design to give him a sense of responsibility in completing the work on the building: Latrobe's staircases were too crowded and difficult to get to, and the passages were "intricate and dark." The "sombre" appearance of the "whole interior," with the exception of the two great rooms, also left Bulfinch dissatisfied, and this he proposed to remedy. Under his direction the wings of the building were completed, the central portion was built on an area formerly covered by "a mass of earth, rubbish and old foundation,"

and the Rotunda was executed. Bulfinch's original contribution was the design and construction of the western projection of the center, which rendered "the western approach grand and striking in the highest degree." [2]

After Bulfinch's departure the Capitol fell under the influence of what Horatio Greenough in 1842 called "the demon of Bad taste." The interior, which was "coated with white lead," looked, Greenough thought, "as flimsy as a Yankee meeting house." He found the interior of the building characterized by "tawdry pretension and meanness":

> everything is painted white that they can reach with their brushes; the portraits of the Presidents, by Stuart, stuck against pilasters (white) opposite a staring suite of windows that go down to the very floor; seven interesting busts crowded into a window opening, getting their light from every point of the compass.

Greenough found some "good points" about the Capitol, "notwithstanding its anomalies," but questioned the possibility of ever rendering the building "harmonious" without the services of an architect. [3]

Whatever its lack of harmony, more serious, by 1850, was the Capitol's inadequacy in meeting the needs of Congress. Between 1830 and 1850, as a result of the tremendous growth of the country both in territory and in population, membership in Congress burgeoned, so that the halls of Congress were teeming, not only with legislators who needed seats, but with their constituents who sought favors, and with the many visitors who came to hear the debates. Besides the discomfort of crowding, the acoustics, especially in the Hall of the House of Representatives, were extremely poor. This was not a "Hall," complained an irritated congressman, but "a Cavern," "a mammoth cave, in which men might speak in all parts, and be understood in none." There were also problems of heating and ventilation. The chambers of the legislators were suffocating in the winter and oppressive in the summer, and the lack of proper ventilation in the Senate threatened, in Jefferson Davis' opinion, the very lives of Senators who felt "the injurious effects of breathing the atmosphere infected as that of this Chamber becomes after a long session. . . ." In 1850, then, Congress passed an act authorizing the President to appoint an architect to

supervise the construction of two new wings for the Capitol and appropriated $100,000 to begin the work.[4]

Even before construction got under way in 1851, artists petitioned the Library Committee and Congress itself for commissions to decorate the new wings. Commissions were not forthcoming, however, because Congress was in a suspicious—and certainly economical—mood when it viewed the activities for the new extension. Hardly more than a year had passed before a congressional committee was busily investigating Thomas U. Walter, the architect, and his contractors, expecting to find, in view of the approaching presidential contest, that some of the appropriation money had been used for "electioneering purposes."[5]

Although the committee finally cleared Walter of any wrongdoing, its investigations revealed some dishonest workmanship by contractors that resulted in a loss of confidence in the architect's ability. Therefore, when President Pierce took office in March, 1853, he was easily persuaded that "the public interest" called for the supervision and control of the work by the Army, and he asked his Secretary of War, Jefferson Davis, to appoint an officer to take charge of the building. The fact that the superintendency of this important construction job, with all its possibilities for conferring patronage, was taken from the control of the Department of the Interior and turned over to the Secretary of War suggests political intrigue. The Secretary of the Interior under Pierce, Robert McClelland of Michigan, played a weak role in national politics, being an administrator "and nothing more," whereas Davis, together with Caleb Cushing, the new Secretary of the Treasury, "held the controlling hand in domestic affairs." Davis, an ardent states' rights southerner, gave the job, however, to Captain Montgomery Meigs, an army officer from Philadelphia, whose loyalties were entirely with the Union and whose strong sense of probity and dedication to service promised that political considerations would have no place in awarding contracts. It seems unlikely, therefore, that Davis could have hoped to make political capital out of the assignment. The administration undoubtedly believed that greater efficiency would be achieved with an army engineer in control than with a professional architect, who might be competent in his designs but impractical in matters of economy.[6]

As time passed, Meigs increasingly came to dominate the Capitol construction scene, while the architect was relegated almost to the

position of a draftsman. Walter, one of the founders of the American Institute of Architects and prominent in his profession, was naturally sensitive about the subordination of his position, and as soon as there was an opportunity, he attempted to assert his power, especially in those areas where architectural plans were concerned. Congressmen soon became involved in the controversy, which they regarded as representative of the everlasting conflict that existed between civilian and military authorities. Representatives like Edwin Stanton of Kentucky and Edward Ball of Ohio vehemently insisted that civilians "had an eye to the cost, as well as to the appearance and dignity" of the building, whereas "the military engineer," as they chose to call Captain Meigs, and other "gentlemen schooled in the military service" —Jefferson Davis—knew a "great deal more about constructing public works with *strength* than with *economy*, and seem to have no idea of the value of money." [7]

The debate about putting the construction of the Capitol Extension into either civilian or military hands soon developed into an argument between the Department of the Interior and the Department of War and became another reason for criticizing the Secretary of War, who ran his department in an autocratic fashion and thus created many enmities both in and out of Congress. The problem of decorating the Capitol, including even such matters as furnishing committee rooms, became entangled in the controversy and provided the political enemies of the Secretary of War with another opportunity to attack him.[8]

Under President Pierce and Secretary of War Davis, Captain Meigs and not the architect had paramount authority in planning and constructing the extension. When a new Secretary of War, John B. Floyd, under a new and less sympathetic President, James Buchanan, came into power, the situation changed. The job of constructing the extensions was rich with patronage possibilities, and these Floyd wished to utilize for his own political and personal ends. Buchanan, who did not "care a button for Captain Meigs, questioned the correctness of his taste and disliked his arbitrary and tyrannical proceedings," was willing to abide by the decisions of his Secretary of War. Eventually, the situation exploded. Meigs was relieved of his assignment in 1859 and temporarily "exiled" to the Tortugas to supervise the construction of Fort Jefferson. There he remained until President Lincoln, urged by his Secretary of State, William H.

Seward, a friend of Meigs's, recalled him to Washington in 1861 to resume the superintendency of the extension and later to become Quartermaster General of the Union Army.[9]

Between 1853 and 1859 most of the art work for the Capitol Extension was planned and executed under Meigs's direction. Congress occasionally commissioned a picture or bust, but for the most part congressmen were too involved with the serious questions of the day, and with politics, to give much attention to artists' petitions. Since Meigs's appropriations until 1858 usually included allowances for "architectural decorations," whatever he could include under this specification in the way of art, he did. Even after he left, his carefully prepared plans were followed because many of the artists he had commissioned remained at work. Meigs's taste and artistic judgment, therefore, were responsible for most of the extension's decorations; and whatever criticism of the character and quality of these arose was directed at him. What, then, were Meigs's qualifications as the government's agent for art patronage, what were the works commissioned during his tenure of office, and what objections were raised against his achievements? [10]

Montgomery C. Meigs was a professional soldier and engineer by education, experience, and inclination. His strength lay in his meticulous administration of large and complicated projects and in practical rather than speculative matters. Meigs was a man of keen intelligence, trained to issue and receive military orders. Certain of his own rectitude, the Captain brooked no questioning of his decisions. Added to his military cast of mind, moreover, was a deep religious conviction that his life and work were directed by the Deity and that he was but "An humble instrument in God's hand." [11]

Meigs took his role as dispenser of the government's funds seriously, especially in relation to art. With the same intensity of involvement that governed all his work for the government, he conceived it as his mission to aid in the process of diffusing an interest in art throughout the nation. He hoped "to see the day when these new portions of the Capitol will contain the germs of a collection worthy the most powerful and the most wealthy nation of the earth, the only one that can point to a prosperous people and an overflowing treasury." To fit himself for the task, Meigs, according to his biographer, undertook "laborious study" to make himself "an art

critic." He read art books "widely," visited art galleries in New York and Philadelphia "on every possible occasion," and "consulted amateur critics such as Edward Everett and Gouverneur Kemble." After he completed his studies, Meigs's "self-confidence rose to the occasion" and "he plunged boldly forward." If Meigs committed errors of taste in the process, his biographer blames them on the "tastes of the times and the talents he could command." [12]

Meigs's advisers on art matters were highly respected connoisseurs and collectors, whose tastes and ideas had been formed in the 1820's and who maintained an active interest in aesthetic developments. Everett's forte was in sculpture, Kemble's in painting, and it was in their respective fields of interest that Meigs turned to them for advice. Everett's cultural nationalism was born during the early years of the Republic and so reflected the classical thought of that period; like others of his generation, his tastes and judgments were derived mainly from European sources and developed during the many years he lived abroad. From the days he had begun writing for the *North American Review* in the 1820's, Everett had disregarded the thought and achievement of the Romantics and remained loyal to eighteenth-century classical theories of art. It was, therefore, not surprising that he should approve of the work of the American sculptors residing in Italy during the middle of the nineteenth century. Their "cold, classical paraphrases," in Oliver Larkin's words, met Everett's ideas of "ideality," and he did not hesitate to recommend Thomas Crawford and Hiram Powers to Captain Meigs as eminent American sculptors worthy of receiving government commissions. [13]

Meigs accepted Everett's advice without hesitation, but he was not quite as ready to accept the advice of Gouverneur Kemble, his adviser on painting. Kemble was a man of intellectual and artistic interests whose mansion at Cold Springs, New York, housed an extensive collection of paintings by Spanish and Italian masters as well as by such American artists as Thomas Cole and Asher B. Durand. Meigs solicited Kemble's help in recommending artists qualified to fill the vacant panels over the staircases and in other parts of the extension, and the advice that he got was sound. Kemble believed that "unless Weir be excepted, we have as yet no artist fully qualified to undertake the decoration of our staircases." Both Meigs and Kemble at the time were thinking in terms of easel painting, or of large canvases which could be mounted on panels prepared to receive them. They hesitated

to assign these panels to American painters because they felt that none of them had the talent or training for such large-scale monumental work; American painters of the 1850's were more skilled in portraiture, landscape, and genre painting—small easel paintings designed for the intimacy of the parlor or the drawing room.[14]

Acting, at first, upon Kemble's advice, Meigs concluded that the best course would be "to finish [the staircases] with surfaces proper for the reception of pictures, but decorated in our architectural forms in color for the present. When the artist arrives, the commission will be given." John Chapman, the artist, seconded Kemble's advice and Meigs's decision; he also attempted to dissuade Meigs from undertaking any fresco painting for the Capitol, a possibility that Meigs already had under consideration. Chapman had very definite reservations about fresco painting; he found its effects thin and weak and felt that it required a superiority of execution that was seldom to be found except in artists of genius. Meigs, who had never seen a fresco although he had read "much at various times on the processes, and upon the results produced," was prepared to accept Chapman's judgment. Only his "very strong desire to use the opportunities & the influence" which his position gave him "for the advancement of art in this country" persuaded him to ignore the advice he had so earnestly sought.[15] "While debating in my own mind," he wrote to John Durand,

> how I should meet this difficulty [of painting the walls of the Capitol Extension], in a fortunate moment an Italian artist applied to me. . . . He asked the use of a wall on which he might paint an example of his skill, saying that he could not carry fresco paintings with him, had executed none in the United States to which he could refer me, but if I gave him the opportunity he would paint one at his own expense. I . . . at length told him that the room in which I then sat, which had only a rough coat of brown plaster, might be assigned to the Committee on Agriculture, and he might paint in the lunette of the wall, a subject relating to agriculture provided the sketch . . . seemed to me worthy . . . as he was a Roman (expatriated for his share in the last revolution), I suggested Cincinnatus called from the plough to defend his country—a favorite subject with all educated Americans, who associate with that name the Father of our Country.[16]

In this way, Constantino Brumidi entered into the employment of the federal government, to remain there for twenty-five years until his death in 1880. His employment and his work sparked a burst of criticism of all the art work in the new extension, a small flame which threatened to become a major conflagration when "the Artists of the United States in Convention assembled" protested the art policies pursued by Meigs in a memorial to Congress.[17]

When Meigs awarded commissions for statuary and fresco paintings he scarcely could have foreseen that these would create such heated passions. In fact, he was very cautious in carrying through his plans to make sure that what he did was legally within his power and conformed to the taste of his times. Profiting from the criticism that had attended the unveiling of Greenough's *Washington* a decade earlier, Meigs solemnly warned the sculptors Crawford and Powers, when he invited them to submit designs, that they should guard against any obscure symbolism in their work. "The sculpture sent here by our artists [from Italy] is not altogether adapted to the taste of our people," he wrote; the success of a statue in this country was probably due not alone to its beauty, in his opinion, but even more "to its meaning being within the comprehension of all." After accepting Crawford's design, which represented "the advancement of the white race and the decadence of the Indians," Meigs was so anxious to ensure the authenticity of the groups that he promised to send Crawford a "work upon the manners and customs of our Indian tribes" which was about to be completed for the government. "If it be true," wrote Meigs, "that a shoemaker can criticize a shoe tie, will it not be well for the artist to disarm his criticism by making the shoe tie correctly? If it is all that he be able to appreciate, let him too be gratified." [18]

Meigs's approval of Crawford's design as both "appropriate" and "intelligible"—although to us today it seems commonplace, superficial, and unpleasant in its inferences—casts no reflection on the Captain's judgment. Such a design may have seemed quite "appropriate" to Americans who were filled with a sense of their country's "manifest destiny" as they looked northwest to Oregon and southeast to Cuba for fulfillment of their national purpose. Americans of this generation also overwhelmingly accepted the idea of the white man's superiority and the inevitable triumph of the Anglo-Saxon over the "inferior" colored groups. Moreover, since the days when John

Quincy Adams had produced his design for Persico's pediment for the eastern portico of the old Capitol, "intelligibility" had always been a sculptural quality in demand by Americans.[19]

Crawford's design consisted of fourteen figures and "numerous accessories." In the center of the group stood "a majestic goddess," America; on her left were figures intended to represent "the march of civilization," from the Indian grave through various Indian figures representing the domesticated Indian and the warrior and hunter, leading to the pioneer felling a tree; on the right of America, the figures represented the typical activities of the triumphant white race —the mechanic, the schoolmaster, Youth, the merchant, and the soldier. In 1856 Crawford was also commissioned to prepare the model for the oversized figure of Liberty to surmount the new dome of the Capitol, to design two bronze doors for wings of the Capitol, and to model a group entitled *Justice and History* which would be placed over the Senate entrance on the main floor.[20]

In order to facilitate progress on Crawford's assignment, statuary shops were constructed on the Capitol grounds for the use of Italian stone cutters imported for the purpose. As the individual pieces emerged, congressmen who stopped to make on-the-spot investigations became incensed at what they saw. The congressmen who were most agitated came mainly from the West. The knowledge that appropriations for such "gewgaws" had been approved, while favorite projects of theirs, like improving the navigation of the Mississippi River or the Great Lakes, failed to receive the necessary appropriations, increased their anger. Besides, they objected to the employment of foreign workmen on the marble cutting, even though there probably were not a sufficient number of skilled Americans for the project; and they were offended by the lack of realism in the execution and conception of the Indian figures being embodied in stone.[21]

"Shade of John Randolph," exclaimed Representative Edward Ball of Ohio as he viewed one Indian figure who "stood leaning forward with a large bowl resting on his back just below the neck." "Step forth, and rebuke this utter falsification of Indian character. When did we ever make a hewer of wood and drawer of water of an Indian? We have broken his heart, but never his spirit. . . . Sir, I protest against this outrage upon truth!" [22]

Two years later Senator Sam Houston of Texas kept his colleagues

amused for almost an hour as he ridiculed the statuary. Amidst much laughter from the senators present, Houston expressed sympathy for the poor Indian woman in Crawford's pediment, who was seated on a slab of marble with a papoose in her arms, "its little head sticking out like a terrapin . . . and its little neck, without the least curve or grace . . . very stiff like an apple on a stick." "A contemplation of this figure," he believed, would "inflict agony on every human being of sensibility." Houston also found "the poor Indian boy, who looks as if of Oriental stock, with water to spout continually on him from the large shell on his shoulders," a figure for his commiseration because he had never seen "a creature" in such a "servile, miserable, cruel, agonizing attitude." Houston could not "believe that a native artist would make such sketches, a native artist who could observe nature as it is in our forests and in our wilds. . . ." [23]

Crawford's large figure of Liberty also suffered the fury of Houston's blast. The statue bore the imprint of Secretary of War Davis' hand, for it was under his influence that Crawford replaced the Liberty Cap which he had originally planned for the statue with a plumed helmet. The Liberty Cap, Davis believed, was "inappropriate to a people who were born free and would not be enslaved:

> Why should not armed Liberty wear a helmet? Her conflict being over, her cause triumphant . . . the visor would be so as to permit . . . the display of stars expressive of endless existence and of a heavenly birth.[24]

However, it was not the headdress that came under Houston's fire; it was the lady's feet, and especially the "formidable pair of russet brogans" instead of sandals that she wore. These, in Houston's opinion, were more fit for "laborers in the swamps of the South" than for a lady of mythical consequence. The "tout ensemble," in fact, suggested to the senator from Texas the portrait of "some unfortunate lady that had fallen into great bodily agony and infelicity of feeling"; and when Davis, who was now a senator, rose to defend the work, Houston redoubled his assault, maintaining that it was "impossible" to believe that "genius, taste, or fancy" could ever produce "such a thing" as this statue.[25]

The other sculptural works which Meigs commissioned—Randolph Rogers' bronze doors and Hiram Powers' statues of Jefferson and Franklin—escaped congressional criticism of their artistic values,

but were denounced as examples of unjustifiable extravagance. What mitigated much of the criticism was the fact that these commissions had been awarded to American sculptors, a policy which could only elicit approval from native artists and congressmen alike. All of the commissions, in fact—even Crawford's much maligned work—were considered by most congressmen to have been "judiciously bestowed," because in them was seen "a nationality and a suitability to the purposes for which they were designed." [26]

Not so the decorative paintings executed in fresco by Brumidi. After Captain Meigs approved Brumidi's work in the Agricultural Committee Room, the artist was assigned other committee rooms to decorate in similar fashion. For his services he was paid on a *per diem* basis at the same compensation allowed congressmen, and when congressmen's salaries were increased, so also was the painter's. During 1855 and 1856 the artist received eight dollars a day; during 1857 and through 1860, he worked at the rate of ten dollars a day. Throughout these years his average monthly pay amounted to two hundred and sixty dollars. For such compensation, Brumidi decorated the walls of the room occupied by the Committee on Agriculture, a good portion of the President's Room, part of the room of the Senate Military Affairs Committee, the whole of the room of the Senate Committee on Naval Affairs, some of the ground floor corridors of the Senate Extension, and part of the House of Representatives Chamber, notably the large picture portraying *The Surrender of Cornwallis.* The decoration of the Agricultural Committee Room consisted of two lunettes—"the calling of Cincinnatus from the Plow" and "the calling of Putnam from the Plow to the Revolution"; and two panels, one showing an American harvest scene of early date, and the other, a threshing scene in which a McCormick reaper appeared as an indication of the contemporary. Portraits of the five members of Washington's Cabinet adorned the walls of the President's Room, while on the frescoed ceiling appeared four symbolic groups representing Religion, Legislation, Liberty, and Executive Authority. At each corner of the ceiling were four full-length life-sized portraits of representatives of the various forces in Civilization—Columbus (Discovery), Vespucci (Exploration), Brewster (Religion), and Franklin (History), and the whole was connected with floral wreaths and flying cherubs—almost a trademark of Brumidi's work. The room of the Senate Committee on Naval Affairs was fashioned after a Pompeian bath, with marine gods and goddesses

scattered about the ceilings and antique vessels adorning the walls, while the room for the Senate Military Affairs Committee bore five large lunettes depicting scenes from American revolutionary history which were surrounded by victors' garlands, shields, guns, and other emblems of war, and of course, more flying cherubs.[27]

As Brumidi's fat naked little babies and bright flowers began to make their appearance between 1855 and 1860, along with his nymphs, tritons, and marine horses, American taste became highly offended and cries of outrage arose. The artist's defenders stoutly maintained that such decorations in style, symbolism, allegory, and classical allusion were found in all the prominent public buildings of Europe and were appropriate to the kind of monumental building which the Capitol represented. Jefferson Davis defended Brumidi's work by noting that congressmen had assured him informally that they "wanted the building finished in the very highest order of modern art" and that "Brother Jonathan was entitled to as good a home as any prince or potentate on earth." Davis was sure that "as Congressmen became accustomed to looking at art [they] will become more cultivated and better able to appreciate it." Captain Meigs, who was responsible for Brumidi's employment in the first place, defended his action on the grounds that American artists were not trained to paint in fresco or in any other type of mural painting, "their attention being given heretofore to oil painting on canvas, generally of small size and elaborated with great expense of time and labor." It was more economical, as well as more appropriate, Meigs thought, to employ the fresco style of painting on the walls of the Capitol Extension. "The pictures bought by Congress for the Rotundo," he explained to John Durand,

> cost from ten to twelve thousand dollars each. After the commissions were given, the artists took years to paint them. At this rate, the rooms of the Capitol would cost $40 or $50 thousand each, and each would be twenty years in painting. The painting of one hundred Committee Rooms alone would cost four or five millions. The whole cost of the two wings is only about five millions.[28]

None of these arguments placated the opposition. Economy was, as usual, one of the foremost issues raised. Congressmen were asked "to compare the republican simplicity, plainness, and grandeur" of the old Hall of Representatives with the new one; and it was pointed out

that "all the gorgeous gilt thrown about the new Chamber . . . does not comport with our character and dignity as a free people." Rather, such decorations offered a way in which "cormorants, contractors, stockjobbers, plunderers of the Federal Treasury" obtained jobs and contracts from the government and "swindled" it of thousands "from which no real good can result." Taste, too, was invoked in the controversy. Senator Jacob Collamer of Vermont thought the walls looked like "a sort of Joseph's coat," and he hoped for "a little more chastity" in the future decorations of the extension. Representative Taylor of New York was even more outspoken; the decorations were "contemptible . . . , disgraceful to the age and to the taste of the country." "Have we no artist to illustrate the history of our country?" demanded Taylor,

> . . . no commerce to illustrate—no history to perpetuate? that we are compelled to employ the poorest Italian painters to collect scraps from antiquity to place upon these walls . . . a libel upon the taste and intelligence of the people? [29]

"Pictures are symbols of ideas," proclaimed Owen Lovejoy of Illinois in the House of Representatives as he discoursed on the lack of American ideas in the paintings decorating the walls of the Agricultural Committee Room. Lovejoy was dismayed at not finding among the cupids, cherubs, "&c to the end of heathen mythology," a single specimen of the "valuable breeds of cattle, horses, sheep &c which are now found in this country." Worst of all, Lovejoy lamented, there was not a single picture which represented "maize," which he felt should have been shown "in its different stages: as it emerges . . . from the ground; as it sways in the dark luxuriance of June and July; and then as it waves its tasseled crest . . . and last in its rich golden maturity." Finally, unable to resist taking advantage of an opportunity to advance the cause of abolition, the congressman proposed that the pictures illustrate "the present mode of culture of free labor." In the place of the Putnam picture he would put a "hardy yeoman" driving a span of bays, with arched necks and neatly trimmed harness; in the place of Cincinnatus he would put "a negro slave, with untidy clothing, with a slouching gait, shuffling along by the side of a mule team, with ragged harness and rope traces . . . [which] would represent the idea of slave labor. Thus we should have a symbol of the two systems of labor now struggling for the ascendancy." [30]

CHAPTER SEVEN

THE ARTISTS' PROTEST

It is probable that congressional criticism of Brumidi's frescoes was stimulated by the concerted attack of American artists on the government's policy with respect to decorating the Capitol. American artists woke up one day to discover that a foreigner had quietly pre-empted the job of ornamenting the new building and had thereby deprived them of the possibility of receiving important and highly remunerative commissions. "It is forever to be regretted," wrote the painter J. A. Oertel to the *Crayon*,

> that from the commencement there did not exist in some leading mind a just conception of how a great national Epic might be told upon the walls of the Nation's Capitol . . . or that untoward circumstances prevented the effective extension of such conceptions . . . but it is now already cut up, and its unity destroyed . . . not in choice of subject only, but also in style of ornamentation.[1]

Resentment was widespread and was made especially acute by the rampant anti-foreignism or "know-nothing" sentiments of the period.[2]

The Washington Art Association, which consisted of a group of gentlemen—artists and patrons of art—headed by the sculptor Horatio Stone, led the protest with an invitation to the artists of the United States to meet in convention and act upon the problem presented by the Capitol decorations. On March 20, 1858, the convention met and drew up a memorial to Congress that reflected the outrage American artists felt at being deprived of their patrimony by the government. The memorial solicited "for American art that consideration and encouragement" which American artists felt they were entitled to receive from the government. It criticized "the folly and extrava-

gance" displayed in the decorations of the Capitol and protested against the "injustice" of employing foreign artists to do the work. Such a policy, the memorial complained, deprived American artists of the opportunity "to embody in enduring and beautiful forms . . . all that is glorious and ennobling in our history, character, and life as a people." Finally, it affirmed the belief that what a developing national art required was "a liberal, systematic, and enlightened encouragement"; to this end the artists of the United States urged the establishment of an Art Commission "composed of those designated by the united voice of American artists . . . who shall be the channels for the distribution of all appropriations to be made by Congress for art purposes, and who shall secure to artists an intelligent and unbiased adjudication upon the designs they may present for the embellishment of the national buildings.[3]

The artists' memorial bore almost one hundred signatures of artists and friends of art, some of whom were among the most prominent men in the profession at the time. These men were not unimportant figures in American art history; in their time, Albert Bierstadt, William Loring Elliott, Sanford R. Gifford, George Inness, Asher B. Durand, and James Suydam, among others who signed the petition, were popular and impressive painters. What they did not realize, however, was the fact that American artists were quite untrained to compete for the kind of painting monumental building required. For twenty years they had been virtually ignored by the government, and therefore they had never had the opportunity to develop the appropriate skills. Instead, dependent as they were on private patronage, they had concentrated their talents on small easel paintings devoted to portraiture, landscape, and genre subjects. Moreover, the government's negative attitude toward the arts had reduced the expectations of artists, during these twenty years, that the government would develop a coherent large-scale plan of patronage. Although individually some of them sought commissions, they were quite convinced that the government would never sponsor schools or exhibition galleries, and so together with wealthy individuals in their own communities, they had developed their own institutions. Now, when the opportunity presented itself for working out a comprehensive scheme of government patronage, the artists were unprepared to meet the challenge. Their views, whether expressed in the convention or in their memorial, were exceedingly narrow, and they therefore missed a

splendid chance to further their cause with the national government.[4]

The Select Committee appointed by Congress on June 1, 1858, to consider the artists' memorial was very sympathetic to the artists' plea. The committee's report, which had been drawn up by Edward Joy Morris of Pennsylvania and George H. Pendleton of Ohio, embodied "broad and national views." "Painting and sculpture," they informed their fellow congressmen,

> are the handmaidens of history, to record the traits and characteristics of national life, and to convey to after ages, by images presented to the eye, the costumes, arts and civilizations of such periods as the artist may embody upon his canvass or grave upon the marble.[5]

Moreover, the committee continued, art "to be living" must be "projected from the life of the people . . . must be familiar, must partake of the nature and habits of the people for whom it is intended, and must reflect their life, history, hopes and aspirations." American history deserved to be written in the imperishable materials of art; the United States government was the proper agent for encouraging such effort, the public edifices were the appropriate places for such illustrations of American history and life to appear, and American artists alone ought properly to be employed in this "great work." The legislators believed that the art already executed for the Capitol, although "doubtless the result of an honest effort to produce effect," did not fulfill the requirements of a national art; it neither illustrated the history and life of the American people nor did it "touch" the American's "heart" or inspire his patriotism.[6]

In order to change the existing system of decorating the Capitol the committee suggested the appointment of an Art Commission that would be empowered to draw up "a general plan of decoration and embellishment" for the building, which could be followed "at leisure and according to the will of Congress expressed from time to time." Meanwhile, "a plain coat of whitewash" was preferable to the "tawdry and exuberant ornament" that covered many of the walls and ceilings of rooms and passages. Given the incentive of government patronage, American artists in due time would become skilled in the "higher walks of art" necessary for such monumental work and would produce "results worthy of the age and the land in which

[they] live." The committee agreed that the opportunity to encourage American art, which the new building made possible, should not be lost. "Statesman and artist," exhorted the congressmen, "should join in this noble work and permit no profanation of it. . . ." [7]

The committee's recommendation that an Art Commission be appointed was in accord with an act of Congress passed almost a year earlier, authorizing a somewhat similar commission to pass approval on designs submitted for the decoration of public buildings. Further legislation followed on March 3, 1859, carrying out the committee's suggestion, and on May 15 of that year President Buchanan appointed to the commission, Henry K. Brown, a sculptor, James R. Lambdin, a portrait painter, and John F. Kensett, a landscape painter, men eminent in their professions. [8]

Almost a year later the Art Commission produced a conservative and objective report that should have carried some weight with Congress and the American public. Unfortunately, the report fell far short of its mark. The commissioners were uncertain how to proceed to fulfill their assignment, which had been given to them in the most vague terms. Their instructions required them "to examine the system of decoration now installed in our public buildings" and "to make recommendations for the future." The committee that had recommended their appointment had been a little more definite; the committee report had assigned the commissioners the task of suggesting "a general plan of decoration and embellishment" and of pointing out "a correct system which can be pursued with true economy." [9]

Whatever the expectations, in their seven page report the commissioners limited themselves to a criticism of the existing decorations, a discussion of "national honor" in connection with "national art," and a recommendation of specific incidents to be included in specific works of art for particular areas. They concluded with a criticism of the government's coinage designs—a weak ending to a weak document. Appended to their report was an estimate for appropriations necessary to carry out the decoration of the two halls of Congress which were then ready to receive works of art. The estimate came to $166,900, a modest sum, but one which could only excite hostility from congressmen already infuriated at the huge expenditures being lavished on the extension's ornamentation. [10]

The disappointment that followed the publication of the art commissioners' report brought to an end most of the agitation

directed against the ornamenting and decorating of the extension. The report was issued in February, 1860; in June of that year an amendment was offered to a Sundry Civil Appropriations Bill for 1861 by Senator Robert Toombs of Georgia that was designed to repeal the existing law authorizing an art commission. Defenders of Captain Meigs—James A. Pearce, Toombs, Pierce, Davis, and John Slidell—took the occasion of general disappointment in the Art Commission to urge the engineer's return from his exile in the Tortugas, claiming that it was to him the country owed "whatever there is very valuable in the design." Captain Meigs was not to be vindicated yet, but the amendment was passed, and after various consultations with House committees, the commission was dismissed. Commissioner Lambdin attributed the dismissal to a "prearranged plan on the part of . . . the bosom friends of Captain Meigs, who desires to be reinstated in his former position"; and he asked John Durand, editor of the *Crayon*, to explain the situation in his journal in order to rally the artists of the country to the support of the commission. But the artists of the country were unable to muster the required energy, and the project failed through inertia.[11]

In 1868, F. C. Adams, writing an account of "Art in the District of Columbia" for Henry Barnard's special *Report on Education in Washington*, attributed to the "weak and feeble" report of the commissioners the failure to revive the commission or appoint a new one. "Since that time," Adams wrote, "art has in a measure been left to take care of itself." Adams was not quite correct in blaming the commissioners, although it was true that a good opportunity had been missed for advancing an over-all plan of government patronage of the arts, complete with the establishment of a national museum and perhaps a national art school. Adams used the British experience as an example of what could have been done after a similar fiasco following the decoration of the House of Parliament. By showing how art could be made "to promote the material industry of the country," and thereby how the government would be justified in giving it aid and protection, the report, Adams believed, might have accomplished more. It seems very unlikely, however, in view of the American government's longstanding reluctance to undertake anything extensive in the way of encouraging art that Congress would have approved a large-scale scheme even if such had been advanced. Moreover, 1860 was a climactic year in American history, when

political conflict and sectional antagonisms were mounting to inevitable war. Congressmen were so terribly beset with their own difficulties in that year that "even a hint about art . . . would turn the fat into the fire." [12]

During and after the war, decoration of the Capitol continued much as it had before this tempest had blown its brief fury. Brumidi continued his fresco work throughout large parts of the extension, filling the "eye" of the Capitol dome with an elaborate allegory called *The Apotheosis of Washington* and with a frieze celebrating the history of the country from the landing of Columbus through the Revolutionary period. As for Captain Meigs, who was responsible for the storm in the first place, he insisted that his policy had been a correct one. "I have labored faithfully and diligently," he reported to the House of Representatives through Secretary of War Davis, "to construct this building in such a manner that it would last for ages, as a creditable monument of the state of the arts at this time in this country." Meigs regarded Brumidi's fresco painting as a considerable achievement; as an investment, the Captain believed it was in the long run a cheaper substitute for wallpaper or whitewash. Historical paintings of the kind his critics called for, Meigs believed, properly belonged in the panels he had provided for them. These panels were eventually filled with Leutze's *Westward, The Course of Empire Takes its Way*, Walker's *The Battle of Chapultepec*, and two landscapes by Albert Bierstadt entitled *Discovery of the Hudson River* and *Entrance into Monterey*.[13]

After the Civil War, government commissions were almost the complete responsibility of the Joint Committee on the Library, which exercised its authority only on the instruction of Congress. The artists remained relatively quiet, waiting to be called to fulfill individual assignments, and there was little interest shown in attempting to persuade the government to embark on a broadly conceived program of patronage of the arts. Not until the fourth decade of the twentieth century, in a time of great economic depression, would artists and their supporters again make any large-scale attempt to enlist government patronage for art on a national level.[14]

PART III

ART AND THE COMMUNITY

Then temples rose, and
towns and marts;
The shop of toil, the hall
of arts.

EMERSON

In 1860 RALPH WALDO EMERSON defined the great question that had faced cultural nationalists in the United States for many decades. "How to give all access to the masterpieces of art and nature," wrote Emerson in *The Conduct of Life*, "is the problem of civilization." Pictures, engravings, statues, and casts, he realized, were all important for the development of individual, no less than national, culture; yet they involved costs far beyond their purchase price, and the expense of galleries and their curators necessarily limited the enjoyment of works of art to the few who could afford private collections. Emerson agreed with the Greeks that it was "profane that any person should pretend a property in a work of art, which belonged to all who could behold it." The only solution to the problem for America, concluded the Concord philsopher, "where democratic institutions divide every estate into small portions after a few years," lay in the public ownership of art "properties"—ownership by the states, towns, and lyceums, agencies which ought to "provide this culture and inspiration for the citizens." [1]

American artists and friends of art who felt as Emerson did combined their efforts for the cause of art in all the ways he suggested. First, they tried the national government; but despite their various attempts to solicit government aid and to receive government commissions, they soon realized that the difficulties and obstacles were great, and so never gave it their full attention. Nor did they ever press, except in 1859–60, for any large-scale plan of government patronage. In fact, American artists looked to the government only half-heartedly, with a kind of wistfulness that accepted failure even before they failed. "The governments . . . of our nation, or of the separate states," said John Trumbull, President of the American Academy of Fine Arts in New York, as he addressed the aristocratic membership of the institution, "cannot be looked up to by the arts with any hope of protection . . . ; the church offers us as little hope as the state; and the fine arts . . . are in this country thrown for protection and support upon the bounty of individuals and the liberality of the public." In similar fashion, James Herring, Corresponding Secretary of the Apollo Association, in 1840 expressed the conviction that "in this country the artists can place no dependence

on the permanent patronage of government; *it is on the people they must rely*." [2]

Unimpeded, therefore, by false expectations of government help, and in the tradition of enlightened gentlemen, leading citizens in the different communities attempted to meet the problems facing art and artists. Sometimes aided by the municipality or state, but more often not, they pooled their energies in community or group enterprises that were designed with a twofold purpose: to create and diffuse a taste for the fine arts among the American people through exhibitions of works of art, in order to raise the cultural level of the country; and to offer professional training to young artists, in order to encourage the growth of a native art.

Since Americans were guided mainly by European experiences, they first thought of establishing art institutions that would stimulate an interest in art; only secondarily did they consider the need of young artists for professional instruction. As the number of artists increased, however, the need for better training facilities became more apparent, and often dissension arose between the laymen, whose efforts and financial support were required for the success of the enterprise, and the artists, who had different goals in mind. Artists needed schools in which to train, and then galleries in which to exhibit and, of course, to sell their work. When the galleries established by the academies failed to meet the requirements of the artists, new facilities had to be created or old policy modified. Where the needs of the artists were not at all adequately met, often the art life of the community was restricted, because artists like skilled workers and professional men generally avoided communities where their services seemed unwanted.

In some cities artists combined to form their own institutions; elsewhere, laymen established galleries, art unions, or art distribution associations. In fact, Americans never seemed to tire during these years of "getting up the machinery of Societies," to use Edward Everett's phrase. Colleges, athenaeums, mercantile libraries, young men's associations, historical societies were all utilized as art exhibition centers or as schools for young artists. Out of these efforts to communicate with the public, artists and patrons of art created institutions that, notwithstanding numerous false starts and some dismal failures, eventually grew into the free publicly-supported art museums that we know today. [3]

Variations in geographical location, cultural traditions, and social forces meant that different communities in the United States would attempt to meet their cultural problems in varying ways. These variations account for the different degrees of success each community finally achieved. What was uniformly manifest in all these efforts, however, was the belief that public co-operative enterprises devoted to the cause of art were necessary, useful, and valuable to the community as well as to the nation, and that their development was the responsibility of men of wealth, position, and leadership within the community.

CHAPTER EIGHT

NEW YORK SETS THE PATTERN: THE AMERICAN ACADEMY OF FINE ARTS

THE FIRST ART ACADEMY of importance formed in this country as a result of community effort was the Society of Fine Arts in New York City, organized in 1802 by leading citizens of that metropolis. There had been earlier efforts to organize art schools and museums in New York, Boston, Charleston, and Philadelphia, but these were either too short-lived to be significant or represented the energies of individuals, usually artists, who sought to establish schools of drawing or institutions that combined instruction with entertainment in order to secure a livelihood. Edward Savage and Archibald Robertson of New York, and Charles Willson Peale of Philadelphia, successfully ran such institutions at the turn of the century as private enterprises, although they were often clothed with an expression of public purpose; for example, Peale's Philadelphia Museum was designed to advance "the interests of religion and morality by the arrangement and display of the works of nature and art." [1]

Museums of natural history had also been established at an early date: the Charleston Museum was organized by the Charles-Town Library Society in 1773 to procure for the province "a full and accurate Natural History." The museum contained some paintings, and in 1815 its purpose was broadened to include "the promotion and encouragement of the arts, sciences, and literature generally." However, its collections were overwhelmingly scientific rather than artistic, which was also the case with the Museum of the Tammany Society in New York, or, as it was later called, the American Museum. Established in 1790, the American Museum expected to

exhibit "everything relating to the history of America; likewise every American production of nature or art"; but the emphasis was on natural history.[2]

The early art academies did not grow out of any felt need of artists to form associations; most of the professional artists of the period were more interested in pursuing their studies in Europe, where the masterpieces of painting and sculpture, together with "nature in profusion," provided their sources of instruction. Copley, West, Allston, Morse, Sully, and Vanderlyn, among a host of others, hastened to England, France, and Italy as soon as they could find the means to finance such excursions, and the trek to the "land of promise" continued throughout the century. These trips were often financed by wealthy merchants and public-spirited gentlemen who commissioned the young artists to paint copies of the Old Masters, which then became the nucleus of their picture collections; these gentlemen were, in large measure, also the founders of the first art institutions in the country.[3]

The Society of Fine Arts in New York City, which later was called the American Academy of the Fine Arts, set the pattern. The Academy owed its inception to Chancellor Robert R. Livingston, a prominent member of the large Livingston clan, which was conspicuous for its landed wealth and its participation in New York State politics during the Federal period. Livingston was a typical enlightened gentleman; his interests ranged from political theory and the causes of yellow fever to natural history and the invention of a "mould board" for a plow. A founder and the first President of the Society for the Promotion of Agriculture, Manufactures, and the Useful Arts in New York in 1793, Livingston was also a gentleman farmer; at Clermont he experimented in improved breeds of sheep and in cultivating fruit orchards, all of which he hoped would be "of consequence to [his] country."[4]

In 1801 Livingston was appointed Minister to France in recognition of political services rendered to Jefferson during the presidential campaign. In France the Minister became an interested observer of all aspects of French society. Although he deplored the endless round of parties and the frivolity of French life, he found much in that country that pleased him. So taken was he, for instance, with French gardens that he planned to "Frenchify" his estate on his return; and he sent his sister Janet Livingston Montgomery, who was planning her mansion,

Montgomery Place, a plan for a Parisian house, which, however, he feared would be "too magnificent for her use." He also volunteered to have cast for her a copy of the statue of Apollo, suggesting that it could be supplied with an apron in America if she thought it necessary. When Livingston returned from France he brought with him many "rare and beautiful objects" for the embellishment of his home in New York; among these treasures were Gobelin tapestries, engravings, and paintings.[5]

Possessing such an interest in the arts, then, it is not surprising that Livingston should have conceived the idea of having "plaister casts" made of the famous collection of antique statues in the Louvre to form the basis of a school and academy in New York. Such an institution would be valuable, he believed, for training native artists and would provide an interesting place of resort for "admirers" of the fine arts who "may not have had the means or the leisure to visit the originals." In 1801, therefore, he suggested that his brother Edward, then Mayor of New York City, arrange for a subscription among the city's important citizens that would defray the expense of purchasing these sculptural and architectural models and also make possible the acquisition of copies of some of the more famous paintings in France.[6]

Seventy-nine public-spirited citizens responded to Edward's solicitations, each subscribing fifty dollars a share in an organization for which they entertained high hopes. "One of the great advantages that will result from this Institution," wrote one of the subscribers, John R. Murray, to John Trumbull, "besides the general improvement of taste, will be the creation of An Academy, which may bring the Genius of this Country to perfection without so much foreign assistance." But first things first: "the great Mass of our Gentry," Murray noted, ". . . want a little of the Leaven of Taste."[7]

By 1802 the Academy was well launched. In 1803 John Vanderlyn, then a young painter in New York City, was sent to Paris, where he had previously studied, in order to purchase and paint copies of famous paintings and to supervise the casts that were being made for the Society. Paintings of Raphael, Correggio, Domenichino, Titian, Paul Potter, Caravaggio, Rubens, Poussin, and Rembrandt were all proposed as "suitable for the purposes of the Academy." The cattle picture of Potter alone, Vanderlyn prophesied, "would attract crowds to see it at half a dollar a head." Vanderlyn's salary was five hundred dollars annually, and he was furnished with ample means to

fulfill his assignment. What he actually purchased for the Academy is not completely clear. Copies of at least four paintings were received from him: Veronese's *Feast at the House of Levi*, Titian's *Scourging of Christ*, Rubens' *Elevation of the Cross*, and Caravaggio's *Entombing of Christ*.[8]

New York City in 1801 seemed a good place to establish such an institution for the fine arts. By that time it had already become the most flourishing city in the United States. Although New York's merchants had suffered severely from the effects of the Revolutionary War and business life had been confused, first by the depreciation of the currency and then by the dumping of British manufactured goods on the city's wharves—a ruinous source of competition for American manufacturers as well as for the American carrying trade—nevertheless, New York made a surprisingly quick and vigorous recovery. By 1800 it had outdistanced all other American cities in its commercial activities, in the value of its exports and imports, and in the volume of its foreign and coastal shipping. Banking and insurance enterprises had also been stimulated by the revival of trade, and New York's economic life was experiencing boom years.[9]

The economic prosperity that characterized the city when Mayor Livingston made his rounds for subscriptions to the Society of the Fine Arts was matched by a social and cultural growth that favored the development of educational institutions and societies of all kinds. Although up to that time New York City had not provided a permanent home for any great number of artists, it was soon to become a flourishing center for the arts. The mounting prosperity of the city was chiefly responsible for this development, but it was also hastened by the transference of the nation's capital from Philadelphia to the District of Columbia, which lessened Philadelphia's attractiveness for portrait painters who had collected there to paint the country's luminaries. Some of these artists, aware of New York's growing economic strength and New Yorkers' "rage for portraits," set up their studios in this prosperous port. In 1802 Edward Savage transferred his Columbian Museum from Philaelphia to New York, S. I. Waldron took over the Museum of the Tammany Society, and David Longworth continued to show paintings at his Shakespeare Gallery. New York seemed ready for a formal academy.[10]

Yet the American Academy of Fine Arts was never wholly a success; it fluctuated between occasional triumphs and frequent

failures, with intermediate years of sluggish and uninspired activity. During the early years of the Academy the institution was guided by the amateurs who were largely responsible for its founding, the two Livingstons and DeWitt Clinton, Mayor of New York City and eventually Governor of the state. The successive directors of the Academy and its stockholders were mostly "men of affairs"—as Sizer has pointed out—"statesmen, bankers, merchants, physicians, and philanthropists—the most prominent New Yorkers of the period." These were individuals of cultivation and wealth, whose ideas and modes of behavior had been influenced by the heritage of the Enlightenment and whose interest in art and in its encouragement in this country was genuine.[11]

John R. Murray, Luther Bradish, Dr. John W. Francis, Peter Irving, Gulian C. Verplanck, were all prominent New Yorkers of established social position. When they were younger they had all taken the Grand Tour of European art galleries and had been duly impressed and educated by the glories of the Old Masters. Murray, David Hosack, Philip Hone, Gouverneur Kemble, James Fairlie, and Verplanck owned notable collections of paintings, both European and American. Most of the directors, like John Pintard, Hosack, Rufus King, Bradish, and others, were active in other organizations for the advancement of knowledge or culture that were founded during the same period, such as the New-York Historical Society, the Lyceum of Natural History, and the Literary and Philosophical Society. Some of the directors associated with professional artists in the Sketch Club, and all of them in one way or another, frequently through their positions as public officials, or as private citizens, participated in organizations for the encouragement of art, or patronized young American artists.[12]

These men clung to eighteenth-century classical traditions, and the direction the institution took under their guidance was to a great extent determined by their tastes. According to the classical tradition, a sound education in art required primarily a good collection of models from antiquity and paintings or copies of paintings from the Old Masters. Once these were provided, once the "germ of those arts . . . so highly cultivated in Europe but not yet planted here" was transferred to the new world, there was little to do but sit back and enjoy the results. Then would the American Republic, "like that of Greece and Rome . . . prove another honorable and instructive

example of the intimate connection of Freedom with the Arts—of Science with Civil Liberty." [13]

Unfortunately for the Academy, the belief of its founders that little more was required of them than to provide "the finest models" of antique art grossly oversimplified the problem of maintaining a vigorous organization in a vigorous city; between 1805 and 1815, therefore, the institution experienced almost complete stagnation. Without funds for a permanent building to house its collections, the Academy found it necessary to store them either in the Customs House or in the celler of the City Hall—a "poor place for the gods and goddesses—after Olympus," mourned "Jeremy Cockloft" in *Salmagundi* in 1807. "Cockloft" pondered further on "the ups and downs of life" that could "coop up" Apollo and Venus in a cellar because the American Academy could not afford them "home-room": "Eulogy on the gentlemen of the academy of arts," the writer concluded,

> for the great spirit with which they began the undertaking, and the perserverance with which they have pursued it—It is a pity, however, they began at the wrong end—maxim—if you want a bird in the cage always buy the cage first.[14]

Because of inadequate space and especially because the directors chose to emphasize the museum aspects of their academy—which resulted in their treating the collections as "a mere show,"—young artists found it difficult to gain access to the collections to further their education. Increasingly, the Academy came to assume the character of an exclusive club, inaccessible to both the ordinary citizen and the aspiring artist.[15]

After the death of Robert R. Livingston in 1813, DeWitt Clinton took over the presidency of the moribund institution. A politician known for many "miracles," Clinton was able temporarily to resuscitate the organization in 1815–16 by arranging with the Corporation of the City of New York the free leasing of two stories of "the old Alms-House" to the Academy for a period of ten years. A loan of fifteen hundred dollars from the Mechanics Bank and a resurgence of enthusiasm among the members of the Academy's Board of Directors made possible the "fitting up" of new rooms for a great exhibition "calculated to diffuse a knowledge of the principles and to spread a taste for the practice of the Fine Arts." The resuscitation of the

Academy was, in fact, one of the first events heralding the new wave of cultural nationalism that followed the War of 1812.[16]

On October 25, 1816, the Academy opened to the public an exhibition of paintings and statuary that was probably the institution's most impressive, and therefore most successful, exhibition; it fulfilled without doubt the desires of the Board of Directors who had wished to assemble a collection that would "give elevation to this city and reflect honor on our country." For the exhibition, the directors had carefully culled their own collections and those of their friends to assemble a group of paintings by Benjamin West, Stuart, Trumbull, and Mignard, which in their "freshness," "their newest gloss," "dazzled, delighted and instructed" New Yorkers who ventured into the gallery. The directors also proceeded to put the rest of the Academy's affairs in order by appointing teachers and officers, increasing the number of directors, and providing in the constitution for the election of "Academicians"—"men of good moral character and artists by profession." Once they had re-established the Academy on what promised to be solid footing, the laymen who directed the institution's affairs retired from the scene. Clinton delivered his farewell oration and handed over the organization to the professional artists by having New York's most renowned painter, Colonel John Trumbull, elected to the presidency. Trumbull, apparently, "put the Academy in his pocket—and kept it there for nineteen long years." [17]

The Colonel's European experiences had influenced his ideas about how the American Academy ought to be run. If the report of a somewhat biased young artist of the time is accepted, Trumbull believed that "Artists were unfit to manage an Academy" because they were "always quarrelling"; therefore, he emphasized the need and, in fact, the propriety for the continued direction of the art institution by wealthy amateurs rather than by professional artists. This policy had serious consequences for the Academy, and its effects were apparent in the kind of exhibitions the institution sponsored as well as in its relations with the artists whose support was necessary for its success.[18]

The exhibition of paintings held in 1828 is typical of the annual exhibitions of the American Academy. In that year the exhibition rooms were renovated to resemble the galleries of the Louvre and the Royal Academy in London. "Two Splendid Saloons" afforded "equal and excellent light" for the paintings and works of sculpture

Ophelia and Laertes [*Ophelia's Madness*], by Benjamin West (1738–1820). Courtesy Cincinnati Art Museum.

When Robert Fulton lent West's *Ophelia* and *King Lear* to the Pennsylvania Academy in 1807, he hoped that these famous works "in a grand style of composition and finely painted" would prove that the American public had a taste for the fine arts. Philadelphians and New Yorkers fulfilled his expectations by flocking to the exhibition of these works at the Pennsylvania Academy and a decade later at the American Academy of Fine Arts.

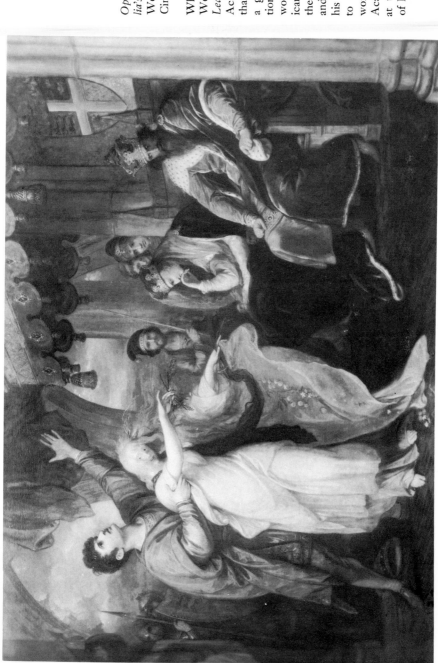

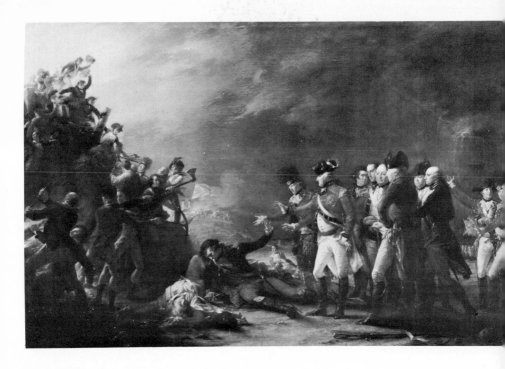

The Sortie from Gibraltar, by John Trumbull (1756–1843). Courtesy Boston Athenaeum. Photo Courtesy Museum of Fine Arts, Boston.

The *Sortie* was called one of Trumbull's best works, one which would secure him "a rank with the greatest masters." First exhibited at the American Academy of Fine Arts in New York City between 1816 and 1828, it was purchased by the Boston Athenaeum in 1828 for two thousand dollars. Bostonians continued to find merit in the work, but some New Yorkers found it a "thing of brass, *mere* brass."

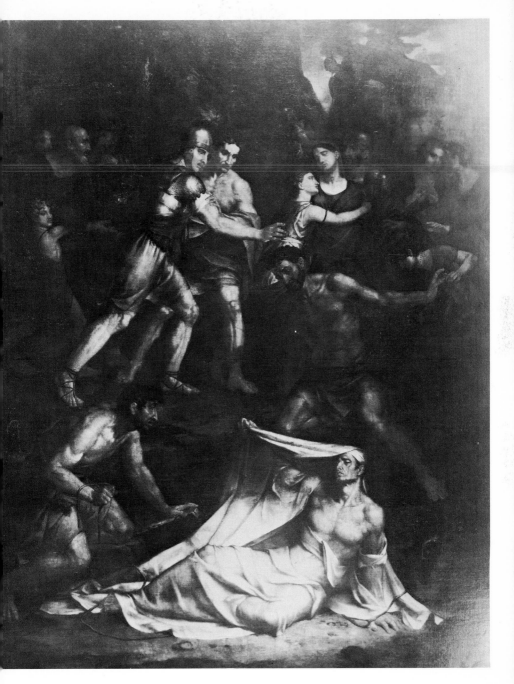

Dead Man Restored to Life by Touching the Bones of Elisha, by Washington Allston (1779–1843). Courtesy The Pennsylvania Academy of the Fine Arts.

The purchase of Allston's painting in 1816 by the Pennsylvania Academy was regarded as a great coup. It had been an artistic sensation in England and had earned for the artist an award of two hundred guineas from the Royal Academy. "If it were . . . exhibited by itself," wrote the Philadelphia *Guide* in 1837, "all strangers of taste . . . would consider it as indispensable to see . . . as the Mint or the Water Works; but as it is placed in the Academy, with a thousand other valuable works of art, a visit to it is apt to be postponed till it is forgotten."

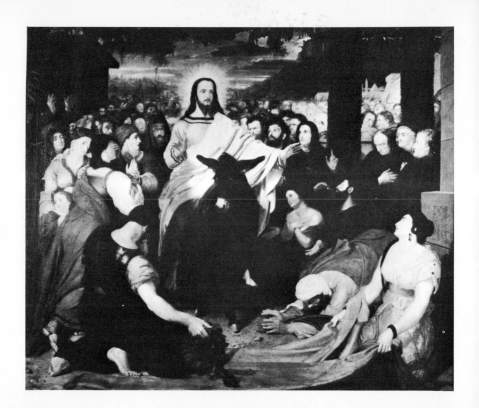

Christ's Triumphal Entry into Jerusalem, by Benjamin Haydon (1786–1846). Courtesy The Athenaeum of Ohio. Saint Gregory's Seminary, Cincinnati, Ohio.
Death on a Pale Horse, by Benjamin West. Courtesy The Pennsylvania Academy of the Fine Arts.

Some Americans believed that these paintings in the grand style were the best their country had to offer, and that the "rich collection" of the Pennsylvania Academy was rendered "superior" to any in the country by their presence. The exhibition of *Death on a Pale Horse* alone, claimed the Philadelphia *Guide* in 1837, would have made the "fortune of an itinerant exhibitor of works of art."

Study for *Belshazzar's Feast*, by Washington Allston. Courtesy Museum of Fine Arts, Boston. Bequest of Miss Ruth Charlotte Dana.
Elijah Being Fed by the Ravens, by Washington Allston. Courtesy Museum of Fine Arts, Boston. Gift of Mrs. Samuel and Miss Alice Hooper.

Boston's merchant princes established the Allston Trust to permit the artist to complete his great picture *Belshazzar's Feast* "without his mind being paralyzed by want of means." The never-completed work underwent constant revision—perhaps as a result of what one carping critic believed was the artist's "want of moral courage and generous self-confidence." Contemporary opinion, however, believed that Allston's genius, as evidenced in the *Elijah*, approached that of "the great masters of past ages" and that his works were "among the most illustrious examples of the loftiest poetry of art."

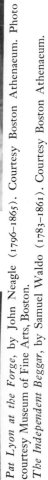

Pat Lyon at the Forge, by John Neagle (1796–1865). Courtesy Boston Athenaeum. Photo courtesy Museum of Fine Arts, Boston.
The Independent Beggar, by Samuel Waldo (1783–1861). Courtesy Boston Athenaeum.

Both these paintings were acquired by the Boston Athenaeum, and both were great favorites with the Boston art public. Pat Lyon represented the self-reliant man who rose from lowly beginnings to fame and fortune. The independent beggar, defiant in defeat, indicated how

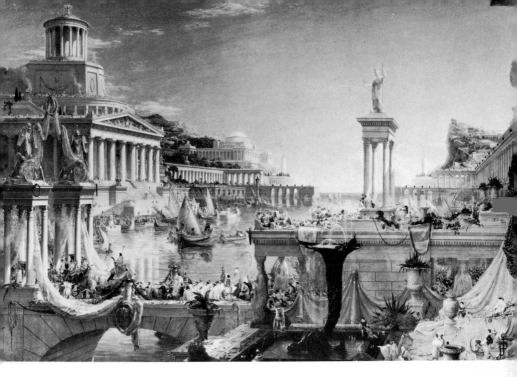

Consummation and *Destruction* from *The Course of Empire*, by Thomas Cole (1801–1848). Courtesy The New-York Historical Society, New York City.

Commissioned by Luman Reed, this series of five paintings, "illustrating the nation's rise, progress, greatness, decline and fall," enjoyed great popularity wherever it was exhibited. Cole "could not believe," wrote G. W. Greene in 1853, "that beautiful things were spread around us so lavishly merely to give a transient pleasure; but rather as instruments of moral culture, and elements to be woven, by the skilful hand, into emblems and illustrations of holy truths."

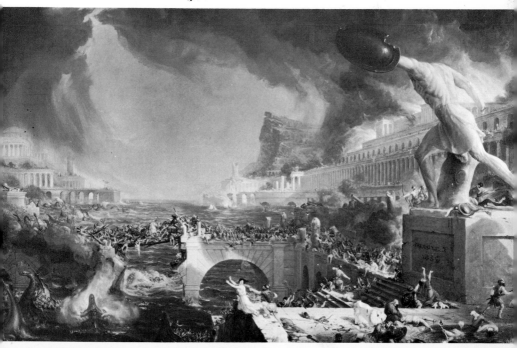

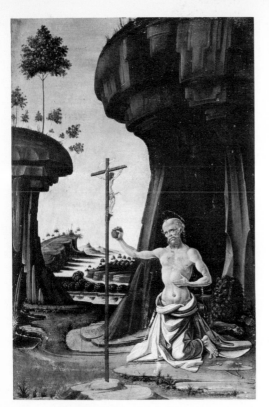

Penance of St. Jerome (tempera on wood), by Fiorenzo di Lorenzo (Italian, Umbrian School, *ca.* 1440–1521). Courtesy Yale University Art Gallery. James Jackson Jarves Collection.

St. Anthony Tempted by the Devil in the Shape of a Woman (tempera on wood), by Stephano di Giovanni Sassetta (Italian, Sienese School, 1392–1450). Courtesy Yale University Art Gallery. James Jackson Jarves Collection.

Nineteenth-century Bostonians, like many other Americans of their time, were not enthusiastic about James Jackson Jarves' collection of "queer quaint pictures," nor did they see any merit in images portrayed, as Henry James wrote, "with patches of gold and cataracts of purple, with stiff saints and angular angels, with ugly Madonnas and uglier babies, strange prayers and prostrations."

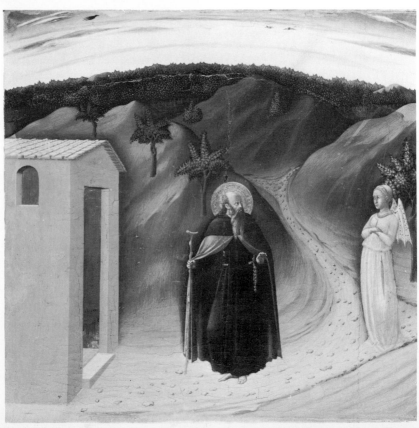

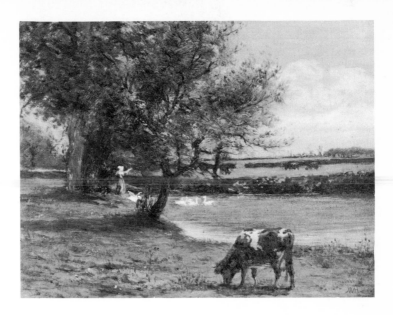

Landscape with Cow, Swans, and Apple Tree, by William Morris Hunt (1824–1879).
Courtesy Museum of Fine Arts, Boston. Gift of the Slater Family.
The Buckwheat Harvest, by Jean François Millet (1814–1875). Courtesy Museum of
Fine Arts, Boston. Shaw Collection.

Hunt gave up his studies at the popular Dusseldorf Academy and came under the
influence of Millet and the little-understood and even less appreciated Barbizon
School of painters. Returning to Boston, he exhibited his paintings, which press
notices called "morbid." Bostonians nevertheless bought them, perhaps because of
Hunt's personal charm and social position, and under his influence acquired a taste
for the Barbizon painters even before they were accepted by the French.

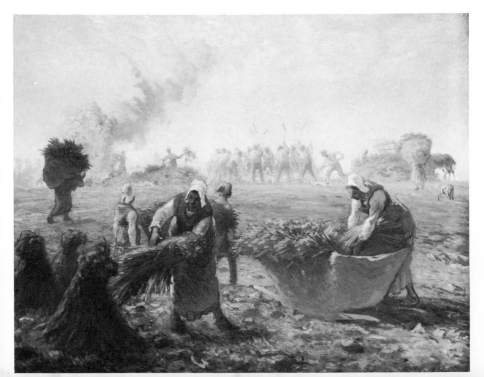

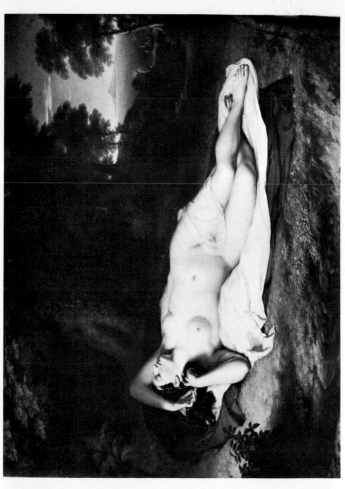

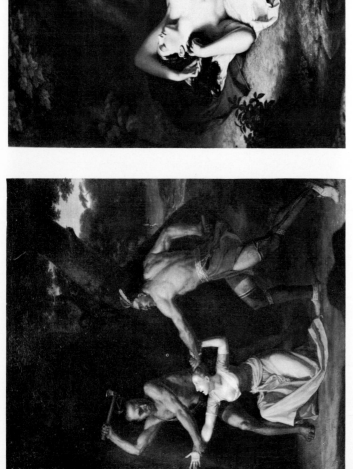

The Death of Jane McCrea, by John Vanderlyn (1776–1852). Courtesy Wadsworth Atheneum, Hartford, Connecticut.

Ariadne Asleep on the Island of Naxos, by John Vanderlyn. Courtesy The Pennsylvania Academy of the Fine Arts.

Popular exhibition pieces in the mid-century, these paintings drew large numbers of Baltimoreans to the Peale Museum in the 1820's on the assumption that they were interested in viewing the "beauty, softness, symmetry, and grace of the female form." Allston believed that *Ariadne* "had no superior in modern coloring," while *The Death of Jane McCrea* was considered

Ruth (marble), by Henry Kirke Brown (1814–1886). Courtesy The New-York Historical Society, New York City.

Boy and Dog, or Chi Vinci, Mangia (marble), by Henry Kirke Brown. Courtesy The New-York Historical Society, New York City.

Sculpture figured prominently in mid-nineteenth-century exhibitions and collections. The sculptor made two replicas of *Ruth* because of the interest the statue aroused. "Nothing can be more graceful," wrote the poet William Cullen Bryant in 1845, "than her attitude, or more expressive of melancholy sweetness and modesty than her physiognomy." The *Boy and Dog* was presented to the New-York Gallery of Fine Arts by bequest of C. M. Leupp, a mid-century collector of native art.

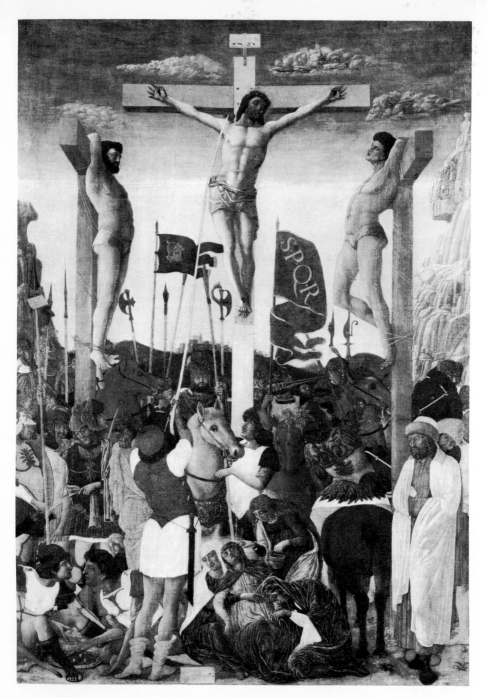

The Crucifixion, by Andrea Mantegna (1431–1506). Courtesy The New-York Historical Society, New York City. Bryan Collection.

Thomas Bryan's "great educational" Gallery of Christian Art, illustrating the various schools of painting from the thirteenth to the eighteenth centuries, could not even be given away to an American art institution, so foreign did they appear to American taste. In 1860 the New York *Daily Tribune* noted that the best works in this collection were French, Dutch, or Flemish, and that the few early Italian works were "not all of outstanding beauty." The New-York Historical Society finally accepted the collection.

exhibited. The high points of the exhibition were the two famous pictures by Benjamin West, *Ophelia's Madness* and *King Lear*. These had been part of the Academy's exhibitions since 1816, when their original owner, the widow of Robert Fulton, in a burst of enthusiasm for the resuscitated Academy, lent them for the institution's first exhibition in its new quarters. Paintings borrowed from private collections included two small landscapes by Salvator Rosa from the collection of Joseph Bonaparte of Bordentown, New Jersey, a landscape by Washington Allston from the collection of E. Weeks, Catlin's recently painted full-length portrait of DeWitt Clinton from the collection of portraits owned by the city of New York, landscapes by the American Thomas Doughty and the Scottish painter Thompson from the collection of Philip Hone of New York, and other paintings, mostly by unidentified artists, from the collections of New Yorkers John Hone, Jr., A. Ludlow, David Hosack, J. Crumby, W. Hall, and R. Donaldson. Since the Academy had "walls to cover" and could "refuse nothing," it was forced to exhibit "copies and portraits"—"mere common daubs," in the estimation of one viewer, "stupid, tasteless concerns, most of them, and hardly fit to hang in the private parlors from whence they came." The sculpture purchased during the early years of the Academy's existence was just as bad, it was felt, and constituted by this time "an indecent collection of dirty, mutilated, plaster casts." Rounding out the exhibition were the pictures in the permanent collection of the American Academy— Sir Thomas Lawrence's portrait of Benjamin West, commissioned by the Academy in 1818; portraits by Sir Henry Raeburn and Archibald Robertson, presented to the Academy by the artists when they were elected to membership in the institution; two landscapes by Vernet, "very elegant specimens of art and genius," a gift of Napoleon Bonaparte; and four paintings by Trumbull that had been exhibited many times before, one of which—*The Sortie from Gibraltar*—was described by a visitor as a "thing of brass, *mere* brass." [19]

What does this exhibition reveal about the Academy, its purposes, and its place in the life of the New York community during the first three decades of the nineteenth century? In the first place, the exhibition was not a popular success. If the admission receipts from this exhibition are compared to those that preceded it, it is fairly obvious that interest in the Academy's exhibitions was declining. From February 28, 1828, when the exhibition opened, to March 29,

1829, presumably the end of the exhibition year, receipts from gallery admissions totalled $585.20. In 1824–25, the sum was $1030.35; in 1825–26, $1168.24; in 1827–28, $802.68.[20]

The waning popularity of the Academy's exhibitions did not mean that New Yorkers were becoming less interested in the arts, for temporary exhibitions of other collections of pictures in the Academy's galleries during these years boasted much better attendance records. For instance earlier in 1828, the exhibition of "rare paintings" in the collection of Signor Antonio Sarti of Florence, which had remained in the Academy for just a little over a month, netted for that short period $442.30—almost as much as the Academy's own exhibition received for the full year. Richard Abraham's collection of "the best pictures from the Old Masters which America had seen," from March 23 to December 10, 1830, brought in the large total of $4,090. Obviously New Yorkers were interested in looking at pictures but were weary of the Academy's collection, despite the merit of some of the works, and found little pleasure in what the president and keeper had been able to beg or borrow to fill out the meagre offering. Although the writer in the *Evening Post* may have been far more caustic in his criticism than the exhibition deserved when he called it "a sort of Noah's Ark, in which [are] things of every kind, *clean* and *unclean,* noble animals and creeping things," yet his disgust with its repetitiousness, the mediocrity of some of the works, and the numerous copies, was echoed by others. "The pictures at the old Academy," Samuel F. B. Morse wrote in December of 1828, "are for the most part *execrable* trash, the vile daubings of old picture manufacturers or the rude copies of students, good, bad, and indifferent. There are some tolerable copies, and some few very good copies, and perhaps as many as six very good original pictures in a low class of art. . . ." Morse, like the writer for the *Evening Post,* was not an entirely disinterested observer, for as founder and president of the rival National Academy of Design he had felt the sting of Trumbull's scorching tongue; but his comments, even when taken in the light of the hostility that existed between the two men and their institutions, bear out the impression that the 1828 exhibition—and the exhibitions that followed—were not very attractive.[21]

Lack of funds hampered the Academy's activities from the beginning and continued throughout the institution's life to be an obstacle to its success. Casts, copies, portraits, and hit-or-miss borrowings

could not provide sufficient inspiration either for the artist who needed training or the public that needed education. There were relatively few people in New York during these years who cared to spend fifty dollars for a subscription to the stock of the Academy, or even—after 1808—twenty-five dollars. The large expenses incurred in mounting exhibitions usually absorbed most of the admission receipts, and after an exhibition there was often a balance of no more than one hundred dollars left in the treasury. Besides, the Academy saddled itself with some large expenses; in a moment of optimism it contracted to buy Trumbull's collection of paintings—a purchase which it could ill afford; it commissioned a portrait of West from the famed English painter Lawrence, and it incurred a heavy expense in outfitting its gallery.[22] Beyond receiving a charter of incorporation the Academy got no help from the state. Municipal aid, although of more significance than aid received from the state since it involved the free use of a building, did not include financial support, without which the Academy could not build up an impressive collection. With no substantial help forthcoming from local government sources and little from the founding fathers, whose energies seemed to have been spent in establishing the institution, the last resort for the Academy, whose life depended upon exhibition receipts, lay in the support of the institution by artists, whose contributions were essential for attractive exhibitions. If the Academy had not funds to purchase works of art, it still could have become an important exhibition center for contemporary painters and sculptors. An ever-continuing supply of new works by contemporary artists would have provided novelty, variety, and interest to a public that not only sought such experiences, but whose tastes, still relatively uneducated, responded to the works of its own countrymen.[23]

The American Academy lost the confidence of the public largely because it never solicited the confidence of artists. Founded by and for the layman "as a place of rational amusement to our citizens and strangers, and a delightful study to the Amateur," it only grudgingly attempted to meet the needs of professional artists when pressed to do so. From 1817 on, artists were permitted to use the rooms of the Academy between the hours of six and eight in the morning, later between six and nine. Young artists were made to feel like "beggars" when they attempted to use the Academy's facilities; but artists were especially offended by the wording of the By-Laws of 1816, which

seemed to their sensitive minds to discriminate in favor of "Amateurs" —patrons of art and stockholders in the Academy—and to show contempt for artists. "All artists of *DISTINGUISHED* merit," read the regulation dealing with exhibitions, "shall be '*PERMITTED*' to exhibit their works," while "*AMATEURS* shall be '*INVITED*' to expose in the Gallery of the Academy any of their performances." That the interests and tastes of the amateurs always received precedence over the needs of the artists is illustrated by the directors' attempt, in 1831, to raise a subscription for the purchase of copies of the Elgin Marbles for the Academy. The directors were obviously still convinced of the need for classical models for students and public alike, but this was money that might better have been spent as part of a building fund, or a purchase fund for the work of native artists, or prize money for a competition that would stimulate and encourage young artists, or for some other educational purpose. Nothing came of this subscription since only one hundred and seventy-five dollars was raised, but the fact that the project was attempted, given the pressing needs of the institution, suggests that the directors of the society were out of touch with the realities of the world of art in which they were functioning.[24]

One of the most irritating features of the Academy's policies, as far as artists were concerned, was the fact that despite their contribution of works to the Academy for both its permanent collection and for exhibition purposes, thus "adding to the revenues of the Academy," artists were required to own stock valued at twenty-five dollars before they became eligible as Academicians or Directors. The American Academy's narrow policy with respect to artist participation was almost the single reason for the founding of a new organization made up solely of artists—the National Academy of Design. Where the American Academy failed to arouse interest in art among New Yorkers, the National Academy succeeded.[25]

The object of the National Academy, as stated in its charter, was "the cultivation and extension of the Arts of Design." Contrary to the method of organization followed by the older academy, the National Academy assumed as a basic principle that "every profession in society knows best what measures are necessary for its own improvement." The program of the National Academy was twofold: first, the founding and maintenance of a school where anyone whose work had been approved by a committee of member artists and who was of

"good moral character" could study free of charge; and second, the establishment of a gallery where the work of artists could be exhibited. Within the school's program, classes were supervised and premiums awarded for achievement. An attempt was made to establish a library consisting of standard European works on art and engraving, an undertaking which was truly impressive for a young institution, considering the few free or subscription libraries that existed at the time. The "paramount significance" of the National Academy's exhibitions was that during its early years it permitted the exhibition of almost all the works submitted and gave artists of all ranks an opportunity to have their work judged and to judge their own work in relation to that of others. Although in later years it was necessary to screen the works submitted—so great were their numbers—still the National Academy was able to show a majority of the proferred paintings, and artists could look forward to the possibility of their work being seen and perhaps sold in an exhibition that commanded a large audience.[26]

New Yorkers flocked to the National Academy's annual spring exhibitions in a way that was never experienced by the older American Academy. So successful were these yearly shows that during the first decade of its existence the National Academy managed to pay the expenses of its school and the costs of its exhibitions solely from admission receipts. A number of reasons can account for this phenomenal success. First, it seems clear that Americans of the generation of the 1830's, who were for the most part unfamiliar with European paintings, found great excitement in the work of their contemporaries. The American Academy had been born at the turn of the century out of the eagerness of enlightened gentlemen to bring the refinements of Europe to American shores. These men emphasized the need for "good pictures of our old masters or great foreign artists"—paintings that not only added to "the interest of the collection" but contributed towards "forming the public taste." The nationalistic sentiment that existed during these early years of the nineteenth century had thus sought to develop a "native" culture by either importing or engrafting European models on the American cultural environment.[27]

By 1826, when the National Academy of Design emerged as a force in the artistic world of New York, Americans were beginning to think of Taste in different terms. Without the large means or the

inclination or education that would enable them to become familiar with the Old Masters, the taste of this new generation was formed by studying the works of their contemporary Americans. The cultural nationalism of these decades increasingly came to embrace a philosophy of the contemporaneous which rejected the past. As Samuel F. B. Morse put it in his speech defending the existence of the National Academy, "the encouragement of national genius is more directly promoted by giving *practice* to our own artists in the highest department of painting, than by any efforts to place before them the best *models*." [28]

Despite the fact that by 1826 the American Academy (which had never really been successful in the first place) had outlived its usefulness, it must be credited with some achievements. As the first art museum in the country, it brought New York City to the forefront of the American artistic world. It not only enlarged the popular interest in art in the city, it also set an example which, given the rivalry that existed among municipalities during the early years of the Republic, encouraged groups in other cities to emulation. In Philadelphia and Boston the response to the New York institution was immediate; other cities—Charleston, Baltimore, Hartford, Albany, Pittsburgh, Troy, Providence, Buffalo, Cincinnati, St. Louis, Detroit, and Chicago—with more or less success, followed the pattern just as soon as their social and economic life had developed sufficiently to sustain such institutions. By the time of the Civil War, groups of leading citizens in all of these cities had taken some steps in the direction of establishing institutions for the encouragement of art.

CHAPTER NINE

PHILADELPHIA: THE PENNSYLVANIA ACADEMY OF FINE ARTS

PHILADELPHIA BEGAN THE PROCESS of emulation. Reputedly "the Athens of America," the Quaker City had for many years provided the most comfortable home for artists on American soil. The colonists who had accompanied William Penn to the American wilderness were not inhibited by either religion or economics from indulging their taste for the fine arts. As members of "the thrifty prosperous middle class" of England, their thrift and prosperity in the new world combined to make Philadelphia very early in colonial times outstanding in commerce, banking, and law. By the decade of the 1750's, Philadelphia had also become "the most active artistic center in the colonies," with a school of portrait painters well enough established to be on the way to "genuine accomplishment." Here families like the Hamiltons, the Shippens, the Powells, the Hopkinsons, the Allens, the Binghams, the Willings, and the Biddles surrounded themselves with all the comforts of upper-class living. From their trips abroad they had returned laden with "art books, prints, drawings, copies, and one or two old masters," and they filled their homes and gardens with "Italian antiquities and neoclassic statuary." [1]

The reputation of the Philadelphians for being hospitable to the arts brought many painters to the city before the Revolution; a number of these—Charles Willson Peale, Matthew Pratt, and Thomas Sully, most notably—remained to set up permanent studios. During the last decade of the eighteenth century, when Philadelphia was the seat of the federal government, numerous artists descended on the

city in search of patronage and commissions from legislators as well as from the refined and wealthy citizenry.[2]

Early attempts had been made in the city to establish an institution for the encouragement of the arts, but these were all the efforts of artists. In December, 1794, twenty-nine artists headed by Charles Willson Peale organized an academy "for the protection and encouragement of the Fine Arts," to be operated by the artists themselves; Honorary Members or Patrons, however, were given privileges within the school, its projected library, and its exhibition hall if they made a contribution of from ten to one hundred dollars. Before the organization got under way the artists quarrelled, and eight members resigned in protest against "the inconsistent and indecent motion" to have students draw from the living figure in the absence of casts. Other differences of opinion arose with respect to the scope of the organization. Peale and his fellow Americans were satisfied to begin with a simple drawing school and exhibition center, while the opposition group, consisting mostly of foreign artists, aspired to make of the organization "a national college" of the fine arts, along the lines of the British Royal Academy.[3]

The Columbianum—for that was what the artists called their institution—continued as an organization until 1796; it expired without having accomplished much, although it did sponsor the first public exhibition of contemporary art to be held in this country, and, more important, it fixed in the mind of Peale the desirability of a museum or an academy in Philadelphia for the encouragement of the fine arts. His own museum, consisting partly of displays of natural history and partly of his own paintings, was fairly well launched when in 1800 he wrote to a member of the state legislature suggesting the establishment of a public museum and outlining his ideas of what such an institution should be and how it should be operated. After he had fulfilled his "duty" to Pennsylvania by offering not only to aid the enterprise but also to help train others in museum work, Peale requested a grant of land for his own museum building, which, he declared, would be "useful and honorable to the State." The legislature ignored Peale's request; and although the artist managed to maintain his own museum without state aid, his hopes for an art academy languished. The failure of the Columbianum was due, he felt, to the fact that it was "particularly unfortunate" with regard to some of its members. Despite Philadelphia's vaunted receptivity to art

and artists, Peale believed that the citizens of the city had not fulfilled their responsibility toward the fine arts. "In Philadelphia," he lamented, "the public spirit is wanting for such encouragement." [4]

Peale's experience with an association consisting primarily of artists undoubtedly made him more receptive to the idea of an academy organized along the lines of the New York institution, with the direction chiefly in the hands of laymen. Therefore, when the lawyer Joseph Hopkinson returned from New York in 1805, "stimulated by the view of the New York Academy casts and by his own taste and patriotism," and proposed the establishment of a similar institution in Philadelphia, Peale was ready to join forces with him and his friends for the purpose.[5]

The seventy Philadelphians who assembled in Independence Hall in the spring of 1805 to draw up a constitution for the new art academy comprised the city's most distinguished citizens. Forty-one were "prominent at the bar," two were medical men, distinguished not only in their profession but in "general literature," one was a successful auctioneer of "cultivated tastes," and the others were, for the most part, successful merchants. One "carver"—the sculptor William Rush—and the painter Peale represented the artists of the city. Being men of affairs, Hopkinson and some of his colleagues began to push the project even before the meeting by soliciting subscriptions which, they hoped, would provide for the erection of a suitable building and the purchase of the necessary casts and copies of good paintings. Peale believed that admission receipts, student fees, and commissions from sales would support the academy and the school that was planned, but he was unable to relinquish completely the hope that the state would come to the aid of the institution. What he especially had in mind was the purchase by the state of the paintings of Benjamin West, who was "very anxious" to have his paintings placed in Philadelphia in order to make that city "the vortext of all that was mental in the Western world." The paintings, Peale thought, would be used by the school "as models of coloring, composition &c." The artist was not too optimistic about the legislature extending its aid in this fashion, however. "If [West] knew the Constitutions of our country better," he wrote to Thomas Jefferson, "he would loose [*sic*] all hopes from that quarter." [6]

The response to the subscription raised by Hopkinson and his committee was overwhelming. More than $2,500 was subscribed,

which, in Peale's exultant words, would make of Philadelphia "one of the most desirable cities on the continent." Once the financial security of the academy was thus assured, the next steps were clear: first, the Philadelphian Nicholas Biddle, who was in Paris at the time, and General Armstrong, the United States Minister to France, were asked to obtain casts of the famous classical statues in the Louvre, which Robert Livingston earlier had had copied for New York; then, a building was to be erected to house these art works; and, finally, a public exhibition of the collection was to be prepared.[7]

In 1807 Robert Fulton lent the academy his newly purchased collection of paintings, which included the two large Shakespearean canvases by West—*King Lear* and *Ophelia*—that later adorned the exhibitions of the American Academy. With these paintings Fulton believed that the Pennsylvania Academy would "make a fair experiment of the public taste for fine paintings"; and the people of Philadelphia did not disappoint the proud collector: an average of four hundred Philadelphians a month paid twenty-five cents to look at the paintings and casts, despite the prudery of the day that insisted upon separate attendance of the sexes at the antique statue gallery.[8]

The great success of this exhibition suggested to the directors the possibility of holding annual shows "for the advantage of the academy and the improvement of the public taste." In this way the activities of the Pennsylvania Academy fell into the pattern generally prescribed for art academies of the day. The yearly exhibitions contained paintings borrowed from private collections, some sent for sale by American artists (mostly Philadelphians), and some purchased by the Academy for its permanent collection. Philadelphians were much more generous than New Yorkers in contributing money towards the purchase of important works of art. By 1837 the Academy owned not only the casts that Biddle had sent from Paris, but such large paintings, "superior to any collection of the kind in the country," as Murillo's *Roman Charity*, Allston's *Dead Man Restored to Life*, Haydon's *Christ Entering Jerusalem*, West's *Death on a Pale Horse*, and a copy of David's "celebrated painting" *Napoleon Crossing the Alps*. In 1826, and various times thereafter, the Baltimore collection of Robert Gilmor, Jr., which consisted of European and American works, was "a great attraction," while other private collections, such as Powell's "original paintings" of Old Masters, James McMurtrie's collection of Old Masters, and Samuel B. Fales's

large collection of contemporary paintings from the English, American, and French schools, added variety and interest to the exhibitions.[9]

As early as 1823 the Charleston Museum, or, as it was called, the South Carolina Academy of Fine Arts, initiated the custom of borrowing paintings from the Pennsylvania Academy for its exhibitions; and toward the mid-century, as other art institutions in eastern cities were established, the practice of exchanging pictures became more widespread. In 1847, for instance, the Albany Gallery of Fine Arts sent the Pennsylvania Academy five paintings from its permanent collection in exchange for six from the older institution, and they continued to exchange paintings in 1848 and intermittently thereafter. In 1853 the Maryland Historical Society in Baltimore borrowed paintings for its Fourth Annual Art Exhibition, acquisitions which did much to enhance the rather slight offerings of the fledgling institution. In this way, the Pennsylvania Academy of Art became something of a "parent" in relation to younger institutions that were appearing throughout the late 1840's and 1850's in smaller communities where the desire for "culture" was strong although the financial resources were meager.[10]

Despite the Pennsylvania Academy's initial success and the fact that it had been able to muster a more impressive collection than any other American academy, the Philadelphia organization still ran afoul of the interests of the artists just as the New York Academy did, and for pretty much the same reasons. The artists resented an academy run by businessmen and felt that the institution had done little for their direct benefit. Long-range hopes of encouraging a love for art among the citizens of the country did not fill the empty pockets of working artists. The artists also deprecated the idea that casts were to be used for exhibition purposes rather than merely for teaching students, for they felt that a public exhibition of such antique statues was "extremely indecorous and altogether inconsistent with the purity of public morals." What the artists obviously wanted was exhibitions that would feature contemporary work—their own—and thus assist them in making sales.[11]

Without waiting as long as the New York artists had to assert themselves, in 1810 a group of Philadelphia painters, architects, carvers, engravers, and other artisans, along with a few "Amateurs," organized the Society of Artists of the United States. Their purpose

was similar to that expressed by the Columbianum, or any other artist-sponsored organization that made its appearance during the first half of the nineteenth century: to furnish practical assistance to professional artists and craftsmen in the form of drawing schools and exhibition galleries. The Philadelphians also planned to provide relief to destitute members of the society or their families.[12]

At first the Society of Artists did not act in opposition to the older academy, but attempted to merge forces with it. By a purchase of $2,000 of the Academy's stock, the Society was to be allowed privileges within the organization, including the use of the building; and in 1811, the first exhibition of the Society was held in the Pennsylvania Academy with great success, the receipts for six weeks amounting to $1,860. Subsequent negotiations, however, revealed the chasm existing between the interests of the "men of business" who ran the Academy and the artists who would not (and probably most could not) pay the required fifty dollar initial fee that would give them a voice in running the institution. The artists thought they should be included as members because of their professional status, without being obliged to pay the high fee exacted of "Amateurs." The directors of the Pennsylvania Academy compromised; in 1812 a resolution appointing forty "Pennsylvania Academicians"—"painters, sculptors, architects, and engravers of merit"—established the "first body of artists to be affiliated with a chartered Academy of the fine arts in the United States." With this resolution the Society of Artists was more or less dissolved, although under the name of the Columbian Society of Artists it continued to hold exhibitions for the next two years.[13]

By 1815 the Pennsylvania Academy held the field alone and reverted to being an institution, in Dunlap's estimation, "merely . . . for collecting and exhibiting pictures and statuary." Dunlap believed that the Academy "as such" was still valuable, since it tended to "the civilization, refinement and taste of the public"; but he was at the same time bitterly critical of the way in which the directors treated the artists and their grievances. "The artists of Philadelphia," Dunlap wrote,

> did not ask for any remuneration for exhibiting their works, they asked just consideration, distinction, and honorable treatment. The directors tauntingly tell the artists that having been paid by their employers for their pictures, they are at the

disposal of the purchasers and may be borrowed for exhibition without any debt due to the artist. The directors claim the right to elect the teachers, that is, lawyers, physicians, and merchants elect the competent lecturers and masters in schools of art! [14]

After the Pennsylvania Academy had successfully met the threat of the competing artists' association, it broadened its policies somewhat; it purchased many pictures from American artists, including a good many Philadelphians; it opened its exhibitions to those artists who wished to sell their works, and it continued to maintain its school for training young artists. Still the Philadelphia fraternity of artists was not happy with the institution, and throughout the half century, there were sporadic attempts to alter its policies or to form separate organizations. In 1828, for example, George Bridport and Thomas Doughty, two inveterate dissenters, called a meeting of the artists to draw up "a remonstrance to the Academy on account of sundry grievances existing in the government of the Institution." Earlier, in 1824, the Artists' Fund Society of Philadelphia was founded, the purpose of which was to hold exhibitions of artists' works with a view to sales; the Fund charged a commission of five percent on all sales of the work of "Amateurs," but no commission was charged to professional artists. An important aspect of the Fund's purpose, like that of the earlier Columbian Society of Artists, was the provision of help for indigent or distressed artists or their families. The group showed little strength until about 1835 when it held the first of ten annual exhibitions. Soon, however, the Artists' Fund exhibitions became "a fashionable lounge for . . . connoisseurs or patrons of art, desirous of learning by comparison of their respective works who among the artists may be most worthy of . . . encouragement." [15]

During the depression years of the late thirties, artists throughout the eastern states must truly have had need for such patronage as the Artists' Fund Society afforded, even with the opportunities offered them by the rival activities of the National Academy of Design, the Boston Athenaeum, and the Apollo Association. New York artists, however, seemed to have resented the Artists' Fund Society because of unenumerated "objectionable features"; yet, despite their misgivings about the society and its ultimate success, some New Yorkers like Samuel F. B. Morse and Thomas Cole accepted honorary membership in the group ("a mere cypher," wrote Morse), and, more important, sent their paintings for exhibition and for sale. Artists, like most

businessmen, were obviously ready to use any means available during these years for the sale of their pictures, even organizations they disliked.[16]

Notwithstanding competition from splinter groups, criticism from artists, and even physical destruction by fire in 1845, the Pennsylvania Academy remained an influential force in the life of Philadelphia. It was able to exert this influence because of the vigor of the community leaders who gave their energies to it. The willingness of these men to meet the artists more than halfway when they demanded participation, recognition, and remuneration in the Academy's activities, established a policy of absorbing artists and organizations of artists into the Academy's fold instead of permitting these dissident groups to remain powerful outside of the organization. When differences arose, the Academy pacified the artists with the assertion that they had "but one object in common—the advancement of the arts"; and of course this was ultimately the bond that kept the artists tied to the Academy and contributed to the Academy's success.[17]

The laymen whose energies and far-sightedness were responsible for this policy were truly "harmonious men of good taste, liberal patrons of art, full of zeal." Their roll, to a large extent, matches the rolls of other cultural and charitable enterprises in Philadelphia during the first half of the nineteenth century. Men like Joseph Hopkinson, William Meredith, James McMurtrie, Zaccheus Collins, Chief Justice William Sansom—to name but a few—were men who worked in the tradition of the Enlightenment. Their activities ranged from the law or medicine or business to participation in such institutions as the City Library, the Athenaeum, the American Philosophical Society, the Society for Political Inquiries, the Academy of Natural Sciences, among others. Just as they dominated the economic and professional life of Philadelphia during this period, these urban patricians dominated the city's cultural and humanitarian institutions. They did so at least partly out of a feeling of responsibility for the welfare of the community, and also out of a belief shared with an enlightened Philadelphian of a previous generation, Dr. Benjamin Rush, that "every man is public property. His time and talents—his youth—his manhood—his old age—nay more, his life, his all, belong to his country."[18]

CHAPTER TEN

BOSTON:
THE ATHENAEUM GALLERY

> This mart of commerce, this rich mine
> of wealth;
> This field of plenty; this residence of
> health . . .
> Shall all things else but *genius* flourish
> here?

THE QUESTION POSED BY WINTHROP SARGENT [1] in 1803 about his native city of Boston became, during the years following the achievement of independence and especially after the War of 1812, a matter of some concern to other Bostonians. Was their city, "the town which was appointed in the destiny of nations to lead the civilization of North America," to be outdistanced and outflanked by New York and Philadelphia in the fine arts? These cities had already surpassed Boston in commercial and banking activities, but it would be a "standing shame," wrote E. and J. Everett in the *North American Review*, Boston's famous learned journal, if this "metropolis of the Eastern States," noted for its patronage of learning, should permit these ports to gain the ascendancy in the arts.[2]

Very early in their history, in 1636 in fact, Bostonians had demonstrated their enthusiasm for scholarship and the liberal arts by founding and contributing to the development of Harvard College and the Boston Public Latin School; in the midst of crisis and battle— "in the darkest hour of the Revolutionary War"—Bostonians had organized the American Academy of Arts and Sciences as a demonstration of their faith in scholarship, and a decade later, in 1790, they

again came together to establish the Massachusetts Historical Society. In the area of the fine arts specifically, Boston had a longstanding tradition that went back to the 1740's, when the English portrait painter John Smibert settled in colonial Boston; this tradition continued through the flourishing careers of Jonathan Blackburn, John Singleton Copley, and Gilbert Stuart. Bostonians may have regarded the art of painting as "no more than any other usefull trade . . . like that of a Carpenter, Tailor, or Shoemaker," but Boston merchants and religious divines enjoyed seeing their likenesses reproduced and gave enthusiastic support to the portraitists who made their homes among them.[3]

Despite their Puritan ancestry and traditional distaste for graven images, Boston's merchants had by Copley's day begun to decorate their homes with paintings other than portraits, including some Old Masters. John Hancock, Governor James Bowdoin, Peter Chardon, James Perkins, and other Boston merchants and financiers collected works of art as well as books on aesthetic philosophy and the history of art that testified to the depths of their connoisseurship, or, at least, to the existence of a philosophical and literary interest in the fine arts that foreshadowed the development of an active art life in the community.[4]

Notwithstanding a tradition of patronizing art and an intellectual interest in the historical and philosophical aspects of art, as well as the accumulation of sufficient wealth in the hands of a large enough merchant class to make art patronage possible, Bostonians did very little during the first quarter of the nineteenth century toward establishing an art institution. As early as 1804, some of Boston's enlightened gentlemen founded the exclusive Anthology Club, which they devoted to the "Improvement of Taste and the Encouragement of Genius"; their efforts, more literary than artistic, culminated in the establishment of a reading room or library that became the Boston Athenaeum. One of the aims of the trustees of the Athenaeum was that it become a "repository for specimens in the fine and pleasing arts" so as to "provide for the improvement and emulation of arts and for the correction and refinement of taste in those who aim to be connoisseurs and able to bestow praise and censure with discrimination"; not until fifteen years later, however, was anything done by the Athenaeum to realize this aim.[5]

During these early years, individual artists and entrepreneurs made

attempts to found museums in the city for their own profit. In 1803 the Columbian Museum on Milk Street solicited the support of Bostonians of all classes by holding out the promise of "elegant paintings," wax figures of historical personages, a perfect mold of a mammoth's skeleton, and "a surprising variety of both natural and artificial curiosities." Before the year was over, the Columbian faced competition from the rival Washington Museum which had established itself at the foot of the Mall and attempted to appeal to intellectual Bostonians with a combination of literature and art in an exhibition of Shakespearean characters. In 1818 the peripatetic Edward Savage, after the failure of his museum in Philadelphia and New York, brought his New England Museum to Boston; but Savage sold out in less than six months to Ethan Allen Greenwood, whose Gallery of Fine Arts, which was located near Savage's on Court Street, offered unfavorable competition. Greenwood, who was a portraitist, maintained his museum intermittently until 1825, having augmented his collections at various times with the contents of the New Haven Museum, the Boston Museum, and the Columbian and City Museum of Boston.[6]

Other itinerant artists or traveling showmen brought collections of paintings or panoramic views to the city, which was considered a regular and profitable stop in their nationwide circuit. So, in 1815, views of the battles on Lake Champlain and at Plattsburg were shown by Mr. Corny, "one of the best painters of ships alive." The same desire to take advantage of the patriotism and national feeling kindled by the late war prompted Colonel Henry Sargent to exhibit that same year his large historical painting, *The Landing of the Fathers of New England at Plymouth.* Two years later Mr. Farina of Naples showed a collection of "old masters" consisting of paintings presumably by Raphael, Titian, Domenichino, Caracci, Salvator Rosa, and Paolo Veronese, among others; and the following year, Sargent again appealed to Bostonian taste by showing his large religious painting *Christ's Entry into Jerusalem.*[7]

These and other traveling exhibitions like them did not satisfy a group of gentlemen who were struck by the progress being made by the New York and Philadelphia academies and were chagrined that Boston should be so backward about establishing one for itself. Dr. John C. Warren, I. P. Davis, S. Wells, Theodore Lyman, David Sears, Jr., R. Sullivan, C. Codman, and William Tudor were much

concerned about the future "prosperity of the town, and the enlargement of polished society in it." Their reasons for wishing to establish an art institution in Boston were cogently commercial and indicate how highly they valued the fine arts as instruments of civic improvement and progress. A letter from William Tudor to Harrison Gray Otis urging his subscription to the plan bears effective testimony to this idea. "I have heard a good deal of talk this summer," wrote Tudor on September 2, 1815,

> from the circumstances of my residence among southern people & foreigners, and the general opinion of all these people was that Boston does & must decline, that New York, Baltimore, & Philadelphia must run away with our population and capital. This I do not believe, but I believe that exertion is at this time very necessary to secure our standing & future increase. They are straining every nerve in Phila. & Balt. in rivalship, so in New York. The object here contemplated, may, with a bold effort at first, go at once beyond them, and will produce permanent advantages. If we can make ourselves the capital of the arts and sciences, and we have already so many powerful institutions that we may do it, our town will increase in that sort of society which is principally to be desired. I think the present state of Europe will drive many to this country. Other events may happen which will keep up the emigration from England of persons who are not mere laborers & mechanics. An object of this kind trifling as it may be in reality will tend more than ten times the sum employed in any other way to give us our share of this increase of population.[8]

Tudor also urged his project through the pages of the *North American Review* and in his small volume of essays, *Letters on the Eastern States* (1820). His first proposal, expressed in somewhat tentative language, as if he were trying the temper of Bostonians, appeared in the *Review* of November, 1815. Undoubtedly, it raised the temper of some Bostonians to a higher degree than that normal for these cool people, for a few months later Tudor came forth with a lengthier article detailing the plan and answering quite fully all the objections that some Bostonians had raised against introducing the fine arts into their city. Tudor's plan partly followed conventional and nationalistic lines. First, he would import from Paris casts of all the busts and statues in the gallery of the Louvre for the benefit of

student artists; then he would devote a part of this exhibition and study room to an annual display of the artists' work in the expectation that artists might effect sales among the people who were drawn there out of interest or curiosity; finally, he hoped that with whatever surplus funds remained from admission receipts, the institution would be able to purchase paintings and sculpture from some of the exhibiting artists. In this way, Tudor felt, the organization would acquire a considerable collection of native works and at the same time afford help and encouragement to American artists. Tudor did not disdain the great works, such as the New York institution had emphasized in its purchases, but realizing that the absence of large fortunes made the purchase of original Old Masters almost impossible, he believed that Americans could still nourish Taste by being exposed to the works of contemporary artists.[9]

Tudor and his friends worked hard to raise a subscription for their projected art academy, but the results were disappointing. Samuel F. B. Morse found Boston's labors in this respect "all forced" and predicted that they would "miscarry": "they can talk and talk, and say what a fine thing it would be," observed Morse pessimistically to Washington Allston, "but nothing is done; I find by experience that what you have often observed to me with respect to settling in Boston is well-founded, I think it will be the last in the arts, though without doubt, it is capable of being the first if the fit would only take them." [10]

1822, the year in which Boston formally although reluctantly gave up its township form of government to become a city, also marked a turning point for art. That year the Athenaeum moved into new quarters made possible in great part by the donation of the merchant, James Perkins. Possibly to commemorate the move, Augustus Thorndike, a new member of the Board of Trustees, presented the Athenaeum with a group of ancient statues; and several months later, the trustees commissioned Gilbert Stuart to make a copy of his portrait of their benefactor, James Perkins, who had just died.[11]

Surrounded by artists' studios—Washington Allston's, Rembrandt Peale's, Chester Harding's—the new Athenaeum became one of the important centers of Boston's cultural life. The trustees had almost immediately realized that the new building would be suitable for lectures—a popular evening pastime in Boston—and appointed a committee to consider the problem. In 1823 the committee recom-

mended the building of a lecture room which would also be utilized as an art gallery. Their report noted that twenty years had elapsed since the desirability of such a room "for the cultivation of a taste for the Fine Arts in this city" had been called to the attention of Bostonians. The example of the Philadelphia Academy, which after many early difficulties was "in a very flourishing state," was cited. It was a mistake, the committee contended, to look upon such an institution "simply in the light of taxes upon those who have the liberality to subscribe to them." Such institutions not only enhanced the reputation of the cities in which they were established, and added to the "pleasure of [the]inhabitants," but they also contributed directly to the city's "prosperity and wealth." "We perceive," the committee argued,

> that the widening of our streets, the ornamenting of our public walks, the erection of splendid public edifices, and the hundred other means by which we increase the comforts and pleasure of our inhabitants, are not public losses, but, on the contrary, that they increase the value of our real estate, and materially enlarge our own personal sources of enjoyment. This proposition cannot be denied by any intelligent man. The only question which remains is, whether we are ready to tax ourselves to promote that class of public improvement, which the constituted authorities of the town could not undertake to carry into operation by a general assessment.[12]

Forty-eight public-spirited Bostonians contributed $4,275 early in 1823 in response to the committee's plea for funds for a "Museum of the Fine Arts"; and when these funds proved insufficient to meet the costs of erecting "a suitable Building," further subscriptions were solicited. Thomas H. Perkins and his nephew, the younger James Perkins, whose family's fortunes had been made in the China trade, each contributed $8,000 more toward the new building on the condition that "an equal sum be subscribed" by other contributors. By 1826 the Athenaeum Gallery was ready to be occupied, first by Gilbert Stuart to facilitate his work on the portrait of Thomas H. Perkins which had been commissioned by the trustees to memorialize Perkins' contribution to the institution; and later by Washington Allston for use while working on his painting of *Belshazzar's Feast*, which was purchased for the Athenaeum by a group of subscribers. The first public loan exhibition of paintings was held in May, 1827,

and from that year on until 1873, with the exception of 1849, annual spring exhibitions were held in the Athenaeum Gallery.[13]

The exhibitions themselves were fairly eclectic, consisting of portraits and Old Masters which had been borrowed from Boston collections and the current works of native artists. The first three exhibitions were remarkably successful, but after that, despite the efforts made by the Art Committee to make each exhibition a completely new experience by refusing to exhibit a picture that had been shown before, receipts began to decline. A competitive exhibition in 1831, at which two premiums of $200 each were offered for "the best landscape or marine view" and for "the best historical or fancy cabinet picture," somewhat stimulated attendance, but the following year a drop in admission receipts suggested to the Art Committee the need for stronger measures. Arrangements were made to show at the annual exhibition of 1833 a collection of original paintings of the Italian, Spanish, Flemish, Dutch, French, and English schools which had been brought to this country by an Englishman, John Watkins Brett, and was being exhibited in New York with some success. Old Masters obviously appealed to Boston taste and curiosity, for the Brett Collection drew a responsive audience and the Athenaeum Gallery shared a net profit of $3,000 with its manager; thereupon, the Art Committee of the gallery continued to fill the annual exhibitions when they could with collections of old paintings either borrowed from American collectors on the basis of "patriotic feelings" or on commission from European collectors, who were finding it profitable to bring collections of old paintings to the United States in the expectation that the country's art-starved citizens would be happy to pay to see them.[14]

If Boston's taste ran in great measure to Old Masters, the Athenaeum did not hesitate to commission or purchase works by living Americans as well. Funds for the Athenaeum's purchases were obtained from two sources primarily—from admission receipts and from private subscriptions specifically made by wealthy members for a stated purpose. The purchases reflected the taste of the Committee on the Fine Arts, the trustees of the Athenaeum, and the general public. Usually the Athenaeum purchased the paintings and sculpture that had elicited the most favorable response at the exhibition at which they had first been shown. One of the earliest purchases, for instance, was Trumbull's *Sortie from Gibraltar*, which had been on

exhibition throughout the summer of 1828 at the American Academy in New York City, "where it attracted great attention." This painting continued to be a great attraction in Boston, and it was shown repeatedly in the Athenaeum's annual exhibitions. Similarly, John Neagle's well-known portrait-genre picture of *Pat Lyon at the Forge* was purchased for $400 in 1828 from the receipts of that year's exhibition, because it had been "the most popular painting in the show." The history of the painting, which was given in the catalogue, together with its subject constituted the source of its appeal; the Boston gentry had obviously been attracted by the complicated narrative of a false imprisonment and by the sentiment of the lowly beginning of a blacksmith who became a financial success. A portrait of Franklin by Greuze from the Thomas Jefferson collection, which had been exhibited at the Athenaeum in 1828, West's *King Lear*, landscapes by the Boston artist Alvan Fisher and by Thomas Doughty, Allston's *Mother and Child*, Waldo's *The Independent Beggar*, and a portrait of Chief Justice Marshall by Chester Harding were other purchases that reflect contemporary taste in Boston. Subscriptions were usually taken among the wealthier supporters of the Athenaeum for portrait commissions; Harding was commissioned in this way to do a full-length portrait of Massachusetts' famous senator, Daniel Webster, and one of Hannah Adams, the first woman permitted to use the Athenaeum Library and an early historian of note. Gifts were generously bestowed by Bostonians of means, like Henry Pickering, F. C. Gray, and Thomas H. Perkins; but whether acquired by gift or purchase, most of the Athenaeum's permanent works reflected an enduring conservatism in taste.[15]

Even when it was a question of Old Masters, Bostonians usually favored the paintings of the well-known, traditionally reputable Dutch and Italian artists of the sixteenth and seventeenth centuries. Their conservative tastes were clearly in evidence in 1859–60 when James Jackson Jarves offered his unique collection of primitive Italian paintings to the Athenaeum for $20,000, a price far below the actual value of the collection. The primitives represented a form of art so alien to prevailing taste that Jarves' offer threw Boston art circles into a flurry of excited controversy. Jarves withdrew his offer and the collection was neither purchased by the Athenaeum nor exhibited there.[16]

Paintings of the Pre-Raphaelite School, although successfully exhib-

ited at the Athenaeum in 1858, were never purchased by the Athenaeum committee. Bostonians were not hospitable to the works of the Pre-Raphaelites, a writer in the *Crayon* explained, because they were so "unaccustomed to paintings of this style" that they regarded them as "curiosities rather than as works of Art. . . ." [17]

Bostonians were conservative, too, with respect to the subject matter of their paintings. Religious and allegorical pictures such as Thomas Cole's *The Course of Empire* series, landscapes such as Frederick E. Church's *The Andes of Ecuador*, portraits, and historical works comprised the most popular kinds of painting. When William Morris Hunt exhibited a work in 1855 which showed the influence of the Barbizon painters, press notices called it "a clever picture . . . of the morbid manner so popular in France." Needless to say, nudes met with similar criticism; when William Page in 1858 exhibited his *Venus Arising from the Sea*—a painting of a life-sized female nude attended by Cupids and doves, standing on a small sea shell in the middle of the ocean—the work was so hostilely received that it was withdrawn from the exhibition. The *Crayon* shared Boston's disapproval; the painting, it said, was "a muddy extravaganza," suitable more for "an oyster-cellar instead of . . . the walls of the Boston Athenaeum." [18]

The same conservative taste determined the contents of the Athenaeum's collection of sculpture. Interest in this art form developed rapidly in Boston after 1835 as American sculptors—John Frazee, Horatio Greenough, Henry Dexter, Ball Hughes, and others—began to attain eminence in the field. Long before 1835, however, the trustees of the Athenaeum had demonstrated their enthusiasm for sculpture. Among the institution's earliest purchases were the plaster casts that served as models in 1817 for Horatio Greenough and the Charlestonian John Stevens Cogdell who were just beginning to learn the craft. When Augustus Thorndike presented eleven classical busts to the Athenaeum in 1822, his gift gave rise to the idea of forming a gallery devoted purely to statuary. Other gifts followed. Three years later the Athenaeum's collection of busts amounted to a total of forty, chiefly classical or in the neoclassical style of contemporary Europeans. [19]

At one time or another the work of every important early American sculptor was exhibited in the Athenaeum Sculpture Gallery, and many of these sculptors had one or more works in the

Athenaeum's permanent collection. Either with a commission or through purchase, the Athenaeum extended patronage to Horatio Greenough, John Stevens Cogdell, Richard Greenough, John Frazee, Ball Hughes, Hiram Powers, S. V. Clevenger, Thomas Crawford, Henry Dexter, E. A. Brackett, and W. W. Story. Given the fact that the art of sculpture was hardly practiced in this country until the end of the first quarter of the nineteenth century, the Boston Athenaeum in a brief period of twenty-five years formed an impressive collection of examples of this art.[20]

The Athenaeum obviously served Boston's art needs despite the occasional voice of criticism that was directed at its policies. Its gallery was sustained throughout the entire period of its existence by Bostonians of wealth and culture. In 1876 the collections were transferred to the newly opened Boston Museum of Fine Arts, which was merely a continuation of the older gallery in separate and more spacious quarters. The tradition of community enterprise in Boston was strong, and the funds for the new museum, which had been proposed in 1869 and incorporated in 1870, were immediately forthcoming. Before the summer of 1871, enough money had been pledged to begin the construction of the building. The history of the Boston Museum of Fine Arts belongs to another period in American history, but the incorporation of the new institution was the culminating achievement of a movement begun fifty years earlier by enlightened gentlemen who assumed the obligation of stimulating and maintaining the cultural devlopment of their city.[21]

CHAPTER ELEVEN

CHARLESTON: THE SOUTHERN EXPERIENCE

OF ALL THE SOUTHERN CITIES in the early years of the nineteenth century, Charleston, South Carolina, was probably the most active in encouraging art and artists. Richmond, Virginia, was generously disposed to portrait painters, and William Dunlap in the 1820's found there and especially in Norfolk, Virginia, work to occupy him for at least three winters. Charleston, however, had developed its urban life early; as the greatest port in the province and one of the principal ports of all the colonies, its merchants and bankers had achieved great wealth. Later in the eighteenth century, with the planters' discovery that Charleston was a pleasant place in which to build town houses, the city expanded socially and culturally. Moreover, intimate trade connections with England brought residents of this southern seaport into contact with English cultural traditions and upper-class behavior patterns. Eighteenth-century Charleston gentlemen—the Pinckneys, the Rutledges, the Laurens, the Middletons, the Manigaults, the Izards—were educated in England and there absorbed a taste for the objects which were considered necessary for cultivated living. When they returned home, they brought with them not only English aristocratic tastes, but such actual symbols of culture as fine china, silver ornaments, scientific instruments, good-sized libraries, and portraits by Lawrence or Gainsborough.[1]

Whatever social changes may have occurred as a result of the American Revolution, Charleston's city life remained unaffected, and society in the city retained its aristocratic character. Charleston's prominent citizens were "rice millionaires" who lavished their wealth on mansions of considerable beauty, and these planters were joined later by cotton planters and wealthy merchants to constitute the city's

121

aristocracy. From January to March, planters and their families traveled to Charleston for the gay season—the St. Cecilias, the dancing assemblies, the musical concerts, the races, and, above all, the Jockey Ball. Again in May, and until November, the planters returned to the city to take refuge from the malarial rice fields and rural boredom. This "little oligarchy of rice and cotton planters who ruled Charleston" had an air of cultivation early in the national period that was impressive enough to evoke comment; they were, wrote Henry Adams, "travellers, readers and scholars"—and Adams' appraisal was repeated by many other visitors to the southern port.[2]

The ideals of the eighteenth-century Enlightenment persisted in Charleston even after the turn of the century, and Charlestonians were accustomed to look to art for "entertainment . . . recreation, liberality of sentiment, and a refinement of knowledge." Moreover, the gentry of Charleston shared the nationalistic sentiments that the War for Independence aroused, and therefore it was to be expected that given their wealth, cultivation, and cosmopolitanism, together with an intellectual justification for such activities, Charleston's aristocracy would be receptive to art and artists. Indeed, the large demand for portraits did encourage many artists to visit Charleston during the first quarter of the nineteenth century, and they were received hospitably and generously.[3]

As early as 1784 efforts were made to establish an institution for the encouragement of "INGENIOUS ARTISTS" in Charleston. Since the state government had by this time contributed to the establishment of a college, it did not seem out of place to a writer in the *South Carolina Gazette and General Advertiser* to urge the state to foster art as well. The value of art exhibitions for fund-raising purposes was recognized in 1791 when one was held for the benefit of the newly founded College of Charleston. Interest in the establishment of a picture gallery was demonstrated again in 1797 when the *South Carolina Weekly Museum* published an article proposing such an institution; the reasons advanced were similar to those generally given: an art gallery would "prevent much time going to utter waste among the indolent," it would excite "virtuous emotions and interesting thoughts," and it would improve taste. Only after the War of 1812, however, were any constructive measures taken toward founding an institution for the fine arts in Charleston.[4]

Between 1816 and 1820 the Charleston Library Society began to

include paintings and engravings in its accessions. Portrait artists were plentiful in the city at this time, and thoughts again turned to the possibility of creating an art institution in Charleston. In 1816 a loan exhibition of paintings opened in the South Carolina Society Hall "to gratify the public and lay the foundation of a permanent institution"; but it was not until 1821 that the South Carolina Academy of Fine Arts was incorporated with membership open to "any individual professing any of the liberal arts," and not until 1823 that the Academy held its first exhibition.[5]

Artists and amateur artists were most active in promoting the Charleston Academy of Art. One of the more important figures in the organization was John Stevens Cogdell, a lawyer by profession, but a sculptor and painter by avocation. The Charlestonian had studied the casts at the Boston Athenaeum with Horatio Greenough in 1817 and had seriously considered devoting his life to art; presumably he was dissuaded by his friend Washington Allston, who advised him that his family could not live on the earnings of an American artist. Cogdell remained interested in the arts, however; he continued to sculpt and paint in Charleston, at one time joining Morse, Alvan Fisher, and Charles Fraser in copying from a few casts they had managed to acquire. Prospering at the bar, he became a generous patron of the arts, and presumably "many a poor but deserving artist" had reason to "bless the day that he crossed [the lawyer's] path." Cogdell was also involved in benevolent enterprises in Charleston; he was Commissioner of the Orphan House and a founder of the Apprentices' Library Society, which preceded the Academy of Fine Arts as a place where exhibitions of paintings and sculpture were held. Helping Cogdell fulfill his desire to form "an organization for the encouragement of art and artists in Charleston" were Morse, John Blake White, also a lawyer and amateur artist, and Joel R. Poinsett, a versatile Charlestonian with interests that ranged from politics and diplomacy to botany and art.[6]

The South Carolina Academy of Fine Arts started off bravely, but Morse, "not very sanguine as to its success," found his pessimism not unwarranted. Only a few months after the institution was chartered, its director Stephen Elliott wrote in a discouraged vein to Poinsett, the President. "We meet with so little encouragement from our wealthy and fashionable citizens," despaired Elliott, "that we can only look forward to months, perhaps years of embarrassment." Even

worse, Henry Ravenel, a member of one of Charleston's old families, objected to having the Academy built so close to his own house, and the city council, sustaining his objections, ordered the Academy to build elsewhere. To obtain the necessary funds for upkeep and acquisitions, the Academy joined forces with the Literary and Philosophical Society to run yearly lotteries, but competition from foreign-sponsored lotteries which offered greater rewards kept the Academy's subscriptions down. Perhaps the major source of its difficulties, however, was the fact that the institution never secured a broad base of support among those citizens of Charleston whose support counted most. "The Legislature," wrote Cogdell to Dunlap, "granted a Charter, but . . . as they possessed no powers under the Constitution to confer taste or talent and possessed none of those feelings which prompt to patronage, they gave none to the infant Academy. . . . The institution was allowed from apathy and opposition to die." The obituary notice of the Academy in the *City Gazette and Commercial Daily Advertiser* confirmed Cogdell's estimate of the friendless state of the institution. "Its circle of acquaintances was at no period sufficiently extensive for its wants and requirements," wrote the mournful columnist. "Its friends were too few at all times to minister to its necessities. . . ." [7]

One of the reasons for the institution's failure lay in the poverty of its exhibitions. Without the support of the city's older and wealthier families, most of whom owned paintings, the institution lacked a major source from which to draw art works for exhibition. The Academy also could not depend upon the contributions of the work of artists who might come to Charleston from time to time; for the only artists who found it profitable to visit the city or to remain there for any length of time were portraitists, and portrait painters could not provide variety enough to attract many visitors to the gallery. All art institutions established in the United States during the first half of the century found the problem of providing interesting exhibitions a difficult one, given the relatively meager sums at their disposal for permanent acquisitions. The art institutions that were successful—the National Academy of Design, the Art-Union, the Pennsylvania Academy of Fine Arts, the Boston Athenaeum Gallery—owed their success to the variety of works, both old and contemporary, that they were able to exhibit. These provided an interesting enough exhibition to attract the inhabitants of the city to the gallery, and most of these

institutions were dependent upon admission receipts for their maintenance and development. Without the means, then, to provide attractive exhibitions, since it lacked the support of both interested amateurs and artists of varied talents, the Charleston art gallery was doomed to failure.[8]

The demise of the South Carolina Academy of Fine Arts did not pass unlamented. The *Mercury* of June 29, 1830, had called in vain for financial support for the moribund institution and had taken Charlestonians to task for supporting "churches and schools outside of the city in the North or East" while ignoring their own institution, "the evidence of the taste of Charleston." Newspapers continued to chastise Charleston's gentry for neglecting the arts; it was a reproach to the city, declared the *Courier* in 1837, that here, "where everything that is beautiful should flourish, the work of our own and other Artists should not have been appreciated, nor their labors suitably rewarded." In 1838 William Gilmore Simms, later to become editor of the *City Gazette* and one of the South's foremost novelists, organized the Academy of Arts and Design, but the institution hardly survived its first birthday, and nothing further was done to bring the city a formal art exhibition center until 1858.[9]

Public art shows were not completely absent from the city's intellectual life between 1838 and 1858, however. For several winters during the 1840's and 1850's, the Apprentices' Library Society held loan exhibitions and one-man shows, and it was hoped that these occasional displays of both old and contemporary works of art would bring about "the most beneficial results." "Patronage and encouragement—the cordial *well done* of an approving community, is the only basis," commented the *Rambler* in 1834, "upon which excellency in any department of art can be built up." The moving spirit behind these exhibitions was the Charleston painter Charles R. Fraser, whose miniatures and portraits often constituted a good part of the entire exhibition. Most of the paintings in the loan exhibitions were portraits done in the classical manner by artists of an earlier generation; and the absence of contemporary work suggests that interest in art was waning rapidly by the period 1840–50.[10]

The Carolina Art Association was formed in 1858 and an art gallery was improvised. Popular paintings, such as Leutze's *Jasper Rescuing the Flag at Fort Moultrie*, were exhibited, and the newspapers were importunate in urging the "Ladies" to visit this "agreeable

and instructive" resort. Nevertheless, the Association did not receive much support, and in the three years of its existence, before the "Great Fire" destroyed its gallery in 1861, it purchased only twelve paintings. After the fire, efforts were immediately made to rebuild the gutted building, and a benefit run for the Association brought in $6,000, which was lent at interest with a view to the future purchase of a site upon which a new hall could be built. By this time South Carolina had seceded from the Union, and a good many years elapsed before Charleston's citizens could "resume [their] labor of love for the creation of an Art Gallery in [their] midst." [11]

What factors of an economic, social, and even political nature account for the decline of an active art interest in Charleston by the mid-century, when in the beginning of the city's history all things seemed so favorable? Although Charleston had been an important seaport before 1812, after the war it began to lose much of its business to the more northern ports, especially New York, and to New Orleans. The value of Charleston's imports for the period 1821–60 amounted to less than one percent of the total imports of the nation, while exports were under seven percent. Not only were Charleston's merchants undergoing economic difficulties, so were the planters, who with the merchants constituted the group of potential art patrons. Shortly after 1826 a far-reaching economic revolution developed in the South that seriously affected the financial life of the old Tidewater aristocracy, in Charleston as well as in other southern cities. Tobacco and rice plantations became less productive, and the cotton planters of the older South found themselves facing competition from the rich fields of Alabama, Mississippi, and Louisiana. If southern planters generally, and Charleston planters in particular, were to maintain themselves, they had to expand, and many of them did, buying fields farther west which they operated as absentee landlords and into which they sank large sums of capital for slaves and plantation upkeep. Undoubtedly, because of the way in which an agrarian economy absorbed available liquid capital, Charleston gentry found it difficult to support artists and art galleries. Samuel F. B. Morse's experience in Charleston during the depression year of 1820 illustrates the plight of the artist in an agrarian society. Morse sought to collect $400 due him from Mrs. Ball of that city and found himself forced to dun the lady for his bill. "Must I understand . . . , Madam," he irately exclaimed, "that the goodness or badness of your

crop is the scale on which your conscience measures your obligation to pay a just debt, and that it contracts or expands as your crop increases or diminishes?" Morse left Charleston the next year and never returned; while other northern artists, like John Wesley Jarvis, Rembrandt Peale, and John Vanderlyn also began limiting their visits to this southern city at about the same time. The deteriorating economic situation of the city compared to the growing economic strength of northern cities, especially New York, may partly account for their loss of interest in Charleston as a potential market for their talents.[12]

Northern intellectual justifications for patronizing art hardly seem to have influenced the thought of most Charlestonians after 1830. Politics rather than art occupied Charleston's "noisy community of Nullifieri," despite newspaper articles that constantly urged the city's inhabitants to become "tamed and civilized" by supporting art institutions. Charleston society had obviously changed, and this difference in generations was noted by Robert Gilmor, Jr., in 1827. "The Society here," the Baltimorean wrote in his diary, "has always been celebrated as one of the best in America. It retains still some of this character, but has much degenerated in my own time. When I first came here, the Pinckneys, Rutledges, T. R. Smith, B. Smith, W. Loughton Smith, Allen Smith, the Bees, and many others, all well educated men, made society charming. The sons, with some exceptions, are degenerate." [13]

After 1830 the Enlightenment, which had produced one of its best American products in the southerner Thomas Jefferson, lost its influence in the South; and in art, as in other aspects of intellectual life, southerners began to turn away from cosmopolitanism to a conservative sectional patriotism. In matters of taste this conservatism emphasized the classical portrait in the aristocratic manner. Any other kind of portrait, except the miniature, was not welcome in Charleston, nor were figure paintings of a social or humorous nature, such as those painted by William S. Mount in New York or George Caleb Bingham on the Missouri frontier. Historical paintings, unless they rendered patriotic events in the grand manner practiced by West and Copley during the late eighteenth century, were also not particularly favored. In fact, Charleston's interest in portraiture and copies of the Old Masters, to the exclusion of other kinds of art, irritated a writer in the *Courier* in 1842, who found this taste "artificial, and not in

accordance with the spirit of the age"; it was "discouraging," he felt, to modern artists when Charlestonians commissioned such paintings instead of "fancy or historical" compositions.[14]

Artists who aspired to other heights than portraiture realized the limitations of the taste that prevailed in the city and increasingly avoided Charleston. Morse and Sully were ambitious in their youthful days to become historical or religious painters, and although both eventually compromised with necessity, as young artists they showed preferences for cities where taste seemed broad enough to bring their dreams to fulfillment.[15] Allston's works were scarcely purchased by Charleston art patrons, although the artist was a prominent native and his productions were "extravagantly praised" in the city. John Blake White, the Charleston lawyer who had begun his career as an artist, changed his profession because he became convinced that "nothing but portrait painting could . . . meet with sufficient encouragement" in Charleston and "the object of [his ambition and delight] was historical painting." Even such a minor painter as an artist by the name of Shields, who painted "pretty pictures" of game and wild life, became convinced after a brief residence in Charleston that there would be no patronage for him there and left without having disposed of any of his work. Undoubtedly, Charleston's conservative taste, which reflected the social and political conservatism of its society, along with cogent economic and political factors, combined to inhibit the growth of a significant art life in that city.[16]

CHAPTER TWELVE

BALTIMORE: ART IN A
BORDER CITY

Most southeastern cities during the first half of the nineteenth century scarcely went as far as Charleston in developing a community interest in the fine arts. Largely because the southeast was predominantly agrarian, its population was incapable of achieving the prosperous and diversified economy necessary for the successful development of cultural resources. "It is a fact well known to every intelligent Southerner," wrote Hinton Helper of North Carolina in 1857, "that we are compelled to go to the North for almost every article of utility and adornment, from matches, shoe pegs and paintings up to cottonmills, steamships, and statuary; that we have no foreign trade, no princely merchants, nor respectable artists; that in comparison with the free states, we contribute nothing to the literature, polite arts and inventions of the age. . . ." [1]

The early wealth of New York, Boston, and Philadelphia was based on the mercantile activities of the cities' residents; manufacturing, banking, and transportation enterprises became increasingly important after the War of 1812 and assured further accumulations of capital in a constantly developing economy. Not only did wealth increase more rapidly in the North, but it was more readily available in the form of cash and not so completely tied up in land, labor, and equipment as apparently was the case in the South. According to Helper, the surplus capital of the North was responsible for "the erection of their magnificent cities and stupendous works of art which dazzle the eyes of the South and attest the superiority of free institutions." [2]

The city of Baltimore, although southern in its ties and culture,

because of its economic development along northern lines followed the cultural pattern established by the northern cities. Baltimore's gentry were mainly preoccupied with the movement of ships and merchandise, for the city was the entrepôt of the settlements of the hinterland as well as a major export center. As early as 1783 Baltimore's clipper ships achieved a reputation of daring venturesomeness as they ran both the British and French blockades in their successful attempt to continue the rich trade in sugar and molasses that they carried on with the French colonies in the Caribbean. Overland to Baltimore came merchants from Rochester, Pittsburgh, Cincinnati, Harrisburg, Williamsport, and Knoxville, as well as from settlements in western Maryland, in order to purchase the groceries and supplies needed at home and to dispose at the same time of their flour, tobacco, corn, and pork for export abroad. "Nowhere," wrote the German traveler Johann David Schoepf in 1783, in "the middle part of the American states," with the exception of Philadelphia, were there so many merchants "ready to take up what is offered." By 1799 the development of commerce in Baltimore made that city the third largest commercial port in the United States, an early importance that the presence of three banks in the city—the Bank of Maryland, the Bank of Baltimore, and a branch of the Bank of the United States—confirms. After 1820 new markets in South America continued to bring prosperity to Baltimore merchants who found in Argentina, Peru, Chile, and Brazil, outlets for their wheat flour and a source for copper, silver, hides, and especially coffee. The coffee trade, in fact, brought fortunes to many Baltimore families, and merchants in the city for several decades after 1820 remained conspicuous in this profitable form of enterprise.[3]

The men of Baltimore, wrote Elizabeth Patterson Bonaparte, one of the city's more caustic critics, "are all merchants; and commerce, although it may fill the purse, clogs the brain. Beyond their counting-houses, they possess not a single idea. . . ." Mme Bonaparte was not completely impartial; she had much earlier shown her contempt for her native city when, in opposition to her family's wishes, she had insisted upon marrying the rakish younger brother of Napoleon, and her "loathing" of Baltimore may be accounted for by factors other than the city's cultural limitations. The fact of the matter was that foreign observers like the Frenchman M. Levasseur, secretary to LaFayette when the French general made his triumphant tour of the

United States in 1824, found Baltimore's hospitality charming—a mixture, as he put it, of "American frankness and French ease"; and even more conservative British visitors like Captain Hall found Baltimore society "agreeable and intelligent" and the interests of Baltimoreans far more free-ranging and extensive than those of most other Americans.[4]

Baltimore possessed strong cultural traditions extending back to the time when Lord Baltimore and his cavalier associates brought over from England, along with all the necessities for founding a plantation in the New World, an interest in art which was maintained by many of their descendants in their spacious and well-designed homes. Portraits by Hesselius, Blackburn, Charles Willson Peale, Gilbert Stuart, and Thomas Sully adorned their walls, while fine silver and china filled their sideboards and cupboards. The Gilmors, Edmondsons, Garrets, and Machens owned large and excellent libraries, and they also owned collections of paintings that became well known throughout the nation. Gilmor's collection became, in fact, a kind of school for artists; Groombridge, Guy, Doughty, Mignard, Greenough, and Flagg, among others, came frequently to examine and copy the old prints and original masterpieces that it contained. Portrait painters like John Wesley Jarvis, Thomas Sully, Jacob Eichholtz, Gilbert Stuart, Charles B. King, Henry Inman, Chester Harding, Edward Savage, and Joseph Wood, although "birds of passage," did find enough patronage to maintain studios in Baltimore long enough to be listed in the city directories as householders. Baltimore offered employment to landscape painters like Francis Guy and William Groombridge long before the Hudson River School emerged to make landscape painting a popular art form; later in the period, painters of religious pictures like James L. Wattle and Thomas Coke Ruckle found patronage in Baltimore, as did a painter of the West like Alfred J. Miller.[5]

The wealth of Baltimoreans during the first decades of the nineteenth century, considered in relative terms, was not great, but it was sufficient to enable many Baltimore families to achieve a measure of genteel comfort. A salary or income of $3,000 per annum, John H. B. Latrobe recalled, "gave its possessor the reputation of being a rich man," and the income of many Baltimoreans far exceeded this amount. Given its wealth, its striking urban development during the first three decades of the century, its cultural traditions, and the many

individuals interested in art, Baltimore seems slow in developing sufficient community interest in the arts to generate a movement in favor of a public art gallery or academy. Perhaps the city was too close to Philadelphia and could not compete in attracting a large enough resident community of artists whose aid was essential for the success of such an institution. It may be that Baltimore's men of wealth and culture found sufficient satisfaction for their intellectual and artistic pursuits in private clubs like the Delphian Club or the Anacreontic Society and therefore did not feel any compulsion to exert themselves on behalf of organizations that would have a more public scope. A more cogent reason may have been the fact that a privately sponsored museum had existed intermittently in the city since 1791.[6]

In 1791 Charles Willson Peale had for a very short time opened a branch of his Philadelphia establishment in Baltimore, and this institution had been succeeded in 1796 by the "Baltimore Museum," which was managed by Peale's son Rembrandt. The "New Museum" was opened in 1807, followed by the "Baltimore Permanent Museum, C. Boyle, Prop.," and finally, in 1814, by the most famous of all these institutions, the Peale Museum or "Baltimore Museum." This institution represented another attempt by Rembrandt Peale to establish an institution devoted to art in the city. Described as "an elegant rendezvous of taste, curiosity, and leisure," the Peale Museum was devoted to "the improvement of public taste and the diffusion of science"; it represented a combination of public zeal and business that was typical of museums of this kind during the first half of the century. Natural history specimens, both mounted and alive, and paintings that ranged from portraits of heroes to large allegorical displays constituted the main offerings of the museum, although when Rubens Peale assumed the management in 1822, he introduced theatrical performances and spectacular attractions of all kinds in order to meet the annual deficit of the institution that was "near reducing the exhibitor to bankruptcy." Of the more serious works of art exhibited at the Peale Museum, the most noteworthy were such large traveling pictures as Henry Sargent's *Christ Entering Jerusalem* (1823), Sully's *Capuchin Chapel* (1823), Dunlap's *Christ Bearing the Cross* (the late 1820's), and a copy of David's *Napoleon Crossing the Alps;* more sensational works of art exhibited were a wax statue of *The Grecian Beauty*, and paintings like Rembrandt Peale's *The*

Dream of Love, Vanderlyn's *Ariadne* and his lurid depicting of *The Death of Jane McCrea*, and West's *Musidora*. These paintings drew large numbers of Baltimoreans, "of which a respectable proportion were Ladies," who were attracted apparently by the opportunity given them to view the "beauty, softness, symmetry, and grace of the female form." [7]

Scientific demonstrations were carried on often at the museum as part of its educational program, but probably the most important contribution that the Peale Museum made to the development of an art life in the city of Baltimore was the fact that it provided the first formal art exhibition held in the city. In 1822 and 1823 exhibitions of "Sculpture, Painting, Drawing, Engraving &c" were held, in the hope that through such shows the taste of the city would be cultivated and "native genius" incited to create great art. Rubens Peale had canvassed the Philadelphia art market, and with the help of his family in the Quaker city, had gathered a collection that was reported to have had much in it "to admire—much to claim the attention of the stranger and the citizen as well." Baltimoreans responded to the paintings lent by the Peale family, William Birch, Thomas Sully, and Thomas Doughty—among other Philadelphia artists—and the exhibitions were successful. Rubens Peale even sold some of the paintings that had been on display, but despite this temporary success no further exhibitions were held. [8]

The Peale Museum never provided the kind of continuous exhibition of works of art capable of creating in Baltimore a tradition of community support for art galleries. Nor did the museum afford any facilities for young artists to learn the techniques of their craft or to practice their art, although Rembrandt Peale had originally planned to conduct a school in the museum building. The institution was primarily a private enterprise whose policies and programs were shaped by the particular needs of its owners, and when it could no longer make a profit, it was sold. [9]

In 1817 the museum's management had been expanded to include a Board of Directors, whose purchase of stock helped Peale meet some of the financial burdens that the institution seemed to impose on him. Peale had hoped to buy in the stock in eight years from the receipts and profits of the institution, but this had never been possible. The proprietor blamed many of his subsequent difficulties on the "unjust and severe conduct" of the museum's stockholders, as well as on such

factors as "an unfortunate" site and unpropitious times. Since many of Baltimore's most prominent citizens were among the group of stockholders, some of whom participated actively in later organizations designed to encourage art, one suspects that the reasons behind the artist-proprietor's complaints were primarily pique and irritation at the restraints they undoubtedly imposed. Whether these restraints were imposed on the kind of entertainment the museum offered or whether they were restrictions imposed by the "sordid calculations of shortsighted commercial avarice"—as Rembrandt Peale claimed—the subsequent history of the institution is a story of gradual deterioration from a museum devoted to art and science to a theatrical "saloon," and finally to a P. T. Barnum showcase.[10]

Between 1830 and 1844, the years during which the Peale Museum suffered its vicissitudes, Baltimore underwent changes. By 1830 it had displaced Boston as the third most populous city in the United States, outranked only by New York and Philadelphia. The increase in population was accompanied by an increase in wealth, and the character of the city began to change from what had been essentially a small town with a tightly-knit closed society to one more distinctly marked by class divisions and nationality differences. The influx of thousands of immigrants from Germany and Ireland in the 1840's also contributed to the change.[11]

This sociological change had significance for art in a number of ways. In the first place, it meant that the old aristocratic groups were challenged to protect the city's cultural traditions and interests, once a matter of individual concern only. They felt compelled to develop a historical society that would preserve the records of the city's past achievements and that would also assert the nationality and homogeneity of the older families. Second, in order to retain control of the city's cultural life, these aristocratic groups were forced to extend and expand their activities to provide for the cultural needs of a broader segment of the public. In effect, this meant the establishment of organizations along the lines of those formed in the other northern ports.

A change in attitude among Baltimore's citizens with regard to the responsibility of the merchant and professional classes for the cultural life of the community was reflected in the brave effort made in 1838 to establish a Maryland Academy of Fine Arts. The incorporation of this institution was followed in 1839 by the creation of the Mercantile Library Association, the work of a "number of young men of lit-

erary taste who desired greater facilities for mental improvement than the city afforded." The Library Association was more successful than the Academy, but for the brief period of its existence the latter institution excited hopes that finally Baltimore would possess "a place of rational resort for the young" and "a school for the improvement of taste." "Other states and cities," the Baltimore *Monument* noted, "have their societies and Academies for the advancement of the Fine Arts and the improvement of taste"; if the state's citizens would "come forward and show forth their liberality in the measure," the *Monument* was certain that the organization could "exhibit to the world one of the most splendid galleries of paintings and sculpture in the United States." [12]

Baltimore's citizens did come forth and lend their paintings and other works of art to the Academy's first exhibition in September, "with a liberality worthy of all praise." What happened to the Academy from this time on is obscure; no doubt, it too was a victim of the devastating depression that overwhelmed the country and particularly cities like Baltimore, whose citizens were involved in trade, real estate speculation, and especially in the construction of enormously expensive internal improvements such as the Chesapeake and Ohio Canal and the Baltimore and Ohio Railroad. [13]

As Baltimore and the rest of the country emerged from the bleakness of the depression, interest developed once again in improving the city's cultural resources. A historical society that would combine research facilities and a library was a first consideration, but an art gallery figured prominently in the plans. The editor of the *Monument* was not alone in thinking Baltimore "backward" in comparison with New York, Boston, Philadelphia—"even Cincinnati"—in taking measures for the "promotion of science and the fine arts." Baltimore, wrote William Rodewald, was wanting in a "place of resort to literary men of all classes"; the absence of a "choice selection of public amusements" gave "distinguished strangers" who visited the city "an unfavorable impression" that a gallery of fine arts and a reading room would change. Moreover, such a gallery would serve a useful purpose by promoting a "public taste for paintings and sculpture" and by giving "at last an opportunity to our native artists to exhibit their works and thus introduce themselves to the public which thus far may have been ignorant of their very existence." The creation of such a gallery for the public, Rodewald emphasized, was a

public duty, and the "patriotism of the citizens" was called upon in behalf of such an "enterprize calculated in an eminent degree for the public benefit." As privately sponsored institutions, art galleries and libraries had demonstrated a history of failure; only, therefore, as public enterprises, sustained by the contributions of the citizenry, could they be expected to succeed.[14]

Among the twenty-two gentlemen who were engaged in drawing up the plans for an organization that would "collect and arrange the data and scattered materials of the early history of Maryland" were many of the leaders of Baltimore society who had previously given so liberally of the contents of their collections to the exhibition of the Maryland Academy—such individuals as John P. Kennedy, novelist, politician, and diplomat, owner of an extensive collection of art works; John H. B. Latrobe, son of the architect Benjamin Latrobe and distinguished in his own right as a lawyer, artist, engineer, businessman, and philanthropist; Robert Gilmor, Jr., retired merchant and one of Baltimore's earliest art collectors of reputation; Sebastian F. Streeter, also the owner of an important collection of paintings; and Robert Carey Lord, architect and art patron. Generous themselves in making donations to the new institution, they also successfully stimulated the interest of other Baltimore merchants and financiers, like L. Warrington Gillet, who responded to their request for donations with a picture which he hoped would serve to "inscribe his name upon that column of [Baltimore's] Fame, which rests on Art." By 1848 the Athenaeum Building was ready to receive the Historical Society, its Art Gallery, the Mercantile Library Association, and the Baltimore Library Association, and in October, 1848, the first exhibition of the new gallery was opened to the public.[15]

Two hundred and fifty paintings were on display at this first exhibition. These included "several originals by old masters," many "admirable" copies of "approved" works, and numerous originals from the "pencils of modern artists." The exhibition was designed for "the encouragement and advancement of art and the improvement and elevation of the public taste," and all receipts were pledged to this end. The society planned annual exhibitions and urged collectors to lend their works of art; similarly, the artists of the country were asked to support the society's objectives by sending their paintings and sculpture to the gallery for exhibition.[16]

The founders of the Historical Society and its gallery of art

believed that the establishment of these cultural enterprises represented a welcome union between the commercial classes and the literary and artistic groups of Baltimore. "In a Republic," observed Brantz Mayer, lawyer, editor, and son of one of Baltimore's prominent merchants, ". . . the majority of the people must be engaged either in commerce, agriculture, or the mechanic arts." Since this "large and influential" group possessed "the great bulk of national wealth," Mayer raised the question whether the possession of such wealth imposed special cultural responsibilities on such citizens. He believed that it did; "the lawful patronage of genius," he declared, was properly the duty of the wealthy "wherever art and literature can constitutionally receive but little direct encouragement from the government." As spokesman for the merchants of Baltimore whose wealth had built the Athenaeum, not in "the expectation of revenue," but as a "labor of love," Mayer spoke in highly nationalistic terms about the value of such an institution for the country's cultural development; and nationalistic benefits, he felt, would be derived "from the mingling and mutual appreciation of the scholar, the student, and the merchant." "Such are the results," he assured his receptive audience, "which the vast wealth deposited in the mercantile class is to produce, when liberally directed. . . ." [17]

Six exhibitions were held by the Maryland Historical Society Art Gallery between 1848 and 1858. If the taste of Baltimoreans can be judged on the basis of these exhibitions, it would appear that portraiture was still the favorite of art patrons during these years. Many landscapes, a good number of genre or figure paintings, and a sprinkling of historical, religious, still life, and literary pieces testified to a broadening of taste, however, but it was a taste that remained conservative whatever the subject matter of the paintings that were lent for exhibition. In the exhibition of 1853, for example, at least half of the paintings on display were either copies from Old Masters or presumed originals; relatively few of the artists represented in this exhibition were contemporary Americans, and even fewer were from Baltimore. The same distribution of artists may be seen in the exhibition of 1858: most of the paintings were by unknown artists, many by Europeans of both earlier times and the present, and some were by Americans, with few by contemporary residents of Baltimore. The exception to this pattern was the exhibition of 1855, when the Gallery held a joint show with the newly formed Artists'

Association of Maryland. Twenty-six members of the Association presented their works as a "hasty effort" to mobilize public support for a permanent gallery in Baltimore, devoted exclusively to American art. The Artists' Association lasted no longer than any of its predecessors, but the Historical Society Gallery endured, and until the Walters Art Gallery was opened to the public in 1890, it provided Baltimore with its only public resort where paintings of the past and present might be examined and enjoyed.[18]

The various loan exhibitions which the Gallery held, and its accumulating permanent collection, maintained interest in art exhibitions in Baltimore until other institutions—the Walters Collection and the Baltimore Museum of Art—took up the burden of bringing art to the community. The presence of the Gallery in the city undoubtedly encouraged some artists to take up residence in Baltimore during the late 1840's and thereafter, as the new names of Baltimore artists in the catalogues of these years testify. In turn, the presence of artists brought art to the attention of men and women capable of developing an appreciation or of extending patronage to artists. By 1870 Baltimoreans had demonstrated a sufficient interest in art to suggest the founding of another academy—the Maryland Academy of Art—which proposed to "concentrate" in an organized form "the congenial art elements of the community." Although the Academy lasted only until 1873, it did provide Baltimore with its first school for artists, which later institutions like the Peabody Institute continued. Baltimore's art life saw its most fruitful developments after the Civil War, but the seedbed of its growth and of the tradition of community responsibility for nurturing it was planted in the prewar period.[19]

PART IV

PATRONS AND TASTE

The Liberal support and the warm and
hearty appreciation of Art is to our Artists
what Capital is to our enterprising Mer-
chants.

<div align="right">CRAYON, 1859</div>

At the beginning of the nineteenth century many Americans doubted that the United States could create a native art because of the dearth in the country of great art of the past. How to overcome the shortage of great works of art, when the capital of Americans and their attention were so heavily committed to problems of economic development, posed a large question. Who could pay for Old Masters in a country where wealth was customarily divided among heirs and where the presence of "middling wealth" distributed broadly, instead of enormous fortunes in the possession of a few, threatened to inhibit the creation of important collections of works of art? Jefferson felt that it was "useless and preposterous" for Americans to attempt to become "connoisseurs," because of the great expense of paintings and statuary. Many decades later, Edward Everett, just as much a classicist in taste as Jefferson, noted that there was little hope for the "expensive arts" in this country because of the fact that "private fortunes, in consequence of the law of distributions, which is the cornerstone of the republic, will always remain small." [1]

The dilemma seemed especially great for these men and for other Americans like them because, in realizing the expensiveness of great art, they also believed that a knowledge of art and the development of Taste began with the Old Masters. Both artists and patrons were considered to be dependent upon the artists of the past because they had achieved a perfection of technique and craftsmanship, as well as insight into nature, that were worthy of imitation and admiration. "Whoever has so far formed his taste, so as to be able to relish and feel the beauties of the great masters has gone a great way in his study," wrote Sir Joshua; and Americans who had learned about art from Reynolds agreed. "Taste is only acquired by a close study of the Old Masters," wrote Morse in 1814, and therefore he urged that "first-rate pictures . . . be introduced" into the country. Without "large supplies" of "really good specimens of European art, ancient or modern," Americans, it was generally believed, would never produce good artists.[2]

Americans were not slow in facing up to the dilemma that confronted them. Where they could, they purchased Old Masters;

and when their means were limited or Old Masters were unavailable, they bought copies or commissioned young American artists to paint copies for them. Old Masters figured in many colonial collections, and these were augmented by what American tourists were able to purchase on their Grand Tours. As wealth accumulated, its possessors scoured Florence and Rome in search of art treasures. "Our good people," complained E. D. Nelson to John Durand in 1858, "when once they come abroad feel at first a duty to admire the Masters, and secondly to buy the 'good copies' which are quite as valuable as the originals." Collections that consisted mainly of European Old Masters often contained other examples of classical taste: American "old masters"—the paintings of Copley, Stuart, Trumbull, and Allston—and portraits by the reputable and fashionable portraitists of the day such as Inman, Sully, and Harding, or later, Huntington, Elliot, Healy, and Gray. Classical sculpture or sculpture in the classical mode from the studios of Powers, Crawford, and Rinehart also satisfied such collectors who participated in the classical tradition.[3]

New tastes and ideas began to permeate American thinking about art in the late 1820's and 1830's. Reynolds had always insisted upon the necessity for artists to learn from nature as well as from the Old Masters; but more and more, with the influence of Alison and the Associationists, the writings of Gilpin and Price on landscape and the picturesque, and the emphasis of Wordsworth and the English Romantic poets on the intimate relationship existing between man and nature, Americans began to stress nature and instinct more, formal training and experience less. Interest in nature was also stimulated by the poetry of William Cullen Bryant and the essays of Emerson as they appeared in the late 1830's. As sentiments of cultural nationalism grew, some Americans of taste and wealth began to question the emphasis on Old Masters and to turn their attention, instead, to collecting works of native "genius." They saw no reason why American painters in sympathy with the American environment should not create pictures as beautiful as those created in the past. The artist must be encouraged to paint whatever his instinct for beauty led him to, and this encouragement was provided; by the 1840's, American landscape and genre paintings took their places beside American portraits in the collections.[4]

The early patrons of American art were few in number, but their influence was considerable. It soon began to be fashionable as well as

patriotic to form "American collections." From the thirties through the fifties, therefore, most collections of paintings in this country were national in their emphasis.

The interest in collecting the works of contemporary American artists was encouraged by the American Art-Union, an organization formed by community-minded gentlemen of New York City who were distinctly nationalistic in their cultural attitudes. The Art-Union acted as a collective patron of the fine arts in the country, and as such its history is important in a consideration of art patronage in the United States. Like the early collectors, the Art-Union in its early years emphasized copies of Old Masters, portraits, and presumed originals of great works which it borrowed from private sources; as the organization increased in strength and related itself more to the spirit of the American environment, it turned its attention to the purchase and collecting of American works alone. Between 1842 and 1852 it functioned as the largest and most democratic patron of the fine arts in this country, dispensing its advice, aid, and encouragement to hundreds of American artists. While the Art-Union lasted, its force as a patron was great; and when it withdrew from the American art market, it created, according to the editor of the *North American Review*, "a gap," which "in many respects, has never since been filled." [5]

The patronage of individuals, institutions, and organizations that was extended to artists expanded opportunities for art in this country which foreign artists and foreign art dealers were quick to take advantage of; these men brought contemporary European art to American cities and, therefore, to American collections. Especially popular among Americans were the paintings of the Dusseldorf school and of the accepted academies in Paris. In the fifties and sixties wealthy Americans found it more to their taste to buy these European paintings than to remain faithful to Americans. Only American painters like Church, Bierstadt, Leutze, and Kensett, whose high-priced works connoted social prestige, continued to be patronized by such collectors. It was a short step, then, back to collecting Old Masters in the 1870's and 1880's for men of great wealth—the new post-Civil War entrepreneurs and financial titans—who were able and quite willing to pay the very high prices demanded for old paintings and who found excitement in gambling in the market of connoisseurship.

CHAPTER THIRTEEN

AMERICAN COLLECTIONS

THOMAS HANDASYD PERKINS, one of Boston's most prominent philanthropists and businessmen during the first half of the nineteenth century, was a representative collector of Old Masters in the classical tradition. The son of a New England merchant and the grandson of one of the "leading fur exporters" of the province of Massachusetts, Perkins received the education typical for a Yankee merchant. Instead of entering Harvard College with his friend and fellow aristocrat, Harrison Gray Otis, Perkins joined the Boston mercantile firm of the Shattucks and remained with it until he reached the age of twenty-one. In 1789, he sailed as supercargo on one of Elias Hasket Derby's ships on a voyage to China, which was so successful that it is said to have been the foundation for "many Boston fortunes." A year later, Perkins bought a vessel of his own and sent it to the Northwest Coast to collect sea otter skins; at the same time, he joined his elder brother James in shipping enterprises that involved trade with Santo Domingo, the West Indies, and the Far East.[1]

President for a short time of the Boston branch of the Bank of the United States, builder in 1827 of one of the first railroads in the United States, and President of the Granite Quarry Company of Quincy, Massachusetts, Perkins early in his career accumulated the fortune that established him as one of Boston's foremost merchant princes. Philip Hone, who visited Perkins in 1838, noted the splendor of his home in Brookline, its "extensive grounds," and his "fine collection of pictures." Perkins practiced philanthropy in a princely manner also, endowing with generosity institutions like the New England Institute for the Blind, the Massachusetts General Hospital, and the Boston Athenaeum and its Gallery of Art.[2]

The fine arts was one among many interests that Perkins pursued as

AMERICAN PATRONS OF ART

(Top Left)
Robert R. Livingston (1746–1813), by John Vanderlyn (1776–1852). Courtesy The New-York Historical Society, New York City.
The chief satisfactions that Chancellor Livingston derived from public service are suggested by the documents visible in Vanderlyn's portrait. One is the "Plan for establishing an Academy of the Fine Arts in New York," on which his right hand rests, and the other, Livingston's credentials as "Minister Plenipoten^y" to France.

(Top Right)
Luman Reed (1785–1836), by Asher B. Durand (1796–1886). Courtesy The Metropolitan Museum of Art. Bequest of Mary Fuller Wilson, 1963.
A farmer's son who earned his fortune as a wholesale grocer in New York City, Luman Reed "lov'd . . . to nurse the growing Arts" of his native land. He became one of nineteenth-century America's most famous and esteemed patrons.

(Above Right)
John R. Murray (1774–1851), by Gilbert Stuart (1755–1828). Courtesy The Metropolitan Museum of Art. Gift of Mrs. Walter Oakman and Helen Hubbard, 1950.
"Patriotic principle and pride," and pleasure in the study of "Sublimity and Taste," stimulated Murray's activities as a director of the American Academy in New York, as art collector, and as patron of American artists.

(Bottom Right)
Mr. Gilmor of Baltimore (1774–1848), by Gilbert Stuart. Courtesy Museum of Fine Arts, Boston. James T. Fields Collection.
Three large houses could not accommodate Robert Gilmor, Jr.'s extensive collection of European and American works of art. As Baltimore's foremost art patron, Gilmor generously made his collection accessible to young American artists for study and inspiration.

Evening Landscape, by Gaspa
Poussin (1615–1675). Courtes
The New-York Historical So
ciety, New York City. Durr Col
lection.
The Repose in Egypt, by Nichola
Poussin (1594–1665). Courtes
The New-York Historical So
ciety, New York City. Bryan Col
lection.

Early American collectors an
artists regarded the "grandly com
posed" paintings of Gaspar an
Nicholas Poussin as the "highes
achievement in classic landscape.
The Poussins' emphasis on the an
tique, nature, drawing, and reaso
in the classical tradition continue
to exert a far-reaching influenc
on American art and taste wel
into the fourth decade of the nine
teenth century.

Sunrise, by Claude Lorrain (1600–1682). Courtesy The Metropolitan Museum of Art. Fletcher Fund, 1947.
Bacchus and Ariadne, copy after Titian (1477/87–1576). Courtesy The New-York Historical Society, New York City. Durr Collection.

"Claude's pictures are truly and wonderfully beautiful," wrote Divie B. Duffield, a young lawyer from Detroit in 1855. In them, Duffield discerned "nature in her very loveliest attitudes." The westerner's admiration extended also to Titian, Correggio, Murillo, Rubens, and "all the choicest masters," reflecting a taste that had pervaded and influenced American aesthetic thought and practice for at least a hundred years.

The Three Trees (etching), by Rembrandt Harmensz van Ryn (1606–1669). Courtesy The Metropolitan Museum of Art. Bequest of Mrs. H. O. Havemeyer, 1929. The H. O. Havemeyer Collection.

The Harvesters. Flemish, seventeenth century. Formerly in the Gilmor Collection. Courtesy The Baltimore Museum of Art.

"Dark, Rembrandt-looking hemlocks" suggested America's "affluent forest-grandeur" to Americans of the nineteenth century, while the "exquisite performances of the Flemish School" emphasized, in Robert Gilmor's opinion, the necessity for American painters to "make nature and truth [their] models" if they wished to achieve "excellence."

View of Baltimore from Beech Hill, the Seat of Robert Gilmor, Jr., 1822, by Thomas Doughty (1793–1856). Formerly in the Gilmor Collection. Courtesy The Baltimore Museum of Art. Gift of Dr. and Mrs. Michael A. Abrams.

The collector and patron Robert Gilmor, Jr., possessed ideas about painting which have been called "unwittingly ahead of his time in [their] straightforward realism." "As long as Doughty *studied and painted* from Nature . . .", Gilmor wrote to Cole, "his pictures were pleasing, because the scene was real, the foliage varied and *unmannered*, and the broken ground and rocks and masses had the very impress of being after *originals*, not *ideals*."

Landscape, by Salvator Rosa (1615–1673). Courtesy The New-York Historical Society, New York City. Durr Collection.

A Wild Scene, by Thomas Cole (1801–1848). Formerly in the Gilmor Collection. Courtesy The Baltimore Museum of Art.

It was the "quality of wildness" in Cole's scenes that reminded Robert Gilmor of Salvator Rosa and drew him to the young artist. The result of his commission, *A Wild Scene* (1832), shows not only the influence of Rosa in the organization of the picture, but also—in Gilmor's insistence that the artist include "falling water" in the manner of Ruysdael—the influence of the European masters on nineteenth-century American taste.

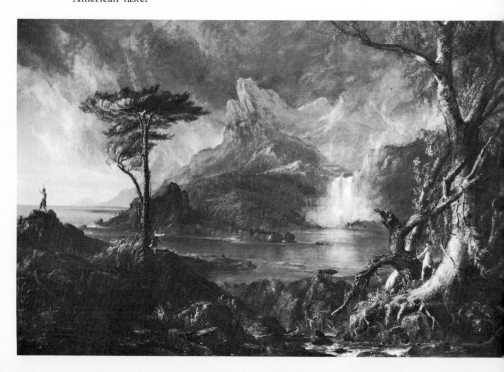

John Quincy Adams, by Asher B. Durand. Courtesy The New-York Historical Society, New York City. Reed Collection.

The Woodchopper's Boy, by George W. Flagg (1816–1897). Courtesy The New-York Historical Society, New York City. Reed Collection.

Luman Reed's "national" feelings were responsible for his commission to Durand of the series of presidential portraits, of which *John Quincy Adams* was the last. And it was his nationalism, too, that prompted his patronage of Flagg's scenes of country life. "I really look to you to give a spring to the art in this country," the patron wrote to Flagg, "not by startling objects and gorgeous coloring & a thousand incongruities to catch the gaze of the vulgar, but by boldness of design, truth in expression & simple arrangement of figures and coloring that shall bring our nature itself to view."

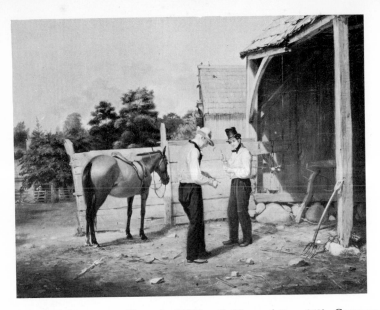

Bargaining for a Horse, by William S. Mount (1807–1868). Courtesy The New-York Historical Society, New York City. Reed Collection.
The Truant Gamblers, by William S. Mount. Courtesy The New-York Historical Society, New York City. Reed Collection.

"William S. Mount never visited Europe," wrote the New York *Evening Post* in praise of the artist's "truly American" paintings; "yet in his particular department he is unquestionably without a superior." Luman Reed was one of the first Americans to recognize Mount's peculiar genius and reward it with generous patronage.

Wrath of Peter Stuyvesant on Learning of the Capture of Fort Casimir, by Asher B. Durand. Courtesy The New-York Historical Society, New York City. Reed Collection.

Luman Reed's desire "to make something of ourselves, out of our own materials," was the stimulating force behind Durand's painting of this episode and launched the former engraver on a career of painting which in Dunlap's opinion possessed "little of those vicissitudes or struggles which give pungency to the tale of the biographer." In later years, as president of the National Academy of Design, Durand exerted a large influence on landscape painting in this country.

Distribution of the American Art-Union Prizes, lithograph from a painting by T. H. Matteson (1814–1884). Courtesy The New-York Historical Society, New York City.

"In the days of the American Art-Union," wrote the editor of the *North American Review* in 1877, "its walls were lined with native scenes and the success of this institution was without parallel." The Art-Union was not only a "promoter of American art," but "a gauge of the public taste"; and when its services were brought to a halt, to many contemporary American artists and subscribers the loss seemed considerable indeed.

Fur Traders Descending the Missouri, by George Caleb Bingham (1811–1879). Courtesy The Metropolitan Museum of Art. Morris K. Jesup Fund, 1933.

The American Art-Union paid seventy-five dollars in 1845 to Bingham for the *Fur Traders*, and continued to buy his paintings of border life and history despite the attack of some critics on his lack of "refinement in execution." The Union managers believed that Bingham's work embodied "the spirit—the sentiment of the nation" and that the "Americanisms" in his work were of greater importance than technical excellence.

Captain Glen Claiming Prisoners after the Burning of Schenectady, February 9, 1690, by T. H. Matteson. Courtesy The New-York Historical Society, New York City.

The American Art-Union's purchase of Matteson's *The Spirit of '76* in 1845 was "hailed" by a "shout of praise" and launched the struggling young portrait painter upon a prosperous career of historical and genre painting. *Captain Glen* was painted soon after for James W. Beekman of New York. This kind of historical painting was encouraged by the Art-Union because, in Tuckerman's opinion, it met the "average taste of the people."

befitting a man of his station. He responded to art, and especially to the great art of the past, with a restrained but genuine enthusiasm. On his fairly frequent trips to Europe he visited museums and galleries in The Hague, Rotterdam, London, and Florence. For example, in 1823, he persuaded Edward Everett, who was then in London, to accompany him on an expedition to The Hague where the museum was "rich in reproductions of Flemish masters"; and with Everett he admired the Paul Potters, which he believed were "the finest in the world." He was also pleased with the paintings by Rubens, Vermeer, Rembrandt, and many others; at Delft Haven in Rotterdam he bought some paintings, among which was "a very fine Vermeer" for which he paid 1200 florins. Later, on another tour of Europe in 1835, Perkins visited the studio of the sculptor Chantrey in London, the British Institute at Pall Mall, Greenough's studio and the Pitti Palace in Florence. The comments in his diary about the art he examined are brief and to the point; admitting that he had "little knowledge of paintings," he yet felt that he could visit those in the Pitti Palace "every day for a month, and think the time too short." On the other hand, he did not enjoy the paintings of the living artists at the British Institute as much, although some of them were "fine." While in London later that year, Perkins found time to visit the National Gallery to see a "few of Claude's best pictures." [3]

These sparse notations indicate the course that Perkins' taste took with respect to art. The "highly esteemed" works of the accepted sixteenth and seventeenth century masters who dominated English and American taste during the eighteenth and the beginning of the nineteenth centuries were the paintings he sought out, and whatever respectable examples of these artists' work he was able to purchase became part of his collection. [4]

Other Bostonians of comparable wealth and station shared Perkins' taste. Harrison Gray Otis, the Federalist politician and orator, Peter Chardon Brooks, merchant, and Israel Thorndike, entrepreneur and "one of the wealthiest merchants of Boston," were all intimate friends of Colonel Perkins and lived as he did in homes filled with paintings and sculpture that satisfied their sense of opulence and their aesthetic tastes. Their copies of "striking" Salvator Rosa landscapes or rural Flemish scenes, along with an occasional original Old Master or portrait by Stuart were desirable "ornaments" for their rooms as well as signs of taste and culture. Despite their interest in collecting art and

in supporting the Boston Athenaeum with donations of money as well as paintings, Perkins, Thorndike, Brooks, and other Boston merchant princes like David Sears, Nathan Appleton, I. P. Davis, Charles Russell Codman, and William Gould Shaw were not connoisseurs in the eighteenth-century sense of "cognoscenti," but were men of business who had absorbed the tastes that were fashionable at the time.[5]

Since it was fashionable for men of wealth to extend patronage to young American artists of "genius," these merchants were quite willing to play the role of Cosimo by aiding and encouraging especially the painter Washington Allston and the sculptor Horatio Greenough, both of whom gave promise of achievement along lines which they could understand and respect. Thus, in 1811 Perkins purchased the young Allston's *The Poor Author and the Rich Bookseller*, a satirical painting in the tradition of Hogarth, and later he bought Allston's *Saul and the Witch of Endor*. The merchant also arranged passage for Horatio Greenough to Leghorn, so that the young sculptor might study his art in Italy, and he offered to provide Thomas Cole with similar transportation to Liverpool in exchange for a picture of northern scenery for which he had a "penchant." Allston received commissions from other members of the Boston mercantile and professional community—David Sears, Edmund Dwight, Warren Dutton, Nathan Appleton, C. R. Codman, George Ticknor, and Franklin B. Dexter, but probably the most significant act of patronage extended to him by these men was their contribution to the Allston Trust for the purchase of *Belshazzar's Feast*—a Trust designed to give the artist financial aid while completing what was believed to be his greatest work. If, in their desire to "do honor to their city," they inadvertently burdened the artist with an impossible task, they did so with the best intentions and in a princely and generous manner worthy of their station in society.[6]

Just as in Boston the major collectors of European art of the past were associated with the founding and management of the Boston Athenaeum's gallery, so too in New York, merchants and professional men who collected art in the classical tradition were involved with the American Academy of Fine Arts. John R. Murray, a member of an old landholding family and one of New York's successful merchants, was one of these.[7]

Given an appropriate education as the scion of an "opulent" family,

Murray supplemented his formal studies with lessons in drawing at the school of Alexander Robertson; here he studied with other boys who were to make their reputations in the "commercial annals" of the city—Isaac G. Ogden and the Macomb brothers, among others. When his formal education was completed, Murray was sent on a Grand Tour of Europe which included visits to Berlin, Potsdam, Prague, Vienna, Warsaw, and St. Petersburg. In Berlin in 1799–1800 he visited the chateau built by Frederick I and there enjoyed "three hours of converse and instruction with Sublimity and Taste, under the influence of Correggio, Rubens, Van Dyke, Rembrandt &Titian." He "fell in love" with Titian's figures: "such extreme delicacy of form, such softness of expression and beauty of coloring could not have a less effect"; and he also was delighted with "the exquisite performances of the Flemish school" at the Hermitage in St. Petersburg. Here, too, he "feasted" on Claude Lorrain's works and developed his "partiality" for Murillo, who, he felt, "had taken Nature for his guide & he painted her with her pencil, dipped in her own colors, and . . . directed by her Genius. . . ." In 1800 Murray returned to New York to participate in the city's developing mercantile prosperity and cultural life. Besides giving his aid and energies to the various benevolent institutions of the city, the merchant maintained his longstanding interest in art for personal pleasure as well as out of "patriotic principle & pride." [8]

Murray's taste was reflected in his collection of paintings which consisted mostly of works of Old Masters, either copies or "originals." Presumably he had brought some back from Europe; others he probably purchased from Paff or Flandin, two New York dealers in Old Masters; and some copies he commissioned from young Americans who wished to study art in Europe. Of the known painters to whom works in the merchant's collection were attributed, Correggio, Gaspar Poussin, Nicholas Poussin, Andrea del Sarto, Rembrandt, and Teniers were prominent. In subject matter Murray's taste emphasized religious themes or landscapes in the classical style, with arcadian shepherds or fountains and villas. Only a half-length portrait by Copley and *Birds* by Wilson were by American artists. [9]

Murray's was a fairly typical collection of the first generation of American collectors who were influenced by the classical tradition: some copies, some paintings with only partial attributions, a few less important original works of the less important painters, and one or

two really good paintings by the more important masters. None of the collections reflected a system or plan, but rather the desire to own great works of art, the possession of which would indicate Taste and superior refinement. Given the limitations of their fortunes—large enough by American standards, but not large enough to acquire really great masterpieces—and the difficulty of obtaining good old pictures that were authentic, collections of this sort were all that Americans could hope or expect to obtain.

—2—

The taste for Old Masters had far-reaching effects on American artists of this generation and on the way American art developed. The high value that American men of wealth and education placed upon the works of the sixteenth and seventeenth century painters influenced artists like Allston, Vanderlyn, Morse, and Sully to aspire to achievement in the historical-religious-biblical fields in emulation of the "grand style" of the masters. In Allston's case this brought about a conflict between his inclination to follow a more introspective art and his desire to paint a grand picture in the style of Raphael; Vanderlyn, who excelled as a portrait painter, was embittered by what he believed to be an unsympathetic environment for large historical works; and both Morse and Sully suffered from the desire to continue in the tradition of the Old Masters, while their proficiency as well as the demand lay in portraiture.[10]

American artists who rose to eminence during the first three decades of the nineteenth century were also so convinced of the perfection achieved by the Old Masters that they found it difficult to accept innovation. Allston, for instance, was so impressed by the "grand and awe-inspiring" landscapes of Salvator Rosa and Ruysdael that quite early in his career he began to shape his own work to express the "aspect of nature" that he found in theirs. Cole's favorite landscape painters were Claude and Gaspar Poussin. He rejected Turner's late style as being "a great falling off" which produced "the strangest things imaginable"; while the rest of modern English painting he dismissed as "the embodiments of affectation and extravagance." Asher B. Durand shared Cole's contempt for the modern English schools—Constable, for example, was scarcely noticed by these Americans—and he also preferred the work of Claude for his "pleasure and instruction" to that of any other landscape painter.[11]

Although the influence of the Old Masters may have been unfortunate for early nineteenth-century artists, the presence of these paintings, or copies from them, in American collections exerted a broadening effect on taste. Portraiture, of course, continued to be the most profitable activity for artists; but slowly other forms of painting began to find welcome, as patrons became convinced that American artists should be concerned with something nobler, more ideal, than portraiture. By the middle of the 1820's, landscape painting and historical and scriptural compositions, which, it was believed, "lay open the deepest springs of feeling [and] . . . stir up those hidden sympathies of our nature," became desirable. Until this time, such paintings had been conceived chiefly in terms of huge canvases for exhibition purposes. As Americans became acquainted with such works as Breughel's *Christ Restoring Sight to the Blind* or Caravaggio's *Rachel at the Well*, they became aware of the possibilities of having such subjects expressed on smaller canvases that were more suitable for the parlor or library. In the same way, the Flemish and Dutch painters suggested that American artists might profitably exploit the native social scene, and so genre painting, illustrating what Emerson called "the common . . . the familiar . . . the low," became a popular art form, one eminently suited for a democracy. It was, however, primarily in the field of landscape painting that Americans felt the influence of Old Masters. It would be vain, contended Franklin B. Dexter, to dream of reaching the stage of excellence achieved by the historical painters of the sixteenth and seventeenth centuries; for "a state of society and education—and . . . religion—existed in the beginning of the 16th century which soon ceased, and which never can exist again. . . ." But landscape painting, Dexter believed, which "rose into existence under different influences" was dependent upon "the degree of poetical culture" within the age; and "certainly in this we are not necessarily inferior to any preceding age." "The mind is now as susceptible as ever of the impressions of natural beauty and of poetical and moral associations. . . . We see no reason why men should not arise in our day to surpass all that was accomplished by Claude, Gaspar, or Salvator." [12]

These landscapists—Claude, Poussin, Salvator Rosa, and Ruysdael —drew the attention of American artists and patrons of art to the picturesqueness of America's rugged mountains and rock formations, her tangled forests, unrestrained rivers and waterfalls; the pastoral

charm of her quiet brooks, placid lakes, and ordered fields. Americans
of this generation began to look at their scenery through the eyes of
the Old Masters. Cooper, for instance, often referred to American
forests as "dark Rembrandt-looking hemlocks," or as providing
pictures that "Salvator Rosa would have delighted to draw." Simi-
larly, Philip Hone found "the lofty mountains and the rich vallies" of
Northampton, Massachusetts, "with the pretty village, its neat white
houses, and the spires of its numerous places of worship," suggestive
of the charms of a Ruysdael landscape.[13]

Representative of the way in which American art patrons were
drawn to American landscape painting under the influence of seven-
teenth-century European artists is the development of the collection
of Robert Gilmor, Jr., probably America's most prominent patron of
landscape painting during the first three decades of the nineteenth
century. Gilmor had begun acquiring European paintings at the turn
of the century when, as a youth, he traveled through western Europe,
especially in Belgium and Holland. His special interest in landscape
painting developed even earlier, when at the age of twenty-three he
had made a brief trip through the eastern states sketching rather
accurately and carefully views of the places he visited. Among the
many paintings that overflowed his town home, his country home,
and his sister-in-law's walls, there were at least three Ruysdaels, the
Angiers of Salvator Rosa, and landscapes by Hobbema, Berchem,
Poussin, and Cuyp.[14]

From such an intense involvement in the art of the Old Masters,
Gilmor developed fairly definite ideas about landscape painting and
was not at all hesitant about expressing these ideas to the American
artists he commissioned. The "decayed trees" in some of Cole's
paintings and the quality of wildness in Cole's scenes reminded
Gilmor of Salvator Rosa; this resemblance of style drew the Baltimore
merchant to the young artist in the first place, and he kept calling
Cole's attention to Salvator Rosa as an artist worthy of emulation.
From his study of the landscapes of Ruysdael, Gilmor concluded that
water added an element of interest to landscapes, either *"falling"* or
"still, lake water" which would reflect "the tints of sky, foliage,
grass" and would show "the play of light on a slight motion of part of
it. . . ." Because Gilmor, like many other Americans, attributed the
greatness of the Old Masters to their close study of nature, he urged
Cole and other American artists to whom he gave commissions to

"make nature & truth" their "models": "truth in *colouring*, as well as in *drawing* the scenes of our own country is essential," Gilmor warned Cole. What he wished to see Cole capture was the "desolate wilderness of American nature," and this required being "true to nature."[15]

Cole and Gilmor differed on the relative merits of landscapes that were taken directly from nature and those that were put together from sketches in a "composition" picture. Their controversy revealed the importance that each attached to the Old Masters as providing almost absolute criteria in matters of art, for both artist and patron cited the practices of the Old Masters to justify his point of view. Gilmor found the direct approach to nature in Ruysdael's "finest landscapes" the most satisfactory; Cole felt that Raphael's pictures and those "of all the great painters" had in them "something more than imitations of nature as they found it" and concluded that "a departure from Nature is not a necessary consequence in the painting of compositions." What Gilmor would have Cole emulate of the Old Masters was their technique; what Cole wished to imitate was their achievement of great poetical ideas in painting—their idealized subject matter. If Cole had adopted Gilmor's views and had concentrated on the kind of landscapes he painted for Gilmor early in his career rather than on idealized compositions that had philosophical or literary content, he might have produced a body of work of more lasting artistic significance than he did. Instead, Cole's taste, which reflected the growing taste of the mid-century for a pious, sentimental, and superficially philosophical art, determined his course as a painter and directed him into channels of moralistic fantasy and trite allegory.[16]

—3—

Cole's interest in allegorical painting was aided and encouraged by two New York patrons who commissioned his two important series of allegorical paintings—Samuel Ward, the banker, for whom Cole painted four canvases depicting *The Voyage of Life*, and Luman Reed, the commission merchant, for whom he created *The Course of Empire*, five large canvases that told the story of "how nations have risen from the Savage State to that of Power & Glory & then fallen and become extinct." Of the two men, Luman Reed is more significant because he represents a new kind of collector–patron; in

many ways his activities in art collecting form a kind of bridge linking the earlier collectors of Old Masters with the later mid-century patrons.[17]

Luman Reed was born in 1784 in a small village in Columbia County, New York, the son of a farmer of limited means. After a simple education of the kind that was then "within the reach of farmers' boys," he left home to become a clerk and subsequently the partner of a merchant in Coxsackie, a town on the Hudson River. Endowed with energy and evident business ability, he moved on to New York City, where in 1815 he established himself as a wholesale grocer. Between 1825 and 1830, Reed rapidly accumulated the means by which he could indulge his taste for art. His reading of history and art criticism directed his attention to the Old Masters, and he "commenced his education as an amateur" by buying works attributed to these painters, only to discover that he had been duped by the "hypocrisy and knavery of picture dealers, and the delusion of those who still remained in darkness." Undeterred by the unhappy experience, Reed continued to buy Old Masters, but he increasingly turned his attention to the general question of the state of art in America. His desire to achieve "a high standard of the art [of painting] here" was heightened by strong nationalistic sentiments: "to make something of ourselves out of our own materials," therefore, emerged as the motivating impulse behind his patronage of young American artists. The merchant extended patronage to four painters whose careers were just beginning in the 1830's: Asher B. Durand, Thomas Cole, George W. Flagg, and William S. Mount. Toward them he displayed an understanding and generosity of mind and pocketbook that made available to them "every facility and encouragement" necessary for the progress of their careers.[18]

To a great extent it was Reed's interest in Durand that made possible the artist's transition from engraver to painter. Reed was convinced on seeing one of Durand's paintings that if the engraver was given the opportunity of concentrating on this art alone "he would become a distinguished painter." What was more suitable, then, given Reed's "National" feelings, than to encourage a native artist by commissioning him to paint portraits of the Presidents, from Washington to John Quincy Adams? Such an assignment would fulfill the purpose of subsidizing the artist and launching him on his career, while the portraits constituted an appropriate gift for a

"public institution of Science and Natural History" as evidence of increasing American pride in its past. On Reed's order, too, Durand painted a portrait of John Quincy Adams' grandaughter for presentation to the former President. Thus Durand was well launched. In Boston and Washington, where he traveled to fulfill his commissions, he received other assignments on the strength of his performance. Reed's encouragement of Durand was of the most unselfish kind, involving a sympathy and understanding of the artist's problems that extended beyond mere subsidy. "He is determined to make something of me," wrote Durand to his fellow artist Casilear about Reed, "and if I ever attain to any excellence in painting it will be more owing to him than any other cause." [19]

Reed developed a similar paternal attitude toward the young artist George W. Flagg, whom he sent to Europe "to complete his studies as an artist." Flagg was only eighteen years old when Reed discovered him and was immediately impressed by his talent. It was the nationalist in Reed that spoke when he advised Flagg of the need for "high standards," simplicity, and boldness if American art was to be advanced. "I am much pleased to hear you denounce the French school of painting," he wrote,

> pure simple nature is the school after all. . . . I really look to you to give a spring to the art in this country, not by startling objects and gorgeous coloring & a thousand incongruities to catch the gaze of the vulgar, but by boldness of design, truth in expression, & simple arrangement of figures and coloring that shall bring our nature itself to view, execution is an important point, a cat well painted is better than a venus badly done.[20]

Reed's empathy with artists may be seen especially in his relationship with Cole. He urged Cole to draw on him for money whenever the artist needed it: "I do assure you that it is gratifying to [offer] this," he wrote to the artist; "I have wondered how you got along with so little unless you had resources that I did not know of." When Cole seemed depressed about the progress he was making on *The Course of Empire* series that Reed had commissioned, Reed wrote to the artist cheerfully; he indicated that he had no "misgivings" at all about the work and that Cole probably expected more of it than he could possibly realize and so imagined that it was "faulty." Yet Reed understood the artist's drive for perfection, for he suggested that if, after a while, Cole wished to repaint the pictures, then he would

permit him to do so "without detriment to you in a pecuniary point of view . . . that this undertaking should be carried out to your entire satisfaction is my sincere wish. . . . The basis of these pictures is the foundation of your fame & fortune"; and Reed assured Cole that he would be "carried through safe and sound." "The undertaking is immense," wrote the patron, but "the success is sure. . . ." [21]

Reed's activities and tastes were significantly influenced by the cultural nationalism of his time. The paintings he commissioned from American artists reflected his strong desire to participate in the creation of a native art. For instance, just before his death, he employed Durand, Mount, and Flagg to paint panels on the doors and walls of his private art gallery, and the scenes he chose were typically American in locale and subject matter, reminiscent of the idyllic farm experiences he had forsaken when he came to the city to make his fortune. These included "landscapes with figures" of a rural nature: "a woman churning under a shed with a child on the floor & Landscape in the distance," "a school let out with school house and landscape," "farmers eating dinner under a tree," and six small panels of country scenes. Mount also painted *Bargaining for a Horse* and *Undutiful Boys* for Reed, which delighted the patron with their "perfection." [22]

Reed's patronage of young American artists and his collection of American works gave him a distinction among his contemporaries that was quickly recognized and, even more important, imitated. His death, wrote I. P. Davis to Durand, was "a great public loss, it is rare to meet so much united with all his business talent, such a love of the Fine Arts, with great liberty and good taste." He was, noted Philip Hone in his diary, "a respectable citizen, an upright merchant, and what does not always follow, a man of taste and a liberal patron of the arts." Probably the best testimony to the influence of Reed lies in the fact that upon his death a group of New Yorkers, friends and colleagues of the collector as well as artists who had benefited from his assistance, "concerted a scheme" to transform his collection into a "City Gallery" of American art—the first gallery of its kind in the country. Thirteen thousand dollars was subscribed by a group of wholesale grocers headed by Theodore Allen, Reed's son-in-law, and Jonathan Sturges, Reed's former partner. Most of the fifty trustees of the gallery may have known "more about pork and molasses than . . . art," as James Gordon Bennett of the New York *Herald*

caustically commented, but they did have respect for the interest in American art that had so occupied Reed's later years.[23]

One hundred and seven paintings—the bulk of Reed's collection—were on permanent display in the gallery and could be examined for the nominal fee of twenty-five cents; life membership for one dollar gave an individual free access to the gallery whenever it was open. The aim of the founders was to maintain the collection intact, as a memorial to Reed's taste and generosity, and so additions were not made nor were exhibitions varied. This policy meant that the gallery could not maintain itself financially, and finally, in 1858, when Sturges and Thomas H. Faile, trustee and art collector, "became weary of making up a deficiency each year," the gallery was closed and the collection placed in the care of the New-York Historical Society.[24]

—4—

Although Reed deserves special attention because of the quality and extent of his efforts in behalf of American art during the early period of its development, he was not alone among the merchants of the Jacksonian period who found in the pursuit of art satisfactions and diversions from their business concerns. The New Yorker Philip Hone, for instance, like Reed a self-made and self-educated merchant, accumulated a sizable collection of paintings consisting primarily of contemporary works. The stimulation behind Hone's collecting may ostensibly have been patriotism, but Hone also seemed to enjoy his paintings as a demonstration of his refined tastes and position among the aristocracy of New York. Although the son of a joiner who had lived in an unpretentious frame house at the corner of Dutch and John streets in New York City, Hone, once he had accumulated his fortune, associated himself with "the richest and most distinguished New York society," with whose homes and furnishings he was much impressed. He became rhapsodic, for instance, when describing the magnificent mansion of Robert Ray of New York, with its "painted ceilings, gilded moldings, rich satin ottomans, curtains in the last [latest] Parisian taste, and splendid mirrors." Wherever he traveled—to Baltimore and Boston in particular—the homes of wealthy families were visited and commented upon for their elegance and taste. Hone's concern for art, then, probably resulted from the pleasure he experienced at being surrounded by beautiful objects, testimonials to class

distinction, property, and refinement. Whatever his motives, however, his taste was affected by the spirit of nationalism that pervaded his society. Some acceptable "Old Masters" or copies of their works appeared in his collection—Ruysdael, Van Ostade, Teniers, Canaletto, and copies from Salvator Rosa—but the paintings which he thought were most notable and which he most "esteemed" were those of the Americans Thomas Cole, Leslie, Vanderlyn, Rembrandt Peale, Ingham, Morse, and Weir.[25]

Hone's preference for modern American works was shared by most other northern men of wealth who formed collections of paintings during the mid-century. These men came from various backgrounds; some were born into wealth, others were the "architects" of their own fortunes. What they did have in common, however, was the taste, morality, and social values of their generation. Thus their collections, rather than reflecting sharply individualized taste or experience, conformed to a pattern that indicated that they enjoyed the same subjects and patronized the same artists.[26]

The interest in American scenes and American views was largely responsible for the popularity of the painters of the Hudson River School. C. G. Childs of Philadelphia asked Thomas Cole to paint a scene for him in which the "gorgeous colors of our Forest trees in autumn might be introduced, the bright reds, the orange and deep brown which make such striking contrasts and which alone are found in great beauty in this country." A. N. Skinner of New Haven commissioned "a true American landscape" from Cole, in which might be seen "what is the most delightful of all sights, a rich green valley just pictured after a shower in the soft repose of a summer sunset upon which 'the increasing Mountain-shadows fall' "; J. C. Gray of Boston proposed that Durand do a study from nature for him, an American landscape, he carefully specified.[27]

Out of their intimacy and involvement with nature, Americans who were interested in art sought to have that art delineate nature with a literalism that insisted upon a careful and minute study of the objects or scenes to be copied. Realism in art, therefore, became an articulated aesthetic ideal, closely bound to the idea of a national art and to the morality of the democratic faith. How could a painting actually express such concepts? Walt Whitman's response to Walter Libbey's *Boy with a Flute* in the Brooklyn Art Union exhibition of 1851 suggests one way that Americans thought an artist might capture

the American character. A European artist, Whitman held, would have imposed "the stamp of class" on the boy, portraying him as nothing but "a young boor"; but the American artist, in the "spirited well being of the figure," in such "exquisitely fine" details as the natural grace of his hands holding the flute, had so rendered the boy that, country lad though he was, he might still some day become President or—even better—"an editor of a leading newspaper." [28]

The smoothly idealized paintings of American children engaged in the virtuous activities of prayer, industry, or study also demonstrated how art could convey morality and nationality at once. Jonathan Sturges' collection contained many of these: Weir's *A Child's Devotion*, Ingham's *Flower Girl*, Edmonds' *The Bashful Cousin*, Inman's *The Newsboy*, and Gray's *The Young Poetess* were pictures that showed healthy, frank, modest youngsters, respectable even when poor; they expressed in their appearance and in their activities the genteel notions of morality and virtue that marked American taste of the mid-nineteenth century. These paintings were considered "fine in sentiment" and "refined in character"—phrases that frequently appear in the art criticism of the period. The blending of nationalism, naturalism, and morality helps to explain the large melodramatic historical paintings that appeared in these collections: Leutze's *Washington Crossing the Delaware* in the Marshall O. Roberts collection, or his *Mrs. Schuyler Firing Her Wheat Field at the Approach of Burgoyne's Army* in the C. M. Leupp collection; the religious-scriptural paintings of Huntington in Roberts' collection—*Mercy's Dream* and *The Good Samaritan;* and the meticulously painted and prosaic views of Casilear, Cropsey, Oddie, and William G. Wall that appear in almost all of the mid-century collections along with the more important landscapes of Cole, Durand, Kensett, and, occasionally, Inness.[29]

Who were some of the leading collectors of American works? Robert L. Stuart was a sugar refiner and philanthropist of New York City, whose wife was instrumental in helping him acquire his art collection.[30] R. M. Olyphant was a merchant whose family fortune had been acquired in the China trade; Olyphant expanded the fortune by investing in the Delaware and Hudson Canal Company and later in the Delaware and Hudson Railroad. The merchant contributed liberally to the National Academy of Design and eventually was elected a Fellow of that organization.[31] Marshall O. Roberts began his

career as a ship's chandler and later became involved in navigation on the Hudson River and in the activities of the Erie and Lackawanna Railroad. His steamship company was subsidized by the United States government in 1847, and from that time on his business prospered on the basis of service to Havana, Panama, and New Orleans.[32] James Lenox was the scion of a mercantile family in New York, whose wealth was founded on lucrative real-estate investments; at his death in 1839 his father was considered one of the five wealthiest men in the city. Lenox himself received his degree at Columbia College, and like other young men of his position and fortune he was sent on the traditional Grand Tour of Europe. The New Yorker owned an extensive art collection, together with a famous book collection which became the basis of the Lenox Library in 1870.[33]

In contrast to these men, Joseph Harrison of Philadelphia was a man of little formal schooling, who worked his way up by dint of his mechanical aptitude in the railroad locomotive manufacturing business. An important contract from the Russian government in 1843 firmly established his fortune; and after his return from Russia to Philadelphia, he was able to build a "palatial" residence filled with paintings and other works of art. By 1858 Harrison was reported to have purchased two hundred paintings by American artists.[34] C. M. Leupp was also a self-made man; "after many years of toil and commercial enterprise, fortune smiled upon him & he honored it by appreciating her gifts in the most useful and intelligent manner." The example of the merchants and entrepreneurs of New York City influenced Leupp to participate in the "ennobling cause of Art"; and his exposure to the Old Masters in Europe, together with sentiments of nationalism, led him to conclude with others of his generation that "with liberal support and intelligent appreciation" the United States would soon be able "to take a stand by the side of other countries" in the fine arts.[35]

Most of these men who formed American collections shared Leupp's cultural nationalism. Most of them, too, seemed to enjoy their paintings, and their letters to artists ring with enthusiastic praise for the "gems" that they added from time to time to their collections. Some of these collectors may have patronized artists, as Stuart was accused of doing by R. M. Olyphant, "because others thought he ought to!", while some, like Harrison, may have collected paintings as an indication of status and wealth. Whatever their individual motiva-

tions may have been, and surely they were complex, support from such individuals to American artists was so generous during the decade of the fifties that in 1857 the *Cosmopolitan Art Journal* could report to its readers that even if "the patronage of the nation were withdrawn, the ample purses of private persons, the mercantile princes of our Atlantic cities, longing to emulate the Medici of old, would guarantee the merited recompense to successful art." [36]

In 1879 Earl Shinn, under the pseudonym of Edward Strahan, published *The Art Treasures of America*, a three-volume compendium of public and private art collections in this country and Canada. Shinn compiled his work in the belief that "it was a good time to provide an estimate of the country's civilization . . . as is furnished by its love of art, the most obvious test of enlightenment for any nation." The author noted the existence of more than one hundred and fifty substantial collections in New York, Boston, Philadelphia, Baltimore, San Francisco, Washington, D.C., Providence, New Haven, St. Louis, Louisville, Chicago, Cleveland, Cincinnati, Green Bay, and Milwaukee. They contained, according to Shinn, "a great modern art . . . the development of this century." For Old Masters, however, Shinn added, Americans would have to go to the Vatican and the Louvre. Very soon this too would be changed, as American men of fortune, with the same ruthless energy and enterprise that characterized their business ventures, ransacked the collections of Europe and brought back to American shores a vast variety of art, old and new, that would enrich American institutions and thereby the cultural experience of Americans. [37]

CHAPTER FOURTEEN

THE AMERICAN ART–UNION

PERHAPS THE MOST STRIDENT of the voices raised in behalf of a national art during the mid-nineteenth century, and the most formidable of the art patrons, was an organization founded and maintained by a group of prominent New Yorkers for the express purpose of encouraging the development of art in America. The American Art-Union, as the organization eventually came to be called, began as an art gallery; under the influence of European examples it evolved into a lottery for the distribution of works of art; and finally, because of peculiarly American circumstances, it developed into an organization concerned with educating the taste of over sixteen thousand Americans, disseminating information about art and artists, and providing opportunities for sales to American artists. The appearance of the Art-Union in the mid-century marked a recognition of the changing status of the artist in the newly developing industrial society where the older patterns of patronage no longer sufficed and where strong nationalistic sentiments dictated the desirability of creating an individualized national culture based upon contemporary creativity rather than upon the culture of the past. Designed to spread support for the arts among a larger segment of the population, the association also represented a recognition of the necessity of democratizing art and culture if these were to be made acceptable to a theoretically egalitarian community that was still suspicious of luxuries.[1]

The American Art-Union grew out of the Apollo Gallery, an enterprise of the portrait painter James Herring, who in the fall of 1838 had conceived the idea of establishing in New York City a "suitable depot for the temporary exhibition of [artists'] works . . . and for the lovers of Art a place of resort, where they might expect to find a rich variety of subjects for study or for sale."[2] Such an

institution seemed necessary, given the relative size and prosperity of the city and the limited facilities available to artists for the display and sale of their work. The only institutions in New York in 1838 where "an agreeable hour might be spent among works connected with the Fine Arts" were the American Academy of Fine Arts and the National Academy of Design, and neither of these institutions was completely satisfactory from the point of view of the art-minded public or the producing artist. The American Academy was by this time almost completely without resources. The National Academy, more vigorous, held exhibitions for only a short period of time each year. Not only did National Academy regulations restrict what an artist might exhibit, but the many works submitted and the limited amount of wall space often kept the paintings of younger and less well-known artists obscured. Furthermore, the National Academy left the question of patronage unsolved, since most of the works in its annual exhibitions were borrowed from private collections, with very few offered for sale, and few of those being sold. Any new enterprise, therefore, that promised a chance for sales was welcome, especially to eastern artists who had been hard hit by the banking and commercial depression that followed the Panic of 1837.[3]

The panic and the subsequent financial embarrassments that it caused did not affect Herring's plans for the Apollo Gallery. The artist had had sufficient success in his previous business ventures—the Enterprize Library and the National Portrait Gallery—to retain the necessary confidence. He had, too, the example of Sully & Earle's successful gallery in Philadelphia to encourage him; and at the time he projected his art gallery, there was a short-lived but intensive revival of commercial activity which promised relief from the economic doldrums the city had been experiencing.[4]

The newspapers welcomed the opening of the gallery as "affording at a very moderate expense a pleasant and instructive occupation for an occasional hour of relaxation," and Herring was praised for his "magnificent" plan, good taste, and patriotism. Despite the "puffs," however, Herring's business did not prosper. Sales were not made, nor did attendance receipts meet his expectations. The proprietor blamed the dullness in trade on the uncertainties of the times, and from the point of view of sales, undoubtedly, the "times" did affect his business. Even such well-established artists as Thomas Cole and Asher B. Durand, neither of whom found it necessary to utilize

Herring's gallery, saw much in the times to complain of as far as sales of pictures were concerned, although both were busily engaged on commissions. But the reason for the failure of Herring's exhibition lay not necessarily in the economic uncertainties; institutions of similar character, and theatrical entertainments, did not suffer from the depression.[5]

The catalogue of the Apollo Gallery's first exhibition suggests other reasons for the public's lack of interest in the enterprise. The preponderance of paintings shown were portraits or copies from the Old Masters, and by this time, as far as the general public was concerned, both kinds of painting had lost their appeal. The *New York Mirror*, for instance, had much to do to defend the presence of copies from the Old Masters in exhibitions like Herring's; while praising the exhibition, its writer was forced to admit that "some . . . have sneered at the idea of exhibiting so many copies; but we can assure such persons that a good copy from a good original is a work they may study with great profit. . . . We cannot therefore join in the general condemnation of copies and would most heartily rejoice if the money spent upon spurious originals, purchased under the auspices of some notorious picture dealer, was spent in orders to our talented young artists in copies of good originals in their foreign studies. . . ." The same kind of revulsion was felt for portraits, which in Philip Hone's opinion were "horrid . . . like enough in all conscience to the originals, who I wish were hanged in their places."[6]

Few prominent artists exhibited at Herring's gallery in the fall of 1838. Some of the exhibitors were to achieve their reputations years later, but few artists of contemporary popularity chose to exhibit their work. Thomas Doughty, who exhibited the rather astonishing total of thirteen paintings, all marked "For Sale," was a landscape painter of some fame, considered by Dunlap in 1834 as standing in the "first rank" of his profession. His landscapes, in fact, were recommended by the newspapers as the "gems of the collection," and the artist was placed first among the exhibitors for "chasteness in composition and effect." But probably neither he nor John G. Chapman, the other well-known name, was a good enough attraction; Doughty was being eclipsed in the public eye by Cole and Durand, and Chapman's reputation was that of a competent portraitist, copyist, and illustrator. The names of Daniel C. Huntington and George C. Bingham had not

yet become associated with works of merit or fashion—indeed, they were still in their formative years as artists; and despite the fact that Miss Martineau's mention in her book of the Cincinnati artist, J. H. Beard, gave this western painter a certain amount of notoriety, he was still not known well enough to attract New Yorkers to the exhibition. Only a third of the artists represented in the gallery had studios in the city and most of them were young.[7]

Whatever the reasons for New York's lack of interest in Herring's exhibition, his gallery failed. Beset on all sides, not only by his own needs but by the "distress and even, in some instances, destitution of artists of merit . . . followed by very natural importunities for temporary loans," the artist found an answer to his dilemma in the plan suggested by the Association for the Promotion of the Fine Arts in Scotland. This organization was founded in Edinburgh in 1834 under the guidance of a group of private individuals in association with the Royal Academy; Herring's plan followed its model exactly. *The Prospectus and Constitution of the Apollo Association for the Promotion of the Fine Arts in the United States,* which was adopted at the meeting of "Gentlemen Friends of the Fine Arts," lifted large segments *verbatim* from the prospectus of the Scottish institution. "The object of this Association," read the prospectus of both organizations, "is to advance the cause of Art . . . by affording additional encouragement to its professors." Both organizations recognized the existence of a potential market for works of art among those who possessed a "cultivated taste" but who were not wealthy enough to buy paintings; both recognized the effect insufficient support had upon artists and the development of a national art alike; and both proposed to bring about "by mutual cooperation, what might be beyond the reach of individual resources." Specifically, the Edinburgh plan called for the annual purchase of works of merit exhibited at the Royal Academy by means of a fund accumulated through a general subscription of one pound from each subscriber; at the close of the exhibition, the works purchased would be distributed by lot among the subscribers. Herring had merely to substitute for the Royal Academy, the Apollo Gallery, and for the pound sterling, the American equivalent of five dollars. The plan catered to what DeTocqueville called the American's "general taste for association," and it continued the custom, once widely resorted to, of using lotteries as a means of fund raising.[8] The plan of the organization was

simple. Artists would send their paintings to the gallery, and the funds from subscriptions would make possible the purchase of some of these works, which would be distributed to the subscribers by lot at the close of the year. The gallery would provide a constant exhibition that would educate Americans in the arts, while the annual distribution of art works would continue to stimulate their interest as well as improve their tastes. Above all, the "destitute artist" would be cheered and encouraged "in his struggle against the drifting current of adversity." [9]

Certainly American artists needed aid; many were suffering from bank disasters and the confusion of the money market that resulted from the severe economic depression that prevailed between 1839 and 1841. "I have not seen, during thirty years of my residence here," wrote Thomas Sully from Philadelphia, "a worse state of entanglement in money affairs. As in this country particularly we all depend upon each other, the pressure affects the arts and artists materially." Jonathan Mason, the Boston merchant, was equally discouraging. Writing to Thomas Cole in the late fall of 1839, he complained, "It is a dreadful time for selling anything. . . . While the best notes are discounted at 2½% per month, [the men of the city] laugh in my face when I talk of pictures." Depression did not mean that individuals stopped purchasing paintings completely, but it did limit severely the number of individuals who could spare the funds for such luxuries. And because at the same time the country was being flooded with numerous paintings from modern French artists which were sold at auction for sums ranging from five to twenty dollars, the American painter of average ability and reputation found himself bearing the double burden of foreign competition and depressed times. [10]

During the years 1839–41, under the leadership of a Committee of Management that was accustomed to creating eleemosynary rather than cultural institutions, the organization considered the aid it rendered to "meritorious artists known to be struggling under difficulties" as one of the guiding principles in the purchase of works of art. Concerned with charity rather than quality, the committee bought out of kindness pictures which Herring admitted "we should be ashamed to send to subscribers in Washington, Richmond, and Baltimore." Those subscribers who prided themselves on their taste in matters of art were often offended by the lack of merit in the paintings distributed; and the alienation of this group, whose support

was necessary before the organization could expand among those still uninitiated, was a serious matter for the success of the association.[11]

During its first year of operation, the Apollo Association collected the fairly substantial amount of $4,145, out of which $3,085 was spent for the purchase of thirty-six paintings. Although a few choice artists received fairly large sums for their work, half of the paintings were purchased at prices ranging from $25 to $50. During its second year, 1840, with less than half of the 1839 fund to spend ($1,120), fifteen paintings were distributed, of which more than half had been purchased for prices between $30 and $50. The tremendous loss of subscribers between 1839 and 1841 convinced the committee that they had to improve the quality of the works intended for distribution; in 1841, with little over a thousand dollars to spend, the committee purchased only seven paintings, all at higher prices than they usually paid, with more than half the paintings receiving between $100 and $160.[12]

Determining the value of a work of art always poses a delicate problem for both the patron and the artist; even more so when the patron is a group of individuals with an indefinite sum of money at its disposal for which the competition is keen. One of the principles guiding the committee in its purchases was "reasonableness of price," and so works on which higher prices had been fixed were either turned down or purchased at a lower price. Often, an artist was offered only fifty percent of the price he set, despite Article 3 of the constitution, which provided that an artist should receive the price he had fixed. Some artists expressed their indignation in no uncertain terms. "I did not expect," wrote Thomas Doughty,

> that the gentlemen composing your committee would so far wound the feelings of an Artist as to offer him a price so far below the value of his productions! . . . Your Committee may plead in extenuation of such conduct the extreme harshness of the times, but . . . if the Times are hard, do not add to their severity by permitting the works of your Artists to be sacrificed for little more than half their value!!! [13]

Doughty, who was the highest paid among the artists receiving patronage between 1839 and 1841, continued to send his paintings to the association, however, and so did other artists who were equally hard pressed. Some artists, like Allston, Sully, Cole, or Durand, who

worked primarily from commission and preferred to send their paintings to the National Academy, did not participate fully in the organization's activities. As a result, the exhibitions of the National Academy were more popular than those of the Apollo Gallery, and the latter institution suffered from the competition. Not enough original works were sent to the association's exhibitions by native artists to warrant a succession of shows from January through December; yet these exhibitions were central to the plan of the organization, for from them works of merit were to be purchased for distribution and by them new subscribers were to be attracted. Without the full co-operation of eminent artists, the committee was forced to fall back on works of European masters borrowed from private collections, on copies, and on portraits to fill out the sparseness of the show. For the same reasons that Mr. Herring's earlier exhibitions were not successful, these failed too.[14]

From its inception, the Apollo Association was considered a supplement to private patronage, not a substitute. The exhibitions, therefore, were also designed to attract purchasers for the works of the exhibiting artists. There was little logic, then, in including in such exhibitions copies, portraits, or borrowed works, none of which were for sale. In any case, the exhibitions were expensive to maintain and tended to divert funds and energies from the main purpose of the organization, which was to cultivate taste by sending examples of refinement into the homes of subscribers. It was three years before the Association could bring itself to discard these exhibitions, which were seen as burdensome from the beginning, mainly because they were part of an educational plan that was dear to the heart of Mr. Herring. Herring envisioned a permanent Gallery of American Art that would be evidence of "the genius and talents of our Artists" and would demonstrate that Americans, "republicans as [they] are, know how to appreciate them. . . ." Herring's project was too visionary for the time and had to be abandoned at the end of 1841 when the Association realized that success lay in its initial plan of buying and distributing works of art and engravings among its subscribers.[15]

The members of the Committee of Management during these early years were not inexperienced businessmen, as their management's lack of plan might suggest; nor were they, as was later claimed, men "who *knew little* about the arts and *cared* less." Highly successful, in fact, as merchants, bank directors, founders of manufacturing establishments,

and professional men, a majority of them owned collections of paintings and were active patrons of American artists; some already were or were soon to become Honorary Amateur Members of the National Academy of Design, while others were intimate with artists in the exclusive social organization known as the Sketch Club. But they were probably uncertain about the nature of the organization whose affairs they managed and so left many of the policy decisions to James Herring, as initiator of the whole project. A change of personnel and organization was required, as well as an upswing of the economic pendulum, before the Association could establish itself as a factor in the art life of the community and the nation.[16]

The change came in 1842 when all but seven of the former Committee of Management retired and a new group took over the tottering organization. First, the committee abolished the exhibitions and as a substitute hired a room where they could deposit the art works they purchased and where the public and artists could meet. This was the beginning of the free exhibition that eventually became one of the major attractions of the organization and was antecedent to the public art museum. The committee then decided that all activities extraneous to the purchase of works of art be stopped so that the funds of the organization could be almost completely devoted to such purchases. Artists were invited to co-operate with the Association so as to develop it to their future advantage. The name was changed to "one more distinctive"—the Art-Union, as such institutions were termed in Great Britain and Germany—in order to convey "an exact idea of the precise objects of such an institution." And, finally, a prize was offered for the best painting "of a national character" that would be suitable for an engraving, copies of which would be distributed to the entire membership.[17]

As the country slowly worked its way out of the depression, and as the organization more systematically established a network of agents called "Honorary Secretaries," who drummed up subscriptions in the various cities of the Union, received and transmitted monies, and distributed prizes and engravings, the fame of the American Art-Union spread. The number of paintings and other works of art distributed gradually increased, from only thirty-five paintings in 1842 to forty-six in 1843, to ninety-two in 1844, until it reached the total of thirty-three hundred in 1850. The organization patronized painters, sculptors, engravers, and die-casters. In 1848 the Art-Union

began the publication of its *Bulletin*. Featuring such articles as Mrs. Jameson's "Some Thoughts on Art" (1849), "The Art of Landscape Painting in Water Colors" (1851), and "A Biographical, Technological and Topical Dictionary of Art" (1851), together with biographical sketches of American artists and engravers, wood-engraved illustrations, and plates of works owned or about to be distributed by the Art-Union, the *Bulletin*, with its large circulation of over sixteen thousand Art-Union members, exerted a considerable influence.[18]

The American Art-Union as it evolved between 1842 and 1852 was a beneficiary of the democratizing forces at work in the political, social, and economic life of the country during the mid-century. American democracy required an art that was easily comprehensible, that was modern and national in subject matter, simple and "fresh" in execution. Therefore the Art-Union advised American artists that "subjects illustrating national character, or history, or scenery," the "literature or manners of the country," the "native soul, its sentiments and own peculiar views" were best because they appealed "most strongly to the national feeling." Artists were promised success if they expressed "the more childlike, the simpler feelings of humanity" which presumably characterized the American people. A free art gallery, it was felt, was the appropriate way to bring art to a democracy, and the distribution of works of art at a nominal fee was a truly democratic way, in the eyes of the men who ran the association, of making art available to all the people, regardless of their economic or social status.[19]

The Art-Union met the requirements of American artists by affording them patronage on a generous scale and by providing them with a gallery in which to exhibit their works, even when the Union did not purchase them. The organization even went so far as to attempt to meet the educational needs of young artists by constantly giving them advice about pictures, purchased or not purchased, and by affording them financial help for further study abroad. The Art-Union believed that its method of patronage had as democratizing an effect on the artistic profession as it had on patrons. The Committee of Management was guided in the selection of its purchases by the principle that "all artists of the country should be equally regarded, without distinction of birth-place or residence. . . ." The organization sought, rather, to "encourage genius and talent wherever they may be found." Statistics given in 1848 revealed that of the 231 artists

whose 2,000 works had been distributed by the Art-Union up to that time, one hundred and forty-five came from New York, twenty-seven from Pennsylvania, ten from Massachusetts, seven from Ohio, five from New Jersey, and four from the District of Columbia, with smaller numbers scattered in Maine, Rhode Island, Connecticut, Virginia, South Carolina, Alabama, Louisiana, Missouri, and Michigan.[20]

Furthermore, as far as the Art-Union was concerned, there was to be no aristocracy of painters or sculptors in this country that would be based on age, experience, or reputation, such as John Trumbull had hoped to see develop here. Merit, rather, and a sufficient level of competence, would give all American artists the opportunity to receive patronage from the organization. In 1845 the committee justified its use of discretion in "patronizing the young, the rising, and the unknown artist" and "in purchasing from those who may already be called masters among us," with the explanation that it was obligated to "minister to a various taste." The organization could not aim only at elevating public taste, but in its purchases it had to "reflect it" and to make its selections representative of what was being produced. In this way, the art that the committee purchased was indicative of the national level of excellence; if this art turned out to be mediocre, as many claimed, then this only indicated that most of the country's art at the time was mediocre. As a democratic institution, the Art-Union could only purchase what constituted "the majority of quality" that prevailed; it could not discriminate in favor of exclusive excellence. "We must purchase many works of small comparative value, and fewer of higher value"; but most of the expensive works had to be left to the "wealthy connoisseurs." [21]

The Committee of Management of the Art-Union, while trying to meet the public need for art and the artists' need for patronage in a democratic fashion, did not at all experience the dilemma that Alexis de Tocqueville posed in 1831 when he foresaw in the expansion of the country's population and in the growth of its institutions a potential expansion of the market for art. Tocqueville predicted that the increase in the number of consumers and in the number of works of art produced would be accompanied by a corresponding loss of quality in the art life of the country; this, he believed, was a problem that democracies would eventually have to reckon with in their pursuit of culture. On the contrary, the Art-Union committee

believed that by fostering and encouraging art on all levels of genius, they were contributing to the progressive improvement of the nation's art life, not to its deterioration. "There can be no mountains without valleys," explained the committee, and "so there can be no great works without an infinitude of lesser ones." Taste could only grow by being fed; and it was the task of the Art-Union so to provide cultural nourishment that great art might eventually find an appreciative environment in which it could flourish.[22]

Although the merchant–amateurs who controlled the affairs of the Art-Union from 1842 until its demise in 1852 were primarily members of upper-class New York society, they recognized that the basis of their power lay in their ability to gauge the extents and limits of the taste and aesthetic experiences of their middle-class subscribers. Like good politicians, they acted on the assumption that they had to play a dual role in conforming to the public's tastes, while at the same time influencing these to ends or goals which they felt were worthwhile. The choices that the managers made with regard to the pictures they purchased from the large number of works presented to them each year, the pictures they chose to be engraved for distribution, and the information included in their *Bulletin* involved the exercise of judgment and taste. Their task was not as difficult as they often imagined it to be, for to a great extent American taste was fairly uniform among all the middle-class groups that participated in the Art-Union in the mid-century; in fact, American taste was established even before the Art-Union appeared to confirm it or meet it.[23]

The managers of the Art-Union established "informal rules" that they urged participating artists to follow. Baker has synthesized these into a "decalogue": the need for artists to break with the past, to renounce subservience to Europe, to develop their own originality, to paint native subject matter, to maintain pure and truthful standards in their art, to "cherish American simplicity and freshness," to plan their pictures better, to strive for higher finish, to achieve more accurate drawing, and, finally, somewhat contradictory, "to maintain native superiorities while emulating the excellencies of foreign schools." [24]

This advice did not tell artists anything new. Despite the persistence of the classical tradition, by 1828 Americans had begun to show a marked preference for modern works and to reject the Old Masters —a trend that was marked by the emergence of the National Academy of Design with its emphasis on the modern and contempo-

rary. Interest in native subject matter had also begun to develop in the late 1820's, and under the influence of romantic and folk writers like Sylvester Judd or Catherine Maria Sedgwick, whose books were best sellers during the period that the Art-Union functioned, the American response to national themes markedly increased. In a society whose justification for art from the beginning of its national life had been based on art's moralizing and refining influences, on the "uplift" and "exaltation" that it provided for the individual character, it was inevitable that the Art-Union managers should seek these qualities in the paintings they examined. Therefore, their concern that the art they distributed shun "impure ideas," "voluptuousness of figure," or "enchanted, sensual atmosphere," and remain truthful and pure, did not reflect any peculiar Victorianism on their part; rather, it reflected the Victorianism of the entire society. Even more, it reflected standards of taste that emerged logically from eighteenth-century aesthetic philosophy as this philosophy was interpreted and transmuted by Americans who were desirous of finding republican justifications for art forms that had in the past been associated with sensual living and decadent monarchical traditions. Just as republicanism offered morality in political relationships, so a republican art had to reflect that morality; hence the motto "Truth and Purity," which the Art-Union managers urged upon their artists, was neither new nor unexpected but was part of the American tradition as it developed from the early years of the country's independence.[25]

The Art-Union met its death from a combination of circumstances, partly within the organization and partly without. In 1851, acting on the basis of the previous year's experience, the Committee of Management expended sums for works of art far beyond the income received from subscriptions, in anticipation of last-minute registration. Disappointed in their expectations, they determined to postpone the distribution of prizes until sufficient subscriptions had been received to warrant the full distribution list. Before the day arrived on which the postponed distribution was to take place, legal proceedings were brought against the organization because of the lottery feature of the Art-Union's plan. The organization denied that it was a lottery "in any usual, legal or moral sense." "We associate for the promotion of the fine arts," the managers argued, ". . . and to furnish . . . a copy of the [large engraved] print . . . and each of five other plates of less size . . . to every member . . . [and] to publish monthly a

large, valuable Art Journal. . . . There is no lottery in this. . . ."
There had to be some way, they insisted, of dividing the accumulated
works of art in order to fulfill the organization's various purposes, and
the only just and impartial method was the one they had chosen. "It is
a partition, a mere division among the owners of what cannot
otherwise be enjoyed either jointly or separately." [26]

Whatever the moral arguments, the legal situation was clear.
Lotteries were illegal in New York State, and enemies of the Art-
Union, by attacking this feature, succeeded in forcing the District
Attorney's office to take notice of the situation. A suit was instituted
in May, 1852, and the decision of the courts was unfavorable to the
Art-Union. "The mode of distribution" of prizes being pronounced
"illegal and unconstitutional," the Art-Union had no alternative but
to sell its art works at auction, pay off its debts, and close up shop.
The organization tried to invent "a prudent plan" whereby it could
continue to operate "as the benefactor of Art." But even though it
possessed a gallery that could be used for exhibition purposes and for
the sale of American paintings, the Art-Union was unable to carry on
its activities; it was primarily the lack of income for operating
expenses that made the organization decide to give up the struggle and
turn its "face towards the past, and not towards the future." [27]

The Art-Union did not die a barren death. Whatever remained of
its funds and works of art was given to the New-York Gallery, which
housed the Luman Reed collection of American art, and with that
Gallery was later removed to the New-York Historical Society.
Thus, this "earliest and most important addition" to the art collection
of the New-York Historical Society started that institution "on the
road to become a foremost gallery of historic American art";
stimulated by former Art-Union enthusiasts, the Historical Society
succeeded in "assembling one of the finest collections of American art
in the country" and became, in 1860, "the first to formulate a plan to
establish a museum and art gallery for the public in Central Park"—a
plan that eventually led to the founding and establishment of the
Metropolitan Museum of Art.[28]

PART V

FRONTIERS OF ART

. . . a truly national literature and art must
have their birth-place in this Western valley,
where the native mind will naturally have
its fullest and freest development.

C. B. BOYNTON, 1847

As THE COUNTRY and its population expanded westward, so did artists and an interest in the fine arts. Western cities emulated northeastern cities, and the transit of ideas and tastes took a similar course. Transportation routes also extended from the East to the West, binding both sections with economic and social ties that by 1860 found expression in political partnership; intellectual and cultural forces, therefore, strengthened a relationship that geography and economics had already influenced. In this connection, despite the colonialism of the West in its relations with the East, and despite the discontent of the West with the results of this cultural colonialism, when sectional controversies increased to the point at which lines were drawn and decisions of a far-reaching nature made, the West allied itself with the North and with nationalism.

The frontier settlements repeated, with some variations, eastern experiences with respect to the fine arts. Whatever differences occurred may be accounted for by the greater distance of the western towns from Europe and European influences and the fact that these influences came secondhand to the West, after being filtered through eastern experience. Moreover, the West developed at a faster rate than had the East, in a more explosive fashion, and with less time available for the growth of traditions and beliefs that give strength and depth to cultural movements. The sense of cultural inferiority to Europe that had earlier given incentive to easterners to develop their own and, in their minds, the nation's cultural resources became in the West a recognition of the barrenness of frontier civilization generally, a barrenness that some feared would grow in proportion to the material growth of the region itself. In the scramble for wealth and substance, in the "great business of adding dollar to dollar," the frontier was faced with a challenge to the spirit as well as to the muscle. At the edge of civilization, who had the time or interest to become concerned about "those graceful nothings, which of no value in themselves, still constitute one great charm of polished society"? Against the attractions of a "fine Mule, a Fat Hog, or a fine stout Negro," how could paintings and statuary compete? And yet, the moral and refining influences of the arts, as they were defined in the

nineteenth century, were considered highly desirable if the coarseness of character, the crass materialism, and the rude passions that had resulted from the constant struggle with the wilderness and the "grovelling pursuits of commercial operations" were to be softened and calmed and elevated. Western settlers who cared about preserving culture and civilization as they had experienced them in the East or in Europe realized that their homes had but recently been places of "rudeness and barbarism" and were greatly concerned about the continuing low level of social and intellectual life in the new regions. The drinking, swearing, spitting, and gambling of their fellow pioneers appalled them, while the degrading and inhumane forms of amusement like cockfighting and ganderpulling that prevailed threatened to render the "pleasures of the intellect . . . dull and tame" by comparison. To cope with such attitudes of mind and spirit, to attempt to substitute the more organized civilization of academies, theaters, art galleries, and libraries for the rough amusements of the frontier was an almost overwhelming task for the westerners who cared about the cultural level of their communities. Formidable as the task was, however, it was undertaken by a small group of settlers who were convinced of the ameliorative powers of the fine arts.[1]

The westerners who extended sympathy and patronage to art and artists during the early years of western history were inhabitants of the newly founded towns. Many of them had arrived in these towns "after the age of manhood from places where they had opportunities of acquiring a correct taste." Often well-read and educated, constituting "the agreeable and polished society" of their communities, they had absorbed the rationale which justified art and art institutions in terms of their effects on manners, on character, and on the prosperity of a community. Like Dr. Daniel Drake of Cincinnati, these community leaders believed that the westerners' "grossness of manners" was incompatible with their blueprints for the ideal society they projected for their cities, and by founding "public enterprises" that would be devoted to increasing knowledge and refining tastes, they hoped to promote "public prosperity." It was important, a man like John Foote of Cincinnati emphasized, to educate public taste "while the character of our society is forming and before false taste and vicious habits become too inveterate to be overcome." Foote did not doubt that his city was destined to become the "emporium" of an extensive and wealthy country blessed with a fertile soil and free government;

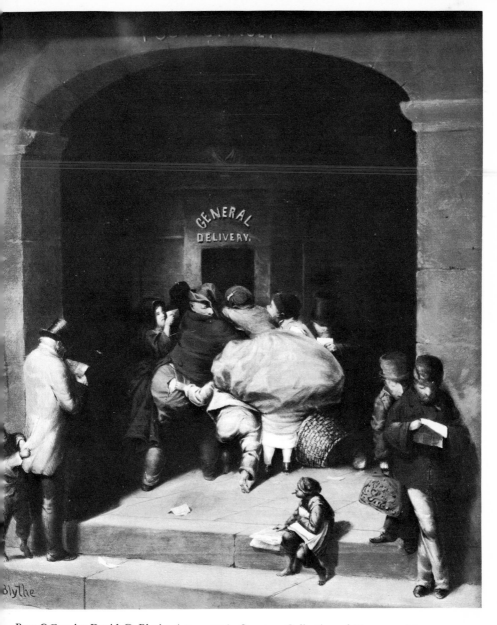

Post Office, by David G. Blythe (1815–1865). Courtesy Collection of Museum of Art, Carnegie Institute, Pittsburgh.

Blythe's "cleverness" was acknowledged by his contemporaries. "David is a regular genius," noted the *East Liverpool* (Ohio) *Mercury* in 1861, "and like his paintings must be seen to be appreciated." Blythe sold many of his ludicrous caricatures to Pittsburgh collectors; even so he constantly struggled against poverty and bankruptcy, and his paintings—like *Post Office*, purchased by George W. Hailman, Pittsburgh iron manufacturer—seldom sold for more than thirty-five dollars.

Portrait of Henry Clay, by James Reid Lambdin (1796–1863). Courtesy Collection of Museum of Art, Carnegie Institute, Pittsburgh. Gift of G. David Thompson.

Lambdin's fame as museum entrepreneur and portraitist is associated with the frontier city of Pittsburgh, where he painted "rich merchants and important judges," and instructed and advised aspiring artists in the techniques of the craft. Lambdin began his career in Louisville, however, and one of his earliest and most successful portraits was of the famous author of the "American system," Henry Clay.

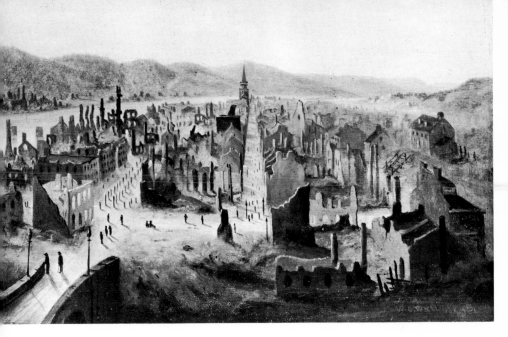

Pittsburgh after the Fire of 1845, from Boyd's Hill, by William Coventry Wall (1810–1886). Courtesy Collection of Museum of Art, Carnegie Institute, Pittsburgh. *The Mill,* by T. Worthington Whittredge (1820–1910). Courtesy Cincinnati Art Museum. Bequest of Reuben Springer.

Westerners wanted "original" works of art which would give "character to the West" and possess "the rare merits of being transcripts from Nature." The meticulous views of local scenery by such painters as Wall and Whittredge which appeared in many Pittsburgh and Cincinnati collections in the 1850's were the result.

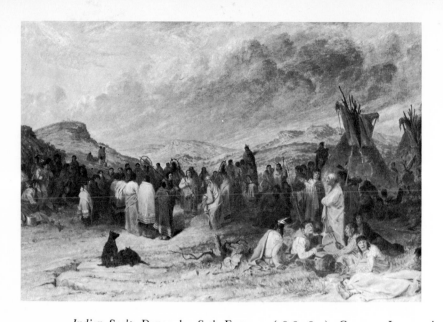

Indian Scalp Dance, by Seth Eastman (1808–1875). Courtesy Layton Art Gallery Collection of the Milwaukee Art Center.
Trapped Otter, by John J. Audubon (1785–1851). Courtesy Layton Art Gallery Collection of the Milwaukee Art Center.

Artists came to the American West to paint wild life, landscape, Indians. Audubon, best known for his drawings of American birds, also painted the animals native to the "broad lakes . . . [and] the wildest solitudes of the pathless and gloomy forests." Seth Eastman's years among the Indians as an army officer gave him, he believed, the deep "knowledge of their habits and character" which he brought to the painting of Amerind life.

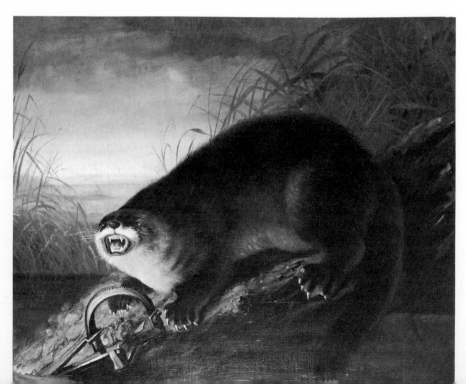

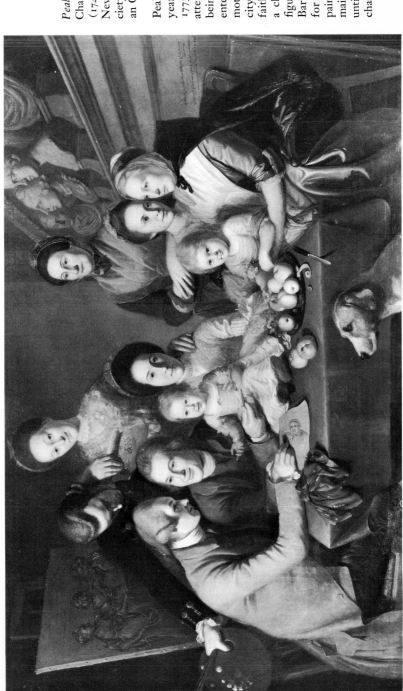

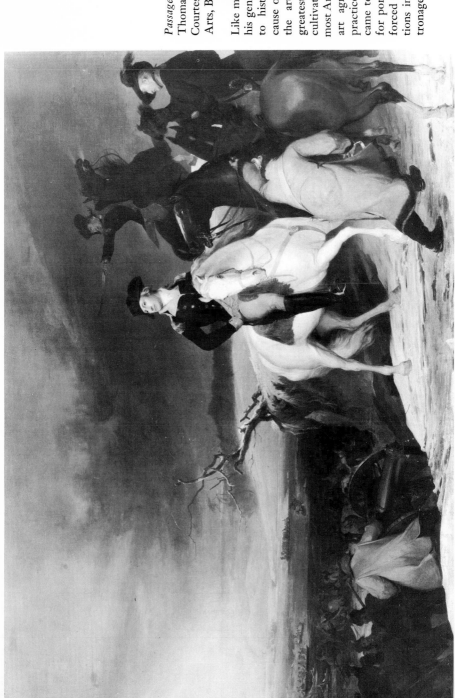

Passage of the Delaware, by Thomas Sully (1783–1872). Courtesy Museum of Fine Arts, Boston.

Like many other painters of his generation, Sully aspired to historical painting, because of all the branches of the art, it demanded the greatest amount of "mental cultivation." Theoretically, most Americans interested in art agreed with Sully; in practice, however, they came to the artist primarily for portraits, and Sully was forced to modify his aspirations in response to his patronage.

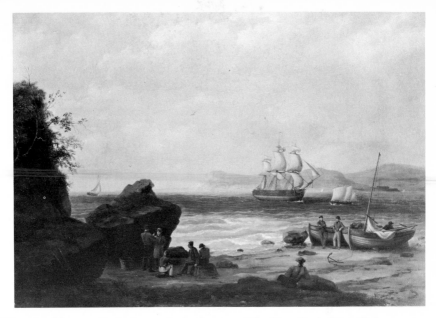

Marine View, by Thomas Birch (1779–1851). Courtesy The New-York Historical Society, New York City. Reed Collection.
The Chess Players—Check Mate, by George W. Flagg (1816–1897). Courtesy The New-York Historical Society, New York City. Reed Collection.

Influenced by engravings from Vernet's *Seaports,* Birch painted marine scenes outstanding, in Cummings' words, for their "freshness of atmospheres and clearly painted waves." His popularity marked the beginning of the expansion of American taste in the 1830's to include anecdotal painting of homely scenes—like Flagg's *Chess Players*—as well as all kinds of landscapes and historical and religious works.

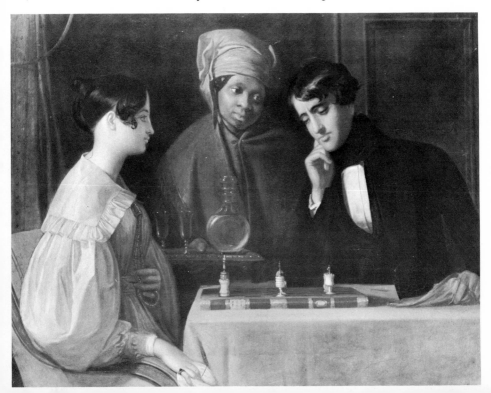

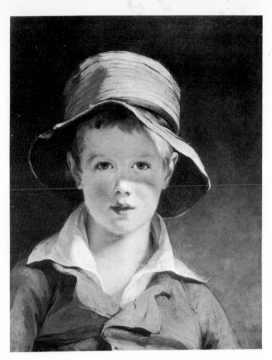

The Torn Hat, by Thomas Sully. Courtesy Museum of Fine Arts, Boston. Gift of Miss Belle Greene and Mr. Henry Copley Greene.

The Flower Girl, by C. C. Ingham (1796–1868). Formerly in the Sturges Collection. Courtesy The Metropolitan Museum of Art. Gift of William Church Osborn, 1902.

Both these anecdotal portraits appealed to Americans during the first half of the nineteenth century. With their careful finish and smooth idealizations, they were typical of the many paintings of American children to be found in collections of this period and were praised as being "fine in sentiment" and "refined in character."

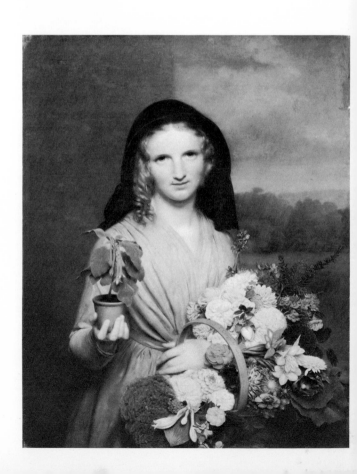

The Greek Slave (marble),
by Hiram Powers (1805–
1873). Courtesy National
Collection of Fine Arts,
Smithsonian Institution.
Gift of Mrs. Benjamin H.
Warder.

The Greek Slave became
"town talk" in the mid-cen-
tury, and "everybody of
any taste or pretensions to
taste" went to see it. Sun-
day-school children were
taken to its exhibition in
groups; John Jay (accord-
ing to a New York joke)
was said to have "got out a
habeas corpus for it by mis-
take"; and clergymen ex-
pounded from their pulpits
on the statue's "appeal to
the soul" which "entirely
controlled [its] appeal to
the sense."

The Sybil, by Daniel Huntington (1816–1906). Courtesy The New-York Historical Society, New York City.

The American Art-Union purchased this painting in 1840 for one hundred and fifty dollars and later distributed it as an engraving to its many members throughout the country. It was considered "High Art" by nineteenth-century Americans and, along with further patronage by the Art-Union, launched Huntington on a successful career as landscape, historical, religious, and portrait painter.

Eel Spearing at Setauket, by William S. Mount (1807–1868). Courtesy New York State Historical Association, Cooperstown, New York.
Long Island Farmhouses, by William S. Mount. Courtesy The Metropolitan Museum of Art. Gift of Louise F. Wickham in memory of her father, William H. Wickham, 1928.

"Out of the most simple and humble materials, Mr. Mount has contrived to make . . . the most thoroughly original and successful little pictures it has ever been our lot to behold," wrote a critic in 1846. Mount's accuracy of vision and his pictorial realization of the quality of rural life and landscape call to mind Whitman's lines in "A Farm Picture":

> "Through the ample open door of the peaceful country barn,
> A sunlit pasture field with cattle and horses feeding,
> And haze and vista, and the far horizon fading away."

Woodland Vista, by George Inness (1825–1894). Courtesy Museum of Fine Arts, Boston. M. and M. Karolik Collection.

Although Inness was early influenced by Asher B. Durand and the painters of the Hudson River School (as demonstrated in the rendering of the tree in the foreground of *Woodland Vista*), he broke from the restraints of that school and painted landscapes which Tuckerman called "among the most remarkable works of the kind produced among us." Some Americans complained that Inness' "French style" vitiated "the legitimate individuality of the artist," but Bostonians found much in Inness to admire and were his "most intelligent" patrons.

"whether those riches are to be a blessing or a curse to our posterity," however, would, he believed, "in a great measure depend upon the impulse given to public taste at this period." Therefore, Foote, like others of his background and status in the community, advocated the encouragement of the fine arts.[2]

Moreover, those westerners who were immediately involved with the development of their cities were convinced that the industrial progress of a community depended upon "the manufactures of its mechanics." And skill in manufactures developed from taste, which was, as Foote explained, "a most powerful and efficient auxiliary in all the useful arts"; beauty being the revelation of perfect utility, "the artisan who renders his work externally beautiful has generally a just idea of the proper arrangements of all its parts, so as best to combine durability with utility." Undoubtedly, this utilitarian justification for encouraging the arts was most important; but in argument, it was subordinated to the broader and more idealistic view that the influence of the fine arts, extending to all members of the community, affected the progress or lack of progress of society as a whole:

> The principle object and end of their encouragement in the early stages of society, in a country situated like ours, is not merely to create Painters, Sculptors, and Architects for the sole purpose of ministering to our luxury and vanity, but for the purpose of inspiring and diffusing among us generally a correct taste—such as shall enable us, by an accurate perception of the most suitable and proper construction of everything for the uses to which it is designed, to exercise a judicious economy and not waste our cares, our labours, our wealth upon things dispropor-tioned and unsuitable. . . . Under all forms of government their power is felt for the benefit of the human race—to the free and enlightened, they have ever been a source of pride and delight, and under despotic governments, they are the only resource of humbled genius. . . . To religion they have always rendered their first homage. . . . And if at some times, and under some circumstances, they have been perverted, and brought into subservience to vicious purposes, that is only another proof that there is nothing human above the reach of evil, and nothing on earth worth possessing, that we ought not carefully to guard against contamination.[3]

CHAPTER FIFTEEN

ART IN THE WEST

THE GROWTH OF WESTERN TOWNS proceeded at a pace with the rapid settlement of the trans-Appalachian West. Between 1790 and 1830 these towns developed into sizable cities as a result of trade and their strategic location on arteries of overland or river traffic. Lexington, Kentucky, for example, one of the earliest-founded cities in the western regions, served as a major distributing center for men and goods headed for western Kentucky or Tennessee. From a small military outpost in 1781, this "Philadelphia of Kentucky," as it came to be called, was the largest city in the West by 1800, with a population exceeding four thousand. The economy of St. Louis in its early years depended upon the fur trade, but eventually the mining of lead, manufacturing on a limited scale, and commerce made the city an important and prosperous metropolis at the confluence of the Missouri and Mississippi rivers. Similarly, because of its location at the junction of the Allegheny, Monongahela, and Ohio rivers, Pittsburgh in the 1780's and 1790's attracted many residents who converted this wilderness outpost into a commercial and manufacturing center of increasing importance. Money accumulated in outfitting transients and migrants for the regions beyond the Ohio was invested in industrial enterprises devoted to large-scale production for extensive markets. By 1815 Pittsburgh, the "Birmingham of America," surpassed Lexington as the largest western town, and despite depressions and recessions it continued to grow industrially, commercially, and in population. Louisville's rate of growth lagged behind Pittsburgh's, but because of its important location at the falls of the Ohio River it gradually grew in wealth and population, first as a cotton and pork market, and then as a result of the introduction of steam boats on western rivers and of railroad communications—all of which infused commercial energy into the city. The gulf port of New Orleans

prospered exclusively from commerce, acting as a trans-shipment point for goods coming from the South and West and headed for destinations out of the country or northward via ocean routes. By 1840, New Orleans had become the fourth largest city in the United States in population, a growth due in great measure to its geographical position and its fertile hinterland.[1]

East of these river towns, but also considered a "western" settlement, Rochester, New York, owed its success likewise to its position on the Genesee River and to the trade needs of the settlements that surrounded it. Rochester's boom years began with the opening of the Erie Canal in 1825, an event that transformed it from a "leading market town of the northwestern frontier" in the twenties to a "major provisioning station for the ever-swelling westward movement" in the thirties.[2]

Cincinnati was probably the most outstanding example of western urban development. When the Ohio legislature authorized the construction of the Miami Canal and the building of a state canal system in 1825, Cincinnati's economic leadership in the West was assured. The city became "the nexus of trade lines that reached from the Atlantic Ocean to the Gulf of Mexico" by connecting the Great Lakes with the Ohio River. By the 1830's, fabrics from Cincinnati's looms, and other manufactures, were making their way throughout the rural areas of Ohio and Kentucky, and during the decades that followed, the "Queen City" continued to maintain her leadership as a producing and distributing center.[3]

These were the cities that made the most rapid advance during the first half of the nineteenth century, but during the decade of the fifties, Cleveland, Chicago, and Detroit also began to rise in importance as the industrial development of the Great Lakes region, the increased use of steam-driven lake freighters, and the extension of railroad lines brought the products of the western farming and mineral areas to these centers for processing and for redistributing eastward, southward, and westward. Certainly by the mid-century, if not earlier, the urban communities of the West had developed their unique social and economic patterns and could now look to the development of their cultural resources with an optimism justified by their aggressive and dynamic pasts.[4]

Two factors of significance stand out in the history of the growth of these western cities: the first was the intense rivalry that existed

among them as they sought to gather to themselves the economic fruits of the new territories they serviced; the second was the influence exerted on them by the eastern metropolises which they consciously sought to emulate. When cities of the West, therefore, became involved in the competition for population, business enter- prises, and economic ascendancy that characterized their rivalry with each other, they found themselves burdened also with concern for their cultural reputation. "Cincinnati may be the Tyre, but Lexing- ton is unquestionably the Athens of the West," admitted the Cincin- nati journal *Liberty Hall* in 1820; and the paper advised the city's inhabitants to take time off from the commercial pursuits which were demeaning their character "to cull and admire the varied sweets of those literary and scientific effusions which have stamped Lexington as the headquarters of *Science and Letters* in the Western country." A decade later, in 1834, the *Cincinnati Mirror and Western Gazette of Literature and Science* continued to urge the citizens of this booming city to co-operate in the founding of institutions "for the purpose of elevating our intellectual character," because "upon the advances made in literature, science and the arts our reputation as a refined people essentially depends." When, during the following decades, Cincinnati began to outstrip Lexington in its cultural development, the "Queen City" now became the standard by which other western cities directed their energies. "Cincinnati has shown us an example worthy of emulation," wrote a citizen of Pittsburgh to the *Morning Post* in 1849;

> she is the Athens of the West; but if it were not for the genius of her Power [Hiram Powers, American sculptor] and other gifted sons, she would be known as the Pork City! Iron is a black metal, but it is capable of a high degree of refinement and polish; and if we want the *"Iron City"* to reflect a lustre worthy of her greatness we should encourage and patronize those who labor to gratify the Taste and the Intellect.

St. Louis also pointed to the institutions established by her eastern rival, Cincinnati, as an example of what her citizens ought to do as a distraction from "the busy routine of [their] utilitarian existence." [5]

The belief that the "celebrity" of the eastern cities—Philadelphia, New York, and Boston particularly—was the result of the patronage and sympathy these cities had extended to art institutions and artists intensified rivalry in cultural matters. It was recognized that commer-

cial advantage accrued to a city when art and artists were encouraged. "The importance of a flourishing city is greatly enhanced in the estimation of a judicious public," wrote a Pittsburgh editor, "by the cultivation of the FINE ARTS. Indeed," he added, "it might easily be shown that the increase of wealth in a commercial community depends in no inconsiderable degree on a taste for the Fine Arts and a patronage of such as are proficient in them." [6]

Some westerners feared the competition of these eastern cities in drawing off the business and artistic talent of the West, for the East offered rewards to such individuals to an extent and degree that western cities could not begin to rival. Just as eastern artists at the turn of the century—Benjamin West, Samuel F. B. Morse, Washington Allston, Charles R. Leslie, and John Vanderlyn, among a host of others—had traveled to Europe to study the techniques of their art and to experience the inspiration of the works of the past available in European collections and museums, so the young western artists a few decades later—Matthew Harris Jouett, Joseph H. Bush, Oliver Frazer, George Bingham, and Louis Morgan, among many—went to the eastern states to study in the academies and to "learn something of [eastern artists'] methods and experience." Occasionally a western artist might prefer Europe for "further improvement in the Arts"; but the East—especially New York with its National Academy of Design and Philadelphia with its School of Fine Arts—proved an adequate substitute for those who could not afford or did not desire such extensive travel. The East for many western artists as early as the 1830's appeared as the *"sanctum Sanctorum* of Genius" compared to the "great variety of Miserable pictures [to be seen] . . . scattered throughout the [western] country." Some of the western painters and sculptors chose to return to their native states, assured at least of an income from portrait commissions from admiring neighbors; but many remained in the East, drawn to that region by the greater attractions of patronage and institutions.[7]

Westerners faced this situation realistically. They understood that their communities could never effectively maintain an active cultural life if they could not offer similar attractions to those of the more established eastern cities. A writer in a St. Louis journal in 1851 summed up the fears of inhabitants of the western cities and expressed their "profound humiliation" in an article entitled "Civic and Rural Embellishment." Commenting on the relative unattractiveness of the

city and country regions of the West, especially in and around St. Louis, the writer decided that of all the influences affecting the financial condition of the interior, "the artistic attractions of the eastern cities" were the most potent. Citizens of means from these newer areas—"pretenders to taste as well as those who possess true refinement"—found it pleasant, he wrote, to make yearly hegiras to the East in the spring, not to return until fall, because of eastern cultural institutions. Easterners, on the other hand, could not be persuaded to come West, except on business, for similar reasons. Therefore, the money of the country tended to concentrate at "the principal points of popular attraction," while the "producing" districts became poorer and "less able to encourage the ornamental arts at home." If this process continued, the writer lugubriously predicted, the West would eventually become highly dependent upon the East; without employment, workers, retail merchants, craftsmen, and artists would not remain in the western cities. In order to guarantee "a diffusion of the benefits and burdens of civilization throughout all regions of the country," so that all portions of the Union would progress together rather than one progress while the other retrogressed "until revolution becomes necessary for the purpose of severing their relations or of placing the parties upon a more equal footing," westerners were obliged to encourage at home "the productions of objects similar to those which attract our people to distant lands." Even more important than subscribing to the stock of railroads, this writer believed, was the necessity for civic government to adorn the city and improve its cultural resources—something which could best be done by municipalities since "in a republican government like ours such works must be left chiefly to the taste and enterprise of the citizens, for the [federal] legislature possesses no power over the subject." [8]

Despite their competitiveness and fears, westerners experienced tremendous pride in their achievements as a region, and this local pride associated itself with national pride. The West regarded itself as the most American of the sections, the section that most truly represented national interests and loyalties. Long before Frederick Jackson Turner articulated the myth of the frontier as the stronghold of American democracy and nationality, westerners believed that the destiny of the democratic faith lay in the "great free West"; and that this democratic destiny would find its fullest expression in "a truly

national literature and art" that would be born in the valleys of the Ohio and Mississippi rivers. The time was not distant, many western-ers believed, when the Mississippi valley would become the center of population in the United States, and with population would come "political power, the arts, sciences and literature." Therefore, it was in the West that the American mind would assume its "true tone, character, and *nationality*," and it was in the West that American institutions would "receive the impress of their final destiny." This being the case, the "young men of the Mississippi Valley" were obligated to foster "western genius," to encourage "western writers," and to aid in the creation of a "western heart." By such cultural efforts would the West be "true to her destiny" as the guardian of national traditions whenever sectional controversy brought about discord, or worse, a dissolution of the Union. And it was this nationalistic aspiration, regional loyalty, and concern for the prosper-ity of their respective cities that stimulated some westerners to create whatever art institutions and art life they could during the years preceding the Civil War.[9]

—2—

Artists came to the American West with the first settlers, especially the itinerant portraitists whose passage through the settlements was as swift as it was ephemeral. Emanating from the East, the itinerants followed the favorite route for western travel, from New York or Boston to Albany via the Hudson River or the Connecticut River valley, across country to Olean, down the Allegheny to Pittsburgh, and from there to Cincinnati, Louisville, St. Louis, and New Orleans. With the opening of the Erie Canal in 1825, Rochester and the Great Lakes settlements of Cleveland, Detroit, and Chicago became ports of call. Along the way, the artists' travels were eased by occasional commissions from the wealthier farmers or town dwellers; but it was the lure of the land as well as such commissions that brought many of these painters to the West.

Wild life lured J. J. Audubon to Louisville, where he combined portraiture with the painting of American birds; his interest was at once scientific and artistic. The Mississippi and Missouri rivers with their variety of foliage and exotic landscape, the bluffs, the islands, the uncivilized Indians who made their homes along the river banks, the forts, and the log cabins invited reproduction; and artists like J. J.

Banvard, Leon Pomarede, Henry Lewis, John R. Smith, and Samuel Stockwell found it highly profitable to paint and exhibit panoramas of the rivers—lengthy documentaries that offered to transport the spectator directly into the life of the forest regions. Life on the rivers also appealed to the imagination of less commercially-oriented painters like George C. Bingham or the eastern landscapist John F. Kensett, who found in the life and landscape picturesque subject matter for their pencils. During the late 1830's and the decades of the forties and fifties, the American Indian in all his strangeness of attire and customs drew a host of artists into the wilderness, intent on recording this colorful and curious race in romantic fashion for their own generation and for posterity; Alfred Miller, George Catlin, Seth Eastman, Karl Bodmer, Charles Deas, Paul Kane, John Mix Stanley, Charles Wimar, and others all hoped to profit from the sale of lithographs, water-color portfolios, or oil paintings of Indians and Indian scenes. Finally, artists employed by the United States government to accompany topographical surveys or explorations penetrated some of the wildest regions of the West and recorded their impressions upon canvas or paper.[10]

Some of the artists who visited the West remained in the more hospitable cities to paint portraits and identify themselves with the cultural life of the western towns. Lexington, Kentucky, attracted artists at an early date, probably because the presence of Transylvania University gave its residents the reputation of being sympathetic to culture. Established in 1780 by the legislature of Virginia "to promote the diffusion of useful knowledge even among its *remote* citizens, whose situation in a barbarous neighborhood and savage intercourse might otherwise render [them] unfriendly to science," Transylvania University suggests that Lexington's first settlers were possibly the "men of culture, education and refinement" that one of the city's early historians claimed; in any case, these Kentuckians found it desirable to maintain the semblance of the polished society they remembered in the older states of Virginia, North Carolina, and Pennsylvania, and so they treasured portraits as symbols of aristocracy. Such painters as William West, who arrived in Lexington in 1788, or Asa Park and the Becks (husband and wife) who followed in 1800, found sufficient encouragement to remain in this cultural oasis on a more or less permanent basis; Beck remained until his death in 1812. To Lexington, too, John Neagle (1818) and Chester Harding

(1819) came for brief periods of time, to leave behind examples of their artistry, which in turn helped stimulate further interest in painting; and natives like Matthew Harris Jouett, Louis Morgan, and Oliver Frazer continued to find in the city during the following decades sufficient commissions to keep their brushes busy and to provide a comfortable livelihood for themselves and their families.[11]

In Louisville, Joseph Bush and other portraitists found seasonal encouragement of a sufficient nature to make this town their permanent residence. From Louisville, Bush would travel to New Orleans and Natchez during the winter months, visiting the planters of Louisiana who welcomed portraitists. Itinerancy proved very remunerative since Bush "charged more for his portraits and was at no expense in living." Like Bush, Samuel Page found Louisville winters unprofitable, especially during the frequently recurring depressions; in 1857 he reported that the residents of the town did not go out much during the winter, and "however rich," they showed more concern with the price of coal and the state of the river than with art. Still, the "hospitality" of the inhabitants made the artist optimistic about his opportunities once the weather and the economic stringencies of the time had improved. Obviously, other artists shared his hope, for Louisville continued to grow in the number of its resident artists and in its art activities.[12]

Nashville proved a profitable town for John Grimes (1799–1837), who painted portraits there until his return to Lexington just before he died in 1837; and the planters of the Blue Grass region were so enthusiastic about the portraits painted by Louis Morgan (1814–52) during the first half of the nineteenth century that their commissions to him "assumed the proportions of an epidemic." [13]

New Orleans during the ante-bellum period attracted many eastern portraitists like John Wesley Jarvis, Samuel F. B. Morse, John Vanderlyn, Henry Inman, James Earl, George P. Healy, and William Reinhart, as well as westerners like Jouett and George Catlin, all of whom found wintering in this gulf port rewarding and exceedingly pleasant. New Orleans was a "mecca for portrait painters at this period," offering them the possibility of earning (it was reported) as much as $60,000 a season. In New Orleans the emphasis in art was almost entirely placed on portraits, as it was in most other southern cities.[14]

St. Louis, too, encouraged portraitists primarily, and such artists

who made winter tours to the South often paused here to satisfy the demands of the residents for likenesses. Among the many artists who left examples of their talent behind were Chester Harding (1820 and 1866), Emmanuel de Franca (1840), Ferdinand T. L. Boyle (1858), Wilkins (1858), W. Coggswell (1858), A. J. Conant (1857 and after), Miss Sarah M. Peale (1847–78), Charles Deas (1840–45), the sculptor McDonald (1860), the landscapist J. R. Meeker (1860), Charles F. Wimar (*ca.* 1849–63), and Thomas S. Noble (1860 and after). By the outbreak of the Civil War, in fact, St. Louis had drawn sufficient talent to itself to contemplate a vision of its becoming the "center of the western art world." [15]

Rochester, New York, enjoyed the services of artists as early as the 1820's, when the "portrait and ornamental" painter Daniel Steele opened his studio in that city. J. L. D. Mathies fared better than Steele, but he did not depend on Rochesterians' love of art; he also opened a soda fountain in the city, a store for the sale of musical instruments and groceries, a tavern, an art gallery (in partnership with William Page of New York), and a studio for the taking of portraits when requested. During the 1830's Grove S. Gilbert made his home in Rochester, painting portraits while regretting that his talents should be thus squandered; soon he was joined by a flock of portraitists like Colby Kimball, Alvah Bradish (who later moved to Detroit), and Thomas LeClear (who later moved to Buffalo and helped found that city's Fine Arts Academy in 1863), among several others. Artists in Rochester—a city of "no very high character for art patronage" according to Gilbert—seemed to make a precarious living, if the fact that Colby Kimball found it necessary to augment his income by adding a live alligator to his display of portraits is indicative of the city's receptivity to art; but as the decade of the thirties flowed into the forties, artists found it possible to vary their work as Rochester citizens began to respond to historical paintings, sacred paintings, and miniatures. Rochester became, in fact, a port of call for artists traveling along the route of the Erie Canal, either for the scenery or on their way West, and many stopped to sketch the city's famous aqueduct—the longest in the country—or its falls, and perhaps pick up a commission for a portrait or two. In this way the inhabitants of Rochester, like those of the other western towns, became familiar with artists and their work. As the city progressed materially and as individuals began to accumulate private fortunes

with the development of industry and trade, patronage of art increased and expanded along the patterns established by the eastern ports.[16]

Thomas Cole was just one of the many painters—although perhaps the most famous one—who passed through Pittsburgh during the first half of the century; in 1823 Cole advertised himself as a portraitist and even contemplated opening a drawing school in this Allegheny River town, but he did not meet with sufficient encouragement to carry out his intentions. Instead, he continued his pilgrimage eastward, like so many other western painters of the time, to make his fortune and reputation in New York as a landscapist.[17]

Other painters who followed Cole fared better in Pittsburgh. The native Pittsburgh youth, A. Bowman, showed such talent in making "elegant and distinguished likenesses" that in 1822 the important men of the city collected a "pocketbook" that would enable him to study in England under Sir Thomas Lawrence, and in France, where for nine months he was a protege of LaFayette. S. H. Dearborn painted landscapes in early Pittsburgh, and in the 1830's, F. A. O. Darley, A. L. Dalbey, and Thomas Sully visited the city to paint portraits of its distinguished citizens. By the late 1840's and 1850's, a large group of painters had begun to make their homes in the already industrialized city. Trevor McClurg returned from studies in Europe to paint portraits and attempt to turn the tastes of Pittsburghers toward serious figure painting with his *Pioneer's Defense;* Orgeon Wilson, who had also studied in Europe, opened his studio in 1855, painting portraits and taking on pupils like Rhodes; George Hetzel and Emil Foerster also returned from their European art studies in the 1850's to paint landscapes and portraits respectively. Jasper Lawman started as a scene painter in Pittsburgh, studied under Couture in Paris, and returned to Pittsburgh to do portraits and an occasional landscape. B. F. Rinehart worked in the city before leaving for New York; and Alfred S. Wall and William Wall also painted in Pittsburgh in the fifties, Alfred's studio being, in fact, a kind of meeting place for the others. Thus an artistic atmosphere slowly asserted itself in the city, as this group was joined by the talented David G. Blythe, the so-called Ostade of Pittsburgh, and Emil Bott. For the development of the community's art life, however, the most important painter to take up residence there in the early decades of the century was James R. Lambdin, Pittsburgh's leading portraitist and museum entrepreneur,

Lambdin painted the "rich merchants and important judges of the first half of the 19th century," becoming a kind of teacher and mentor for the younger Pittsburgh artists. Although after the Civil War the wealthy merchants and industrialists of Pittsburgh showed a preference for imported works of art rather than the homemade variety, during the decade of the fifties the fact that at least thirty painters other than those mentioned above—primarily portraitists, but also some figure and landscape painters—worked in the city for short or long periods of time suggests that ante-bellum enthusiasm for contemporary art made it possible to maintain a sizable art community in the city.[18]

Cincinnati was early recognized as the art center of the West, despite the anxiety of many other western cities to snatch the title from her. Many painters and sculptors traveled through the "Queen City" and although few of them remained long enough to have their reputations associated with its history, in their short sojourns they left behind examples of art that accumulated in the homes of Cincinnati's earliest and wealthiest families. Probably Cincinnati's reputation in the arts was based more on her institutions and her patrons than on her artists, who usually achieved their fame after having left the city for the East or for Europe. The city's art life began in 1792 with the arrival of the German artist George Jacob Beck, who came as a scout in Wayne's army and remained until 1800, when he moved on to Lexington. Soon after Beck's departure, Frederick Eckstein, the "father of Cincinnati Art," began his modeling activities in the city, and it was in his studio that Hiram Powers, America's famous sculptor of the mid-century, learned the technique of making wax figures and modeling from clay; soon Powers' nimble fingers were turning out atrocities and deformities of nature for the Western Museum in Cincinnati—a long way, it would seem, from the smooth classical female nudes that later emerged from his Italian studio. Shobal Vail Clevenger and Henry Kirke Brown were also pupils of Eckstein. Clevenger was sent to Europe for further study by the Cincinnati art patron, Nicholas Longworth, but he was never given the opportunity to fulfill the promise Longworth saw in his work; he died of tuberculosis while returning from Europe in 1843. Brown, however, went on to New York to achieve fame and fortune as a sculptor of considerable prominence. As early as 1815, a Mr. Smith, A. W.

Corwine, Joseph Mason, Samuel Lee, and Alonzo Douglass painted portraits and landscapes in Cincinnati. In 1834 James H. Beard opened his studio in the city for the taking of portraits. His paintings of children caught the attention of Harriet Martineau in 1838, and her notice of Beard and his work brought the artist considerable national as well as local attention. Cincinnatians anticipated "much for western art" from Beard, but mankind appealed less to this artist than animals, and he found greater satisfaction as a painter of domestic animals, particularly dogs, subject matter which was not regarded as "high art" in the mid-century. The Frankenstein brothers—John and Godfrey—also contributed to Cincinnati's art life; Edward Brackett cast the first statue in the Mississippi Valley in Cincinnati in 1839—his *Nydia, the Blind Girl of Pompeii;* and that same year the painter John Cranch arrived in the city to "scrape" along "tolerably well, considering the bad and wicked times." Cranch remained only until 1840, when he removed to Washington, hoping perhaps to be given the opportunity to paint "Old Tip" (William Henry Harrison). William H. Powell, whose large painting of *DeSoto Discovering the Mississippi* took the place of Inman's commissioned picture in the Rotunda of the National Capitol when Inman died, also painted in Cincinnati for a short time, as did Miner K. Kellogg, Nathan F. Baker, and many others whose presence undoubtely stimulated the fashionable society of this enterprising city to contribute to and encourage various organizations devoted to art.[19]

Similarly, by the 1840's the lake ports of Cleveland, Detroit, and Chicago had been visited by artists, many of whom remained to enjoy local adulation and applause while others merely passed through. When Allen Smith, Jr., a portraitist, won an Art-Union award for his *Young Mechanic* in 1848, Cleveland shared his glory. Smith was joined in the city by Joseph Gregory and Julius Gollman, also portraitists, and perhaps it was their presence that inspired the educational leader George Willey to deliver a speech in behalf of the arts they practiced. Although Cleveland did not begin to manifest a really active art life until after the Civil War, the presence of portraits in the Western Reserve Historical Society painted by unknown artists, together with a collection of portraits by lesser-known painters such as Alonzo Pease, Jarvis F. Hanks, D. W. Keith, and Caroline L. Ormes Ransom, suggests that interest in art was slowly

increasing, and that when the economy of the city should take a more dynamic turn, this interest would bear fruit.[20]

J. S. Porter came through Chicago in 1835 and returned in 1847, perhaps hoping for a better reception for his talent as a painter of miniatures than he had previously received. In 1840 Beale Bardley exhibited his copies of Dubufe's famous paintings of Adam and Eve— *The Temptation* and *The Expulsion;* and the following year two Londoners from the Royal Academy, Wilkins and Stevenson, brought over two hundred paintings, drawings, and sketches of their own for sale to aspiring Chicagoans. Wilkins and Stevenson were also willing to give lessons and to paint portraits and miniatures, but they did not meet with much success. Other itinerant portrait painters, like Edward McClifford, simply passed through. A few, however, remained in the already prosperous lake port to paint portraits of Chicago's wealthy citizenry. Samuel M. Brookes returned from England in 1846 with copies of Old Masters and fancy sketches which he sold from his studio or by means of a lottery; his portraits and those taken by J. B. Reade during these years received much acclaim in Chicago's newspapers. For other kinds of painting, however, the city's enterprising business men—William B. Ogden, Mark Skinner, Edward Wright, William Blair, Walter L. Newberry, J. Young Cammon, Joseph T. Ryerson, George F. Rumsey, and Ezra B. McCogg—looked to the eastern landscapists like Durand, Kensett, and Mount for reproductions of that "glorious scenery amidst which . . . [their] childhood was spent" or for scenes of rural humor; and when they sought even more "pretentious" works, they looked to Europe for paintings by the old or new masters.[21]

To Detroit's "palatial residences" along the Detroit River several artists were drawn during the first three decades of the nineteenth century, despite the lingering traces of wilderness in the town. The engraver J. O. Lewis lived in Detroit until 1827, leaving behind him most notably engravings on steel of the city's most important earlier citizens, General Cass and Father Richards. Alvah Bradish had left Rochester at the beginning of the 1830's for Detroit, bearing with him letters of introduction to "the best people" who were quite willing to sit for their portraits to the young and well-recommended painter. Bradish immediately made progress in his profession, painting, it is said, over five hundred portraits which included most of Detroit's

"men of political, social or financial reputation associated with the rise and progress" of the city. A project for publishing an illustrated book on the Great Lakes region fell through, but Bradish became an important force in the art life of the community. Thomas Burnham's *Election Day at the Old City Hall* aroused considerable interest in Detroit because of its portraits of the city's political leaders. Ecclesiastical decorations and landscapes of the Hudson River School variety constituted the specialties of the two Dabo brothers—Leon and Theodore Scott—while Indian portraits occupied the attention of John Mix Stanley. Stanley's pupils, Robert Hopkins and Lewis T. Ives, gave their time to scenes and marine views, which also broadened the artistic experiences of the city's residents. Seven artists were listed as resident in Detroit in 1852–53; many of these had arrived earlier and remained in the city until their death, while some spent only short periods of time here. In any case, from lists available it would appear that there were many more artists in Detroit than these seven during the mid-century.[22]

This sampling of names of artists who came to the midwest frontier cities during the first half of the nineteenth century to pursue their craft in what was still so much wilderness suggests much about the cultural development of the American West. The lives of most of these artists and many of their works are lost to history. They achieved a bit of prominence in their native or adopted cities, perhaps a livelihood, but few of them were great enough to have their works live after them, except when these happened to be portraits of eminent men.

Although many western artists emigrated to the East, traffic took a westerly direction too, as easterners of second-class talent went into the less cultivated hinterlands in the expectation of meeting less sophistication, less competition, and more encouragement. They found, for the most part, a cordial welcome in the new lands and communities among recently successful city dwellers and businessmen, many of whom had achieved a new social status here just as the traveling artists hoped to do. They also found willing young students to continue their art traditions—for better or worse—in their native cities after the war; and these artists together with the numerous ladies' groups, men's committees, and mechanics' associations were responsible for the creation of exhibitions and art institutions designed

to spread a taste for art among the uncultivated populace, to increase patronage for local artists, and to advance both the intellectual and commercial reputations of the cities.

—3—

For some western citizens, institutions for the encouragement of the arts were viewed along with sidewalks and industry as necessary to the growth, prosperity, and health of the community. Primitive societies, in the eyes of this small group, needed improvement in many ways; the brawling, knifing, rioting, thievery, and general disorder of frontier life had to be countered by the established institutions of civilization. When, as late as 1867, William Probasco of Cincinnati presented the Probasco Fountain to his city, he did so in the hope of beautifying his town and, even more important, of providing "a thirst slaker for the youth of the city," so that they would not have to have "recourse to Coffee Houses." Even more than water fountains, however, "enterprises . . . to increase the knowledge of science, refine the taste and soften the grossness of manners" were deemed essential. If western city dwellers, like their eastern counterparts, faced the danger of becoming careworn and weary businessmen because they concentrated their complete attention on "gains and losses," then in order to reinvigorate their feelings and imaginations they had to be given the "nobler themes of thought" that art galleries and "a taste for the fine arts" afforded. Moreover, if other cities, especially the older ones in the East, had been rendered "attractive" by these "more beautiful and proper sources of amusement," then the newer western cities would also profit from such institutions. The most important service that a city could render, it was believed—one that justified, in fact, the existence of cities—was to provide for its populace certain social "benefits" which would promote "a general taste for moral, social and intellectual progress." [23]

Not all western cities were immediately successful in organizing and maintaining institutions for the encouragement of the fine arts; in fact, only a few established anything of a permanent or continuous nature. But the experiences of those cities which were more successful than the others not only suggest something about the western urban experience but also something about the problem faced by Americans during the first half of the nineteenth century in their efforts to establish a native art life through institutions devoted to the purpose.

Cincinnati was one of the earliest and more successful of the cities to establish art organizations. In 1812 Nicholas Longworth, later to become one of the city's most prominent patrons of art, formed the Academy of Drawing and Painting. The first museum to be opened in the city (in 1818) was the work of two entrepreneurs, Letton and Willet; by 1826 Letton seems to have secured sole proprietorship of the institution, which now included among its exhibits a gallery of fifty portrait paintings of famous citizens. This museum continued its operations for a decade, but the increasing competition of the Western Museum undoubtedly impelled its proprietor to move on to more lucrative areas. The Western Museum grew out of Dr. Drake's Western Museum Society, organized in 1819 as one of his many "schemes of public enterprise . . . for the promotion of the public prosperity." Founded with the high intention of promoting "the useful and ornamental arts," it nevertheless succumbed to the demands for amusement on a lower scale from the frontier citizens of Cincinnati and its environs. The proprietor, Count d'Orfeuille or, as he was more popularly known, Joseph Dorfeuille, who had "lived long enough at Gallipolis to know the settlers' taste," found it more profitable to show examples of Indian arts and crafts, prehistoric utensils that had been discovered in the excavations of the seven mounds of the region, "animals that did not exist, deformities that ought not to exist," wax figures and caricatures of famous men, and—its most famous exhibit—"the Infernal Regions," where "against a realistic background mechanized figures carried on their work of carrying sinners to the pits with diabolic energy." When this "Blue Devils waxworks" exhibition opened in 1834, its success almost destroyed the museum, which was forced to close down for a short period; the "impressionable ladies of Cincinnati," it seems, found the show so sensational that they could not refrain from "swooning . . . before its realistic terrors." To add to the horror of the experience, an occasional electric shock was transmitted to the viewers from the balustrade against which they had to lean to watch the proceedings below, frightening the "country folk out of their wits." [24]

The Western Museum continued until 1858 under the management of a Swiss exile, Frederick Franks, who as a teacher of drawing and languages, made it a "training school for young artists" like Hiram Powers, Miner Kellogg, the Beards, Daniel Steele, John Tucker,

William H. Powell, and Thomas Buchanan Reed. Its educational value was augmented at various times by the practice of depositing there for safekeeping art collections of transitory institutions or works of art by Cincinnati artists either presented to or purchased by the city. So, in 1839, Edward Brackett's statue *Nydia, the Blind Girl of Pompeii* was purchased by a group of loyal Cincinnatians for deposit in the museum; and when the Cincinnati Academy of Fine Arts declined, its collections were temporarily stored in the museum building, awaiting the day when a new Academy of Fine Arts would restore the city to its position of pre-eminence in the arts in the West. Franks sold the enterprise in 1858 to a Madame English, who seemingly had few ideas about its proper management; depression and war and changing tastes also contributed to its eventual deterioration and demise.[25]

The leading citizens of Cincinnati were interested in more intellectual fare than the Western Museum could provide, and in 1828 they grouped together to incorporate the Cincinnati Academy of Fine Arts as the first step in an "extensive" project for the education of mechanics—the Mechanics Institute. The plan was an ambitious one, undertaken in the expectation that with the "rapid increase in wealth" which the economic opportunities of the city promised, direction of public taste was necessary in order to prevent "idleness, vicious amusements, profligacy, and complete demoralization" from rendering such "riches" a "curse to our posterity." A library and reading room and a regular series of scientific lectures would help to establish a foundation "so broad, that all associations for the cultivation of the arts or sciences might be embraced in it, and all the efforts for the advancement of learning, or improvement in the arts, be there concentrated." With the acquisition of "Trollope's Folly"—the architectural atrocity that Mrs. Trollope and her son erected when they attempted their ill-fated business activities in Cincinnati in 1829—the Institute initiated its annual fairs "for the exhibition of western manufactures and the encouragement of western artists." The first of these exhibitions in 1838 included paintings, engravings, drawings, and flower designs, and its sponsors expected that it would become "the interesting and efficient organ of communication between the artists and the public, and open for them the way to a liberal patronage." The fairs, however, increasingly emphasized the mechanical and industrial arts in the expressed hope that if "the

ingenuity and skill of western artists" were encouraged, those "thousands of dollars which are annually sent across the mountains, and even beyond the Atlantic" would remain at home "to purchase those articles which can be made as cheap, and of equal quality, at our own doors." With such an emphasis it was inevitable that the "truly eminent and talented artists" of Cincinnati would be reluctant to send their work to be exhibited; and when the rotunda over the rear portico of the building, originally intended for the exhibition of paintings, was converted to serve the needs of a drawing class, the Institute deserted the fine arts for the practical.[26]

What has been called "the golden age of art" in Cincinnati—the decade of 1838-48—was launched with the formation of a new Cincinnati Academy of Fine Arts by artists themselves in the expectation that "by their union, they might obtain greater facilities for improvement in the various branches of the fine arts." In 1839 they held their first exhibition of both foreign and native works of art; one hundred and fifty paintings were examined by interested Cincinnatians, but the exhibition was not a financial success. The artists were unable to "accomplish their laudable design of procuring a collection of casts," which was considered necessary (as it had been by easterners a decade earlier) for the education and training of students in the arts. The following year, however, a group of "several liberal gentlemen of Cincinnati" donated the casts to the Academy, "the first collection of the kind ever brought to the West." [27]

In 1840 an even broader educational enterprise was established by the citizens of Cincinnati: the Society for the Diffusion of Useful Knowledge. The organization's plan encompassed pretty much all the subjects in a college curriculum of the period, and, of course, one of the fourteen divisions included a section devoted to the fine arts. "All Individuals desirous of higher culture" joined the association and participated, within the separate sections, by teaching each other through reading and conversation. Lectures were offered by them to the general public; and a public library, a science museum, an art gallery, and the publishing of the more influential lectures and manuscripts were projected; in such manner did the association hope to provide the "moral, intellectual and social influences" so necessary to "the spiritual atmosphere" of the community.[28]

According to Cincinnati's early historian, Charles Cist, "the great body of the Cincinnati artists" belonged to the section of the fine arts,

meeting regularly with amateurs for study, reading, and practice, and to plan their public lectures. The artists who participated co-operated with the exhibitions of the Academy of Fine Arts, and in 1841 Cist foresaw that the two groups would soon unite. "The corps of artists residing in Cincinnati is small, composed of young men of limited resources, and their aid from without will depend much upon their concentration of strength within." [29]

That Cincinnati was humming with art activities during the early forties, despite the fact that the country as a whole was in a state of severe economic depression, is testified by many visitors to the city at the time. In 1842, for instance, William Adams of Zanesville, Ohio, wrote to Thomas Cole in New York of the "astonishing" developments in the western city. "Wealth has engendered a taste for the arts, and its inhabitants seem to be peeping out of the transition state, and entering upon one of taste and refinement. This state of things has tended to develop many instances of latent talent and Cincinnati can boast of her artists. . . ." By 1846, proud of having taken the first rank in the West in the encouragement of art, Cincinnati deemed it "fitting" that an institution for the encouragement of taste, patterned after the American Art-Union of New York City, should be formed. "The establishment of an Art-Union" in Cincinnati, in the words of a local newspaper, "would foster and cherish Art, encourage merit, and reflect upon us the highest credit." The Western Art-Union's management gave point to this expectation. For "the future exaltation and aggrandizement of our city," the cultivation of the fine arts through such an organization would become, they believed, an "extraordinary source of wealth," affording to Cincinnati as the sponsoring city in the West, "fame and influence" and, of course, profit. The directors conceded that Boston might become the "Florence" of the western world because of that city's "superior liberality and union of enterprise"; but it was more probable that a city in the West would carry off the honors, and why not Cincinnati rather than Louisville or St. Louis? [30]

The Western Art-Union excited great interest in Cincinnati, and some opposition. At its first distribution, 74 paintings, which had been purchased at a cost of $2,827.45, were allocated by lot to the 724 paying subscribers. These paintings, some of them "beautiful and desirable specimens of art, and the remainder decidedly respectable," had been purchased at "reasonable prices . . . none of them . . .

costly" from 27 different artists. The directors felt obliged to justify the low prices; they did not care to "furnish to Artists higher pay, but to provide them with a more frequent and steadier market for their productions." The directors feared that if they paid inflated prices for works of art they would "diminish the number of private purchases" made by individuals and that this would "work a serious injury to Art and Artists, by destroying that market upon which they must permanently and mainly depend, viz., private patronage." Moreover, the limited funds of the organization made it impossible to pay "even prices consonant to the principles above stated"; the highest price paid for a painting was $175, the lowest $5, and the average $38.20. Despite this scale, the directors believed that "whilst there is no picture which possesses the very highest excellence, there is not one which an owner of a European gallery need reject, and . . . the average quality is decidedly high for any place or nation." Of the artists thus patronized, nine resided in eastern states, eighteen in western states, while eleven of these were natives of the West.[31]

The directors were especially proud of the free exhibition of works of art that they were able to provide for the public during the time the paintings were being purchased; together with the purchases as they were added, other works by contributing artists were hung in their exhibition rooms, and "some fine paintings . . . loaned for the occasion by liberal friends of the enterprise." Such a continuing exhibition afforded "an agreeable recreation to [our citizens] and to strangers, and a convenient . . . and a very successful mode of disseminating a taste for the arts, and of obtaining subscribers to the Art-Union." Like its predecessor in the East, the Western Art-Union called upon artists throughout the country to aid their scheme by painting appropriate "local and national subjects." And finally, like their eastern counterparts, the directors justified the encouragement of art for its social and moral value and insisted that "the Beautiful Arts" constituted "a learned and liberal profession, requiring the education and exercise of, the highest and noblest powers."[32]

Of course there were dissenters, and the Western Art-Union, after two years of exhibitions, incurred its share of hostile comment. It was accused, as was the parent organization in New York, of poor management and favoritism, of neglect of local artists because it imported pictures from eastern or European artists, and of poor taste in its choice of paintings; its exhibitions were criticized especially

because of the presence there of copies of paintings and portraits. Perhaps because of these elements of dissatisfaction, the Western Art-Union enjoyed only a brief existence before expiring in 1851.[33]

In 1848 a gallery containing portraits of national figures was opened in Cincinnati, but it soon failed, and a few years later—in 1851—William Wiswell attempted a picture gallery with the same lack of success. But there is no question that all of these enterprises stimulated further interest in art, and when in 1854 the ladies of Cincinnati decided to get up a gallery for the exhibition of classic statuary and copies of important European paintings, for the "improvement of the public taste and the encouragement of art," their efforts bore fruit immediately. One of the moving spirits behind this ambitious undertaking was Sarah Worthington Peters, daughter of the former Governor of the state, widow of Edward King, who was the fourth son of Senator Rufus King of New York, and the mother of Rufus King II, one of Cincinnati's more prominent citizens and art patrons. The younger King had been one of the founders of the Western Art-Union and in 1868 was a founder of the Cincinnati Academy of Fine Arts. His mother gathered most of the treasures for the Ladies' Gallery, but Rufus was constantly being called to the rescue for aid in money matters, about which the "good" ladies were somewhat careless. The ladies, for instance, fell into a "frightful mess" in 1854 because of that "severe state of money matters" that brought many banks to the verge of failure; and although King extricated them, he did so not without some irritation at their bad behavior: "they have no courage or management and really need someone not only to tell them what to do but how to do it." King became even more irate at "that terrible access of Virtue and modesty, that 'nasty-nice' taste" which the "females" on the Board revealed when confronted by the problem of exhibiting nude statues in the exhibition of 1856. The modest women proposed to put all the statuary into a separate small room instead of distributing it among the paintings in the larger exhibition hall. "Just imagine," wrote the exasperated King to his mother, who was still in Europe attending to the copying of selected paintings, "the thicket of gods and goddesses, all huddled together, the Gladiator pitching into Venus, and the Belvidere twanging his bow strings right a posteriori to Hercules." [34]

For a child born in the frontier village of Chillicothe, Sarah Worthington Peters had enjoyed "exceptional educational advan-

tages," first at a boarding school in Kentucky and later during visits to the "first families" of Virginia and New York. Her home in Cincinnati attracted "the elite of many sets—artistic, musical, ecclesiastic, literary—among whom she was always equally at home, so that the impress she created on the minds of her friends penetrated far." Mrs. Peters was more cosmopolitan than most of her neighbors and undoubtedly more emancipated, even to the point of wearing "bloomers" during the campaign for women's suffrage. To collect "the objects worthy of study" for the Ladies' Gallery, this energetic woman traveled to Europe five times, exercising in her selections much independent judgment as to what would be attractive to the general public as well as suitable for training artists and students. Raphael's fresco painting of *The School of Athens* in the Vatican at Rome was copied half-size at Mrs. Peters' order at a cost of $1900— "nearly half of [the] total capital which *was* or is promised." When the ladies at home disputed the expenditure because Mrs. Peters had purchased the copy "without directions," her son suggested that to "stop tongues from wagging," she sell it, "as much as he should love it both for her sake and to see it here." The painting was finally accepted—Mrs. Peters was undoubtedly a woman of iron will—and appeared among the other selections of the "highest class," as Julia Ward Howe testified, in the exhibition of 1855. Also in that exhibition were copies of Murilio's *Virgin of Seville,* Poussin's *Diogenes Casting Away his Drinking Cup,* Van Dyke's *Charles I,* Raphael's *Virgin with the Veil,* two self-portraits by Rembrandt, and a portrait of Marie de Medicis, the mother of Louis XIII—all copied from originals in the Louvre. Three original paintings by Kallmeyer were purchased at a total cost of $230: *Lady at the Piano, Old Timber,* and *Hagar and Ishmael;* but for the purchase of the copy of *Descent from the Cross,* which Mrs. Peters insisted upon, King found it necessary to solicit the aid of a few gentlemen who were ready to invest funds which they knew they would never again see "in this world." [35]

The Ladies' Gallery did not achieve a permanent home until the establishment of the School of Design in 1868. For the most part exhibitions were held in the Mechanics' Institute by special arrangement with the Ohio School Library Association. Here, in 1859, a picture gallery was "fitted" up in a new room papered in dark crimson, against which the paintings and statuary produced "a very

fine effect." Charles McMicken presented a group of Greek casts to the gallery, which later became the basis for the School of Design for Women; D. B. Lawler gave the ladies a life-size cast of Eve by Belzoni, "one of the most beautiful of modern statues"; Mrs. Reuben Springer donated Titian's *Belle;* and Mrs. Peters augmented the collection with a copy of Michelangelo's *The Fates.* For their annual exhibitions the ladies solicited the loan of paintings from private collections, and Cincinnatians were urged to "continue to add to this collection until it shall have become a monument of the taste and liberality of our Western Metropolis." Sometime between 1860 and 1864 the ladies turned their collection over to Charles McMicken, who left it in his will in 1864 to the trustees of the Foundation he had established to create a university for the city. The collection and the School of Design were eventually absorbed into a museum association, which in 1884 formed the Cincinnati Museum of Fine Arts; thus Cincinnati finally achieved the goal set by her early settlers: "a collective body," in the words of Dr. Daniel Drake, possessing "the means and the duty of promoting the Fine Arts in the Western Country." [36]

A traveler intent upon sampling the intellectual resources of the western regions, or an artist or lecturer seeking an audience, upon leaving Cincinnati (by the mid-century truly the Queen City of the arts) would undoubtedly head directly for St. Louis, fast rivalling Cincinnati in its efforts to make itself "the center of the western art world." Emerson took this itinerary in 1852, and in 1855 John M. Falconer, a New York artist who toured the western cities on business and to collect art news for the *Crayon,* also made a beeline for St. Louis when he left Cincinnati. The citizens of St. Louis prided themselves on being a society "of great polish and true refinement," cosmopolitan in their commercial and social ties with Paris. In fact, Parisian high society provided the wealthy families of St. Louis with a model which they pursued as diligently and as faithfully as their distance from France permitted. They wore French imports, imported French paintings, and "their salons were beautifully and tastefully decorated in the French style." This European influence is apparent in the first major art exhibition held in the city in 1821, an exhibition of "old masters" and paintings "by the first modern masters of the Italian, French, and Flemish schools," which had been pre-

sented to the Catholic citizens of St. Louis through their Bishop Dubourg by the Catholics of Europe.[37]

Possessing cultivated tastes, or at least a tradition of cultivation, St. Louis residents were eager to provide their workers and "toil-worn and haggard merchants" with "profitable places of retreat," such as art galleries and museums. From the early 1830's on, various museums and exhibitions of paintings helped to cultivate the public taste. Around 1836 Albert Koch opened the St. Louis Museum, where numerous and popular panoramas—"paintings for the . . . most respectable Hydra!"—were on view. In the shop windows of St. Louis' fashionable stores and auction rooms oil paintings and alleged Old Masters were exhibited, and at various times during the following decade, individual paintings or groups of "masterpieces" were shown for private profit or for charity. By 1851 there were many "pictures of rare beauty" hanging in the homes of St. Louis men of wealth, and it was reported that these individuals "would freely offer [them] for a while as a nucleus to form a durable Art Gallery." Such a gallery became possible later in the decade when a "beautiful Gothic structure," the Fine Arts Hall of the annual Agricultural and Mechanical Association's Fair, was erected as a result of the success of the art exhibitions that had appeared at the Fairs since the mid-1840's.[38]

Oak Hall, as this structure came to be known, was ready in 1857 to receive the paintings and statuary "which are sent for the purpose of contesting the liberal prizes offered by the Association, or lent by worthy citizens to increase the interest of the Fair and to adorn the beautiful building which has been dedicated to the refining influence of Art." The Oak Hall exhibition of 1857 drew to St. Louis "thousands of strangers," and its success stimulated the officers of the Agricultural and Mechanical Association, especially Henry T. Blow, James E. Yeatman, and A. J. Conant—"public-spirited men . . . who are actuated . . . by motives as elevated as they are distinguished"—to found in 1859 the Western Academy of Art, the object of which was "the cultivation and extension of Art." With Blow as President, and with the Pennsylvania Academy in Philadelphia serving as a model, the Academy purchased an extensive collection of casts for its "Life and Antique School" and made arrangements for establishing a School of Design open to "pupils of both sexes" for the development of the industrial arts. Its first

exhibition was opened with great ceremony in 1860 at a private
viewing attended by "His Lordship Baron Renfrew and suite"; the
"picked works of art from American galleries and gems from the
studios of Europe" were described as "truly beautiful," and the
gallery was judged to be the "largest in the United States." The
organization hoped that the city's "connoisseurs and those who wish
to cultivate the fine arts" would join in the enterprise and make the
gallery worthy of its name; but, unfortunately for the ambitions of its
projectors, the outbreak of war brought to an abrupt end the
Academy's grand plans, and military men rather than artists took
possession of the building. The small collection of the new organiza-
tion was "quickly scattered abroad," and only the casts remained in
St. Louis, stored in the reading room of the Public School Library as
a memento of the city's large hopes and cultural aspirations.[39]

Not until post-bellum years—in 1872, when the St. Louis Art
Society, organized "for the culture and study of the arts," was
formed, and in 1877, when Hercules L. Dousman opened his private
art collection to the public—were steps taken to reawaken the city's
enthusiasm for public organizations devoted to the encouragement of
art. The establishment of the St. Louis Museum of Fine Arts in 1881,
with the gift of Wayman Crow, is a postwar story, but there is no
question that in good measure it owes its existence to the interest in art
that had been stirred up during the prewar years by the projects of
the city's early leaders.[40]

During the 1840's New Orleans abounded in private art collections,
and the city enjoyed "a remarkable accumulation of important
pictures." There were, then, sufficient works of art in private hands to
provide material for continuous art exhibitions if these were consid-
ered desirable. Early in the decade a group of benevolent capitalists
who were concerned with municipal improvement obviously did feel
this desirable, and so contributed to the founding of the New Orleans
National Gallery of Paintings. Among these were men like Samuel J.
Peters, a Canadian of American descent whose education in New
England had undoubtedly prepared him for a career of public service
as a member of the city council, the planner of a system of city
improvements, the founder of the New Orleans Chamber of Com-
merce, President of the Pontchartrain Railroad, President of the City
Bank, and builder and developer of important real estate in the city

that helped transform New Orleans into the "great and flourishing" metropolis it became in the 1850's; James N. Robb, President of the Chicago, Alton and St. Louis Railroad and an art collector of national repute; Glendy Burke, a "distinguished merchant"; R. D. Shepard, "one of the wealthiest and most philanthropic of the great merchants of New Orleans"; and John Hagan, a land speculator whose enthusiasm for art and for the beautification of his city "led him to present a fine Italian marble statue of Washington to the first St. Charles Hotel." [41]

By 1844 the National Gallery was established in its own building and was busily involved with showing its treasures—heirlooms collected by the numerous French and Spanish families associated with the city's early history; loans from the Robb and Burnside collections, the city's two most important art collections; and numerous portraits and paintings commissioned or purchased from the many visiting artists who had for decades made New Orleans their mecca. The gallery succeeded as an exhibition hall, showing loan collections, or, as in 1846, special visiting shows like Mr. Edwards' *The Ivory Crucifix*, which averaged $80 to $130 a day in admission fees. But as a center for the exhibition and sale of contemporary American paintings it was not successful. George Cooke, the artist-director of the gallery, reported to Thomas Cole in 1846 (the year of the Mexican War) that he despaired of the National Gallery's success, Cole's painting of a *Lake Scene* being the only work of art sold by the institution that year. An Art-Union project sponsored by the gallery in 1845–46 did not succeed either, perhaps because of the war, or perhaps because the citizens of this southern city were more interested in old paintings and portraits than in contemporary works by living American artists. Thus an auction of three hundred and eighty "old masters" held in 1847 in the ballroom of one of New Orleans' largest hotels was very successful, drawing from all over the United States potential purchasers who were intent upon bidding for the advertised masterpieces by David, Vernet, Del Sarto, Titian, Van Dyke, Raphael, Poussin, Leonardo, Salvator Rosa, Correggio, Claude, Guido Reni, Velasquez, Rembrandt, Rubens, Teniers, and Canova. [42]

The auction took place during the season of New Orleans' greatest prosperity, but signs had already appeared to indicate that this era in the city's economy was coming to a close. As the merchants of the city tended to concentrate more and more of their business on the

exportation of cotton only, neglecting the sugar of upper Louisiana, the tobacco of Kentucky, and the flour of the Ohio Valley; as the construction of the Erie, Pennsylvania, Ohio, and other canal systems began to divert trade from the gulf port to New York and Baltimore; as steamships began to be built too large for the port's entrance; and as railroads began to make large inroads on river traffic, a decline in the commercial importance of New Orleans became inevitable. War only brought to a more violent end a prosperity that internal commercial conditions had already doomed; and war together with economic decay brought to an end a flourishing artistic life that it would take decades to resuscitate. Many of the important paintings owned by New Orleans' families were scattered during the devastation of Butler's invading armies and Reconstruction, and it was not until 1880, with the formation of the Art Union, "an association intended to further art and culture," that the artists and art patrons of New Orleans resumed the effort of restoring to the city the brilliant art life it had enjoyed when it basked in its prewar sunshine and prosperity.[43]

"Of all the places in this country," wrote a not very loyal son of Pittsburgh in 1855, "Pittsburgh is the most endowed with the material spirit—hence the Fine Arts lack vitality." Yet it was during this period of time that Pittsburgh really began to develop a community interest in the arts, culminating in 1859 and 1860 in the Pittsburgh Art Association's exhibitions. It is true, however, that up to this time Pittsburgh had not developed the kind of art institutions that local group exertion had brought to the cities of the eastern seaboard or the Mississippi Valley. Why art institutions did not form earlier in Pittsburgh it is hard to say; certainly her more articulate citizens recognized the worthwhileness of art galleries and similar "beautiful and proper sources of amusement, which render other cities so attractive . . . and . . . instruct the mind as well as gratify and amuse the eye." Economically, the city had developed industry early enough to lure James R. Lambdin there from Louisville, where his museum, patterned after Peale's museum in Philadelphia and the Western Museum in Cincinnati, emphasized curiosities of nature and portraits of famous Americans. Again in 1850 an effort was made by a Dr. B. W. Morris, "one of our enterprising citizens," to establish a museum in the city, but it was not until the end of this decade that an attempt was made to found an organization specifically devoted to the

encouragement of art. Perhaps it was the presence of a successful commercial gallery, founded for personal profit but devoted entirely to the sale of art works, that made it seem unnecessary for Pittsburghers or for the city's resident artists to establish such institutions by group effort. From approximately 1832 on, J. J. Gillespie's company provided the residents of Pittsburgh with lithographs, "the finest of the old Masters," and modern paintings from France, England, and the United States. During the mid-century the company's exhibitions were said to have been "directly responsible for the creation of the Art Spirit which later culminated in the Art Department of the Carnegie Institute, from which many great collections were formed"; and Mr. Gillespie has been credited with helping to form the tastes of Pittsburgh's residents for many generations. However accurate a judgment this may be, the Gillespie Company's gallery did provide headquarters for painters who passed through the city during the decade of the 1850's and also a daily meeting place for local artists who gathered there to gossip about their art, "discuss the latest news from Paris," and criticize each other's work. In this sense the commercial gallery encouraged art by affording an opportunity for sales and for that critical evaluation which comes best when artists are able to compare their work with others. By 1859 the wealthier citizens of Pittsburgh had accumulated large enough collections of small American paintings, many of them by local artists, with some copies or alleged originals of "Old Masters," to feel ready to form an organization devoted to art. The first exhibition of the Pittsburgh Art Association in 1859 presented the accumulations of approximately sixty collectors, some of them quite substantial, and with the second exhibition the following year, more than one hundred collectors had exhibited their acquisitions. Undoubtedly, war brought an end to these promising beginnings, and not until the war was over, in 1865, did Pittsburgh pick up her interrupted activities in behalf of art. That year, following the pattern established elsewhere—in Boston, Philadelphia, and Cincinnati—Pittsburghers founded a School of Design for the instruction of women in art that eventually developed into the Art Department of the Carnegie Institute.[44]

Louisville and Chicago devoted serious effort in the 1850's to the development of art institutions. Under the influence of German immigrants, with their "love of the beautiful in nature and in art,"

Louisville held a succession of art exhibitions beginning in 1852 at the Kentucky Mechanics' Institute. From 1847 on, Chicago provided artists with the opportunity to exhibit and sell their works at the fairs of the Mechanics' Institute, but the most impressive show was the 1859 exhibition of paintings and statuary loaned from private collections that was held in the rooms of the Chicago Historical Society. A large number of works appeared here, "some of them not a little pretentious in their claims, many of them of great cost, and some few not without merit." The rooms were "well filled every pleasant day and evening" and the receipts were "very satisfactory." The proceeds from this "decidedly successful" exhibition were devoted to a commission given to the city's famous sculptor, Leonard Volk, for a work of art which would become the property of the Chicago Historical Society; in this way it was believed "the interests of the Fine Arts" would be promoted in Chicago. In 1860, moved by the success of this venture and the obvious excitement about art that had been stirred in his city, Volk projected an Art-Union distribution. The exhibition of the Union's works of art was "much visited," but Volk's experiment was nipped in the bud as a result of the "*unsettled* state of affairs . . . during the reign of revolutionary troubles and national uncertainties." Further efforts in Chicago, as in Louisville and other western cities, had to await the end of hostilities and the beginning of a new era.[45]

Despite their increasing prosperity and the constantly increasing class of well-to-do business and professional residents, most western cities were handicapped in their efforts to maintain permanent institutions for the encouragement of the arts by the lack of sufficient surplus capital available for such purposes. During the first half of the nineteenth century the West in particular was troubled by the alternation of depression and prosperity that accompanied the growing pains of a developing economy and that frequently changed a man's fortunes overnight. Given the possibilities for speculation and investment in land, banking, and industry, what precious surplus capital existed found its way into investment rather than into such luxuries as the fine arts; even the more essential colleges and schools found it difficult to find funds within the local communities for endowment and looked to eastern sources for such aid. Moreover, art institutions in this country usually developed and continued

successfully where individuals possessed sizable collections of art works which could be borrowed for exhibitions. Without such private possessions to draw upon and without a large enough community of artists who could stock an exhibition completely with their own products—as artists were able to do, for instance, in New York's National Academy of Design or Philadelphia's Academy of Fine Arts —art exhibitions and the more permanent galleries or museums which usually evolved from them were doomed to failure. Only those western cities—Cincinnati, St. Louis, New Orleans, and, later in the period, Pittsburgh, and Chicago—which contained a good-sized group of wealthy families with taste or interest enough to buy paintings instead of mirrors to decorate their homes were able to maintain exhibitions for any length of time. Yet, the West was young; and what is surprising is not how little was done for the arts but how much was achieved during years when both its society and its economy were in a state of constant flux, development, and rapid change.

—4—

What of western taste in the arts? If western society modeled itself closely after society in the East, if it acted under the same intellectual and philosophical influences that molded eastern institutions, did it also follow eastern taste in its response to paintings and sculpture? Were any frontier influences prevalent to render western taste in any sense regionally different from the taste of easterners and original to itself?

The great fear of those westerners who thought about taste at all was that western artists would be so imitative of the eastern style and manner that they would neglect their own natural surroundings and not truly represent western experience. Just as easterners feared too great an influence of Europe on their artists, so westerners warned against too great a dependence on the East. In 1848 one of the critics of the Western Art-Union's exhibition expressed the fear that the display of so many landscapes by Thomas Cole (lent to the exhibition from private collections in Cincinnati) would not be the best means of encouraging western artists to pursue their own studies of nature. "The gorgeous coloring of Cole's pictures . . . if it does not create an aversion for the pencillings of youthful Artists are likely from the admiration they excite, to tempt the young and unwary student into

imitative servility." Indeed, this critic saw "the poison" already at
work in the plundering of Cole's skies, trees, and rocks; his criticism
of the exhibition lay in his belief that "with the present enlightened
Board of Directors, topographical paintings of scenes ever changing
and near home find no favor." Instead, what western taste was
interested in were "rocky mountains which 'eye hath not seen,'
'Westward Ho's' purely ideal, and Katskill's duplicated, and done not
only brown, but to death." [46]

This critic's demand for paintings that would represent western
history, western forests and rivers, western farms—"original works
[which] would have given character to the West"—reflected the
general taste for a national art that prevailed at this time. In 1852 the
Western Journal and Civilian of St. Louis, for instance, praised
Scottish landscapes by the American painter, Canfield, but indicated
its preference for "illustrations of American incidents and scenes" and
its hope that "this rising Artist" would make his compositions
"thoroughly American." European paintings that made their appear-
ance in the West were criticized for their pretensions and their
decadence, and such disapproval was usually accompanied by a
display of enthusiasm for American paintings and for artists who
pursued their craft at home. These works revealed "beauty and
force." Even the mediocre paintings of Americans, if "carefully
painted from Nature," were considered "infinitely preferable to the
thousands of works . . . brought purposely from Paris for auc-
tion." [47]

The West was agitated, as was the East, by the conflict between
classicism and modernism, not only in art but in educational areas
generally. Whereas by the 1840's the East had begun to resolve the
problem in favor of modernism, the West remained confused about
its standards of taste and intellectual influences. In 1834–35, for
instance, Cincinnati's College of Teachers witnessed a noteworthy
debate between the educator Alexander Kinmont, who believed that
the classics were "the pillar and foundation of solid learning," and
Thomas Smith Grimke, who favored an "American education . . .
in opposition to the recognized and almost universal basis of instruc-
tion—mathematics and classics." Grimke, as a contemporary historian
characterized him, was "a most remarkable man . . . who had
formed some very peculiar theories of education. The classics, in his
view, were the literature of heathenism and thus inculcated "false

principles and tastes." Grimke attributed the false heroism of the
South, with its emphasis on the duel, its dissatisfaction with the
Union, and its nullification theories, to the influence of the classics on
the southern mind. The "leading men" of South Carolina, he believed,
"dwelt in the ideality of a false heroism rather than in the plain,
simple, practical and Christian sentiment of America." [48]

Most genteel westerners, however, were loath to give up their
Venuses and Mercurys as well as their classics; and they treasured
copies of the Old Masters just as the early republican collectors of the
East had. Collectors in St. Louis and in New Orleans in particular—
perhaps because these were southwestern cities—were more inter-
ested in old paintings than in the works of their contemporaries. But
the wealthy merchants and entrepreneurs of Chicago were as much
interested in classical painting of the sixteenth and seventeenth
centuries as their peers southward or in neighboring Detroit, and
when they could not obtain originals of these, they settled on good
copies executed by American painters abroad.[49]

Second in popularity to the Old Masters in the West of the 1850's
were works by contemporary Europeans, especially Germans of the
Dusseldorf School. Landscapes by Lessing were extremely popular in
Cincinnati in 1854, as were the works of Achenbach; in Pittsburgh,
collections of paintings by J. N. T. Van Starkenborgh and T. Lange
were prominent, along with works by the Munich painter, Buehler,
the Heidleberg artist, L. Braun, and the Berliner, F. Kraus. American
artists who had studied in these German cities—J. W. Whittredge,
Emil Bott, and George Hetzel, for instance—found ready sale for
their paintings among these same Cincinnati and Pittsburgh collectors.
And the distributions of the Cosmopolitan Art Association during the
early 1850's included many paintings from Dusseldorf and from
various German artists whose "highly finished" scenes were finding a
receptive audience among the new patrons of art in the United
States.[50]

During this mid-century period, western collectors also followed
eastern taste in preferring works by their fellow Americans, and in
western cities the local artists were often given a fair opportunity.
The paintings that appeared in Pittsburgh collections in 1859–60 were
predominantly by artists from Pittsburgh and nearby areas; twenty-
six Pittsburgh artists, in fact, were represented, while New York
claimed ten, Philadelphia fourteen, and Europe only sixteen. Even

when westerners patronized American artists, however, there were distinctions made. Westerners with great wealth bought paintings from the acknowledged masters of the East: Cole, Mount, Durand, Kensett. Such enterprising businessmen as E. Parmele and James Robb of New Orleans, or Mark Skinner, William B. Ogden, and Edward Wright of Chicago ordered paintings from the easels of these artists through the mail, much as they might order nails and bolts or tools, although undoubtedly with more enthusiasm and more anxiety as to the final results. Men of lesser wealth and lesser pretension, like the Pittsburgh patrons of the 1850's, patronized artists closer to home.[51]

In subject matter, after portraiture the major interest of western Americans lay in landscape, whether it was a scene by Lessing or by Alfred S. Wall, the "Nestor of Pittsburgh artists." Mark Skinner's nostalgia for the eastern mountain scenes of his youth sent him to Asher B. Durand for one of his "delightful landscapes, predicated . . . on that picturesque gap in the Green Mountains made by Bowen Brook"; and *Stratton Gap*, which resulted, was reported by the proud owner to be one of the three landscapes "most coveted" by visitors to the 1859 exhibition in Chicago; the other two paintings to achieve this distinction were Frederick Church's famous painting, *The Heart of the Andes*, and *A View of the Hinter See* by the Dusseldorf painter, Len.[52]

After landscape, western Americans preferred illustrations of classical or American history and literary paintings that illustrated an easily perceived story or a well-known book. The popularity of the paintings of Mrs. Lily Spencer Martin of Ohio reveals these artistic tastes. Her canvases sold for two hundred dollars—"far below value" —and her commissions were numerous. This presumably untutored artist, "without instruction or example, in the midst of squalor and poverty and obstructions of many kinds, herself seeming to you at first sight like an ignorant savage," created much admiring comment with such works as *Shake Hands, How Tempting!* ("A maiden just flushing into womanhood"), *Don't Touch*, *L'Allegro* (*Mirth*) ("Milton's form decidedly 'Americanized,' yet most admirably rendered"), and *Il Penseroso*. Pittsburgh art patrons enjoyed such canvases by Americans as *Milton Dictating* (Wolff Collection), *The Pioneer's Defense* (G. W. Hailman Collection), and the genre paintings of David G. Blythe, which could be obtained for about

thirty-five dollars each and had to be "seen to be appreciated": *The Post Office* (Hailman Collection), *Whoa, Emma, January Bills,* and *Young America* (Wolff Collection). Blythe's anecdotal paintings of the 1850's grew out of the same emphasis that gave birth to the Long Island paintings of William S. Mount or the river and western genre paintings of George C. Bingham—the belief that in portraying folk or common culture, such art conformed to a democratic aesthetic most suitable for the new nation. Section here seemed to play little part in determining the direction of these artists, although Blythe's paintings are more ludicrous exaggerations than Mount's; essentially the impulse was derived from the same ideology and cultural orientation.[53]

Whatever the subject matter and whatever the origin of the artist, there is no question that westerners like easterners wanted their paintings to be accurate and faithful in detail. Portraiture had to be "as like and as likely" as possible, "matter-of-fact" representations that avoided the "historical-allegorical poetical or fanciful *line*." In landscapes and renderings of local scenery, westerners demanded and admired realistic techniques. The critic who as late as 1873 praised the "exquisite landscapes" of J. R. Meeker of St. Louis for their "faithfulness in detail and drawing," or the historian of Pittsburgh art who wrote in 1898 that the "tendency of art in Pittsburgh is to depreciate the work of impressionists and cling to the realistic school," were both continuing a tradition of taste that prevailed almost without exception during the mid-nineteenth century.[54]

An examination of the collections of eastern and western art patrons in the United States during the mid-century reveals very few actual differences in taste, except that the easterners because of their greater wealth and their access to the larger centers of artistic activity both in this country and abroad, and because they had entered the field of collecting earlier, usually possessed works of higher quality and greater cost than the westerners. In the kinds of works admired, however, and in the techniques praised, American collectors of the mid-century varied according to social station and wealth rather than section. Only in the South and the Southwest were there marked differences in aesthetic response, for here to a greater extent, portraiture, Old Masters, and European works gave greater status to their possessors than paintings that were strictly local or national and contemporary. Like the aristocracy of early Boston, New York, or

Baltimore, these southerners who prided themselves on their aristo-
cratic lineage preferred paintings that suggested old families and
continuity with the past; the men of newer wealth in the North and
West—the wholesale grocers, ironmasters, transportation moguls, dry
goods merchants, and manufacturers—prided themselves on their
relation to a dynamic present and to the national interest, and this
pride they demonstrated by patronizing art that was modern and
native.[55]

CHAPTER SIXTEEN

ART AND NATIONALITY

By THE MID-NINETEENTH CENTURY, all the conditions favorable for the patronage of art were present in the settled regions of the United States. Individuals had accumulated sizable enough fortunes to afford luxuries; the population of cities, constantly increasing, was large enough to provide ample support for art institutions; and as the northern and western economies became more and more dedicated to industry and manufacturing, and as the prospects of economic development enlarged with the advent of a national market and a transportation system geared to it, confidence in the persistence of economic growth permeated the consciousness of Americans and challenged them to achieve greatness in other areas. The social mobility of American society also created a favorable environment for the arts; as individuals of recent wealth moved into the upper strata of society, they became intent upon proving their right to be members of the aristocracy through patronage of artists and the formation of art collections.

Nineteenth-century romantic idealism also profoundly affected American patronage of the arts. By positing an intimate relationship between art and life it rendered the fine arts important in the achievement of greater spiritual and moral values. "The man who is a sensualist," wrote Miss Ludlow in 1851,

> . . . whose chief care is that his table should be well furnished with delicious viands, whose eye lights up only when bottles and glasses begin to rattle . . . is rarely a lover of the arts. . . . And so it is with the treacherous, the cruel, the sly and the crafty; their selfish and corrupt passions unfit them for the tranquil enjoyment of the arts, which are in their nature social, kindly and purifying. . . . The study of the fine arts having, then, an elevating and softening influence, a tendency to render man less

sensual, more benevolent, more alive to the beauties of nature and truth, should be as generally cultivated as possible.[1]

Furthermore, by interpreting art as a reflection of nature, and the physical world as a symbol of the spiritual, romantic idealism imposed the belief that the art which captured the external features of a country's natural surroundings revealed the basic ideology of the nation; American nature, specifically, revealed the morality and idealism of the democratic way of life. The importance that romanticism attributed to nature as landscape also appealed to Americans of this generation, which was fast becoming urbanized but was still not far enough away from the rural to disregard it. Eighteenth-century classicism had viewed nature in human terms. "A blade of grass is always a blade of grass," wrote Samuel Johnson. "Men and women are my subjects of inquiry. . . ." The nineteenth century, however, sent the poet and painter to landscape and the study of natural phenomena in an effort to capture a fresh and original relationship to the source of universal truth; and the belief that landscape was the proper province of art became an intrinsic element in cultural nationalism. What could glorify a country better than an art which captured the beauty of its natural environment, the abundancy of its resources, and the bounteous land that God had bestowed upon it! The greatness of the country would inevitably produce a great art— "the greatest works in the world," Henry James had Roderick Hudson exclaim. "We were the biggest people and we ought to have the biggest conceptions. The biggest conceptions, of course, would bring forth in time the biggest performances." [2]

This belief was a matter of satire to James in 1875, but in the mid-century it was held with a seriousness and intensity of purpose that quickly found expression through action. Art institutions in the smaller eastern cities—Providence, Albany, Troy, Buffalo, Hartford, New Haven, and Washington, D.C.—were established and somewhat shakily maintained. The 1850's saw the movement for the establishment of schools of design for women spread from Boston and Philadelphia to the Peter Cooper Institute in New York, and west to Pittsburgh and Cincinnati, with the increased awareness among Americans that manufacturing and industry profited from training in art. The entrance of the middleman into the American art world was another indication of the growth of an interest in art, as the increasing number of artists and their works introduced an economic complexity

where once a simple relationship had existed. Men like Samuel Avery began to act as agents for artists who lived outside the large cities, and some artists, like John Kensett, began to use their studios as sales rooms. Goupil and Vibert Company set up its office in New York City in the late 1840's and carried on a brisk trade in imported works of art, particularly French; and similar developments in other cities gradually produced changes in the old system of patronage and resulted in the beginning of an impersonal art market.

The thousands of people who flocked to the art exhibitions of the Sanitary Fairs that were organized throughout the North during the crucial years of the Civil War also bear testimony to the impression that art in America had come to be regarded with favor by this time. In Chicago, for instance, 25,000 people visited the gallery during the two weeks of the fair, and to "satisfy the demands of the public" the gallery remained open two weeks longer; 1,850 tickets and 800 catalogues were sold on one day alone, while during the first five days of the fair, the profits from the sale of 7,000 catalogues were "sufficient to defray all the expenses of the Exposition." In Boston, Philadelphia, New York, Brooklyn, Cincinnati, and Pittsburgh, as well, the art galleries not only provided substantial receipts but gave many Americans, particularly those from the rural areas, their first opportunity to view some of the numerous art treasures that had been accumulated in the country during the past half-century. Visitors began to "feel the comforts of self-satisfaction" with respect to the "aesthetical attainments" of their countrymen; and of even greater importance, the numerous "noble" private collections that were now opened to the public made many patriotic citizens aware of the role art had come to play in the lives of their wealthy compatriots, and this, too, increased their respect for the fine arts.[3]

It should be noted, however, that even as late as 1860 Europeans remained unimpressed by America's achievement in the arts, and to a great extent their persistent contempt aggravated the sense of cultural inferiority that some Americans continued to experience throughout the period and their almost obsessive need to justify, explain, or praise their culture. Such an observer as the English consul in Boston, Thomas Colley Grattan, was impressed by the country's physical and material energy, but he saw little in literary or artistic achievement—even in this vaunted center of refinement—to indicate that the United States was a "civilization." To Grattan, America's mission was clearly

not intellectual; rather, it was "to clear the forests, hunt the wild beasts, scatter the savage tribes . . . till the soil, dig in the mines, and work out the rude ways of physical existence. . . ." In all this "labour of the world" there was no time or place for the tasks of the mind and spirit.[4]

There were also some Americans who were not convinced of the country's cultural advance; the fact that European artists were "encouraged and stimulated to exertion by the educated and wealthy of their native lands, and in some cases, munificently supported by their governments," while American artists remained "neglected, struggling for bread, and driven to all manner of shifts for the purpose of remaining a few years in the Temple of Art," indicated without doubt that "America was behind Europe in the cultivation of the Fine Arts." Moreover, as more sophisticated Americans began to find it possible to compare native art with the works of modern European artists (as such works flooded the country in response to the great interest manifested in art during these years) they denied the generally optimistic conclusion regarding the future of American art. To such Americans, native artists were "trained in a school of utterly false principles" and painted "in hopeless and contented ignorance of nature." It was folly to believe that in any way our "National Academicians were in advance of all Europe, to say nothing of the rest of the world."[5]

Undoubtedly, despite the successes experienced by groups interested in encouraging art and the prosperity of individual artists, the lack of widespread cultural interests in the United States during the first half of the nineteenth century not only constituted one of the obvious shortcomings of American life but especially affected the quality of its art. National immaturity, a primitive environment that demanded as well as invited exploitation, and the absence of professional institutions tended to put a high value on physical skills, amateur inventiveness, and shrewd instincts, while undervaluing education, cultural refinements, and intellectual pursuits. The lack of cultural standards and values produced easy applause and then neglect, as Americans concentrated their more strenuous efforts on more immediate interests.

If, then, American life suffered from anti-intellectualism, as a recent study has pointed out, it must also be emphasized that there existed in this country from the time of the earliest Puritan settle-

ments a counterstrain that rejected the view that non-intellectual achievements were all that the nation could expect. Americans who were educated, wealthy, and of a professional background—an elite group to be sure, but an influential one—insisted upon the importance of culture for their communities, and often against great odds maintained cultural enterprises with that end in view. It was merely "fashionable cant," remarked John Bigelow of New York in 1846, "to assume that our popular form of government is unfavorable to the highest achievements of Art; and that in a country governed like ours, by the people . . . Art must pine for want of that bountiful support which it is supposed can alone be obtained . . . by the munificence of a court and the pecuniary resources of a highly concentrated political authority." [6]

Men like Bigelow considered the fine arts to be of crucial importance to national development, actually capable of redeeming the national character itself. In such a belief, Americans of the nineteenth century were not alone; their faith had been shared by most of the western world since the Renaissance. The peculiar circumstances of American life, however, heightened—even exaggerated—the value of the fine arts for the nation. During the Renaissance, art had begun to be valued for something more than the materials out of which it was fashioned or the specific religious service it rendered. The value of a work of art became intangible even as it increased, involving not only the reputation of the artist, but the social and moral benefits it was believed capable of bestowing on the individual, the community, the principality, or the nation that possessed it. Italian princes and popes erected magnificent courts and formed impressive art collections as demonstrations of power, as well as from individual inclination, and they built splendid public buildings not only to serve civic needs but to ingratiate themselves with the public. In the face of church disapproval of worldly accumulations as sinful, and in view of its prohibition of usurious practices, merchants and financiers of the Renaissance justified their acquisitiveness by expending some of their wealth on socially desirable enterprises. Patronage of art and architecture during this period thus developed as a result of economic and political exigencies as well as the enlarged tastes and desires of powerful rulers and capitalists; it was also the product of conceptions of wealth "conditioned by the Christian medieval tradition on the nature of wealth." [7]

Americans felt a particular kinship with Renaissance merchant princes, as well as an affinity for the art produced under their patronage. Newspapers and journals enjoyed comparing American princes of trade with their Renaissance counterparts, dubbing them Cosimos or Lorenzos. Such a book as Charles Edward Lester's *The Artist, the Merchant, and the Statesman, of the Age of the Medici and of Our Own Times,* published in 1845, illustrated Americans' sense of the similarity of the two epochs; Lester hoped that his work would "excite a warmer desire . . . for the day to come when the Arts in America shall . . . take the high eminence they held in Greece under Pericles and in Florence under Lorenzo de Medici—when the Statesman and Scholar shall again be united as they were in the Council of the Free States of Antiquity and of the Middle Ages. . . ." The Reverend Boynton of Cincinnati attributed Italy's glory to "her princely merchants" and looked forward to the time when the "merchants of this young metropolis . . . by their liberal patronage of science, literature and art" would perform the same service for America. In Italy there had been no contradiction between the materialism of its society and the highest development of its artistic and spiritual life, and in Italy, too, the "epoch which witnessed the growing influence of the popular element was also marked by a great advancement in art." America's materialism and democracy were not, then, to be considered impediments to artistic development; if history pointed out lessons for the future, America's mercantile economy and republican form of government were bound to lead to a similar artistic renaissance. In fact, given the advances in science and the resources available to the artist, some Americans believed that the country was entering into an era that would surpass even "the brilliant glory of the sixteenth century." [8]

Eighteenth-century intellectual associations provided Americans with their sense of continuity with the fifteenth and sixteenth centuries, for the eighteenth century saw in its own Enlightenment a continuation of the earlier flowering that had taken Europe out of what it considered the barbarianism of the Goths into the light of Nature and Science. The eighteenth-century mind regarded the Renaissance as a high point in the progress of western civilization, and such progress was correlated with achievements in art and poetry. Thus to the enlightened English aristocracy, the creation of a great national culture in the Renaissance tradition demanded that they

become patrons of the fine arts; as a result, during what Francis Henry Taylor has called "the golden age of the Dilettanti," connoisseurship as it involved collecting of masterpieces, reached a feverish height; and this fever was justified by the insistence that connoisseurship was in the national interest. When, in 1777, the Walpole Collection was offered for sale, its purchase became the subject of a heated debate in Parliament, its defenders claiming that the purchase of such a collection by the English government would make the island "a favorite abode of the arts." Parliament failed to act, and the collection made its way to Russia to form the nucleus of the Empress' collection of art in the Hermitage. The Russian national collection and Napoleon's sacking of Italy for the benefit of the Louvre reinforced the belief that art was "an invaluable national treasure." [9]

Americans accepted the eighteenth-century conviction that culture took a cyclical course, which, as Bishop Berkeley defined it in the 1720's, was inevitably westward. The United States, therefore, stood in the vanguard of progress, destined to complete the cycle of culture begun long ago in the East; as heirs to the Renaissance tradition, historically-oriented Americans were intellectually and psychologically convinced that they were obligated to carry on and extend these traditions in the New World.

Of even greater importance to Americans in confirming their belief that the encouragement of the fine arts contributed to the national purpose was the conception of Taste articulated by British eighteenth-century philosophers. As these writers—Burke, Kames, Hume, Reynolds, Knight, Stewart, and Shaftesbury—argued the case, Taste became an aspect of the study of philosophy, and, like philosophy, it had as its aim the formation of the mind and the development of more moral behavior. These men did not doubt that there was a standard of Taste which was universal, a true Beauty for which an appreciation could be cultivated once the rules were learned. "Right" Taste could be taught or demonstrated, and the end of such teaching was greater refinement for both the individual and the nation. Taste, therefore, possessed social consequences; and art, which was the basis for Taste, became a moral and spiritual treasure as much as an economic one—in both respects it had deep import for the nation that patronized it.

The eighteenth century limited the pleasures of Taste to the aristocracy of wealth and education because of its emphasis on connoisseurship. Connoisseurship demanded not only an appreciation

of the art and rules of the great masters but assumed an experienced comparative knowledge of paintings and sculpture as these had developed historically. Such appreciation and knowledge could come only through constant exposure to and intimate examination of great art works, and for this, travel and collecting on a grand scale were requisite. To Americans whose country held few of these great works of art and whose limited wealth and leisure time prevented them from taking extended trips abroad and, more important, from purchasing the expensive works of the great masters, such connoisseurship was impossible except for the few. As late as 1870 Americans of aristocratic tastes, like Charles C. Perkins of Boston, despaired of the country's ever accumulating such essential treasures for connoisseurship, such "gems of art" as those which adorned the cathedrals of the Middle Ages and which "are now our masters in aesthetic cultivation." The "ideal" museum was "impossible" for a long time to come, said Perkins; a "Louvre is out of our reach." Since American art did not provide "fit implements for the instruction of a nation in art," a museum devoted entirely to native works was undesirable; and therefore, to the conservative Perkins, connoisseurship had to give way to a more simple education in art based on watercolor and photographic reproductions of the great works, and on casts and metallic objects illustrating architecture, sculpture, and paleography "from the Pyramids down to A.D. 1700." [10]

Some Americans in the prewar period would have agreed with Perkins, but generally those who accepted the eighteenth-century belief in the importance of Taste, finding connoisseurship impossible in this country, came to the conclusion that it was actually undesirable. In their efforts to establish the fine arts in America, they asserted native traditions, *American* Taste, the basis for which was "one's own good eyes and untaught good sense," that "critical faculty [which] has its source altogether in Nature . . . [and which] pleases all classes, and in all ages." In short, they turned to a native and contemporary art based on a fresh observation of the American environment, instead of on replicas of past ages, to provide what they conceived to be the proper and democratic basis for improving and refining taste. The nineteenth-century concept of national culture as defined by the French and German schools may have influenced such Americans in this direction, but so did the democratic ethos which received its fullest articulation between 1820 and 1860. In this period

of "national enthusiasm," Americans had little doubt that the country would eventually "throw her influence over the Earth, not by hugeness of dimensions, not by armies or fortifications, nor by all physical powers combined," but by "the living power of thought," by its "intellectual and moral grandeur." Such a belief developed the corollary that only Americans could express the American idea; only an artist "whose life has been passed under the influence of [republican] institutions" could possess the feelings that would enable him to do justice to the "national soul." Encouragement of native art and artists became then a matter of political duty for Americans if the country were to expand the areas devoted to freedom and democracy in the world.[11]

—2—

Because the fine arts were considered to be of educational and moral value, certain tastes in art inevitably appeared which, for the most part, satisfied the needs and aspirations of an emerging capitalist class. Optimism, health, cheerfulness, morality, and democracy were the qualities most desired in American painting and sculpture. An art that embodied such specific qualities emphasized, of necessity, subject matter over form, "the idea"—which to Emerson and his contemporaries constituted the "essence of art"—over "rules" of form. The "technical or mechanical part of painting," American artists were told by their patrons and critics, "may, indeed, be studied and carried to great perfection by itself alone, but all that is intellectual or animated in the art must be nourished by literature, and the habit of contemplating nature with a philosophic or a poetic eye." It was the "emanation of mind" conveyed by a great work, the "mental cultivation" and "education" displayed by the artist, and the elevation that resulted from "historical and poetical associations" that Americans admired. In the emphasis upon art as teacher, rather than art as experience, "mechanics" gave way to sentiment, technique to story.[12]

Nineteenth-century Americans also stressed intelligible subject matter in art as most appropriate for a democracy. An art that was, as Emerson put it, "called out by the necessity of the people" had to include what was important for the education of that people; in particular, what people required from art was a realization of the beautiful in the commonplace: "the meal in the firkin; the milk in the

pan; the ballad in the street." The painter William S. Mount, who of all the artists of this period was probably best able to capture the commonplace and render it beautifully, wrote in a similar fashion:

> Painting of familiar objects has the advantage over writing *by addressing itself to those who cannot read or write of any nation what-so-ever*. It is not necessary for one to be gifted in language to understand a painting if the story is well-told—It speaks all the languages—is understood by the illiterate and enjoyed still more by the learned.[13]

Since intelligibility was an important characteristic of an art of the commonplace, the American democratic aesthetic rejected complicated symbolism as being neither suitable nor beautiful. According to this belief, art could never be great if its meaning was private and obscure. Realism in detail was essential, but realism did not embrace a naturalistic conception of subject; rather, it meant an easily comprehensible and accurate rendition of natural or human forms. Subject matter, on the other hand, had to be idealized if art were to bring about "the reconciliation between . . . essential parts of human life and Divine Providence." When Bingham's *The Jolly Flat Boatmen* was selected by the American Art-Union as the engraving for distribution in the year 1846, the *Literary World* deplored the choice —"the very name of which gives a death blow to all one's preconceived notions of 'HIGH ART.'" The picture contained "no redeeming sentiment of patriotism," nor did it provide "a standard of taste"; in other words, the subject matter of the painting was unrefined. The painting by Daniel Huntington of the *Sybil*, which was also to be engraved by the Art-Union that year, was, however, considered to "amply atone for all that the other may lack."[14]

An art that aimed at the idealization of reality did not provide for the nude figure unless, as in Hiram Powers' *The Greek Slave* or his *Eve*, "exposure" served a purpose other than "beauty." The nudity of *Eve* was justifiable because it was faithful to history; moreover, it embodied the *American* conception of womanhood—"with *intellect* as well as *passion*, with *thought* as well as *feeling*." *The Greek Slave* could be accepted because of her "helpless constraint." Both nude statues awakened "moral emotions." But, "can that be right in a statue," asked the Reverend Orville Dewey in a tone that characterized American thought upon the subject though there were some

dissenters, "which would be wrong, improper, disgusting in real life?"

> . . . suppose that an epic poem, for the sake of heightening the charms and attractions of its heroine, should describe her as walking about naked! Could it be endured? . . . And I doubt not that the ancient art would have given us more examples of this kind if the moral delicacy had been equal to the genius that inspired it. I trust that Christian refinement . . . will supply the deficiency.[15]

According to Dewey, *The Greek Slave* was not only proper because Powers had made "the appeal to the soul entirely control the appeal to sense," but beautiful, because it was "characterized by a most remarkable simplicity and chasteness. . . . No extravagance, no straining after effect, no exaggeration. . . ." On the other hand, Brown's nude statuette of an Indian warrior, twenty copies of which were distributed by the Art-Union in 1849, was heartily protested by some articulate Americans as being improper. The statuette, wrote one irritated correspondent to the *Providence* (R.I.) *Journal*, may have been a "beautiful work of art" and the "workmanship . . . excellent," but to "exhibit a figure like this entirely nude, in our parlours would be going farther than they would go in France or Italy"; this "severe representation . . . of naked figures may do well enough . . . in a gentleman's private library, or on the mantle piece of a bachelor; but imagine a beautiful young lady drawing such a thing as this. . . ."[16]

Most American artists of the mid-nineteenth century were quite willing to conform to such chaste tastes; indeed, the agreement that existed for the most part between artist and patron in matters of taste is noteworthy. Artists may have complained about prices received, lack of patronage, neglect by the government, but seldom did they complain about being misunderstood in their intention or frustrated in their creative purposes. Not so much because they found economic profit in conforming as because they participated in the same religious and social environment did American artists of the mid-century paint the kind of pictures and sculpt the kind of statuary that found warm receptivity among American patrons. In turn, American patrons may have criticized the technique of an artist, or the lack of finish in a painting, or the un-American locale or subject matter; but otherwise

they found in the art of their period, with its tight realism, pious sentiments, moral didacticism, and simple symbolism made trite by repetition, satisfactory aesthetic experiences that pampered their sense of national well-being and heightened confidence in their taste.[17]

Although throughout the first half of the nineteenth century Americans emphasized nationalism in art and extolled the virtues of encouraging a native tradition, it would be misleading to suppose that native works constituted their sole source of aesthetic appreciation. Nationalism tended to stress the importance of native art, but a national art could be cosmopolitan art and was not necessarily limited to American scenes or American history. Cultural nationalism maintained that an appreciation of art was necessary in order to develop in Americans values which it was believed needed further encouragement—values of a spiritual and intellectual nature. As the century rolled toward the crucial mid-point and as American society became more and more complex in its class structure, the question of whether such values were to result from an art that was strictly American in subject matter or from art of a more general nature depended for its answer upon personal inclination, reflecting social and economic status rather than theoretical belief. During the first three decades of the nineteenth century, Americans of large wealth and established social position had emphasized European Old Masters together with some choice American works, but men of newer wealth, who had risen from middle-class positions, showed a greater preference for American scenes, American subjects, American ideas, and usually the work of American artists. The succeeding generation of patrons bought American paintings as a matter of course, but were not at all averse to purchasing European works as well. Like their predecessors, however, they believed that by their activities they were promoting the cause of art in America.

One has only to examine the collections of wealthy Americans to realize that by 1860 the taste for art had expanded beyond the narrowly native. William H. Aspinwall's collection in New York was typical of those owned by New Yorkers of similar wealth and background; it consisted primarily of modern academic French, Flemish, and German works, the whole collection crowned by the proud possession of "a Murillo of which New York may well be proud." Many of these paintings, although bearing the signatures of the most reputable European artists of the day, were scarcely different from the

paintings of the younger Americans who had received their schooling in the academies of Paris, Dusseldorf, and Munich; what the European label represented was not a question of taste, but the expenditure of large sums of money that testified to the opulence of their possessors. In the absence of truly valuable Old Masters, such works provided status and prestige for Americans who were relatively uneducated in the arts and who were still colonial enough in spirit to believe in the superiority of European talent over American, despite all that had been said and done to support a native culture; at the same time these European-influenced Americans could justify their purchases by stressing the propriety of bringing art to America.[18]

Illustrative of the closeness between the Dusseldorf and Parisian artists on the one hand and American taste on the other is the revealing travel diary of Divie Bethune Duffield of 1855. Duffield was a young lawyer who was making the traditional Grand Tour before settling down to a prosperous practice in Detroit. His enthusiasm for the work of the Dusseldorf painters—whom he enjoyed more than he had the "large galleries of paintings in England or France"—resembles the kind of enthusiasm experienced by earlier travelers like John R. Murray as they faced for the first time the masterpieces of Renaissance art. Duffield's aesthetic response consisted of lengthy descriptions of the paintings that caught his fancy, detailing the narrative tediously but with delight in the obvious humor of such genre scenes as *The Schoolmaster* by Tideman, or Carl Hubner's *Asking the Father*. "Would that our rich Americans would procure some of these choice productions of eminent Artists!" Duffield exclaimed to his diary. And procure them they did, in such large quantities that during the exhibition of art held in conjunction with the Patriotic Fund Sale of 1861 in New York City, simple folk viewing these works for the first time exclaimed to each other over the enormous output of the artist "Mr. Dusseldorf"![19]

American collectors of the mid-century seldom ventured beyond the academic confines of European art circles. Like their European counterparts in Paris, Brussels, and The Hague, they remained conservative and traditional, even when patronizing modern artists. One or two exceptions to this pattern of patronage occurred. A cosmopolitan and widely traveled individual like August Belmont of New York, for example, reflected the tastes of his time with a collection that consisted almost entirely of academic French, German,

Belgian, and Dutch paintings; but Belmont, unlike his compatriots—
and, for that matter, unlike members of his class in Europe—found
merit in the Barbizon School of painters; the work of Troyon, Millet,
Théodore Rousseau, Corot, Dias, and Dupré appeared in his gallery as
early as 1857, although the vogue of the Barbizon group in New York
did not begin until about 1880. As little understood here as in their
native land, the Barbizon painters fared badly when in 1858 the
London art firm of Gambart & Company sent over nearly one
hundred canvases by members of the group. Their representative was
unable to dispose of the paintings except at incredibly low prices; and
in 1864, a cautious New York buyer was reported to have secured
from another hard-pressed foreign salesman twelve landscapes by
Corot for three hundred dollars.[20]

James Jackson Jarves and Thomas J. Bryan were two other
Americans who did not conform to the general pattern of American
collecting in the mid-century. Bryan could not even give away his
series of Old Masters of the French, Flemish, Spanish, and German
Schools—a collection consisting of about two hundred fifty pictures
valued at over one hundred thousand dollars. The Pennsylvania
Academy turned down his offer of the collection in 1858 even though
the committee sent to New York to examine it reported that the gift
of the paintings should be accepted because "while not popular," they
were "of great educational value." Bryan was finally able to wear
down the resistance of New Yorkers by sheer perseverance in
keeping his gallery open to the public, and in 1864 the New-York
Historical Society accepted it. Similarly, Jarves had difficulty dispos-
ing of his collection of Italian "Primitives," and after suffering much
humiliation at the hands of the trustees of the Boston Athenaeum, he
finally sold it in 1864 to Yale University for much less than its value.[21]

These collections failed to win the approval of Americans, not
because the paintings were European, but because they lay outside the
styles and subject matter of the accepted schools, both European and
American. The fact is that the wealthier and therefore more powerful
classes of Americans continued to buy the acceptable European
paintings, both old and modern; and that they did so during a period
when the concept of "national culture" was being most stridently
articulated by the North and West especially, suggests the difficulties
under which Americans labored when they attempted to give mean-
ing to a theory which was plainly inconsistent with the facts of their

national life. When Herder and Fichte, for example, articulated a theory of national culture, they rooted it in a faraway mythical past, finding in the nation's folkways fundamental national characteristics. America had no such past; national culture could not be derived from indigenous sources, and instead, Americans had to look to the future to develop what should have grown unconsciously from the very center of their national life. What would go into that culture, of what it would consist, they were not certain. They talked in terms of landscape, environment, and traits of character that resulted from free institutions. But the art that resulted from these ingredients seemed wanting when compared to the glorious achievements of Europe in the past, and it seemed naive when compared to the finished products coming from the contemporary European schools. Europe was still too strong a force for cultivated Americans to reject; and the superiority of European civilization emerged as a constant fact that they had to recognize, whatever they thought of European politics and society. Perhaps this explains why some wealthy and educated Americans continued to buy European paintings while at the same time professing intense nationalistic sentiments. Their example was imitated by the newcomers to wealth and culture who, freely admitting that they possessed "no familiarity with works of art," continued to "snap eagerly at . . . dingy old masters . . . without judgment or taste." [22]

There is another paradoxical aspect of American nationalism during these years. National unity, in the early decades of the nineteenth century was a potential, a state considered desirable but still to be attained; it was obvious to all intelligent observers during the last years of the decade of the 1850's, however, that national unity was not yet a completed fact. Disunion hung over every political argument, sectional loyalties still superseded national patriotism, and when the final test came in 1861, many of the businessmen of the North opted for sectional economic interests—tariffs, navigation acts, a transcontinental railroad, and the like—which they easily rationalized as being in the national interest. In the movement to encourage national art, the same pattern existed. Cities and localities vied with each other in establishing art institutions and encouraging artists to take up residence, and the local interest was identified with the national interest. National art meant, in the long run, regional or local art—something which Nathaniel Hawthorne or Henry Thoreau well

understood when they limited their area of literary concern to New England rather than to the vast and nebulous United States. The popular New England novel *Margaret* by Sylvester Judd also indicates how the regional could be mistaken for the national. A review of the novel pointed out the "national importance" of the work as "the most truly indigenous of our American fictions"; and a few months later, Samuel Osgood, also in a review of the book, emphasized the fact that it illustrated the New England character and mission, both of which he identified with the national.[23]

If the North remained nationalistic, it saw itself as the embodiment of the American character and regarded its own society and culture as the best manifestations of the national spirit. Such a society emphasized middle-class traits which the art it encouraged—whether from Europe or from the easels of natives—admirably embodied. It was not truly a national art that resulted, in that it expressed all the characteristics of the various regions of the country; rather, it was an art that expressed what northern Americans in comfortable circumstances, whose involvement was mercantile and industrial rather than agrarian, pictured in their minds as best characterizing the spirit of the American nation. It was a northern self-image that they mistook, or willingly accepted, for a national image; and in this sense, the way in which northerners approached art parallels the manner in which they met the Union's political disruption when it was upon them—with a reassertion of northern values, which they called *national*, rather than with a willingness to face the consequences of recognizing that the Union was made up of different regions with different systems of values in which they did not always share.

The art that northern Americans enjoyed, whether European or American, was an art that made very little comment about the domestic, social, or political scene. European peasants in colorful costumes were exotic and therefore artistic in their eyes, far removed from the crowds of Irish immigrants pouring into their cities and creating new social and political problems. The beautiful and grandiose Alpine scenes, the quaint interiors, castles, cottages, and villages, the grandiose historical, literary, and religious compositions—all may have been "uplifting" and "elevating," but they were remote from questions of slavery expansion, city crowding, incipient labor problems, and the general drabness of American life in the mid-century, when industrialism was just beginning to leave its ugly marks on the

young society. Oliver Wendell Holmes, who observed the American social scene with little enthusiasm, noted in 1840 that "the mountains and cataracts which were to have made poets and painters, have been mined for anthracite and dammed for water power"—a condition which became more and more prevalent in the following decades. And, as Holmes dryly noted, anthracite rather than art, in the long run, would exert the greatest effect on the American character.[24]

The relationship, then, between nationalism and art in the United States in the pre-Civil War period is a close one, but also a many faceted one. If the nationalism of the period was to a considerable extent the expression of a wish to achieve greater coherence as a community and nation, underlying the nationalistic protestations lay uncertainty about the fate and future of the country and the federal experiment it embodied. The forces for disunion were stronger than the forces for union; and the nation's hope, which took on the strength of a belief, was that a national culture would act where political agreements might fail. A national culture would produce a national character; and where nations existed "equal in all the means and appliances of civilization," that nation which had "the superior unity of national character cannot fail far to outstrip the other in its career of improvement, of happiness and true glory." The "native soul" could best be expressed by an "American school of art," and "the want of a national feeling" on the subject of art possessed serious consequences not only for the "progress of art among us," but for the development of a truly national spirit.[25]

It is significant that cultural nationalism emanated from those regions where national unity was regarded as a desirable and beneficial condition, and, of course, native and contemporary art received its greatest stimulation in these regions. Where nationalism was rejected for sectionalism, there American art received little encouragement—until sectionalism became southern nationalism and the South began to think of itself as a culturally distinct area. Only then did the South realize the necessity for cultural independence from the North, and southerners who smarted under what they considered a condition of economic and political subservience also began to lament their cultural colonialism. "It has too long been a reproach to us," mourned the *Southern Literary Gazette* in 1848, "that we not only derive our Paintings and Statuary from the North and from Europe, but even form our conceptions of excellence in these departments by

the standard of others." Nationalism in the South, however, had too little time to function to reveal what cultural results it might have produced had it been permitted to take its natural course.[26]

Whether there is any significant relationship between the changes in taste that began to show themselves by the 1850's and the violent disruption of nationality that resulted in civil war can only be a matter of conjecture. Certainly, the fact that by 1860 art collections of important eastern businessmen and northern political and social leaders revealed a lessening of interest in native art and an increase in attention to European art, in disparagement of the home product, is suggestive. The replacement of the American Art-Union by the Cosmopolitan Art Association in the 1850's, with its emphasis on "the works of many lands," and the prosperity of the Goupil, Vibert Company in New York, which dealt in the sale of French paintings primarily, are perhaps symptomatic of the change that was taking place in American nationalistic thought generally. As the urgent sense of the need to develop a truly national art weakened, cultural nationalism lost its potency as a determining force in the art life of the nation; and although interest in art remained alive, encouraging native artists seemed less important.[27]

Enough had been done, however, by men and women acting under the stimulation of the nationalistic spirit to create a sufficient taste for the fine arts so that during the decades following the Civil War, Schools of Design, art museums, and artists' organizations could be successfully founded and maintained—and this during a period in which the predominant note in the country's civilization was materialistic. If the Civil War and the culturally bleak decades that followed tended to interrupt and obscure the achievement of the early nationalists, their achievement was, nonetheless, an important one; within the limits of their times and tastes, they propagated in their communities a sense of the cultural possibilities of the fine arts and of the community's responsibility for their development; and they extended to this country western art traditions linking American art to its European past and bringing American society into the larger sweep and context of western civilization.

REFERENCE MATERIALS

REFERENCE MATERIAL

NOTES

PART I APOLOGIA FOR THE ARTS

1. *American Museum or Universal Magazine* (Philadelphia, 1787–92), X (August,1791), 74; XII (February, 1792), 71.
2. Quoted by F. O. Matthiessen, *The American Renaissance* (New York, 1941), p. 159. See also Harriet Martineau, *Society in America* (London, 1839), I, 209–10, 212–13; II, 175.
3. Robert E. Brown, *Middleclass Democracy and the Revolution in Massachusetts, 1691–1780* (Ithaca, N.Y., 1955), chap. 1; Hector St. John de Crèvecoeur, *Letters from an American Farmer* (London, 1940), pp. 39–42, 55; Carl Bridenbaugh, *The Colonial Craftsman* (New York, 1950), *passim*.
4. Jean Lipman, *American Primitive Painting* (New York, 1942); Jean Lipman, *American Folk Art in Wood, Metal and Stone* (New York, 1948); Mary Newton Stanard, *Colonial Virginia, Its People and Customs* (Philadelphia, 1917), pp. 316–18; Dixon Wecter, *The Saga of American Society* (New York, 1937), pp. 22–26; James T. Flexner, *First Flowers of the American Wilderness* (Boston, 1947), chap. 3 *passim*.
5. Carl Bridenbaugh, *Cities in Revolt* (New York, 1955), p. 172; Flexner, *First Flowers of the American Wilderness*, p. 175; Virgil Barker, *American Painting* (New York, 1950), pp. 3–189 *passim*. For colonial interest in portraiture, see C. K. Bolton, *The Founders . . .* (Boston, 1919), three volumes of portraits of colonial figures.
6. J. S. Davis, *Essays in Earlier History of American Corporations* (Cambridge, Mass., 1917), II, 31, 296–97; Rita S. Gottesman, *The Arts and Crafts in New York, 1726–1776* (New York, 1938), *passim;* G. F. Dow, *The Arts and Crafts in New England* (Topsfield, Mass., 1927), *passim;* William Kelby, *Notes on American Artists, 1754–1820* (New York, 1922), *passim;* A. C. Prime, *The Arts and Crafts in Philadelphia,*

Maryland, and South Carolina (Topsfield, Mass., 1929), *passim;* Barker, *American Painting,* p. 325; H. W. French, *Art and Artists in Connecticut* (Boston, 1879), pp. 31–33; *Connecticut Portraits by Ralph Earl* (New Haven: Yale University Art Gallery, 1935); Frank A. Bayley, *Life of John Singleton Copley* (Boston, 1915), p. 7; Harold E. Dickson, *John Wesley Jarvis* (New York, 1949), chaps. 9 and 10.

7. *Travels in North America . . . 1800–1801–1802* (New York, 1828), translator's note, pp. 138–39.

8. Walter B. Smith and Arthur Cole, *Fluctuations in American Business, 1790–1860* (Cambridge, Mass., 1935), pp. 30–31; *North American Review,* II (November, 1815), 136; II (January, 1816), 153–64.

CHAPTER 1 THE NATIONALIST APOLOGIA

1. Jared Sparks, *The Life of Gouverneur Morris* (Boston, 1832), III, 143–44. The literature on early American nationalism is vast. Noteworthy are Hans Kohn, *American Nationalism* (New York, 1957), chap. 1 and *passim;* Benjamin Spencer, *The Quest for Nationality* (Syracuse, N.Y., 1957), chap. 1 and *passim;* Max Savelle, *Seeds of Liberty* (New York, 1948), chap. 10; Russel B. Nye, *The Cultural Life of the New Nation, 1776–1830* (New York, 1960), chap. 2.

2. Merle Curti, *The Growth of American Thought* (New York, 1943), pp. 138, 153–54; Merrill Jensen, *The New Nation* (New York, 1950), pp. 89–110; Gallatin to Matthew Lyon, May 7, 1816, in Henry Adams (ed.), *The Writings of Albert Gallatin* (Philadelphia, 1879), I, 700.

3. Horatio Greenough to R. C. Winthrop, Gräfenberg, Austria/Silesia, November 26, 1844, F. B. Greenough (ed.), *Letters of Horatio Greenough to his Brother Henry Greenough* (Boston, 1887), pp. 180–83; U.S. Congress, *The Debates and Proceedings in the Congress of the United States, 1789–1824* (Washington, D.C., 1834–56), 14 Cong., 2 Sess., p. 854. (Hereafter cited as *Annals of Cong.*)

4. Joseph Dorfman, *The Economic Mind in American Civilization, 1606–1865* (New York, 1946), II, 593; Everett is quoted in Spencer, *Quest for Nationality,* p. 52; David Hosack, *Memoir of DeWitt Clinton* (New York, 1829), pp. 419–20. See also DeWitt Clinton, "Address before the American Academy of the Fine Arts . . . , October 23, 1816," in Thomas Cummings, *Historic Annals of the National Academy of Design* (Philadelphia, 1865), pp. 7–17. For statements about the relation of political freedom to the development of the arts, see the *Literary Gazette or Journal of Criticism, Science and the Arts,* I, 769–75; Edward Everett, "The Circumstances Favorable to the Progress of Literature in America,"

Orations and Speeches on Various Occasions (Boston, 1895), I, 9–44; *North Amer. Rev.*, XX (April, 1825), 417; Clinton, "Address Before the American Academy," in Cummings, *Historic Annals*, p. 11. For a discussion of the relation of literary nationalism to political and economic ideas, see Spencer, *The Quest for Nationality*, pp. 27, 71–72, and *passim;* for a discussion of nationalism in America generally, with relation to political ideas, see Kohn, *American Nationalism*, p. 28 and *passim.*

5. *Literary Magazine and American Register*, III (March, 1805), 181; J. P. Brissot de Warville, *New Travels in the United States of America* (1788), quoted in Oscar Handlin, *This Was America* (Cambridge, Mass., 1949), pp. 73–74; LeChevalier Felix de Beaujour, *Sketch of the United States of North America* (London, 1814), quoted in *North Amer. Rev.*, II (November, 1815), 88–89; Thomas Hamilton, *Men and Manners in America* (Philadelphia, 1833), I, 364; Charles Dickens, *American Notes* (New York, 1842), II, 297; Francis Hall, *Travels in Canada and the United States in 1816 and 1817* (Boston, 1818), p. 175; Henry B. Fearon, *Sketches of America . . .* (London, 1819), p. 390; *Edinburgh Review*, XXXIII, 78–80. For typical reactions of travelers to American vanity, see Frances Trollope, *Domestic Manners of America*, ed. Donald Smalley (New York, 1949), p. 423; "On the National Vanity of Americans," by a French traveler, in *North Amer. Rev.*, II (November, 1815), 82–87; Hamilton, *Men and Manners*, II, 378.

6. "An Essay on American Genius," in *New Haven Gazette and the Connecticut Magazine*, February 1, 1787, quoted in Jensen, *The New Nation*, pp. 91–92; C. F. Adams (ed.), *The Memoirs of John Quincy Adams* (Philadelphia, 1874–77), I, 98–99 (March 18, 1795); "On Collections of Paintings," *Lit. Mag. and Amer. Reg.*, III (May, 1805), 374–75; Ferris Greenslet, *The Lowells and their Seven Worlds* (Boston, 1946), pp. 141–42; Morse to his parents, London, March 1, 1814, Morse Letters, Library of Congress; *Analectic Magazine*, VI (September, 1815), 255; Clinton, "Address Before the American Academy," in Cummings, *Historic Annals*, p. 12; also see E. Everett, "The History of Grecian Art," *North Amer. Rev.*, XII (January, 1821), 179; *Transactions of the Apollo Association for the Promotion of the Fine Arts . . . , December 16, 1839* (New York, 1839), pp. 5–6; Preamble to the "Prospectus of Mr. Paff's Gallery of Paintings" (1812), New-York Historical Society.

7. Franklin is quoted in Constance Rourke, *The Roots of American Culture and Other Essays* (New York, 1942), p. 1; *Lit. Mag. and Amer. Reg.*, VI (July, 1806), 77; Charles Jared Ingersoll, *A Discourse Concerning the Influence of America on the Mind* (Philadelphia, 1832), p. 35. Sparks's review of the book appeared in *North Amer. Rev.*, XVIII (January, 1824), 162. See also Eleanor D. Berman, *Jefferson Among the*

Arts (New York, 1947), p. 51; Clinton, "Address Before the American Academy," in Cummings, *Historic Annals*, p. 8.

8. C. F. Adams (ed.), *Familiar Letters of John Adams and his Wife, Abigail Adams* (New York, 1876), pp. 334, 381. Adams, however, foresaw that the arts might become a natural field of activity for his grandchildren. "To the Democrats of the County of Greene," *Catskill* (N.Y.) *Recorder*, June 25, 1840. The idea that the fine arts were immoral "because they were all liable to great abuse, because they often pander directly to vice, because the pleasures received from them . . . are of a *sensuous* character . . . and because they have flourished among corrupt and degraded nations" was argued well into the period. This quotation is from a review of Mark Hopkins' *The Connexion Between Taste and Morals* (1842) and expresses Hopkins' thesis (*North Amer. Rev.*, LIV [January, 1842], 232–33).

9. "Some Observations on Pictures: With a Proposal," *South Carolina Weekly Museum*, I, No. 22 (June 3, 1797), in Anna Wells Rutledge, *Artists in the Life of Charleston, Through Colony and State from Restoration to Reconstruction* (Philadelphia, 1949), p. 137; Samuel Young to Gulian C. Verplanck, Ballston, July 12, 1824, Verplanck Papers, NYHS; E. and J. Everett, "Review of *Letters on the Eastern States*," *North Amer. Rev.*, XI (July, 1820), 36; William Tudor, "An Institution for the Fine Arts," *ibid.*, II (January, 1816), 156, 157, 158; Daniel Drake, *Anniversary Discourse on the State and Prospects of the Western Museum Society . . . June 10, 1820 . . .* (Cincinnati, 1820), pp. 23–24; "On Literary Institutions," *North Amer. Rev.*, VII (July, 1818), 274.

10. Robert Streeter, "Association Psychology and Literary Nationalism in the *North American Review*, 1815–1825," *American Literature*, XVII (November, 1945), 243–54, has reached a similar conclusion with respect to literature; see also Spencer, *Quest for Nationality*, chap. 1 *passim*.

11. Carl L. Becker, *The Heavenly City of the 18th Century Philosophers* (New Haven, 1932), pp. 64–65, 84–85; Hector St. John de Crèvecoeur, *Letters from an American Farmer* (London, 1940), p. 16; Lord Shaftesbury, *Second Characters* (Cambridge, 1914), pp. 22–23; Lord Kames, *Elements of Criticism* (New York, 1883), pp. 25, 26. See also "Albany Gallery of Fine Arts," 1847 (Art-Union book of newspaper clippings, NYHS), for the way in which Americans, to justify art institutions, utilized Kames's dictum that "an appreciation of the beautiful and true is closely allied to the moral sense, and he who learns to look with admiration upon a work of art, as a natural consequence must admire and learn to imitate a virtuous action. The painter thus becomes a moral teacher."

12. Carl Bridenbaugh, *Cities in Revolt, Urban Life in America*,

1743–1776 (New York, 1955), pp. 172–82, 208–9; Nye, *The Cultural Life of the New Nation,* chaps. 1 and 2, discusses the influence of the Enlightenment on other areas of American thought. For a denial of the influence of the Enlightenment, see Daniel J. Boorstin, *The Americans, the Colonial Experience* (New York, 1958), pp. 149–58, and *America and the Image of Europe* (New York, 1960), chap. 3; William Charvat, *The Origins of American Critical Thought, 1810–1835* (Philadelphia, 1936), pp. 5–6; Van Wyck Brooks, *The Flowering of New England* (New York, 1936), pp. 17–18; Eleanor D. Berman, *Thomas Jefferson Among the Arts* (New York, 1947), chaps. 2–4, discusses the influence of these English aesthetic philosophers on Jefferson's ideas about the fine arts. For English classical influence in a southern state, see Rutledge, *Artists in the Life of Charleston,* p. 101; Everett, "The Circumstances Favorable to the Progress of Literature in America," *Orations and Speeches,* I, 41–42.

13. Van Wyck Brooks, *The Flowering of New England,* p. 2, indicates that between 1810 and 1840 Boston merchants established thirty benevolent societies or institutions in that city. Harriet Martineau, *Society in America,* II, 363, commented favorably on the benevolence of the American merchant group "which busies itself with much expense of dollars and trouble, to provide for the improved civilisation of the whole society."

14. Streeter, "Association Psychology and Literary Nationalism," *Amer. Lit.,* XVII, 243–54. Excerpts from A. W. Schlegel were printed in the *Port Folio* (2d N.S., IV [1817]); other magazines, both British and American, frequently carried translations of the "new criticism" of the Schlegels. For typical orations by the men listed, see the following: Everett, "The Circumstances Favorable to the Progress of Literature in America," *Orations and Speeches,* I, 9–44; Charles J. Ingersoll, *A Discourse Concerning the Influence of America on the Mind* (Philadelphia, 1832); William Ellery Channing, "On National Literature" (*Old South Leaflets,* Vol. VI [Boston, 1903]); Gulian C. Verplanck, *The Advantages and Disadvantages of the American Scholar* (New York, 1836); William Cullen Bryant, "Review of *Redwood, A Tale,*" *North Amer. Rev.,* XX (April, 1825), 245–72.

15. A check of early book auction catalogues in the New York Public Library's collection reveals that Reynolds was included in all the catalogues of books sold at auction which were of a general nature. See *Catalogue of Library of Major D. B. Douglass . . . sold . . . March 15, 1839,* New York, p. 4; *Catalogue of Valuable Books . . . sold 19 November* [1819] *by Mills, Minton & Co.,* Item No. 438; *Catalogue of Books to be Sold . . . by Howe & Spaulding, 2 September, 1824* (New Haven), p. 78; *Catalogue of a Valuable Private Library . . . sold . . .*

by Royal Gurley & Co., October 9 and 10, 1846, p. 15; *Catalogue of . . . Books . . . of the Late Mr. Justice Story . . . sold . . . April 3 and 4, 1846* (Boston), pp. 21, 23; *Catalogue of the Library of the Late Hon. John Pickering to be sold . . . September 15, 16, 17, 18 and September 22, 23, 24, 25* (Boston, 1846). William Dunlap, *History of the Arts of Design* (Boston, 1918), III, 242, mentions portraits by Reynolds in the Farmer family collection at Perth Amboy, New Jersey, and at Tulip Hill, Maryland, the seat of the Galloways. Reynolds' portraits were also to be found at "Carrollton," the home of Charles C. Carroll outside of Baltimore, and in other parts of the South, particularly in Charleston. For typical magazine articles, see *Analectic*, V (June, 1815), 492; VI (September, 1815), 229.

16. Ambrose Andrews to Schuyler, Great Barrington, Mass., April 8, 1825, NYHS; Joseph Dorfman, *Thorstein Veblen* (New York, 1934), p. 22. Charvat, *The Origins of American Critical Thought* (p. 30), and Streeter, "Association Psychology and Literary Nationalism" (p. 246 n.), establish Alison's popularity in this country by different methods.

17. *The Discourses of Sir Joshua Reynolds* (London, 1924), especially discourses 3 and 7, pp. 25–39, 135–60, 163–64.

18. *Analectic*, V (June, 1815), 492. For a discussion of the effect of neoclassicism on the technique and subject matter of American art during this period, see E. P. Richardson, *Painting in America* (New York, 1956), chap. 6 *passim*. For classicism in taste as it influenced the South, see Rutledge, *Artists in the Life of Charleston*, p. 101; Berman, *Jefferson Among the Arts, passim*. For Washington Allston's evaluation of Sir Joshua Reynolds as being one of three men "whose works may be said to have laid the foundation for a new era in art," see Dunlap, *History of the Arts of Design*, II, 305.

19. Archibald Alison, *Essays on the Nature and Principles of Taste* (New York, 1830), p. 33.

20. Alfred North Whitehead, *Science and the Modern World* (New York, 1925), p. 22; Basil Willey, *The Eighteenth Century Background* (London, 1949), chap. 12 *passim*; William P. Hudson, "Archibald Alison and William Cullen Bryant," *Amer. Lit.*, XII (1940), 59–68; Reynolds, *Discourses*, pp. 85–88; Alison, *Essays on Taste*, p. vii. See "Connoisseurship and its Pleasures," *Lit. Mag. and Amer. Reg.* (May, 1806), V, 32, 365, for the way in which an American writer related Reynolds and associationism intimately. "The taste for the [Fine Arts] is, as Sir Joshua Reynolds has observed, entirely acquired, and acquired by the association of ideas. . . ."

21. Clinton, "Address Before the American Academy," in Cummings, *Historic Annals*, p. 12.

22. *North Amer. Rev.*, VIII (December, 1818), 173–74.

23. As late as 1857, associationist aesthetics were appealed to by a writer in the *Cosmopolitan Art Journal* (I, No. 4 [June, 1857], 116), who wished to point out the "Errors as Regards Nationality" that American painters made. Some Americans, it should be noted, who held strictly to classical doctrine never accepted Alison's idea that beauty was derived from its resemblance to emotions or things we know. For an American critique of Alison, see F. W. Winthrop, "Remarks on Beauty and Taste," *North Amer. Rev.*, VII (May, 1818), 1–25.

24. "On Collections of Paintings," *Lit. Mag. and Amer. Reg.*, III (May, 1805), 374; "Review of Catalogue of Pictures in the Athenaeum Gallery," *North Amer. Rev.*, XXIX (July, 1829), 258 ff.; "Remarks on the Progress and Present State of the Fine Arts in the United States," *Analectic*, VI (November, 1815), 375; "Review of First Exhibition of Paintings in the Boston Athenaeum Gallery," *North Amer. Rev.*, XXV (July, 1827), 227. In 1812, Jefferson wrote to Thomas Sully accepting Honorary Membership in the Society of Artists of Philadelphia and expressed the hope that while "embellishing with taste a country already overflowing with useful productions, [the Society] may be able to give an innocent and pleasing direction to accumulations of wealth, which would otherwise be employed in the nourishment of coarse and vicious habits." (Monticello, January 8, 1812, in Berman, *Jefferson Among the Arts*, p. 19.)

25. "Influence of Taste Upon Manners," *Amer. Museum or Universal Mag.*, XI (June, 1792), 283. The phrase "counteracting the . . . business . . . character of the community" is from "Review of the Builder's Guide . . . ," *North Amer. Rev.*, LII (April, 1841), 111, 303–4; "General Reflexions on Taste," *Amer. Museum or Universal Mag.*, XI (June, 1792), 283; "On Collections of Paintings," *Lit. Mag. and Amer. Reg.*, III (May, 1805), 374.

26. Clinton, "Address Before the American Academy," in Cummings, *Historic Annals*, p. 9; Tudor, "An Institution for the Fine Arts," *North Amer. Rev.*, II (January, 1816), 5, 163; "Review of First Exhibition of Paintings in the Boston Athenaeum Gallery," *North Amer. Rev.*, XXV (July, 1827), 227; *Analectic*, IX (March, 1818), 225. Also see *Oneida* (N.Y.) *Observer*, November 22, 1825: "Our citizens are becoming more impressed with the softening influence of the fine arts on the human mind and their consequent elevation of national character." Cf. Alison, *On Taste*, p. vii.

27. "Exhibition of Pictures at the Boston Athenaeum Gallery," *North Amer. Rev.*, XXXIII (October, 1831), 512; Tench Coxe, "Digest of Manufactures," in *American State Papers*, Class 3, Finance, II, January 15, 1814: "A Collection of Additional Facts Tending to Show the Practical Foundations, Actual Progress, Condition and Establishment of the Ameri-

can Arts and Manufactures, and their Connection with the Wealth and Strength of the United States," Part II, p. 687; Tudor, "An Institution for the Fine Arts," *North Amer. Rev.*, II (January, 1816), 162; *Analectic*, VI (November, 1815), 376; IX (March, 1818), 225; VII (July, 1816), 50.

28. *Analectic*, VI (November, 1815), 375; VII (July, 1816), 50; *North Amer. Rev.*, II (January, 1816), 163; Clinton, "Address Before the American Academy," in Cummings, *Historic Annals*, p. 14; William Roscoe, untitled statement in *Analectic*, IX (July, 1818), 225.

CHAPTER 2 THE APOLOGIA CONTINUED: EMERSON, RUSKIN, NORTON

1. Perry Miller (ed.), *The Transcendentalists* (Boston, 1953), pp. 9–10.

2. Ralph L. Rusk, *The Life of Ralph Waldo Emerson* (New York, 1949), pp. 16, 18. As minister of the First Church of Boston, William Emerson participated actively in the founding and developing of the Anthology Society, the Boston Athenaeum, the Massachusetts Historical Society, the Boston Philosophical Society, the singing society, and the Agricultural Society. He did so because he believed that it was his sacred duty to work for the intellectual as well as the spiritual well-being of his parish. (*Ibid.*, pp. 8–10.)

3. "Art" (Emerson's italics), in *The Works of Ralph Waldo Emerson* ed. J. E. Cabot (Boston & New York, 1883), II, 329. See also editor's note, II, 442. The whole tenor of Emerson's philosophy, as expressed in his orations and essays, testifies to his point of view, but specifically the following may be cited (all are from *The Works*): "Beauty," in *Nature* (1836), I, 21–30; "The American Scholar" (1837), I, 81–116; "Self-Reliance" (1841), II, 45–88; "Michel Angelo" (1837), XII, 113–42; "Art," II, 325–43, 351–63, 367–68; *The Natural History of the Intellect*, XII, 1–60.

4. "The American Scholar," *The Works*, I, 113; "The Poet," III, 40–41.

5. "The American Scholar," *The Works*, I, 86; "The Man of Letters," X, 232; *Nature*, I, 28; "The Poet," III, 20; "Art," II, 337.

6. *Nature*, *The Works*, I, 29; Justin Winsor, *Memorial History of Boston, 1630–1880* (Boston, 1881), IV, 304–5; III, 659; Rusk, *Ralph Waldo Emerson*, pp. 390, 391. For Emerson's influence in Cincinnati in the decade of the 1850's, see Louise Hastings, "Emerson in Cincinnati," *New England Quarterly*, XI, No. 3 (September, 1938), 443–69; for a contemporary evaluation of Emerson as a lecturer, see Charles I. Glicksberg, "Bryant on Emerson the Lecturer," *ibid.*, XII, No. 3 (September, 1939), 530–34.

7. *North Amer. Rev.*, LXVI (January, 1848), 110 ff.; *Journals of Ralph Waldo Emerson*, ed. Edward Emerson (Boston, 1909–14), VII, 479, 482; *Atlantic Monthly*, VI (August, 1860), 239. Howard Mumford Jones suspected Ruskin's influence on American taste in his suggestive essay, "The Influence of European Ideas in 19th Century America," *Amer. Lit.*, VII, No. 3 (November, 1935), 263.

8. *Cosmopolitan Art Journal*, I, No. 4 (June, 1857), 108. For influences on Ruskin, see Henry Ladd, *The Victorian Morality of Art* (New York, 1932), p. 26; Joan Evans, *John Ruskin* (New York, 1954), p. 87; Lester Charles Dolk, "The Art Teaching of John Ruskin in Relation to the Aesthetics of the Romantic Era" (Unpublished Ph.D. thesis, Department of English, University of Illinois, 1941).

9. Emerson, "Self-Reliance," *The Works*, II, 66; *North Amer. Rev.*, LXVI (January, 1848), 112–13; LXXXI (October, 1855), 438–39. Also see *ibid.*, LXXII (April, 1851), 320 ff.; LXXIV (January, 1852), 251 ff.; LXXIX (October, 1854), 535 ff.; LXXV (October, 1852), 567 ff. For the influence of Ruskin on Boston architecture, see Winsor, *Memorial History of Boston*, pp. 481, 482, 484. For the response of some typical young Americans to Ruskin, see Allan Nevins and Milton H. Thomas (eds.), *The Diary of George Templeton Strong* (New York, 1952), I, 354; Journals of Gamaliel Bradford V, I, 165, and *passim*. (MS in Harvard College Library); Francis Steegmuller, *The Two Lives of James Jackson Jarves* (New Haven, 1951), p. 290 and *passim*; David Dickason, *The Daring Young Men* (Bloomington, Ind., 1953), *passim*.

10. Ruskin, *Modern Painters*, Preface to 2d ed., p. 23; *North Amer. Rev.*, LXVI (January, 1848), 129; LXXXI (October, 1855), 439; LXXXIV (April, 1857), 379.

11. The comments that follow about Charles Eliot Norton (1827–1908) are based on a study of his manuscript letters in the Harvard College Library; his own published *Letters* (2 vols.; Boston, 1913); his articles in the *Atlantic Monthly* from 1858–61; and Kermit Vanderbilt, *Charles Eliot Norton, Apostle of Culture in a Democracy* (Cambridge, Mass., 1959).

12. Norton to Stillman, Shady Hill, June 9, 1855, John Durand Collection, New York Public Library; *Atlantic Monthly*, IV (December, 1859), 770; V (May, 1860), 628; VI (November, 1860), 634–35.

13. Vanderbilt, *Charles Eliot Norton*, p. 82; *Atlantic Monthly*, VI (November, 1860), 634–35; for Norton's teaching, see Vanderbilt, *Charles Eliot Norton*, chap. 7 *passim*.

14. Emerson, "Art," *The Works*, II, 343; Norton in the *North Amer. Rev.*, CVII (July, 1868), 371.

15. Vanderbilt, *Charles Eliot Norton*, p. 126. Norton recognized the

fact that art was "flourishing" in this country, that "the taste for pictures" was growing, but he found that with all the buying of pictures and the high prices paid for some, that Americans were still "ignorant," "conceited and self-sufficient," and most of all, that they lacked a refinement of "certain high faculties of the soul" which would enable them to love and appreciate beauty in its fullest revelation through works of fine art. ("Review of the Manual of the Jarves Collection," *North Amer. Rev.*, CVII [July, 1868], 371–73.)

PART II ART AND THE FEDERAL GOVERNMENT

1. Merle Curti, *The Growth of American Thought* (New York, 1943), p. 81; Samuel E. Morison, *Harvard College in the 17th Century* (Cambridge, Mass., 1936), I, *passim; Early Proceedings of the American Philosophical Society: Old Minutes of the Society from 1743–1838* (*Amer. Phil. Soc. Proc.*) XXII, 119; Constitution of Massachusetts, 1777, Chap. 5, Sec. 2: The Encouragement of Literature &c. The insertion of this section was the work of John Adams. See Dr. Kirkland's *Discourse in Commemoration of John Adams and Thomas Jefferson* (American Academy of Arts and Sciences, *Memoirs*, New Series, 1833 [Cambridge, Mass.]), I, xxiii.

2. J. C. Fitzpatrick (ed.), *The Writings of George Washington* (Washington, D.C., 1931–44), XXX, 307–8; James D. Richardson (ed.), *Messages of the Presidents* (Washington, D.C., 1896), II, 311; Brooks Adams, *The Degradation of the Democratic Dogma* (New York, 1919), pp. 26–28, 57–59; *Annals of Cong.*, 11 Cong., 3 Sess., pp. xix, 1414; 14 Cong., 2 Sess., pp. 16–17; 17 Cong., 2 Sess., p. 17. In his first Annual Message, Adams asserted that the powers of Congress to promote the general welfare justified "laws promoting the improvement of agriculture, commerce, and manufactures, the cultivation and encouragement of the mechanic and of the elegant arts, the advancement of literature, and the progress of the sciences, ornamental and profound. . . ." Not to act on such constitutional power would be, he concluded, "to hide in the earth the talent committed to our charge"; it would be "treachery to the most sacred of trusts."

3. House of Representatives, Committee Report on National University, February 15, 1811, in *Annals of Cong.*, 11 Cong., 3 Sess., pp. 976–77. Also see *American State Papers*, Class X, Misc., I, 725, 740; *Annals of Cong.*, 1 Cong., 1 Sess., pp. 961, 967, 968, 975; 2 Cong., 1 Sess., pp. 1431–35; 5 Cong., 1 Sess., p. 1200; 7 Cong., 1 Sess., p. 705; *Register of Debates*, 18 Cong., 2 Sess., p. 548; 19 Cong., 1 Sess., pp. 819–21; 20 Cong., 2 Sess., pp. 50–52; DeWitt Clinton, "Address Before the American

Academy," in Thomas Cummings, *Historic Annals* (Philadelphia, 1865), p. 9.

4. Edward Everett, "The Circumstances Favorable to the Progress of Literature in America," *Orations and Speeches* (Boston, 1895), I, 13.

5. William Dunlap, *History of the American Theatre* (New York, 1832), pp. 28, 404–5, and his *History of the Arts of Design in the United States* (Boston, 1918), I, 7–11; "Portions of Essays and Lectures," Cole Papers, New York State Library.

6. Rufus King to Christopher Gore, January 7, 1817, Rufus King Papers, NYHS; John Trumbull, *Letters Proposing a Plan for the Permanent Encouragement of the Fine Arts by the National Government Addressed to the President of the United States, by John Trumbull, President of the American Academy of the Fine Arts* (New York, 1827), Letter No. 1, December 25, 1826, pp. 3–5; Letter No. 2, December 28, 1826, p. 8.

7. S. F. B. Morse to Verplanck, New York, December 21, 1826: Communication addressed "To the Hon. . . . Chairman of the Library Committee on the subject of the National Paintings," Verplanck Papers, NYHS; John Vanderlyn to John Vanderlyn, Jr., Kingston, September 9, 1825, Vanderlyn Papers, NYHS.

8. Thomas Colley Grattan, *Civilized America* (London, 1859), II, 119. Also see the *Family Magazine*, 1838: "The [Arts] are now objects of public regard, but they want the fostering aid of government and the establishment of public galleries and schools. There is, we know, a liberal feeling among the public men of the country, but there are many preventives of efficient action to any useful extent. The fear of offending narrow-minded constituents, and incurring the expenditure and the illiberality of political partisans toward each other, will, most likely, debar the fine arts from government patronage in this country, for a long time. . . ."

9. *Annals of Cong.*, 14 Cong., 2 Sess., p. 762. See Robert Gilmor, Jr., to Thomas Cole, Baltimore, June 22, 1837, Cole Papers, NYSL. Gilmor, like some other Americans of the day, believed that "a revival of taste & encouragement of the arts . . . will depend on the course to be followed by Congress."

CHAPTER 3 BUILDING THE CAPITOL

1. The District of Columbia was actually fixed by Congress in 1790.

2. DeWitt Clinton, "Address Before the American Academy," in Thomas Cummings, *Historic Annals* (Philadelphia, 1865), p. 13; Letter of the Commissioners . . . to the Municipality of Bourdeaux, January 4,

1793, *Documentary History of the Capital* (Washington, D.C., 1904), p. 21. The commissioners recognized that they were facing architectural problems of a nature and scope that Americans had not the skill to handle, for trained architects were not available at this time in the country. Thus, the commissioners, being "ambitious" to "express in some Degree in the Stile of our Architecture, the sublime sentiments of Liberty which are common to Frenchmen and Americans," invited the emigration here of trained artisans from Bordeaux to work on the Capitol.

3. William Dunlap, *History of the Arts of Design in the United States* (Boston, 1918), II, 230–34; Talbot Hamlin, *Benjamin Henry Latrobe* (New York, 1955), p. 261; Eleanor Berman, *Jefferson Among the Arts* (New York, 1947), pp. 98–99, 100–101, 109; Report of Committee of Claims on the Petition of Virginia Franzoni . . . , *House Reports*, 24 Cong., 1 Sess., No. 5, December 21, 1835. Massachusetts, too, turned to a foreign sculptor, Sir Francis Chantrey of Great Britain, to sculpt the statue of Washington intended for its State House in Boston, instead of turning to such local woodcarvers as Samuel McIntyre of Salem or the Skillinses of Boston, who were probably not capable of such work (Oliver Larkin, *Art and Life in America* [New York, 1949], pp. 99–101).

4. Latrobe to Mazzei, Washington, March 6, 1805; April 12, 1806, in Charles E. Fairman, *Art and Artists of the Capitol* (Washington, D.C., 1927), pp. 4, 7; Latrobe to Mazzei, December 19, 1806, *ibid.*, p. 11; Latrobe to Mazzei, April 12, 1806, *ibid.*, p. 7; "Anniversary Oration Pronounced Before the Society of Artists of the United States, on the 8th of May, 1811," by B. Henry Latrobe, in *Port Folio*, V (January–June, 1811), 55.

5. Fairman, *Art and Artists of the Capitol*, p. 12; Latrobe to Peale, Washington, D.C., April 18, 1806, *ibid.*, pp. 9–10; Latrobe to Lenthall, *ibid.*, pp. 12, 22; Latrobe to Jefferson, August 28, 1809, *ibid.*, p. 19; Frances Trollope, *Domestic Manners of Americans*, (New York, 1949), p. 229.

6. Latrobe to Hon. N. Macon, Washington, January 9, 1816, quoted in Fairman, *Art and Artists of the Capitol*, p. 32. The corncob capitals may be seen in the vestibule of the Law Library of the Supreme Court; the tobacco capitals (1816) are in the small rotunda of the Supreme Court section.

7. Fairman, *Art and Artists of the Capitol*, p. 16; Hamlin, *Benjamin Henry Latrobe*, pp. 263–65.

8. Hamlin, *Benjamin Henry Latrobe*, pp. 279–82, 271, 267, 269. In 1817, Bridport and his brother Hugh opened a drawing academy in Philadelphia. Both artists had been active earlier in Philadelphia as founders of the short-lived Columbianum Association (*Philadelphia*

Guide, 1817); Report to President Jefferson, Washington, September 11, 1808, in Fairman, *Art and Artists of the Capitol*, p. 16. John Randolph of Roanoke, congressman from Virginia from 1799 to 1829, was notorious for his sharp and caustic attacks. He had taken Latrobe to task earlier in 1808 for overspending the appropriation (Hamlin, *Benjamin Henry Latrobe*, p. 281).

9. Fairman, *Art and Artists of the Capitol*, pp. 22, 23; George C. Hazelton, Jr., *The National Capitol, its Architecture and History* (New York, 1908), p. 35; Hamlin, *Benjamin Henry Latrobe*, p. 272.

10. Hamlin, *Benjamin Henry Latrobe*, pp. 438 ff., discusses the architect's difficulties in detail, but he omits the fact that Latrobe had exceeded his estimates by such a large sum. See *American State Papers*, Class 10, Misc., II, 511. The committee investigating the work on the Capitol could not explain to their own satisfaction the reason for the "great excess of expenditures over the estimates." "The rise in the price of materials and of labor but imperfectly accounts for it," they declared, and therefore they felt compelled to "attribute it to the alterations which take place in the plans and which occasion the pulling down of vast portions of finished work. . . ."

11. Ellen Susan Bulfinch (ed.), *The Life and Letters of Charles Bulfinch, Architect* (New York, 1896), p. 203; Latrobe to Trumbull, Washington, October 10, 1817, in Fairman, *Art and Artists of the Capitol*, p. 37: "I have to do with a Commissioner and with a very angry President, to whom I have no access for the law forbids it," complained Latrobe to the painter; ". . . what a system is that which shutting out from the President all direct and professional information, interposes that of men whom neither leisure or knowledge of the subject qualifies to give it, or to explain difficulties or remove the misrepresentations of ignorance or malice. And under such a system it is expected that Genius shall freely act and display itself."

12. Bulfinch, *Life and Letters of Charles Bulfinch*, p. 209.

CHAPTER 4 PAINTINGS AND POLITICS

1. William Dunlap, *History of the Arts of Design in the United States* (Boston, 1918), II, 55; *The Autobiography of John Trumbull, Patriot-Artist, 1756–1843*, ed. Theodore Sizer (New Haven, 1953), p. 257; see also appendices which include letters from Trumbull to Jefferson and from Jefferson to Senator Barbour that detail Jefferson's intervention in Trumbull's behalf (p. 310).

2. Arthur Schlesinger, Jr., *The Age of Jackson* (Boston, 1945), p. 19; George Dangerfield, *The Era of Good Feelings* (New York, 1952), pp.

xii–xiii, 99–100; Rufus King to Christopher Gore, January 7, 1817, and Gore to King, January 26, 1817, in *The Autobiography of John Trumbull*, pp. 312–13; C. R. King (ed.), *Life and Letters of Rufus King* (New York, 1894–1900), VI, 45–48, 63; *Annals of Cong.*, 14 Cong., 2 Sess. (January 27, 1817), pp. 761–62, 764. Also see Trumbull to John Calhoun, Washington, February 10, 1817, John Trumbull Miscellaneous, NYHS. *Annals of Cong.*, 14 Cong., 2 Sess. (February 6, 1817), p. 1348.

3. *Annals of Cong.*, 14 Cong., 2 Sess. (January 27, 1817), pp. 761–62. Messrs. Forsyth (Ga.), Ross (Pa.), Robertson (La.), Taylor (N.Y.), and Benjamin Hardin (Ky.) opposed the Resolution; John Calhoun (S.C.), Robert Wright (Md.), Joseph Hopkinson (Pa.), William Henry Harrison (Ohio), John Randolph (Va.), Hugh Nelson (Va.), and Thomas Peabody Grosvenor (N.Y.) advocated it. Randolph was eloquent in his defense of art and in pointing out the good influence it would exert on society generally. His speech here makes an interesting contrast to the bitter sarcasm he later used in relation to Trumbull's finished paintings. (*Debates and Proceedings* [January 9, 1828], pp. 1827–28. See also *The Autobiography of John Trumbull*, p. 257.)

4. *Albany Daily Advertiser*, February 3, 1817; *Analectic*, January, 1818, IX, 66.

5. John Vanderlyn to Thomas Sully, New York, August 6, 1820: "every artist I should think (unless a creature of the Colonel's) must feel somewhat provoked at such peddling conduct from a most and only fortunate artist, besides he attempts to humbug the public as he pleases." Mellen Chamberlain, A.L.S., Boston Public Library; Dunlap, *History of the Arts of Design*, II, 65; *Annals of Cong.*, 15 Cong., 2 Sess. (February 8, 1819), pp. 1142 ff.; 18 Cong., 2 Sess. (February 18, 1825), p. 625.

6. *Annals of Cong.*, 20 Cong., 1 Sess. (January 9, 1828), I, 942. See Trumbull to F. Dwight, Esq., New York, dated from Washington, January 12, 1828, in which Trumbull comments about Randolph's "loss of memory" since he had delivered his "brilliant and beautiful eulogium . . . upon the small picture of the Declaration of Independence, the prototype of the large one which he now so sneeringly abuses." (American Academy of Fine Arts Letter Book, NYHS.)

7. F. C. Adams, "Art in the District of Columbia," in Henry Barnard, *Special Report of the Commissioner of Education on the Condition and Improvement of Public Schools in the District of Columbia* (Washington, D.C., 1871), p. 729; Ellen Susan Bulfinch (ed.), *The Life and Letters of Charles Bulfinch, Architect* (New York, 1896), pp. 237–38.

8. *Annals of Cong.*, 18 Cong., 1 Sess. (March 13, 1824), pp. 1778–79.

9. *Register of Debates*, 20 Cong., 1 Sess. (January 8–9, 1828), p. 929; Morse to Verplanck, New York, December 21, 1826, and Robert C. Sands

to Verplanck, December 23, 1826, Verplanck Papers; Dunlap, *History of the Arts of Design*, I, 356; Basil Hall, *Travels in North America in the Years 1827 and 1828* (Edinburgh, 1829), III, 50; Charles M. Wiltse, *John C. Calhoun, Nationalist, 1782–1828* (New York, 1944), p. 278; Paul R. Frothingham, *Edward Everett* (Boston, 1925), p. 113.

10. *Register of Debates*, 20 Cong., 1 Sess. (January 8–9, 1828), I, 930; Richard Dana to Gulian C. Verplanck, Cambridge, Mass., January 23, 1828, Verplanck Papers.

11. Hall, *Travels in North America*, III, 50–59. Hall was present on both days of the debate and his appraisal of it and his comments, coming as they do from an astonished Englishman, make amusing reading. John Quincy Adams, President of the United States from 1824–28, was, of course, Jackson's opponent during the election of 1828. Trumbull had lingered on in Washington hoping to receive the commission to paint four more paintings "to fill the vacant spaces which now offend every Eye." (Trumbull to Charles Wilkes, Washington, January 28, 1827, NYHS.) *Register of Debates*, 20 Cong., 1 Sess. (January 8–9, 1828), pp. 939–40, 946–50.

12. Dana to Verplanck, January 19, 1828, Verplanck Papers; Hall, *Travels in North America*, III, 56; James Campbell to Verplanck, January 19, 1828, Verplanck Papers.

13. Verplanck to Allston, Washington, March 9, 1830, Verplanck to Allston, May 29, 1830, Dana Collection, Massachusetts Historical Society.

14. Morse to Verplanck, Paris, January 2, 1832, Verplanck Papers; Morse to Mme Frainays, New York, April 10, 1833, Morse Letters, LC. Morse wrote a similar letter to at least twenty congressmen—Woodbury, Bell, Hill, Webster, Tomlinson, Smith, Southard, Calhoun, Clay, Kane, J. Q. Adams, Baylies, Gorham, Barber, Allsworth, Foot, Cambreleng, Selden, Mercer, and Wayne—saying that he had devoted twenty years to art, seven passed in Europe, and referring to his professional life as proof of his ability to do honor to a commission and to the country (March 7, 1834, Morse Letters). In 1846, after the death of Inman, who had been commissioned to do a painting for one of the panels in 1836, a group of artists and friends of Morse from the National Academy of Design petitioned Congress to offer him the uncompleted panel; but again Morse was disappointed, and the commission was later given to William Powell.

15. U.S. Cong., *Journal of the House of Representatives* (hereafter cited as *House Jour.*), 23 Cong., 1 Sess. (January 24, 1834), pp. 237, 316, 592; *Register of Debates*, 23 Cong., 2 Sess. (December 15, 1834), pp. 791–95; *House Jour.*, 23 Cong., 2 Sess., pp. 93, 100; Charles F. Adams (ed.), *Memoirs of John Quincy Adams* (Philadelphia, 1876), IX, 189–90.

16. *Register of Debates*, 23 Cong., 2 Sess. (December 15, 1834), pp. 791–95.

17. *Ibid.; Memoirs of John Quincy Adams*, IX, 90, 265; VIII, 10, 473.

18. *Register of Debates*, 23 Cong., 2 Sess. (December 15, 1834), pp. 791–95.

19. *Ibid.*, p. 795.

20. Leonard Jarvis to Verplanck, Washington, March 1, 1834; Inman to Verplanck, Philadelphia, 1834; Weir to George P. Morris, West Point, January 20, 1835, Verplanck Papers; Cole to Edward Everett, New York, March 10, 1834; Dexter to Everett, Boston, March 12, 1834, Everett Papers, MHS; Dexter to Cole, Boston, March 12, 1834, Cole Papers, NYSL.

21. John O. Chapman to Henry A. Wise, New York, June 29, 1836, Etting Collection, Historical Society of Pennsylvania; Lillian B. Miller, "John Vanderlyn and the Business of Art," *New York History*, XXXXII, No. 1 (January, 1951), 33–44; Vanderlyn to John Vanderlyn, Jr., Washington, February 21, 1832, Vanderlyn Papers; Verplanck to Allston, Washington, February 21, 1832, in Jared B. Flagg, *Life and Letters of Washington Allston* (New York, 1892), p. 253. Even Allston's competitors acknowledged that he was the best man to paint the pictures for the government. See Sully to Morse, Philadelphia, April 22, 1833, Morse Letters; Weir to Morris, West Point, January 20, 1835, Verplanck Papers; Leonard Jarvis to Verplanck, Washington, March 1, 1834, Verplanck Papers.

22. "Report of the Proceedings on the Public Buildings for the Year 1827," December 27, 1827, in *Documentary History of the Capitol*, pp. 294–95; *Sen. Jour.*, 24 Cong., 1 Sess., pp. 397, 410, 413, 490, 498; *House Jour.*, 24 Cong., 1 Sess., pp. 966, 1078, 1108, 1112; *Cong. Globe*, 24 Cong., 1 Sess., III, 415, 433; IV, 213; *Sen. Jour.*, 24 Cong., 2 Sess., p. 297.

23. *Memoirs of John Quincy Adams*, IX, 299 (June 3, July 1, 1836); Jarvis to Allston, July 4, 1836; Preston and Jarvis to Allston, Washington, July 4, 1836, Dana Collection; Flagg, *Life and Letters of Washington Allston*, p. 229; Benjamin C. Howard to Verplanck, Washington, February 13, 1837, Verplanck Papers.

24. Vanderlyn to Charles A. King, Paris, July 27, 1840, Vanderlyn Papers; Adams, "Art in the District of Columbia," in H. Barnard, *Special Report of the Commissioner of Education*, p. 730.

25. Samuel Isham, *History of American Painting* (New York, 1927), p. 133, quotes Bishop Kip as saying that he saw the work progress under the hand of a French artist employed by Vanderlyn; *New York Journal of Commerce*, October 19, 1846; "The Fine Arts in America," *Southern*

Quarterly Review, XXX (July, 1849), 338; Adams, "Art in the District of Columbia," in Barnard, *Special Report*, p. 729.

CHAPTER 5 SCULPTURE, POLITICS, AND THE TASTE OF POLITICIANS

1. Charles Fairman, *Art and Artists of the Capitol* (Washington, D.C., 1927), p. 47.
2. For commissions given these artists by Congress during these years, see Fairman, *Art and Artists of the Capitol*, pp. 29, 30–32, 39, 46–53. For the manner in which sculptors gained influence by taking busts of important statesmen, see Charles Adams (ed.), *Memoirs of John Quincy Adams* (Philadelphia, 1874–77), IX, 193–94.
3. *Memoirs of John Quincy Adams*, IX, 193–94, 201, 216; XII, 158; Ellen Susan Bulfinch (ed.), *Life and Letters of Charles Bulfinch* (New York, 1896), p. 249; *Memoirs of John Quincy Adams*, VIII, 81, 85, 123; *House Jour.*, 23 Cong., 2 Sess., p. 246; *Sen. Jour.*, 23 Cong., 2 Sess., p. 115; *Cong. Globe*, 23 Cong., 2 Sess., p. 140; Ben: Perley Poore, *Reminiscences* (Philadelphia, 1886), I, 45–46. Criticism of Persico's "stealing tricks" was made by C. E. Lester in his unofficial memoir of Hiram Powers, *The Artist, The Merchant, and the Statesman of the Day of the Medici and of our Own Time* (New York, 1845), I, 107, 108. Persico's influential political friends were noted by Edward Everett in a letter to Hiram Powers, London, February 22, 1845, Everett Papers.
4. Fairman, *Art and Artists of the Capitol*, p. 65; *Register of Debates*, 18 Cong., 1 Sess., I, 1044–45, 1046; George C. Hazelton, Jr., *The National Capitol* (New York, 1908), p. 75. The Continental Congress on August 7, 1783, resolved unanimously (ten states being present) that an equestrian statue of George Washington be erected at the place where the residence of Congress should be established, "in a Roman dress, holding a truncheon in his right hand, and his head encircled with a laurel wreath."
5. *Register of Debates*, 18 Cong., 2 Sess., I, 638–39.
6. *Ibid.*, 18 Cong., 1 Sess., II, 2840, 2499.
7. Jarvis to Allston, January 27, 1835; Allston to Jarvis, May 28, 1835, Dana Collection; E. P. Richardson, *Washington Allston* (Chicago, 1948), pp. 11, 34; Alfred Greenough to Henry Greenough, Boston, May 1, 1830, and Horatio Greenough to "Harry," Paris, October 3, 1831, in Frances B. Greenough (ed.), *Letters of Horatio Greenough to his Brother Henry Greenough* (Boston, 1887), pp. 64, 87; W. Dunlap, *History of the Arts of Design in the United States* (Boston, 1918), III, 224; *Cong. Debates*, 22 Cong., 1 Sess. (February 14, 1832), p. 1809; (February 16, 1832), p. 1830; (March 15, 1832), p. 2175; Verplanck to Allston, Washington, February

21, 1832, in Jared B. Flagg, *The Life and Letters of Washington Allston* (New York, 1892), p. 253; Report by Mr. Jarvis from the Committee on Public Buildings, House of Representatives, *Reports of Committees*, No. 21, January 2, 1833; Message from the President of the United States in relation to the statue of Washington by Greenough, August 4, 1841, *House Documents*, 27 Cong., 1 Sess. (1841) Doc. No. 45. Greenough had the approval of his fellow American artists as well as the congressmen. See J. G. Chapman to Henry Wise, New York, June 29, 1836, Etting Collection: "[Greenough's] talents are above my praise—He is our own, too—American in every respect and one that will shed lustre on the age and country."

8. Livingston to Greenough, February 23, 1832, in *House Documents*, 27 Cong., 1 Sess. (1841), Doc. No. 45, pp. 2–3; Bulfinch (ed.), *Life and Letters of Charles Bulfinch*, p. 293.

9. Jarvis to Allston, Washington, May 15, 1834, Dana Collection.

10. Jarvis to Allston, Washington, June 6, 1834, Dana Collection.

11. Allston to Jarvis, Cambridge Port, June 19, 1834, Dana Collection.

12. Greenough (ed.), *Letters of Horatio Greenough* . . . , pp. 185–86; Allen Nevins (ed.), *Diary of Philip Hone* (New York, 1927), II, 694; Mary Clemmer Ames, *Ten Years In Washington, Life and Scenes in the National Capitol as a Woman Sees Them* (Hartford, Conn., 1876), pp. 104–5; Hazleton, *The National Capitol*, pp. 76–77.

13. Greenough (ed.), *Letters of Horatio Greenough* . . . , p. 186.

14. *Cong. Globe*, 32 Cong., 1 Sess. (June 10, 1852), p. 610; Fairman, *Art and Artists of the Capitol*, pp. 138, 143.

15. Greenough (ed.), *Letters of Horatio Greenough* . . . , pp. 187, 183; Horatio Greenough to Charles Sumner, Florence, November 16, 1839, Sumner Letters, Harvard College Library; Everett to Greenough, December 25, 1848, Everett Papers; Ames, *Ten Years in Washington*, p. 105. See also C. C. Felton's defense of Greenough's statue in his review of *A History of Modern German Art*, North Amer. Rev., LV, (October, 1842), 432–58.

16. Thomas Colley Grattan, *Civilized America* (London, 1859), II, 108–9; memorial of Horatio Greenough, in *Senate Documents*, 27 Cong, 3 Sess., Doc. No. 57, pp. 3–4, 11; See also Greenough to F. B. Winthrop, November 26, 1844, in Greenough (ed.), *Letters of Horatio Greenough* . . . , pp. 180–83, and Winthrop MSS, MHS, for further elucidation of Greenough's position with respect to the statue. In this letter Greenough stated that the statue was "intended and designed for the interior of a building and not for the open air." If he had meant it for a square, Greenough explained, he would have put Washington on horse-

back in modern dress. "I should have made my work purely an historical one—I have treated the subject poetically and I confess I should feel pain at seeing it placed in direct and flagrant contrast with everyday life."

CHAPTER 6 DECORATIONS FOR THE CAPITOL EXTENSION

1. Letter of Bulfinch to—, June 2, 1830, in Ellen Susan Bulfinch, *Life and Letters of Charles Bulfinch* (New York, 1896), pp. 261–62, 269; Charles Fairman, *Art and Artists of the Capitol* (Washington, D.C., 1927), pp. 84, 113.

2. Bulfinch (ed.), *Life and Letters of Charles Bulfinch*, pp. 213, 214, 235–36.

3. Horatio to Henry Greenough, Washington, December 1, 1842, in Frances B. Greenough, *Letters of Horatio Greenough* . . . (Boston, 1887), p. 141.

4. *Cong. Globe*, 31 Cong., 1 Sess. (July 24, 1850), II, 1425; 31 Cong., 1 Sess. (September 23, 1850), II, 1944; Fairman, *Art and Artist of the Capitol*, pp. 111–12. Captain Hall noted the bad acoustics of the Hall of the House of Representatives in 1828 and reported that when he commented upon this to a member of the House, the member replied that "for once, in America, utility had been sacrificed to beauty, 'which,' said he, good-humoredly enough, 'you must do us the justice to say is not often the fault of this country.'" (*Travels in North America* [Edinburgh, 1829], II, 123).

5. Fairman, *Art and Artists of the Capitol*, pp. 134, 135, 137–48; *Cong. Globe*, 32 Cong., 1 Sess. (March 13, 1852), pp. 738–744; *Documentary History of the Capitol* (Washington, D.C., 1904), p. 494. See *Cong. Globe*, 32 Cong., 1 Sess., II, 1004, for Senator Cooper's speech in favor of commissioning Leutze to make a copy of his *Washington Crossing the Delaware* for the new building. Also see *ibid.*, 32 Cong., 1 Sess., II, 1533. Walter (1804–87) was a Philadelphia architect whose career was considerably aided by the commission to design and build Girard College in Philadelphia. He remained in charge of the Capitol Extension work until 1865, when he was succeeded by Edward Clark.

6. *Documentary History of the Capitol*, pp. 499–500, 507–9, 574–76, 580–81, 585; Fairman, *Art and Artists of the Capitol*, p. 139; Allen Nevins, *Ordeal of the Union* (New York, 1947), pp. 47, 42, 58; Russell F. Weigley, *Quartermaster General of the Union Army* (New York, 1959), chap. 5 *passim*. Economy seems to have been one of the major points at issue, for in the controversy that developed later between partisans of Walter and defenders of Meigs, each man's administration was defended on the basis of economy or attacked on the basis of extravagance.

7. *Cong. Globe,* 33 Cong., 1 Sess. (June 14, 1854), II, 1393–1402; 34 Cong., 1 Sess. (May 19, 1856), II, 1257.

8. Dunbar Rowland (ed.), *Jefferson Davis, Constitutionalist. His Letters, Papers, and Speeches* (Jackson, Miss., 1923), Vols. II and III *passim,* details many of the controversies in which Davis became involved as Secretary of War. For debate on furnishing the committee rooms, see *Cong. Globe,* 35 Cong., 2 Sess. (March 2, 1859), II, 1587.

9. The Buchanan quotation is from Edward Everett to Hiram Powers, March 24, 1858, Everett Papers; Weigley, *Quartermaster General of the Union Army,* pp. 108, 165.

10. Meigs to John Durand, editor of the *Crayon,* October 11, 1856, Durand Collection. In this letter Meigs delineates the boundary established by law between his power and congressional power to confer commissions for works of art for the Capitol: "While I have desired to do as much as possible for art, I am not able to do all that I could wish. . . . Congress has appropriated money for building the Capitol Extension. Part of this appropriation can be properly spent upon sculpture, which forms a component part of the building. . . . But were I to undertake to fill niches with portraits, statues, or with emblematic figures, I should be trespassing on the ground reserved to Congress itself. . . . With painting, the subject was more difficult. Certainly the walls of such a building are not to be left of uncolored plaster. But were I to purchase pictures to hang upon them, I should go as far beyond my duty as your architect would were he when commissioned to build you a house to undertake to furnish it with paintings." After 1858, because of the criticism directed against Meigs's architectural decorations, it was expressly indicated as an amendment to every Civil Appropriation Bill that included funds for the Capitol Extension that no part of the appropriation was to be spent on painting or sculpture or ornamental decoration of any kind.

11. Weigley, *Quartermaster General of the Union Army, passim,* for an evaluation of Meigs; the quotation is from Meigs's journal in Weigley, pp. 62–63.

12. Meigs to Gouverneur Kemble, in Fairman, *Art and Artists of the Capitol,* pp. 149–50; Weigley, *Quartermaster General of the Union Army,* p. 73.

13. Oliver Larkin, *Art and Life in America* (New York, 1949), p. 184; Edward Everett to Captain Meigs, Boston, July 12, 1853, Everett Papers; Fairman, *Art and Artists of the Capitol,* p. 144.

14. Kemble (1786–1875) was a manufacturer whose "West Point Foundry" produced cannon and manufactured ordnance for the government. An early friend of Washington Irving, he was a member of the

group celebrated in Irving's *Salmagundi*. He was also active in the Democratic Party in New York (W. S. Pelletreau, *History of Putnam County, New York* [Philadelphia, 1886], pp. 615–16); Meigs to Kemble, February 8, 1854, in Fairman, *Art and Artists of the Capitol*, p. 149.

15. Meigs to Kemble, February 8, 1854; Meigs to Kemble, Washington, December 7, 1854, in Fairman, *Art and Artists of the Capitol*, pp. 149, 151.

16. Meigs to Durand, October 11, 1856, Durand Collection.

17. Brumidi (1805–80) came to America in 1852. Myrtle Cheney Murdock, *Constantino Brumidi, Michelangelo of the United States Capitol* (Washington, 1950), p. 4.

18. Fairman, *Art and Artists of the Capitol*, pp. 143, 148.

19. *Ibid.*, p. 479. Crawford received $20,000 for the pediment. See *ibid.*, p. 145.

20. Fairman, *Art and Artists of the Capitol*, pp. 169, 479. One door was completed by W. H. Rinehart from Crawford's design after Crawford's death.

21. *Cong. Globe*, 34 Cong., 1 Sess. (May 26, 1856), Appendix 619.

22. *Ibid.* Randolph was, of course, John Randolph of Roanoke, Virginia, who was part Indian by descent.

23. *Cong. Globe*, 35 Cong., 1 Sess. (May 28, 1858), III, 2461.

24. Fairman, *Art and Artists of the Capitol*, p. 169.

25. *Cong. Globe*, 35 Cong., 1 Sess. (May 28, 1858), III, 2461. Oliver Larkin's criticism of the statue as a "pregnant squaw" bears out Houston's aesthetic disgust (*Art and Life in America*, p. 184). The fact that Houston's first wife was an Indian and that Houston himself had been adopted by an Indian Chief may have had something to do with his reaction. See Marquis James, *The Raven* (Indianapolis, 1929).

26. Actually, the funds that paid for Powers' two statues were expressly voted to the sculptor by congressional act. Congress had left it to the President to complete negotiations with the sculptor with relation to the subject or subjects of the work he would furnish under the appropriation. At first, Powers wished to have his statue of *America* accepted for the full price of the commission—$25,000; but it was felt by President Pierce, acting upon Meigs's advice, that this statue resembled too closely Crawford's *Liberty*. Later, when pictures of *America* were seen, it was believed that the statue's nudity would make it unacceptable for the nation's Capitol. Powers' friends in and out of Congress, especially Edward Everett, Senator Pearce of Maryland, Governor Salmon Chase of Ohio, and General Cass of Ohio, had been active in securing this appropriation for the sculptor; and, fearful that Powers might lose it through default, they pressed him to offer statues of Washington,

Jefferson, or Franklin, which he had already modeled, at $10,000 each, with a third statue of his own choosing for the remaining $5,000. Finally Jefferson and Franklin were decided on; the remaining $5,000 was never used and it passed back into the general fund after two years had elapsed. See Fairman, *Art and Artists of the Capitol*, pp. 144, 157–58, 215; Everett–Powers Correspondence in Everett Papers, *passim;* Report of the United States Art Commission, February 22, 1860, in *House Executive Documents*, 36 Cong., 1 Sess., No. 43, VI (March 9, 1860), 6.

27. Murdock, *Constantino Brumidi*, pp. 67–72; 17, 31, 32.

28. *New York Daily Tribune*, May 31, 1858, quoted in Murdock, *Constantino Brumidi*, p. 22; *Cong. Globe*, 35 Cong., 1 Sess. (May 28, 1858), III, 2461. Also see Davis' Report to Congress, *House Executive Documents*, 34 Cong., 1 Sess., No. 138, Capitol and Post Office Extension; Meigs to John Durand, Washington, October 11, 1856, Durand Collection.

29. *Cong. Globe*, 35 Cong., 1 Sess. (June 1, 1858), III, 2588 (speech of Senator Andrew Johnson of Tennessee). Also see *Cong. Globe*, 35 Cong., 2 Sess. (March 2, 1859), II, 1857; (May 28, 1858), III, 2461; (June 7, 1858), III, 2759.

30. *Cong. Globe*, 35 Cong., 1 Sess. (May 19, 1858), III, 2256–57.

CHAPTER 7 THE ARTISTS' PROTEST

1. Oertel to John Durand, Washington, April, 1857, Durand Collection.

2. F. C. Adams, "Art in the District of Columbia," in H. Barnard, *Special Report of the Commissioner of Education* (Washington, D.C., 1871), p. 733.

3. Circular letter, Washington Art Association, Horatio Stone, President, February 11, 1858, Durand Collection. Also see "Art Desecration of the Capitol," *Cosmopolitan Art Journal*, II, Nos. 2 & 3 (March & June, 1858), 134, for a typical protest against "third-rate imported Italian painters, whose daubs are only calculated to excite derision from every person of taste and patriotism." *House Reports*, 35 Cong., 2 Sess. (March 3, 1859), No. 198, "American Artists."

4. *House Reports*, 35 Cong., 2 Sess., No. 198. Both Mrs. Murdock and F. C. Adams dismissed these signers as unimportant figures in the development of American art. See M. C. Murdock, *Constantino Brumidi* (Washington, D.C., 1950), pp. 18–19; Adams, "Art in the District of Columbia," in H. Barnard, *Special Report*, p. 734. For an example of the simple and limited ideas of artists at the time concerning the possibilities of government patronage of the arts, see T. P. Rossiter, "Plan for a National School of Art," *Crayon*, V (October, 1858), 299.

5. Adams, "Art in the District of Columbia," in Barnard, *Special Report*, p. 734; *House Reports*, 35 Cong., 2 Sess., No. 198, p. 1.

6. *House Reports*, 35 Cong., 2 Sess., No. 198, p. 5.

7. *Ibid.*, pp. 4, 6.

8. U.S. Cong., *Statutes-at-Large*, 35 Cong., 1 Sess. (June 12, 1858), Chap. 154, p. 323.

9. Report of the U.S. Art Commission (Washington, February 22, 1860) *House Executive Documents*, 36 Cong., 1 Sess., Doc. No. 43, VI (February 22, 1860), 1, 8; U.S. Cong., *House Reports*, 35 Cong., 2 Sess., No. 198, p. 6.

10. Report of the U.S. Art Commission, *op. cit.*, pp. 2–8.

11. *Cong. Globe*, 36 Cong., 1 Sess. (June 11, 1860), p. 2820; J. R. Lambdin to John Durand, Ulster County, July 10, 1860, Durand Collection. There is some question whether the commissioners received payment for their work. Debates in Congress opposing the continuation of the Commission indicated that the commissioners were paid approximately $3,000 each for thirteen months of service in Washington. Defenders of the commissioners claimed that the artists were serving voluntarily, "animated by a high sense of duty . . . stimulated by feeling to improve the arts of the country." (*Cong. Globe*, 36 Cong., 1 Sess. [June 11, 1860], p. 2820.) No compensation was voted at this time. (Lambdin to Durand, *op. cit.*) Yet Adams, in his "Art in the District of Columbia" in Barnard, *Special Report*, p. 739, wrote that the Commission cost the government $9,000 or more.

12. Adams, "Art in the District of Columbia," in Barnard, *Special Report*, pp. 725–71, 741; Joel T. Hart to Dr. R. Bush in Louisville, Washington, June 22, 1860 (Pindell Collection, Filson Club).

13. Murdock, *Constantino Brumidi*, pp. 28–29; Charles Fairman, *Art and Artists of the Capitol* (Washington, D.C., 1927), pp. 216, 287, 177, 270–71; Russell Weigley, *Quartermaster General of the Union Army* (New York, 1959), p. 76. See Senator Davis' defense of Meigs in *Cong. Globe*, 35 Cong., 1 Sess. (May 28, 1858), III, 2461; 35 Cong., 2 Sess. (March 2, 1859), II, 1587. Meigs returned to work on the Capitol Extension in February, 1861, and continued until May, when he was appointed Quartermaster General of the Union Army (Weigley, *op. cit.*, pp. 108, 128).

14. Fairman, *Art and Artists of the Capitol*, p. 271.

PART III ART AND THE COMMUNITY

1. "Wealth," in *The Conduct of Life* (Boston & New York, 1860), pp. 700–701.

2. John Trumbull, *Address Read before the Directors of the Ameri-*

can Academy of the Fine Arts . . . *By the President* (New York, 1833), NYHS; Herring to Col. J. J. Abert, circular dated July, 1840, Herring Miscellaneous, NYPL. The italics are Herring's.

3. Everett to Horatio Greenough, January 28, 1841, Everett Papers.

CHAPTER 8 NEW YORK SETS THE PATTERN: THE AMERICAN ACADEMY
OF FINE ARTS

1. Savage's combination of museum and art school was organized in Philadelphia in 1788 and moved to New York in 1802. Robertson's Columbian Academy of Painting was founded in 1791. Peale's Museum, founded in 1784, was incorporated in 1822 and became one of Philadelphia's most famous institutions during these decades. A group of Philadelphia artists also founded the Columbianum Society in 1794, but the institution collapsed nearly as soon as it started. Its formal dissolution came, however, in 1796. (Sidney I. Pomerantz, *New York, An American City, 1783–1803. A Study of Urban Life* [New York, 1938], p. 493; William Kelby, *Notes on American Artists, 1754–1820* [New York, 1922], p. 43; *Philadelphia in 1824; or a Brief Account of the Various Institutions and Public Objects in this Metropolis* . . . [Philadelphia, 1824].)

2. American Association of Museums, *Proceedings* (1915), IX, 53–65; Pomerantz, *New York, An American City*, p. 412; Winifred E. Howe, *A History of the Metropolitan Museum of Art, with a Chapter on the Early Institutions of Art in New York* (New York, 1913), pp. 3–6.

3. William E. West to Thomas Sully, Florence, January 29, 1820, Dreer Collection, HPS. The letter continued: "I wish you were out of America—It is my opinion you could make three times as much money here as you make in Philadelphia and live better on three times less. . . ."

4. John R. Livingston to Robert R. Livingston, January 10, 1802. For all of Livingston's other interests, see correspondence with Joseph Priestley, Richard Bayley, John Stevens, Thomas Jefferson, and Francis Adrian van der Kamp, among many others, in the Livingston Papers, NYHS.

5. Robert R. Livingston to Peter Delabigarre, Paris, July 4, 1802; Livingston to Janet Livingston Montgomery, August 19, 1802; Livingston to Janet Livingston Montgomery, August 1, 1802, Livingston Papers; Howe, *A History of the Metropolitan Museum*, p. 8.

6. American Academy of Arts, Secretary's Book, I, 1, "Original Agreement with Subscribers' Names" (MS, NYHS). Although Edward Livingston was instrumental in getting the Academy launched in New

York City, Chancellor Robert R. Livingston's name is most intimately connected with its founding, to the point that its establishment came to be regarded as "his personal triumph." (Harold E. Dickson, *John Wesley Jarvis, 1780–1840* [New York, 1949], p. 78. See also DeWitt Clinton, "Address Before the American Academy," in T. Cummings, *Historic Annals* [Philadelphia, 1865], p. 16.)

7. "Original Agreement with Subscribers' Names"; Murray to Trumbull, n.d., Trumbull–Silliman Correspondence, I, Connecticut Historical Society. For a detailed story, year by year, of the activities of the Academy, see Theodore Sizer, "The American Academy of Fine Arts," in Mary Bartlett Cowdrey (ed.), *The American Academy and American Art-Union* (New York, 1953), I, 3–63.

8. Sizer, "The American Academy of Fine Arts," in Cowdrey (ed.), *The American Academy*, I, 12; Howe, *A History of the Metropolitan Museum*, pp. 16, 17–18; Vanderlyn to Edward Livingston, Paris, February 12, 1804, Amer. Acad. of Fine Arts, Secretary's Book, I, 6. Vanderlyn was also sent to Italy "to make a full investigation . . . of the state of the Arts there and what may be the particular sources of advantage which that country offers for advancing the view of the Academy (either at present or at a future date, when its means may be more adequate to its great End)." (John R. Murray and Joseph Browne to Vanderlyn, New York, August 6, 1804, Amer. Acad. of Fine Arts, Secretary's Book, I, 7.)

9. Pomerantz, *New York, An American City*, chap. 4 *passim*; J. S. Davis, *Essays in Earlier History of American Corporations* (Cambridge, Mass., 1917), II, 44–46, 80–95, 235, 236, 242; Robert G. Albion, *The Rise of New York Port, 1815–1860* (New York, 1939), p. 8.

10. Pomerantz, *New York, An American City*, chap. 8 *passim*; Aaron Burr to John Vanderlyn, in Robert Gosman, A Biographical Sketch of John Vanderlyn, MS in Vanderlyn Papers, NYHS, p. 237; John Trumbull, *Autobiography*, chap. 17; Dickson, *John Wesley Jarvis*, pp. 53–54, 60, 66, 86–87; W. W. Pasko (ed.), *Old New York* (New York, 1889–90), I, 335; *Catalogue of Pictures at the Shakespeare Gallery*, bound with *New York Directory of 1802–1803*, NYHS.

11. Sizer, "The American Academy of Fine Arts," in Cowdrey (ed.), *The American Academy*, I, 3–93 *passim*, 20. Dunlap commented on the directorship of the Academy in this way: "We had then gentlemen of every profession, but that of an artist. . . ." (*History of the Arts of Design in the United States* [Boston, 1918], II, 105.)

12. See MS diary of John Murray (LC), Bradish Papers (NYHS), John W. Francis Papers (NYPL), "Diary of Peter Irving" (*Bull. NYPL*, XLIV, No. 8 [August, 1940], 587 ff.), Verplanck Papers (NYHS). The

Sketch Club was established in 1829 as another offshoot of the Drawing Association which also formed the National Academy of Design. Its membership included artists, literary men, politicians, merchant-patrons, men who "collectively may be styled the fountain-head of the subsequent prosperity of local Art. The start the [American] school [of art] obtained at this period is due to the men who belonged to this club." (John B. Durand, *The Life and Times of Asher B. Durand* [New York, 1894], pp. 90, 97.)

13. Speech of Edward Livingston, January, 1803, in Sizer, "The American Academy of Fine Arts," in Cowdrey (ed.), *The American Academy*, I, 4, 11.

14. Washington Irving and James K. Paulding, "A Tour of Broadway," *Salmagundi; or the Whim-whams and Opinions of Launcelot Langstaff, Esq., and Others* (New York, 1835), June 2, 1807, II, 43. Early in 1807, the American Academy appealed to the Corporation of the City of New York for grounds "proper for a building . . . for the use of this institution," but met with no success. (Sizer, "The American Academy of Fine Arts," in Cowdrey [ed.], *The American Academy*, I, 14; Isaac N. Phelps Stokes, *The Iconography of Manhattan Island, 1498–1809* [New York, 1915–1928], January 12, 1807, V, 1453.)

15. "Remarks on the Progress and Present State of the Fine Arts in the United States," *Analectic*, VI (1815), 370.

16. Sizer, "The American Academy of Fine Arts," in Cowdrey (ed.), *The American Academy*, I, 15–18; the quotation is from the *New York Spectator*, October 16, 1816, in Sizer, *op. cit.*, p. 18.

17. Clinton, "Address Before the American Academy," in Cummings, *Historic Annals*, p. 8; *Letters of John Pintard to his Daughter . . . 1816–1833* (New York, 1940), I, 36–37; *American Monthly Magazine and Critical Review*, I (October, 1817), 456; Sizer, "American Academy of Fine Arts," in Cowdrey (ed.), *The American Academy*, I, 16, 19, 20. Clinton's address, in the opinion of the historian of the National Academy of Design, was "far removed from the life and welfare of the professional artist," and this criticism exemplifies the great gulf that existed throughout the Academy's lifetime between its founders and directors and the artists. (Eliot Clark, *The History of the National Academy of Design, 1825–1953* [New York, 1954], p. 8.) Whatever its shortcomings for meeting the needs of the time, Clinton's address now provides an excellent summary of most of the classical ideas about art and the nationalistic hopes held by the enlightened gentlemen who gave the movement for American art institutions and the development of a native art its initial impetus.

18. Cummings, *Historic Annals*, pp. 24–25.

19. *New York Spectator,* June 19, 1828; Robertson to Trumbull, April 4, 1826, Amer. Acad. of Fine Arts, NYHS; Trumbull to Survilliers (Joseph Bonaparte), March 5, April 10, May 10, 1825; Survilliers to Trumbull, April 2, 1827; List of Pictures, April 15, 1825; Receipt for Pictures, Point Breeze, April 5, 1826, gives lists of paintings borrowed during these years from Bonaparte (Letters in manuscript collection, American Academy of Fine Arts, NYHS); Mary Bartlett Cowdrey (ed.), *Exhibition Record of the American Academy of Fine Arts,* I, 311, 5, 60, 100, 111, 229, 349, 387, 420–21; II *passim,* for portraits and copies exhibited by Catlin, Copley, Harding, McLelland, Jarvis, Marsiglia, Jane Stuart, Parisen, Steers, Waldo, and Jewett. The visitor was Henry Barnard, who reported his impressions in "A Trip to the Emporium," *New England Weekly Review,* August 18 [1828], MS in Barnard Papers, Wadsworth Athenaeum, Hartford, Conn. *The Sortie from Gibraltar* was purchased by the Boston Athenaeum at the end of this 1828 exhibition from the funds it had accumulated as a result of its first exhibition held in 1827. The West pictures had been lent by their successive owners, Mrs. Dale and Mr. Roosevelt (Sizer, "The American Academy," p. 18).

20. Report of the Committee Appointed by the Stockholders of the American Academy of Fine Arts to prepare a detailed statement of the income and expenditures of the Institution during the last ten years . . . March 28, 1831, Amer. Acad. Keeper's Book, I, 147.

21. Dunlap, *History of the Arts of Design in the United States,* I, 362; figures are from the Committee's Report, *op. cit.,* I, 147; Cummings, *Historic Annals,* pp. 81, 84; Cummings indicates (pp. 18, 19) that the Academy's permanency of materials was its "death" and that one of the causes of the institution's failure was the fact that the "Academy keeps works on exhibition all the year." The *New York Spectator* bravely attempted to refute what must have been a rather popular objection to the Academy's repetitious offerings: "We never tire of these old acquaintances," the writer explained, "for we are of the opinion that paintings as well as wine . . . are the better for age, and we do not turn up our nose, as some fastidious critics affect to do, at everything which we have seen before" (June 10, 1828); Morse to Simeon DeWitt Bloodgood, New York, December 26, 1828, Gratz Collection, HSP.

22. Cummings, *Historic Annals,* p. 18; Committee Report . . . March 28, 1831, Amer. Acad. Keeper's Book, I, 147; Committee Report of January 2, 1836, Amer. Acad. Keeper's Book, I, 178. The Committee estimated that the Academy owed between $1,000 and $1,200.

23. Sizer, "The American Academy of Fine Arts," in Cowdrey (ed.), *The American Academy,* I, 14. Other institutions in the state likewise found it necessary to enjoy "the glorious privilege of being independent."

In 1810 a bill for endowing the New-York Historical Society and for killing wolves and panthers was also rejected by the New York State Legislature (Howe, *A History of the Metropolitan Museum,* p. 6; *A Memorial of George Brown Goode, together with a Selection of his Papers* [Washington, D.C., 1901], p. 69.) City aid lasted only sixteen years, from 1816 to 1832, and it never carried with it the assurance of permanence. Sizer, "The American Academy of Fine Arts," I, 16, 49; Report of January 2, 1836.

24. *American Monthly Magazine and Critical Review,* I (August, 1817), 295; Clinton, "Address Before the American Academy," in Cummings, *Historic Annals,* p. 10; Report of . . . January 2, 1836; Sizer, "The American Academy of Fine Arts," in Cowdrey (ed.), *The American Academy,* I, 21, 50; Cummings, *Historic Annals,* pp. 7, 18, 19, 20 (italics and capitals are Cummings'); Subscription List, Amer. Acad. Keeper's Book, I, 142 (New York, November 11, 1831).

25. [S. F. B. Morse] to the Academy, n.d., no signature, but the handwriting is Morse's, in Amer. Acad. Keeper's Book, I, 66. The events leading to the development of the N.A.D. from the organization known as the New York Drawing Association (1825) are detailed in Cummings, *Historic Annals,* pp. 21–27; Sizer, "The American Academy of Fine Arts," in Cowdrey (ed.), *The American Academy,* I, 35–43; Clark, *History of the National Academy of Design,* chap. 1.

26. S. F. B. Morse, "Address to the Public," in Cummings, *Historic Annals,* p. 29; Clark, *History of the National Academy,* p. 17. During the first years a "voluntary subscription" was made by the members to pay the expenses of the school. (Cummings, *Historic Annals,* p. 36; Clark, *History of the National Academy,* p. 15.)

27. Clark, *History of the National Academy,* p. 19; Gulian C. Verplanck, Director of the American Academy, to Washington Allston, New York, May 18, 1819, Dana Collection.

28. This was Morse's reply to a review of his speech by Franklin Dexter that appeared in the *North American Review,* in Cummings, *Historic Annals,* p. 61. For further discussion of the growing distaste of Americans in the mid-century for old paintings, see below, pp. 156, 162, 170–71.

CHAPTER 9 PHILADELPHIA: THE PENNSYLVANIA ACADEMY
OF FINE ARTS

1. Gilbert Stuart, so the stories go, used to preface his remarks about life in Philadelphia when he was there between 1795 and 1803 with the statement, "When I resided in the Athens of America. . . ." (W. T. Whitley, *Gilbert Stuart* [Cambridge, Mass., 1932], p. 111.) Benjamin

West also looked upon Philadelphia as the "Athens of the western world in all that can give polish to the human mind." (E. Oberholtzer, *Philadelphia: A History of the City and its People* [Philadelphia, 1912], I, 433); Dixon Wecter, *The Saga of American Society* (New York, 1937), pp. 62–63; Carl and Jessica Bridenbaugh, *Rebels and Gentlemen* (New York, 1942), pp. 168, 172, and chap. 6 *passim*.

2. Copley visited Philadelphia in 1771 in the belief that the city was "a place of too much importance not to visit." (*Copley–Pelham Letters* [Boston, 1914], p. 163.) See also A. C. Prime, *The Arts and Crafts in Philadelphia, Maryland, and South Carolina* (Topsfield, Mass., 1929), *passim;* J. T. Scharf and Thompson Westcott, *History of Philadelphia, 1609–1884* (Philadelphia, 1884), II, 1035–65; W. Dunlap, *History of the Arts of Design in the United States* (Boston, 1918), I, 110–16, 156–64; II, 235–64, and *passim*.

3. MS Papers Relating to the Early History of the Academy of Fine Arts of Philadelphia, 1794–1796, December 29, 1794, HSP. "The Columbianum Association"; "Letter of Resignation s/d by eight members," n.d.; Prime, *The Arts and Crafts in Philadelphia, Maryland and South Carolina*, pp. 55–58. A summary of the reasons for the organization's failure is given in a Report of the Society of Artists, April 15, 1812, PAFA, reprinted in Anna Wells Rutledge, *Cumulative Record of the Exhibition Catalogues of the Pennsylvania Academy of Fine Arts, 1807–1870* (Philadelphia, 1955), p. 2.

4. Peale to the Honorable Mr. Finley, Lancaster, Museum, February 18, 1800, Etting Collection, HSP; Peale to Jefferson, Museum, January 25, 1803, in "Papers Relating to the Early History of the Academy of Fine Arts, Philadelphia," HSP.

5. Dunlap, *History of the Arts of Design*, II, 106; Scharf & Westcott, *History of Philadelphia*, I, 521.

6. Oberholtzer, *Philadelphia*, I, 433; Scharf & Westcott, *History of Philadelphia*, II, 1602; Dunlap, *History of the Arts of Design*, II, 110–11; Peale to Raphaelle [Peale], Philadelphia, Museum, June 6, 1805; Peale to Jefferson, June 13, 1805, in "Academy of Fine Arts, Minutes and Papers," HSP. In 1824 a proposal was made by Benjamin West's son Raphael to the Academy's directors that they purchase his father's pictures for the institution. Writing about this plan to Sully, Charles R. Leslie, an American artist who had made London his permanent home, wrote that "such a purchase will be productive of great advantages to the arts generally and to the artists individually in America." Leslie feared, however, "that the calculating spirit of our merchants will be alarmed at the sum. . . ." February 23, 1824, Dreer Collection, HSP.

7. John Sanderson, *Biography of the Signers of the Declaration of*

Independence (Philadelphia, 1823), p. 230; Peale to Rubens [Peale], June 24, 1805; Peale to Dr. E. Stevens, St. Croix, Philadelphia, June 23, 1805, in "Papers of the Academy." Biddle was a connoisseur of the arts as well as a successful banker, but his connoisseurship developed as a result of the chore he was presented with, rather than at an earlier time. When he was solicited by the Philadelphia committee to act as agent for the purchase of the casts, Biddle was delighted "to contribute" his energies in this way "toward an establishment so honorable to our city." See Peale, Hopkinson & Meredith to N. Biddle, Philadelphia, July 8, 1805; Biddle to the Pennsylvania Academy of Fine Arts, Paris, October 24, 1805 (MS letters in the PAFA files); Thomas Payne Govan, *Nicholas Biddle, Nationalist and Public Banker, 1786–1844* (Chicago, 1959), pp. 14–15.

8. Women were usually admitted to see the casts on Mondays, "when without blushing in the presence of their escorts, they could view the Apollo Belvidere, the Laocoon, and other casts lately received from Paris." The oft-repeated story told by Mrs. Trollope is worth repeating again. Mrs. Trollope visited the Academy in 1830; an old woman who was on guard met her with the injunction, " 'Now, ma'am, this is just the time for you—nobody can see you. Make haste.' Looking around her on all sides to be assured that no one was in sight, quite as though she were introducing the visitor to some chamber of shameless nakedness, the custodian took Mrs. Trollope by the arm and hustled her in. The astonished English woman found a sign which asked visitors not to deface or mark the statues, though its warnings had been quite ineffectual. Men who came alone wrote indecent legends on the walls, and on the casts themselves, which women could scarcely avoid reading when their turn was at hand to educate themselves in the fine arts." (Oberholtzer, *Philadelphia*, I, 433; Frances Trollope, *Domestic Manners of Americans*, [New York, 1949], p. 216.)

9. Dunlap, *History of the Arts of Design*, II, 106; *A Guide to the Lions of Philadelphia, Comprising a Description of the Places of Amusement, Exhibitions &c* (Philadelphia, 1837), p. 13; Rutledge, *Cumulative Record*, pp. 343–48, gives the complete listing of paintings and statuary acquired by the Academy between 1807 and 1870, although it does not give the years of their acquisition. The Murillo painting had been purchased for $1,000 in 1816. (I. S. Doney to Morse, Philadelphia, April 24, 1816, Morse Letters.) The David copy is listed as an original in the *Guide*, but in Rutledge (p. 344) it is called a copy by Charles B. Lawrence. For exhibitions, see Rutledge, *Cumulative Record*, pp. 314–15, 320, 335, 336–37. For Gilmor's collection, see Joseph Hopkinson to Robert Gilmor, Philadelphia, October 3, 1826, PAFA files.

10. Joel R. Poinsett to PAFA, Charleston, July 12, 1823; E. Satterlee,

Albany Gallery of Fine Arts to PAFA, Albany, September 27, 1847; List
of Pictures Borrowed, November 19/20, 1847; J. R. Lambdin to Albany
Gallery of Fine Arts, Philadelphia, December 10, 1847; PAFA files. Also
see Albany Gallery of Fine Arts to PAFA for years 1848 and 1851, *ibid.;*
J. H. B. Latrobe to PAFA, Baltimore, October 12, November 3 and 17,
1853, *ibid.*

11. The Pennsylvania Academy's collection was constantly being
augmented by gifts and deposits. See letters to Mr. James Craig, August
13, 1817; R. W. Meade, August 14, 1818, in "The Minutes Book of the
Pennsylvania Academy of Fine Arts, 1817–1828," HSP. For purchase of
Allston's painting, see June 2, 1817, *ibid.;* "A Report of the Committee
Appointed to Examine into the Present State of the Society of Artists . . .
April 15, 1812," PAFA (reprinted in Rutledge, *Cumulative Record*, p. 2).

12. Constitution of the Society of Artists (MS, PAFA). The charter of
incorporation obtained from the Pennsylvania Legislature in 1813 indi-
cates that the artists had changed their name to the Columbian Society of
America.

13. Dunlap, *History of the Arts of Design*, II, 106; I, 424; "A Report
of the Committee . . . April 15, 1812," *op. cit.; Catalogue of the First
Annual Exhibition of the Society of Artists of the United States,
1811* (Philadelphia, 1811), PAFA; H. E. Dickson, *John Wesley Jarvis*
(New York, 1949), p. 152. The Columbian Society lingered on into 1816,
or even longer, if the letter of resignation from the PAFA of G. Fairman
and G. Bridport may be considered evidence. Both of these artists were
resigning as Pennsylvania Academicians, they wrote on April 13, 1816,
because they thought that their "exclusive attention (as professional
artists) should be directed to the 'Columbian Society of Artists'" (PAFA
files).

14. Dunlap, *History of the Arts of Design*, 107, 110–11; Rutledge,
Cumulative Record, pp. 2–3. See Board of Directors of PAFA to
Columbian Society of Artists, Philadelphia, April 27, 1814: "The Board
does not accede to your proposition to dispose of its share of profits of the
coming exhibition to exhibiting artists." Instead, the Board planned to use
the money for the purchase of models and improvements as well as for the
purchase of works of art (PAFA files).

15. Sully's Journal, March 2, 9, 17, 1828, MS in NYHS. More than five
landscapes of Doughty's were purchased at various times by the Acad-
emy; yet Doughty bore a constant grievance against all institutions
designed to help art and artists, possibly because in his estimation they did
not help him enough. See his relations to the Art-Union, below, p. 165;
Rutledge, *Cumulative Record*, p. 344, lists Doughty paintings that were
purchased by the Academy. Thomas Sully in a letter to Robertson, May

16, 1828 (Amer. Acad. of Fine Arts, I, 138, NYHS), wrote that the artists were "angry with the institution" and would not contribute their pictures that year to the PAFA Exhibition. For the Artists' Fund, see Circular of the Artists' Fund Society, 1837 (PAFA); Rutledge, *Cumulative Record*, p. 3; *Guide to the Lions of Philadelphia*, p. 13. During the decade in which the Artists' Fund's exhibitions were held, the PAFA held no annual exhibitions of six weeks duration, as it had previously; instead, it remained open for visitors throughout the year (*Guide to the Lions of Philadelphia*, p. 13).

16. Morse to Cole, New York, March 20, 1837; Artists' Fund Society to Cole, February 25, 1837, Cole Papers. Cole's landscape was offered for sale in 1840 and Morse's portrait of his daughter was exhibited in 1842. Rutledge, *Cumulative Records*, pp. 50, 147.

17. Thos. Sully to A. Robertson, Philadelphia, May 16, 1828, Amer. Acad. of Fine Arts, I, 138.

18. Henry D. Gilpin, to the Board of Directors of the PAFA, May 20, 1859, PAFA files; *Philadelphia in 1824* (Philadelphia, 1824), pp. 95, 97, 100, 101, 109; Thomas Porter, *Pictures of Philadelphia from 1811 to 1831* (Philadelphia, 1831), II, 235, 266; Scharf & Westcott, *History of Philadelphia*, I, 319, 323, 324–25, 409, 445, 455, 521, 538 (for Clymer); I, 577, 585, 600, 611, 615; II, 1206, 1513 (for Tilghman); I, 621 (for Collins); I, 519, 560, 601, 619 (for Meredith); I, 677, 686; II, 1545 (for Gilpin); I, 625; II, 1221, 1531 (for Rawle); I, 511, 535, 599 (for Sansom); I, 832 (for Fales). See Cole Papers, *passim.*, for McMurtrie; also Jared B. Flagg, *Life and Letters of Washington Allston* (New York, 1892), pp. 119, 123, 143, 151, 158, 249, 310, 312, 314, 317; quoted by C. and J. Bridenbaugh, *Rebels and Gentlemen*, p. 223.

CHAPTER 10 BOSTON: THE ATHENAEUM GALLERY

1. Winthrop Sargent, *Boston, a Poem* (1803).
2. R. W. Emerson, "Boston," *The Works . . .* , ed. J. E. Cabot (Boston & New York, 1883), XII, 90; "Review of William Tudor's *Letters on the Eastern States*," *North Amer. Rev.*, XI (July, 1820), 36; for Boston's relative decline in economic importance, as compared to New York and Philadelphia, see George R. Taylor, *The Transportation Revolution, 1815–1860* (New York, 1951), p. 8.
3. J. Winsor, *Memorial History of Boston, 1630–1880* (Boston, 1881), III, 634–36; V, 383–92. Quotation is from *Copley–Pelham Letters* (Boston, 1914), pp. 65–66. See also Carl Bridenbaugh, *Cities in Revolt* (New York, 1955), p. 403. For Boston merchants and Gilbert Stuart, see Van

Wyck Brooks, *The Flowering of New England, 1815–1865* (New York, 1937), chap. 1.

4. Bridenbaugh, *Cities in Revolt*, p. 404.

5. Mabel Munson Swan, *The Athenaeum Gallery, 1827–1873* (Boston, 1940), p. ix; the Anthology Club flourished between 1805 and 1811 and its major activity involved the publishing of the *Monthly Anthology, or Magazine of Polite Literature* (1803–1811). The club consisted at one time or another of seven ministers, four doctors, fifteen merchants or academicians from Boston's "best" families. See Winsor, *Memorial History*, III, 637, for list of members; Eliza B. Lee, *Lives of the Buckministers* (Boston, 1851), pp. 128, 323, 407; William Tudor, *Miscellanies* (Boston, 1821). Records of the Anthology Club are at MHS. See also Lewis Simpson, *The Federalist Literary Mind; Selections from The Monthly Anthology, and Boston Review, 1803–1811* (Baton Rouge, 1962), for the literary contributions of the members. The quotation is from "Memoir of the Athenaeum," in Swan, *The Athenaeum Gallery*, p. 3. In 1809 an unsuccessful attempt was made to establish an academy of art in Boston, to which Stuart, Boston's leading artist in residence, objected; Stuart told Neagle that he objected because "too often the founders of such institutions were endowed with more wealth than knowledge of art." (Swan, *op. cit.*, p. 6.)

6. Winsor, *Memorial History*, IV, 10; American Antiquarian Society, *A List of Portraits Painted by Ethan Allen Greenwood* (Proceedings of the American Antiquarian Society, April, 1946), pp. 4–5. Bowen's Columbian Museum was actually established in Boston "at the head of the Mall" in January, 1796. At that time it boasted one hundred paintings, "some of which are 8 by 10 feet; and valued at one thousand dollars, they being original pieces, painted by the late celebrated Robert E. Pine." The museum also exhibited wax works of "interesting" contemporary heroes and heroines. (A. C. Prime, *The Arts and Crafts in Philadelphia, Maryland, and South Carolina* [Topsfield, Mass., 1929], p. 55.)

7. *North Amer. Rev.*, I (May, 1815), 132, 133; "Review and Register of the Fine Arts," in *American Monthly Magazine and Critical Review*, I (August, 1817), 293; Swan, *The Athenaeum Gallery*, p. 7. Also in 1818, Trumbull's "Declaration of Independence" was exhibited in Faneuil Hall. For Farina exhibition, see the *Hudson* (N.Y.) *Whig*, July 15, 1817, quoting from the *Boston Intelligencer*.

8. Tudor to Otis, September 2, 1815, in Samuel Eliot Morison, *The Life and Letters of Harrison Gray Otis, Federalist, 1765–1848*. (Boston & New York, 1913), pp. 246–48. Warren, Davis, S. Wells, Lyman, Sears, Codman, and Tudor were involved in some way with the Boston

Athenaeum and the Gallery of Art. R. Sullivan was probably Richard Sullivan, Clerk of the Brattle Street Church. Tudor was one of the original Anthology Club members, an amateur essayist, biographer of James Otis, and a founder and first editor of the *North American Review*, the successor to the *Monthly Anthology*.

9. *North Amer. Rev.*, II (November, 1815), 136, 153, 163, 164.

10. Morse to Allston, Boston, April 10, 1816, Morse Letters. Tudor had hoped to start the project off with an initial subscription of $30,000, but only between $4,000 and $5,000 were raised and the project was allowed to "languish." (Morison, *Harrison Gray Otis*, I, 247, 248.)

11. Josiah Quincy, *A Municipal History of the Town and City of Boston During Two Centuries, from September 17, 1630, to September 17, 1838* (Boston, 1852), p. 40. 1822 also brought Dunlap's *Christ Rejected* to Boston in July (W. Dunlap, *History of the Arts of Design in the United States* [Boston, 1918], I, 344). On July 3 of that year, Emerson noted in a letter that he had just visited the new home of the Athenaeum which was "royally fitted up for elegance and comfort." Thorndike's gift especially attracted him "from the tedious joys of writing and reading. The beholder instantly feels the spirit of the connoisseur stealing over him, & ere he can exorcise it, rubs up his Latin & Italian lore. . . ." (Ralph L. Rusk, *The Letters of Ralph Waldo Emerson* [New York, 1939], I, 119–20). Swan, *The Athenaeum Gallery*, p. 134, lists the Thorndike gift, which consisted of eleven full-length figures, eight full-size, and three small.

12. In Swan, *The Athenaeum Gallery*, p. 8.

13. *Ibid.*, pp. 9–10, 14, 18–34, 193 ff.

14. *Ibid.*, pp. 33, 41, 91, 93, 95–97, 98, 99. The provision limiting exhibitions to new paintings did not extend to permanent acquisitions of the Gallery, which were often repeatedly shown. Mrs. Swan quotes a letter to William Vernon of Newport, who owned a considerable collection of fine paintings, from William Ellery Channing, Boston, March 12, 1830. Channing, recollecting the pleasure he had received from seeing Vernon's pictures, wished, he wrote, to share this pleasure with his "fellow-citizens." "I feel, too," he added, "that we all owe it to our country to spread as far as we can a taste for the fine arts, and I do not know how, with your strong patriotic feelings, you can escape the obligation."

15. Swan, *The Athenaeum Gallery*, pp. 111, 37–38, chap. 7, esp. pp. 123, 127, 129, 130, 131. A sum of $2,000 was paid for the *Sortie from Gibraltar* (Trumbull to Franklin B. Dexter, New York, September 18, 1828, Trumbull–Silliman Correspondence, CHS). The reviewer of the 1830 exhibition of the Boston Athenaeum Gallery was of the opinion that

the *Sortie from Gibraltar* was Trumbull's best work and one which secured him "a rank with the greatest masters of the art." (*North Amer. Rev.*, XXXI [July, 1830], 333, 334.) For another contemporary estimate of the painting, see *New York Spectator*, June 10, 1828: "We regret that [this splendid work] cannot remain in its present place as a study for future artists." The article went on to criticize New Yorkers for not buying the work whose "reputation is known and established throughout the world." Also see p. 97 above for a more critical appraisal of the work.

16. Swan, *The Boston Athenaeum*, pp. 107–8; Francis Steegmuller, *The Two Lives of James Jackson Jarves* (New Haven, 1951), pp. 170–95.

17. *Crayon*, April, 1858. New Yorkers seemed to have enjoyed Pre-Raphaelite art more than Bostonians. See David H. Dickason, *The Daring Young Men, the Story of the American Pre-Raphaelites* (Bloomington, Ind., 1953), pp. 65–70.

18. Swan, *The Boston Athenaeum*, pp. 100–101, 103, 131. The *Course of Empire* paintings were lent to the Athenaeum by the New York Gallery of Fine Arts in 1854.

Hunt exhibited at the Boston Athenaeum between 1852–60, 1863–64, 1868–73. The force of Hunt's personality as a teacher and his social connections brought him portrait commissions from "fashionable Bostonians" who did not appreciate the depth of his insight; even in 1878–79, at the last exhibition of his work before his death, "the reception by the local [Boston] public was cool." (Virgil Barker, *American Painting* [New York, 1950], p. 620; Swan, *The Athenaeum Gallery*, p. 241.)

Charles Eliot Norton headed a group of Bostonians who presented Page's *Venus* to the Athenaeum in 1859. Why the Athenaeum accepted the painting under the circumstances is difficult to fathom, except that Norton and his friends were prominent in Boston art circles at the time. Norton obviously was convinced of the merit of the painting because he wrote to John Durand to the effect that it was a picture that "ought to be seen in New York—and it is amusing to find squeamishness about such a work in a community where Sunday School children are taken in a body to see Powers' *Greek Slave*." (April 6, 1858, Durand Collection.) Page was Norton's friend and was highly regarded by Bostonians even though, as Thomas Gold Appleton wrote, his painting fared "badly in Boston." Appleton to Norton, London, August 12, 1856, Norton Letters, Harvard College Library.

19. Swan, *The Athenaeum Gallery*, pp. 126, 135, 136, 140, 141. Sculpture was considered essential for art students. "The study of the antique," wrote Franklin B. Dexter, a member of the Fine Arts Committee of the Athenaeum, "is the very alphabet of art. It is the *only*

practicable method of learning the perfect proportion of the human figure. . . ." (Letter to the trustees, 1833, in *ibid.*, p. 139.)

20. *Ibid.*, pp. 140–59.

21. Winsor, *Memorial History*, IV, 405. In 1834 an "Artists' Gallery" was formed at Harding's Gallery on School Street for the exhibition of works by Boston artists who shared the admission fees. This was in protest against the Athenaeum's policy of retaining admission fees for the gallery's own needs. It was believed that this new group would not "operate at all to the disadvantage of the Gallery, for it will create a desire in individuals to visit both and compare their respective merits together." (Swan, *The Athenaeum Gallery*, pp. 98–99; quote is from the *Boston Advertiser*, May 12, 1834.)

CHAPTER 11 CHARLESTON: THE SOUTHERN EXPERIENCE

1. W. Dunlap, *History of the Arts of Design in the United States* (Boston, 1918), I, 329, 335, 340; Carl Bridenbaugh, *Cities in Revolt* (New York, 1955), pp. 181, 374, 402, 407; T. J. Wertenbaker, *The Old South, the Founding of American Civilization* (New York, 1942), pp. 53–57; Anna W. Rutledge, *Artists in the Life of Charleston, Through Colony and State from Restoration to Reconstruction* (Transactions of the American Philosophical Society, Vol. 39, Pt. 2 [Philadelphia, 1949]), p. 101; Clement Eaton, *Freedom of Thought in the Old South* (Durham, N.C., 1940), pp. 4–9; Mrs. Anne Izard Deas, *Correspondence of Mr. Ralph Izard of South Carolina, from the Year 1774 to 1804, with a short Memoir* (New York, 1844), I, vi, xiv, 92.

2. H. H. Ravenel, *Charleston, the Place and the People* (New York, 1906), pp. 384–85, 387, 466, 354, 464; Wertenbaker, *The Old South*, p. 291. See also "Diary of Robert Gilmor, Jr.," *Maryland Historical Magazine*, XVII, Nos. 2 & 3, 260 ff., for description of Charleston's social life in the 1820's; Henry Adams, *History of the United States During the First Administration of Thomas Jefferson* (New York, 1889), I, 37–39.

3. *South Carolina Gazette and General Advertiser*, February 5–7, 1784, in Rutledge, *Artists in the Life of Charleston*, p. 137.

4. *Ibid.*

5. *Ibid.*, pp. 130, 138, 139.

6. *Ibid.*, pp. 137, 138. Cogdell also held federal office in the customs, served in the legislature of South Carolina, held the office of Comptroller-General, and from 1832 on served as President of the Bank of South Carolina. Dunlap, *History of the Arts of Design in America*, II, 372–73; Edward L. Morse, *Samuel F. B. Morse, Letters and Journals* (Boston, 1914), I, 221–22; John Belton O'Neall, *Biographical Sketches of the Bench and Bar of South Carolina* (Charleston, 1859), II, 217–18; J. Fred

Rippy, *Joel R. Poinsett, Versatile American* (Durham, N.C., 1935), chap. 14 *passim;* Paul R. Weidner (ed.), "The Journal of John Blake White," *South Carolina Historical and Geneological Magazine,* XLII, Nos. 2–4, 55–71, 99–117, 169–86; XLIII, Nos. 1–2, 35–46, 103–17; Dunlap, *History of the Arts of Design,* I, 427; III, 58. The other directors of the Academy were Joshua Canter, a teacher of painting who was "devotedly attached to the art"; the architect, William Jay; the die sinker, Charles C. Wright; and the engravers, Charles Simmons and James Wood. For more about Poinsett, whose library contained "a most elegant collection of books and handsome prints," see A. W. Rutledge (ed.), "Four Letters of the Early 19th Century," in *S.C. Hist. & Gen. Mag.,* XLII (January, 1942), 54.

7. Morse, *Samuel F. B. Morse,* I, 236; Elliott to Poinsett, January 7, 1822, Poinsett Papers, II, in Rippy, *Joel R. Poinsett,* p. 198; Rutledge, *Artists in the Life of Charleston,* p. 139; Cogdell to Morse, April 14, 1821, Morse Letters; Dunlap, *History of the Arts of Design,* III, 59; *City Gazette and Commercial Daily Advertiser,* July 22, 1830, in Rutledge, *Artists in the Life of Charleston,* p. 140.

8. "Diary of Robert Gilmor, Jr.," *Maryland Hist. Mag.,* XVII, 260. Gilmor found "very few pictures worthy of notice" in the exhibition when he visited it in 1827. Cogdell, however, disagreed with Gilmor and wrote Dunlap that the Academy had had "as splendid exhibitions as I have seen in any other city." (Dunlap, *History of the Arts of Design,* III, 59.) According to Miss Rutledge, the exhibitions contained, at one time or another, portraits by the more important members of the English school—Romney, Reynolds, West, Raeburn, Shee—and by the Americans, Stuart, Jarvis, Waldo, Fraser, Fisher, the Canters, Hill, Morse, and others. There were also works "attributed to Correggio, Rubens, Wovermann, Francini, Morland, and Wilkie." (*Artists in the Life of Charleston,* p. 139.)

9. Rutledge, *Artists in the Life of Charleston,* p. 139; *Courier,* December 6, 1837, in *ibid.,* p. 140; *Southern Rose,* February 3, 1838, pp. 183–84, in *ibid.,* p. 141.

10. "The Apprentices' Library Society," *Rambler,* October 16, 1843, p. 26. in *ibid.,* p. 141; Charles R. Fraser, *Reminiscences* (Charleston, 1854); Ravenel, *Charleston,* pp. 466–67. In 1856 Fraser was given a one-man show by a group of Charleston gentlemen headed by the pastor of the Unitarian Church, Dr. Samuel Gilman, a New Englander by birth and "a literary figure of some prominence in his time." (Rutledge, *Artists in the Life of Charleston,* pp. 134–35.)

11. Rutledge, *Artists in the Life of Charleston,* p. 141; *Courier,* December 19, 1861, in *ibid.,* p. 141.

12. George R. Taylor, *The Transportation Revolution, 1815–1860*

(New York, 1951), p. 197; Wertenbaker, *The Old South,* pp. 13–14, 275, 278–79; Francis B. Simkins, *The South, Old and New* (New York, 1947), pp. 39–41; Morse, *Samuel F. B. Morse,* I, 232. Jarvis visited Charleston in 1820, and although presumably he had been successful there, he never returned; Vanderlyn worked in Charleston in 1822 and 1823 and returned briefly at the end of his career, in 1835; Rembrandt Peale successfully exhibited his *Court of Death* in the city about the time that Vanderlyn was there, but he did not return until 1858. (Rutledge, *Artists in the Life of Charleston,* pp. 131, 132; Vanderlyn to Charles King, Charleston, February 21, 1835, Vanderlyn Papers.)

13. *City Gazette and Commercial Daily Advertiser,* July 22, 1830, in Rutledge, *Artists in the Life of Charleston,* p. 140; "Diary of Robert Gilmor, Jr.," *Maryland Hist. Mag.,* XVII, 319–20. By 1835 Vanderlyn noted that "things here in Charleston have become tranquil between parties," but he realized that "angry feelings may again be aroused," and that in the discord, the real sufferers would be those like himself, "who cultivate the poor *arts* of peace." (Vanderlyn to King, Charleston, February 21, 1835, Vanderlyn Papers.)

14. Eaton, *Freedom of Thought in the Old South,* chap. 12 *passim;* Rutledge, *Artists in the Life of Charleston,* pp. 101, 102, 155. The date of the *Courier* article was August 31, 1842. Even the portrait fell out of demand by 1835, and portraitists who visited Charleston during the following years found it increasingly hard to obtain commissions. See Vanderlyn to Charles King, Charleston, February 21, 1835, Vanderlyn Papers.

15. The exception that proves the rule is the taste of John Ashe Alston, who lived on a plantation outside of Charleston. Alston commissioned both Vanderlyn and Morse to paint portraits of his children "with the most superb landscape" they were capable of producing. (Morse, *Samuel F. B. Morse,* I, 215; Vanderlyn Papers.)

16. Rutledge, *Artists in the Life of Charleston,* pp. 102, 131; "The Journal of John Blake White," *S.C. Hist. & Gen. Mag.,* XLIII, No. 2, 104, 107.

CHAPTER 12 BALTIMORE: ART IN A BORDER CITY

1. Hinton Rowan Helper, of North Carolina, *The Impending Crisis of the South: How to Meet It* (New York, 1860), p. 21.

2. *Ibid.,* p. 22.

3. J. Thomas Scharf, *History of Maryland* (Baltimore, 1879), II, 5; J. Thomas Scharf, *History of Baltimore City and County from the Earliest*

Period to the Present Day (Philadelphia, 1881), I, 282, 283, 382–83; Raphael Semmes, *Baltimore as Seen by Visitors, 1783–1860* (Studies in Maryland History, No. 2 [Baltimore, 1953]), p. 3. The fortune of the Gilmor family, of which Robert Gilmor, Jr.—one of the city's as well as the nation's most outstanding art patrons—was a member, was in part based on the coffee trade. (Scharf, *History of Baltimore City and County*, I, 433).

4. Eugene L. Didier, *The Life and Letters of Mme. Bonaparte* (New York, 1879), pp. 218, 220; M. C. Crawford, *Romantic Days in the Early Republic* (Boston, 1912), pp. 243–90; Auguste Levasseur, *Lafayette en Amerique en 1824*, in Semmes, *Baltimore as Seen by Visitors*, p. 65; Capt. Basil Hall, *Travels in North America* (Edinburgh, 1829), II, 392.

5. Thomas C. Corner, "Private Art Collections of Baltimore," *Art and Archaeology*, XIX (May–June, 1925), 239; Baltimore Museum of Art, *A Century of Baltimore Collecting, 1840–1940* (Baltimore, 1941), p. 7; W. Dunlap, *History of the Arts of Design in the United States* (Boston, 1918), III, 272, 292; Frances B. Greenough (ed.), *Letters of Horatio Greenough to His Brother Henry Greenough* (Boston, 1887), p. 30; Baltimore Museum of Art, *Two Hundred and Fifty Years of Painting in Maryland* (Baltimore, 1945), p. 10; H. E. Dickson, *John Wesley Jarvis* (New York, 1949), p. 140 ff.; Dunlap, *History of the Arts of Design in America*, I, 321, 330. In 1820 Dunlap found Rembrandt Peale, Sully, and Eichholtz in the city; Eichholtz, "painting good hard likenesses at $30 a head," received "most of the business" (I, 330); Dr. J. Hall Pleasants, *Four Late 18th Century Anglo-American Landscape Painters* (Worcester, 1943), pp. 190–94, 215–300; Walters Art Gallery, *The West of Alfred J. Miller*, introd. by Marvin C. Ross (Norman, Okla., 1951).

6. John H. B. Latrobe, "Reminiscences of Baltimore in 1824," *Maryland Hist. Mag.*, I (March, 1960), 1; Scharf, *History of Baltimore City and County*, II, 642, 644; Baltimore Museum of Art, *250 Years of Painting in Maryland*, p. 5; "Diary of Robert Gilmore, Jr.," *passim*. The Delphian Club was presumably responsible for stimulating the "cultural life of the city." The Anacreontic Society was limited to an exclusive group of gentlemen who enjoyed musical performances and therefore arranged private concerts for their own pleasure.

7. Scharf, *History of Baltimore City and County*, II, 691; Latrobe Weston, "Art and Artists in Baltimore," *Maryland Hist. Mag.*, XXXIII, No. 3 (September, 1938), 214; Circular of the Peale Museum, in *Rendezvous for Taste, 1814–1830. An Exhibition Celebrating the 25th Anniversary of the Peale Museum. The Municipal Museum of the City of Baltimore, 1831–1956* (Baltimore, 1956), pp. 11, 3–9, 5, 8, 9, 11.

8. Wilbur H. Hunter, "Tribulations of a Museum Director in the

1820's," *Maryland Hist. Mag.*, XLIX, No. 3 (September, 1954), 217. See also Latrobe, "Reminiscences," *op. cit.*, p. 121, for a description of some of the varied activities carried on at the museum.

9. *Rendezvous for Taste*, p. 10. The Peales may occasionally have taken an individual pupil like Alfred J. Miller, but no formal provision was made for the education of student artists.

10. Rembrandt Peale to Charles F. Mayer, October 12, 1830, in Scharf, *History of Baltimore City and County*, II, 692. Stockholders and directors included Henry Robinson, "the largest stockholder"; Robert Carey Long, architect; Robert Gilmor, Jr., merchant and art patron; James Mosher, President of the Mechanics' Bank; William Lorman, merchant, banker, railroad developer; Alexander Fridge, financier; William Wilson, founder of a great mercantile and shipping firm; Alexander McKim, importer; and Jacob I. Cohen, Jr., President of the Baltimore Fire Insurance Company. Cohen, Lorman, and Fridge were involved in founding and organizing early railroads in Baltimore; Gilmor, Long, Mosher, Lorman, Wilson, and McKim were directors or officers of banks; Cohen, Fridge, Lorman, and Mosher were among the original incorporators of the Maryland Hospital in 1817; Long and Gilmor were among the founders of the Maryland Historical Society in 1844; McKim was a member of the corresponding committee of the American Society for the Promotion of Domestic Manufactures and National Industry; and McKim Wilson, Mosher, Lorman, and Cohen served at one time or another as members of the Baltimore City Council. All of these men were among "the most refined and highly educated in the state" (Scharf, *History of Baltimore City and County*, II, 769, and *passim.*); Hunter, "The Tribulations of a Museum Director," *op. cit.*, p. 222. Hunter's most impressive explanation for the failure of the museum was that the Peales, in order to make a profit from their enterprise, were forced to offer popular entertainment, "but in this field they could not compete with the slick humbuggery of a Phineas T. Barnum and instead lost the sympathy of the people of learning and taste" (*ibid.*)

11. George R. Taylor, *The Transportation Revolution, 1815–1860* (New York, 1951), pp. 6–9, 297–98, 393.

12. Scharf, *History of Baltimore City and County*, II, 659; *Baltimore Monument*, II (June 2, 1838), No. 35, 270; II (March 10, 1838), No. 23, 180. Lawyers, journalists, dentists, and a churchman were officers and directors of the Maryland Academy of Fine Arts. One of these was T. S. Arthur, editor and author of the popular *Ten Nights in a Bar Room;* another was William Gwynn, "one of Baltimore's giants of the law," whose house was "headquarters" of the "literati, artists, actors and Bohemians" of Baltimore between 1815 and 1830 and who was the

"presiding genius of the Tusculum and Delphian Clubs"; a third was the Rev. J. N. McJilton, who with Arthur had founded and was co-editor of the *Monument* (Scharf, *op. cit.*, II, 712, 644.)

13. *Monument*, II (September 8, 1838), No. 49, 390; *Baltimore Sun*, May 23, 1838; Taylor, *The Transportation Revolution*, pp. 344–45.

14. William Rodewald, "Some Observations in the Address to be published in behalf of the erection of the Athenaeum," February, 1845, Misc. MS, Maryland Historical Society.

15. Scharf, *History of Baltimore City and County*, II, 658, 659; L. Warrington Gillet to Brantz Mayer, August 30, 1845 (Mayer, Misc. Letters, Md. HS); *Catalogue of Paintings, Engravings &c at the Picture Gallery of the Maryland Historical Society. First Annual Exhibition, 1848* (Baltimore, 1848).

16. Circular, Baltimore, June 5, 1848, s/d J. H. B. Latrobe, Benj. C. Ward, William McKim, Committee, Wisconsin Historical Society.

17. Brantz Mayer, *Commerce, Literature and Art: A Discourse Delivered at the Dedication of the Baltimore Athenaeum*, October 23, 1848. (Baltimore, 1848), pp. 9–10, 8–9, 23. For Mayer, see Scharf, *History of Baltimore City and County*, II, 650–51; I, 388.

18. *Catalogue of Paintings, Engravings &c at the Picture Gallery of the Maryland Historical Society, 4th Exhibition, 1853* (Baltimore, 1853); *Catalogue of Paintings, Engravings &c at the Picture Gallery of the Maryland Historical Society, 6th Exhibition, 1858* (Baltimore, 1858); *Catalogue of Paintings, Engravings &c at the Picture Gallery of the Artists' Association and the Maryland Historical Society* (Baltimore, 1856); Anna Wells Rutledge, "Early Art Exhibitions of the Maryland Historical Society," *Maryland Hist. Mag.*, XLII, No. 2 (June, 1947), 129.

19. Rutledge, "Early Art Exhibitions," *op. cit.*, p. 124; Weston, "Art and Artists in Baltimore," *op. cit.*, p. 219; Scharf, *History of Baltimore City and County*, II, 674. Weston concludes that although the Historical Gallery was essentially a loan collection, its exhibitions did provide "occasions that drew art lovers together" and therefore "were a stimulus to contemporary artists." Instruction in art was given from 1851 on at the Maryland Institute until fire destroyed the building in 1904; but the kind of instruction given was aimed at developing commercial artists or designers. Day and night schools of design were also held at the Institute (Weston, "Art and Artists," p. 218). Probably Baltimore's most important art collection is that which was bequeathed to the city by William T. Walters. Since Walters' collecting began in the 1840's, it might be said that the stimulus behind the founding of the gallery in the later years came from the intellectual environment of the earlier period.

PART IV PATRONS AND TASTE

1. Eleanor Berman, *Jefferson Among the Arts* (New York, 1947), p. 85; *North Amer. Rev.*, XXXII (January, 1831), 18–19.

2. Sir Joshua Reynolds, *Discourses* (London, 1924), pp. 84, 86, 88, 96. For an American artist's belief that Old Masters were necessary for knowledge of the craft, see E. P. Richardson, *Washington Allston* (Chicago, 1948), pp. 86–88; Morse to his parents, London, March 1, 1814, Morse Letters; Thomas Colley Grattan, *Civilized America* (London, 1859), II, 109. See also C. C. Felton in the *North Amer. Rev.*, LV (October, 1842), 431–32; Charles A. Murray, *Travels in North America During the Years 1834, 1835, and 1836* (New York, 1839), II, 209–10; *North Amer. Rev.*, LXXV (July, 1852), 125; CVII (July, 1868), 371–73; CXI (July, 1870), 1–29.

3. Florence, June 16, 1858, Durand Collection.

4. Alison's *Essays on Taste* appeared in 1790, but the book was republished in New York in 1830 (edited by Abraham Mills, "with corrections and improvements"). Sir Uvedale Price's *On the Picturesque* was republished in 1842 in London, with an "Essay on the Origin of Taste." This was the edition that circulated most widely in this country.

5. A. T. Rice, "The Progress of Painting in America," *North Amer. Rev.*, CXXIV (May, 1877), 457.

CHAPTER 13 AMERICAN COLLECTIONS

1. Perkins' dates are 1764–1854. The information about Perkins has been obtained from T. G. Cary, *Memoir of Thomas Handasyd Perkins* (Boston, 1856), Samuel Eliot Morison, *Maritime History of Massachusetts* (Boston, 1921), and other sources as specifically mentioned. Quotation is from Morison, *Maritime History*, pp. 49, 83.

2. Allen Nevins (ed.), *The Diary of Philip Hone* (New York, 1927), II, 359, 672; *North Amer. Rev.*, LXXX (January, 1855), 45. See also Ms. Diary of Philip Hone (NYHS), VIII, 226–27, entry for June 5, 1834, in which Hone notes Perkins' "gem" of a picture, *Joan D'Arc in the Dungeon*, by the French artist Ducis, which he would have liked to own.

3. Thomas H. Perkins, Diary, "London to Margate &c &c, to Hastings & Back to London, Hence by Liner . . . to Holland & Flanders," 1823, MHS; Paul Frothingham, *Edward Everett* (Boston, 1925), p. 56; Perkins, Diary, "Pisa, Florence, Rome, Naples, Venice to Milan, 1835 2d," May 12, 1835, MHS; Perkins, Diary, "Memorandum in England, Landed at

Weymouth from Ship Canada, with T. H. P., 2 & 3, 1835"; "Journal in Europe in 1835, Wiesbaden to England, and to the Highlands of Scotland . . . ," August 19, MHS.

4. Nevins (ed.), *Diary of Philip Hone*, II, 359; see also J. & T. H. Perkins, *et al*, "Extracts from Letter Books, 1786–1838," compiled by J. E. C. [James Elliot Cabot], MS. Boston Athenaeum, p. 119, indicating that classical statues from Leghorn had arrived for T. E. H. (1805).

5. For the companionship of these men, see S. E. Morison, *Harrison Gray Otis* (Boston & New York, 1913), I, 291. For the quotations about their paintings, see Edward Everett to Sidney Brooks, January 13, 1841, and Everett to Peter Chardon Brooks, March 17, 1841 (Everett Papers). Everett, who was P. C. Brooks's son-in-law, purchased many of the merchant's paintings while in Europe, either when on tour or as the United States Minister to the Court of St. James. See Mabel M. Swan, *The Athenaeum Gallery* (Boston, 1940), p. 36, for mention of the merchants who loaned their paintings to the Gallery for its second exhibition; see also pp. 9, 27, 80. Perkins had such a strong sense of duty with respect to the Gallery that when chairman of the art gallery's committee to plan its initial exhibition, he first took a tour of Europe, in 1826, and there made conscientious notes about galleries and lighting arrangements of European institutions which might aid the Athenaeum in 1827 (Swan, *op. cit.*, pp. 18–19).

6. E. P. Richardson, *Washington Allston* (Chicago, 1948), pp. 93, 127; Henry T. Tuckerman, *American Artist Life* (New York, 1867), p. 143; Swan, *The Athenaeum Gallery*, pp. 60–61, 141; Thomas Cole to Perkins, New York, April 4, 1829, Cole Papers, NYSL.

7. John R. Murray's dates are 1774–1851. There was also a John Murray, Jr., of New York (1758–1819), who as a merchant and man of wealth was associated with many of the same groups and activities with which John R. Murray aligned himself; it is, therefore, often confusing to know which Murray is being referred to in some of the old letters and documents. For instance, Sizer ("The American Academy of Arts" in M. B. Cowdrey [ed.], *The American Academy and American Art-Union* [New York, 1953], p. 74) mentions that John Murray was associated with the early years of the Academy from 1802–14 and that John R. Murray did not begin his association with the Academy until 1815. However, early handwritten records of the Academy indicate that it was John R. Murray who was in correspondence with Vanderlyn about the purchase of casts in 1805, and Dunlap puts John R. Murray in the group of the Academy's first directors after it received its charter in 1808 (William Dunlap, *History of the Arts of Design in the United States* [Boston, 1918], III, 48; II, 105, 106.)

8. R. H. Gosman, MS Biography of John Vanderlyn, NYHS; MS Diary of John R. Murray, "Travels in Europe," 1799–1800, LC; John R. Murray to John Trumbull, Trumbull–Silliman Correspondence.

9. Information about the contents of Murray's collection comes from Mary Bartlett Cowdrey (ed.), *The American Academy of Fine Arts*, II, 91, 141, 289, 290, 312, 321, 408, 412, 420; "List of Pictures in the Academy supposed to belong to Mr. Murray," Minutes of December 18, 1831, American Academy of Fine Arts Keeper's Book, I, 5–7, NYHS. Murray commissioned Vanderlyn to paint him a copy of one of Correggio's masterpieces. There are conflicting reports about the fate of this copy. Dunlap reported that Vanderlyn had selected Correggio's "admirable picture of Antiope as large as life" to copy for Murray, but that Murray and his family were too embarrassed by the nudity of the painting to hang it in their home; Dunlap concludes that Vanderlyn had "consulted his own taste, and the advantages of studying such a work more than the habits of his country or the taste of his countrymen." (*History of the Arts of Design*, II, 162.) A letter from Vanderlyn to Murray, however, indicates that Vanderlyn had copied this painting as an exhibition piece, one of his many "pot boilers," and that it was not specifically intended for Murray's collection. "The subject," wrote the artist, "may not be chaste enough for the more . . . modest Americans . . . but on that account it may attract a greater crowd if exhibited publickly. . . ." (John Vanderlyn to John R. Murray, July 3, 1809, in the *Collector*, XXXI, No. 6 [April, 1918], in Vanderlyn Papers, NYHS; Lillian B. Miller, "John Vanderlyn and the Business of Art," *New York History*, XXXVI [January, 1951], 36, 41–42.)

10. Richardson, *Washington Allston*, p. 125; Dunlap, *History of the Arts of Design*, III, 158; Miller, "John Vanderlyn and the Business of Art," *op. cit., passim.*

11. Richardson, *Washington Allston*, pp. 64–65; Cole to Gilmor, London, May 1, 1831, Cole Papers; Durand to his wife Mary, London, June 21, 1840; to his son John, June 28, 1840, Durand Collection.

12. The Breughel was in the Gilmor Collection, 1823; the Caravaggio in the W. I. Davis Collection, 1834; Franklin B. Dexter, "Review of *Modern Painters*," *North Amer. Rev.*, LXVI (January, 1848), 143–44.

13. *The Deerslayer* (New York, 1925), pp. 17, 230. Mrs. Martineau, too, in 1839, found the "wild, black forest" of America similar to a Salvator Rosa she once saw (*Society in America* [New York, 1837], II, 175); MS Diary of Philip Hone, Northampton, June 20 [1834], VIII, 262, NYHS.

14. Robert Gilmor, Jr.'s dates are 1774–1848. See above, p. 272, for biographical details; for Gilmor's collection, see Dunlap, *History of the*

Arts of Design, III, 272–75; Anna Wells Rutledge, "One Early American's Precocious Taste," *Art News,* March, 1949; Gilmor's sketchbook is in the BPL Special Collections. Gilmor continued to buy European paintings from American dealers in New York and Philadelphia and from artists resident abroad, like Greenough. See "Diary of Robert Gilmor, Jr.," *Maryland Hist. Mag.,* XVII, Nos. 2 & 3, and Greenough to Gilmor, Florence, January 13, 1832, Mellen Chamberlain Collection, BPL.

15. Gilmor to Cole, Baltimore, August 1, 1826, December 13, 1826, Cole Papers. Cole had reservations about the necessity for water in a fine picture, but gave in to the wishes of his patron (Cole to Gilmor, New York, December 25, 1826, Cole Papers). Gilmor had also advised Thomas Doughty to continue painting his landscapes directly from nature and told Cole that he preferred Doughty's landscapes "from nature" to his composition pieces. A handwritten notation of Gilmor's on a letter from Doughty to Gilmor, dated "Monday, the 26th," in the Etting Collection, PHS, also indicates that Gilmor believed Doughty's "studies from nature taken on the spot were his best performances."

16. Cole to Gilmor, January 2, 1827, Cole Papers.

17. Cole to Luman Reed, Catskill, September 18, 1833, Cole Papers.

18. The details about Reed's life, except where specifically noted, are drawn from an incomplete manuscript sketch in the John Durand Collection, NYPL; for quotations, see Reed to A. B. Durand, New York, June 18, 1835, Durand Collection; Reed to Thomas Cole, New York, January 16, 1836, Cole Papers; J. P. Whittelsey to J. Sturges, Wallingford, October 1, 1858, Durand Collection.

19. Reed to Durand, New York, March 12, 1835; A. B. Durand to his wife Mary, Washington City, February 28, 1835, March 5, 1835; Luman Reed to Durand, New York, March 10, 1835, March 12, 1835; Durand to his wife, Boston, June 10, 1835; Durand to John Casilear, Boston, June 14, 1835, Durand Collection.

20. Dunlap, *History of the Arts of Design,* III, 261 n.; Reed to Flagg, New York, March 9, 1835, Durand Collection.

21. Reed to Cole, New York, January 6, 16, 1836; February 22, 1836, Cole Papers.

22. Reed to Cole, New York, December 29, 1835; Reed to Cole, New York, February 17, 1836, Cole Papers. Undated note in Mount Papers, NYHS, indicates that these paintings were finished in November, 1835, and went to the New York Gallery of Art with the rest of Reed's collection. The "Bargain" picture was engraved for the Art-Union in 1851 (Art-Union Index, Mount, January 29, 1851, February 5, 1851, NYHS).

23. I. P. Davis to Durand, June 12, 1836, Durand Collection; MS Diary

of Philip Hone, XI, 393 (June 7, 1836), NYHS; Winifred Howe, *The Metropolitan Museum of Art* (New York, 1913), pp. 62–64; J. B. Durand, *Life and Times of A. B. Durand* (New York, 1894), p. 128. See also Mount to Durand, June 13, 1836, Durand Collection: "How pleasing he was in his address—How well he understood the feelings of the Artists. He was one we shall always love to remember."

24. Howe, *The Metropolitan Museum of Art*, pp. 64, 65, 67.

25. Nevins (ed.), *Diary of Philip Hone*, I, ix; I, 110–11; see also I, 480–81, in which Hone comments on the house of William Douglas with its "elegant furnishings"; MS Diary of Philip Hone, I, 134–35. Hone's emphasis on contemporary art is revealed in his note to Dunlap when he furnished Dunlap with his list of paintings: "The above are all the works of artists now alive, and I do not know a finer collection of modern pictures. I have several old pictures some of which are dignified by the names of celebrated painters—but I do not esteem them sufficiently to induce me to furnish you with a catalogue." (MS Diary, VIII, 29–35, February 7, 1834.)

26. The phrase "architects of their own fortune" is derived from the obituary of C. M. Leupp, one of these collectors, in the *Crayon*, VI, (November, 1859), 353. It was a phrase commonly used during these years. See Shephan Thernstrom, *Poverty and Progress. Social Mobility in a Nineteenth Century City* (Cambridge, Mass., 1964), pp. 71–72.

27. C. G. Childs to Thomas Cole, Philadelphia, November 24, 1845; A. N. Skinner to Cole, New Haven, 1839, Cole Papers; Gray to Durand, June 11, 1854, Durand Collection.

28. Quoted in F. O. Matthiessen, *The American Renaissance* (New York, 1941), pp. 596–97.

29. Lillian B. Miller, "Patriotism, Patronage and Taste in Mid-19th Century America," *Magazine of Art*, VII (November, 1952), 322–28.

30. The collection of R. L. Stuart (1806–1882) is given in Henry T. Tuckerman, *Book of the Artists* (New York, 1867), pp. 626–27. Upon Stuart's death, his books and paintings went to the Lenox Library which became part of the New York Public Library system.

31. R. M. Olyphant (1824–1918). Olyphant's collection is listed in Tuckerman, *op. cit.*, p. 625.

32. M. O. Roberts (1814–1880). Roberts' collection is listed in Tuckerman, *op. cit.*, pp. 625–26; *Crayon*, III (August, 1856), 247.

33. James Lenox (1800–1880). Lenox' collection is listed in Tuckerman, *op. cit.*, pp. 624–25.

34. Joseph Harrison (1810–1874). Harrison's collection is listed in Tuckerman, *op. cit.*, p. 630. Quotation is from James R. Lambdin to Durand, Philadelphia, February 17, 1858, Durand Collection.

35. *Crayon,* VI (November, 1859), 353.
36. John Towne to A. B. Durand, June 25, 1846. See also Kensett Letters in E. D. Morgan Collection (NYSL), Cole Papers (NYSL), the Durand Collection (NYPL), and miscellaneous letters of William S. Mount (NYHS); Olyphant to Kensett, Shanghai, April 12, 1859, Kensett Papers; *Cosmopolitan Art Journal,* I, No. 4 (June, 1857), 118.
37. Edward Strahan (pseudonym), *The Art Treasures of America* (New York, 1879), I, v–vi.

CHAPTER 14 THE AMERICAN ART-UNION

1. For a full and detailed survey of the American Art-Union, see Charles E. Baker, "The American Art-Union," in Mary Bartlett Cowdrey (ed.), *The American Academy of Fine Arts and the American Art-Union* (New York, 1953), I, 95–240; "Publications of the American Art-Union," in *ibid.,* pp. 241–93; Malcolm Stearns, Jr., "Addendum: Sale of Art-Union Holdings, 1852," in *ibid.,* pp. 295–311. The present writer has also utilized all the Art-Union publications, correspondence, and records in manuscript on deposit at the New-York Historical Society.
2. *Catalogue of the First Fall Exhibition of the Works of Modern Artists at the Apollo Gallery, 1838,* NYHS. Herring (1794–1867) was the son of a New York brewer. He began his career as an artist in 1812 (when the war put an end to the family business) by coloring published prints which were, according to Dunlap, "suited to the times." (*History of the Arts of Design in the United States* [Boston, 1918], III, 74). The young artist progressed to the business of coloring maps for Matthew Carey in Philadelphia, but being a man of enterprise, he soon was employing girls to assist him and his wife, and at the rate of three dollars a hundred maps, he cleared a profit of twenty dollars a week, a sum not inconsiderable for the time. It was an easy jump from coloring maps to drawing profiles, and from there, to portrait painting. (Dunlap, *op. cit.,* I, 226; III, 73–76, 266; Thomas Cummings, *Historic Annals of the National Academy of Design* [Philadelphia, 1865], p. 148.)
3. *New York Mirror,* 1838, in Baker, "The American Art-Union," I, 96; Asher B. Durand to Thomas Cole, May 24, 1838, in J. B. Durand, *The Life and Times of A. B. Durand* (New York, 1894), pp. 134–35. As a member of the N.A.D.'s Hanging Committee, Durand indicated to Cole that he had been subject to attack by those whose pictures were hung unfavorably. He had been accused of "partiality," "favoritism," "keeping down young artists," "hoisting up Academicians," etc. "The secret of all this," he said, "is the influx of mediocre talent and the hot-bed fermentation visible among juvenal (*sic*) artists to ripen before their time. . . ."

The fact that artists were so adversely affected by the depression indicates that they had already established themselves in their own eyes as well as in the eyes of others as *professionals,* rather than as all-round painters, tinkerers, etc., who painted faces on the side. Since theirs was a luxury profession, it was inevitable that they would be among the first to be hit by any financial stringency, and especially by a commercial and financial depression that affected the financier and the merchant. Baker assigns other reasons for the artists' hard times, referring to Herring's report of the artists' situation published in the *Family Magazine* of 1838, wherein Herring indicated that much "artist talent" was not "known or appreciated, because it had no means of expansion." The local reputation of some artists confined them to local patronage, and Herring believed that there was "no place in all this country where the works of our artists could be kept before the public in safety, and where amateurs might resort, with the certainty of finding a collection from which to select according to their taste" (Baker, "The American Art-Union," p. 97).

4. Dunlap, *History of the Arts of Design,* III, 75–76; *Catalogue of the Enterprize Library* (New York, 1834); *The National Portrait Gallery of Distinguished Americans* by James Herring and J. B. Longacre, under the superintendence of the American Academy of Fine Arts (4 vols.; New York & Philadelphia, 1834–39); George R. Taylor, *The Transportation Revolution, 1815–1860* (New York, 1951), pp. 344–46.

5. *New York Commercial Advertiser,* 21 October, 1838; *Family Magazine,* November, 1838; (N.Y.) *Courier and Enquirer,* October 21, 1838; Cole to Durand, Catskill, May 28, 1838; Durand to Cole, N.Y., May 24, 1838, Cole Papers, NYSL. See also L. L. Noble, *The Life and Works of Thomas Cole* (New York, 1856), p. 237; Durand, *The Life and Times of A. B. Durand,* pp. 135–36. In 1838 the National Academy's exhibition brought in receipts that averaged $69.10 a day for sixty-eight working days—a better than average year despite the times; Miss Ellen Tree and Mrs. Carradori Allen, theatrical performers, did very well in New York; Mrs. Allen's benefit concert at the City Hotel early in December, 1838, in fact, "netted" her "some $700 or $800." (Cummings, *Historic Annals,* p. 150; Allen Nevins [ed.], *Diary of Philip Hone* [New York, 1927], I, 291.)

6. *Apollo Gallery, First Fall Exhibition, 1838; New York Mirror,* October 21, 1838; Nevins, *Diary of Philip Hone,* I, 62. See also Jonathan Mason to Thomas Cole, a few years later; Mason found the "Exhibition of Modern Artists" in New York [Herring's gallery] "a disgrace to such a large city—the portraits, of which two-thirds composed the exhibition were below mediocrity" (June 14, 1841, Cole Papers).

7. Dunlap, *History of the Arts of Design,* III, 176; (N.Y.) *Courier*

and Enquirer, October 21, 1838; John Francis McDermott, *George Caleb Bingham, River Portraitist* (Norman, Okla., 1959), pp. 29–30; Harriet Martineau, *Retrospect of Western Travel* (London & New York, 1838), II, 46–48; *Apollo Gallery, First Fall Exhibition, 1838*.

8. Cummings, *Historic Annals*, p. 148; Alexis DeTocqueville, *Democracy in America*, ed. Phillips Bradley (New York, 1945), II, 119; Taylor, *The Transportation Revolution*, pp. 320–21.

9. *Transactions of the Apollo Association . . . December 16, 1839*, p. 12. Lotteries were banned by the New York State Constitution of 1821. The fact that the legislature permitted this feature to remain in the Art-Union's charter misled the members of the Committee of Management into believing that their method of distribution was legal.

10. Shaw to Herring, Philadelphia, April 10, 1838; Robert Street to Herring, Philadelphia, December 4, 9, 1839; R. M. Sully to Herring, Richmond, Va., January 10, 1840; Sully to Herring, December 3, 1839; Art-Union Correspondence, I; Mason to Cole, Boston, November 3, 1839, December 10, 1839, Cole Papers. For further discussion about the depression of 1837–42 and its effects on artists, see Bayard Tuckerman (ed.), *Diary of Philip Hone* (New York, 1889), II, 1; *Transactions of the Apollo Association . . .* December 16, 1839, pp. 5, 9, 11; *Transactions . . . 1840*, pp. 13, 14; A. B. Durand to Thomas Cole, New York, February 19, 1840, Cole Papers: "I have . . . heard of little encouraging, the times are dark. . . . Still there are plenty of pictures in the City to see & to sell—Not less than five or six hundred mostly modern French pictures have lately been sold at auction & another sale of about three hundred more will take place tomorrow—they go off generally for a little more than they are worth—that is from five to twenty dollars." So serious was the competition of foreign art in its effect on the American artist at this time that it provided the Association with an acceptable justification for its existence: the object of the Association was defined as being "purely patriotic . . . calculated to . . . lead to an attachment to the productions of *our own* skillful and meritorious Artists, and most effectually free the public from the impositions, which have, for a long series of years, been practiced in this country by the introduction of immense quantities of foreign trash under the pretense of favoring our citizens with choice works of Art." (Circular s/d by James Herring, addressed to Col. J. J. Abert of Washington City, July 1, 1840, NYPL.)

11. Report of the Committee of Management, 1839, p. 7; James Herring to J. P. Ridner, Baltimore, October 1, 1840. Art-Union Correspondence, I; John H. Gray to J. P. Ridner, Boston, April 16, 1842. Art-Union Correspondence, II: "I regret that I am unable so far to give you a very favorable account of my success, either in getting new subscribers or

preserving the old ones. For the first . . . no one is disposed to put their names down in these days of despondency. For the latter, they have fallen off most astonishingly. . . . You would hardly believe that Colonel Perkins has refused. He is our great patron of the arts, and his example is followed by others. . . ."

12. Report of the Committee of Management, 1839, p. 8. For prices, see MS List of Pictures Distributed for 1839, 1840, 1841, NYHS. In 1840 the organization was late in starting because of the necessity to incorporate (*Transactions* . . . *1840*, p. 13). In 1841 the committee announced that its "governing principle" would be merit and that it was preferable to offer "not a large number of indifferent prizes, but such, though few, as should be worthy of possessing." (Report of the Committee of Management, in *Transactions* . . . *1841*, p. 9.)

13. For example, in 1839 R. M. Sully asked $100 for *Indian Girl*, which was purchased at $50; Stewart Watson's two paintings were purchased for half of the asking price of $100. For the Constitution, see Minutes of Meeting . . . 8 January, 1839; *Transactions* . . . *1840*; Baker, "The American Art-Union," in Cowdrey (ed.), *The American Academy*, I, 101; Doughty to Herring, Newburgh, December 9, 1839, Art-Union Correspondence, I.

14. Report of the Committee of Management, 1842; *Transactions* . . . *1841*, pp. 18–19, especially cf. the remarks of Col. William L. Stone, who wondered why the National Academy should "clear their thousands while the Association loses money." Baker ("The American Art-Union," in Cowdrey [ed.], *The American Academy*, I, 177–78, 180–82) gives details concerning the conflict between the two organizations over exhibition policies. Cole, Durand, and Allston occasionally had paintings in the Association's exhibitions, but these were usually lent by the owners and were not sent by the artists for sale. Only in 1839 does a Cole painting appear for sale, and the price affixed was $500. Doughty to Jas. Herring, Newburgh, February 1, 1840; Ridner to Committee of Management, December 19, 1840, Art-Union Correspondence, I; Report of the Committee of Management, in *Transactions* . . . *1839*, p. 9; *Transactions* . . . *1840*, p. 16; *Transactions* . . . *1841*, p. 5.

15. *Transactions* . . . *1839*, pp. 11, 12.

16. Edmonds to Thomas Cole, New York, October 28, 1842, Cole Papers. Members of the Committee of Management, 1839–41, were checked against the following sources: *National Academy of Design Exhibition Records*, I, II; Joseph A. Scoville, *The Old Merchants of New York City* (New York, 1863); Moses Yale Beach, *Wealth and Biography of the Wealthy Citizens of New York City* (New York, 1842); Exhibition Catalogues of the American Art-Union (Apollo Association),

1839–41; *Dictionary of American Biography*, ed. A. Johnson & D. Malone (New York, 1928–44); Baker, "The American Art-Union," in Cowdrey (ed.), *The American Academy*, I, 102–3, 105–7.

17. One important reason for the change in the exhibition policy of the Association was the desire to avoid conflict with the National Academy of Design; see Baker, "The American Art-Union," in Cowdrey (ed.), *The American Academy*, I, 176–201; Executive Committee of the Committee of Management, Minutes, January 10, 1842, MS, NYHS; *Transactions of the Apollo Association, 1842;* Report of the Committee of Management, pp. 5–6.

18. *Proceedings . . . for 1842; . . . 1843; Transactions . . . 1844; . . . 1847; . . . 1850.* Register of Works of Art of the Art-Union, 1849–51, MS, NYHS; Minutes of Committee of Management, March 20, 1843; Minutes of the Purchasing Committee, March 11, 1850, MS, NYHS. M. B. Cowdrey, "Art-Union Publications," in her *The American Academy*, I, 254–64, gives details about the contents of the *Bulletin.*

19. Baker, "The American Art-Union," in Cowdrey (ed.), *The American Academy*, I, 166, 167.

20. The organization blamed some of the opposition to its existence on "those who are attached to the old order of things and installed under it as the chief recipients of honor and rewards," thus indicating that the managers, too, saw the presence of a self-appointed aristocracy among artists that seemingly prevented younger artists from moving upwards (*ibid.*, p. 175; *Bulletin*, December, 1849).

21. Baker, "The American Art-Union," in Cowdrey (ed.), *The American Academy*, I, 148, 155; *Transactions . . . 1845*, pp. 7–8.

22. *Democracy in America*, II, 51; *Transactions . . . 1844*, pp. 5–6.

23. Baker, "The American Art-Union," in Cowdrey (ed.), *The American Academy*, I, 103–4, discusses the way in which the managers perpetuated their control over the organization's business.

24. *Ibid.*, p. 165–69.

25. *Transactions . . . 1848;* Baker, "The American Art-Union," in Cowdrey (ed.), *The American Academy*, I, 166–67. In 1849 the Art-Union managers were especially articulate in objecting to immorality in paintings such as those being exhibited by the new French concern that had recently been established in New York—Goupil, Vibert & Company. These paintings, the managers believed, were "faulty both in moral tone and in point of technical merit." They accused the French artists of aiming at "the *Lascivious*," and they feared that the "extensive circulation of such objects would stain the rising fountain of American Art, of which the waters, although not yet abundant, are still, thank Heaven, pure and unpolluted" (Baker, *op. cit.*, p. 145).

26. Baker, "The American Art-Union," in Cowdrey (ed.), *The American Academy*, I, 231; *Bulletin*, April, 1851.

27. Baker, "The American Art-Union," in Cowdrey (ed.) *The American Academy*, I, 233, 235–37; *Bulletin*, December 1, 1852; Broadside of the Art-Union, August 1, 1853. Who constituted the Art-Union's enemies has never been made clear: presumably disgruntled artists; jealous competitors like the International Art-Union, a business enterprise of Goupil, Vibert & Company; disappointed subscribers who felt they were being cheated when they received no prizes; and journalists like Nathaniel P. Willis who wished to push a sensational cause.

28. Cummings, *Historic Annals*, pp. 149–50; Winifred Howe, *A History of the Metropolitan Museum of Art* (New York, 1913), pp. 40–42, 62–67; Baker, "The American Art-Union," in Cowdrey (ed.), *The American Academy*, I, 237, 238.

PART V FRONTIERS OF ART

1. H. McMurtrie, *Sketches of Louisville and its Environs* (Louisville, 1819), p. 119; Ben Casseday, *The History of Louisville from its Earliest Settlement till the Year 1852* (Louisville, 1852), p. 154; William Mitchell to John Durand, Louisville, August, 1853, Durand Collection; *Liberty Hall* (Cincinnati), May 27, 1820, in Richard C. Wade, *The Urban Frontier* (Cambridge, Mass., 1959), pp. 330–31; *Western Journal and Civilian* (St. Louis), VI, 64; *Pittsburgh Daily Gazette*, February 23, 1850; Louis B. Wright, *Culture on the Moving Frontier* (Bloomington, Ind., 1955), p. 12; Blake McKelvey, *Rochester, the Water Power City, 1812–1854* (Cambridge, Mass., 1945), p. 357. Henry Nash Smith points out how the eastern interpretation of the uncivilized and unrefined West affected the efforts of western writers to find admirable values in western society that they could embody in a characteristic western literature (*Virgin Land. The American West as Symbol and Myth* [Cambridge, Mass., 1950], chap. 21.)

2. McMurtie, *Sketches of Louisville*, p. 121; the *Hesperus* (Pittsburgh), May 24, 1828, I, 59–60, noted that it was "the literary characters" of the city who extended patronage to the artists residing there; in Rochester, it was the "intellectuals supported by the churches, the university, or a comfortable legal practice"; in Lexington, it was the "men of culture, education and refinement." McKelvey, *Rochester*, p. 357; George W. Rank, *History of Lexington, Kentucky, Its Early Annals, and Recent Progress* (Cincinnati, 1872), p. 39; E. D. Mansfield, *Memoir of the Life and Services of Dr. Daniel Drake . . .* (Cincinnati, 1855), pp. 142–43; *Act of Incorporation of the Cincinnati Academy of Fine Arts, with an address to the Members of the Institute by John P. Foote,*

President of the Board of Trustees (Cincinnati, 1828), pp. 7–12. Drake, for instance, was born in the frontier West, but his youthful years were spent in Philadelphia where he studied medicine. These years influenced him very much when he returned to Cincinnati and "consciously tried to shape the Queen City's future along Philadelphian lines" (Wade, *The Urban Frontier*, pp. 320, 321).

3. *Act of Incorporation of the Cincinnati Academy of Fine Arts.* . . . Foote was characterized by Governor Anderson of Kentucky in a reminiscence of Cincinnati in 1829 as being "then and ever through his long and most useful life, the friend, advocate, and patron of all education (the fine arts included) and also one of Powers' very earliest and warmest admirers and friends" (*Commercial* [Cincinnati], November 12, 1885).

CHAPTER 15 ART IN THE WEST

1. Richard C. Wade, *The Urban Frontier* (Cambridge, Mass., 1959), pp. 18–20, 43–49, 62–64, 330; John Smith Kendall, *History of New Orleans* (Chicago & New York, 1922), I, 199, 202; Ben Casseday, *History of Louisville* (Louisville, 1852), pp. 247 ff.; George R. Taylor, *The Transportation Revolution, 1815–1860* (New York, 1951), pp. 72–73, 46, 161, 166.

2. Blake McKelvey, *Rochester, the Water Power City, 1812–1854* (Cambridge, Mass., 1945), p. 163.

3. Wade, *The Urban Frontier*, p. 330; Taylor, *The Transportation Revolution*, pp. 9, 397–98.

4. William Ganson Rose, *Cleveland, the Making of a City* (Cleveland & New York, 1950), p. 169; Bessie L. Pierce, *A History of Chicago* (New York, 1937), Vols. I and II; George B. Catlin, *The Story of Detroit* (Detroit, 1923).

5. *Liberty Hall*, May 27, 1820; *Morning Post*, November 17, 1849; *Cincinnati Mirror and Western Gazette of Literature and Science* III, No. 13 (March 22, 1834), 103; *Western Journal and Civilian*, VI, 66–67, also VII, 365: "Why may not St. Louis rival Cincinnati with the Charms of Art?"

6. "The Fine Arts," *Hesperus* (Pittsburgh), August 2, 1828, I, 101; see also Wade, *The Urban Frontier*, pp. 314–21.

7. Samuel W. Price, *The Old Masters of the Blue Grass* (Filson Club Publications, No. 17 [Louisville, 1902]), *passim;* see also Lewis Evans to General Jackson, Natchez, September 18, 1817, Chicago Historical Society MS, wherein Evans asked Jackson to sit for his portrait to William E. West, son of the William West who had made Lexington his home; the younger West wished to publish an engraving of such a portrait and use the profits for a trip to Europe for further study. Also see

letters of Charles S. Elliott to Alvah Bradish, New York, September 14, 1831; Syracuse, June 10, 1832; Syracuse, January 31, 1834; and W. R. Wheeler to Bradish, Adrian (Mich.), July 24, 1833, for comments about the East and its attractions for western artists (Alvah Bradish Papers, Detroit Public Library, Burton Historical Collections).

8. *Western Journal and Civilian*, VII (November, 1851), 75–78.

9. Dr. Daniel Drake, *Remarks on the Importance of promoting Literary and Social Concert in the Valley of the Mississippi, a means of elevating its Character and Perpetuating the Union. Remarks delivered at Transylvania University to the Literary Convention of Kentucky, November 8, 1833* (Louisville, 1833); The Reverend Charles B. Boynton, *Address Delivered Before the Young Men's Mercantile Association, January 19, 1847, "Our Country, the Herald of a New Era"* (Cincinnati, 1847); *Western Journal and Civilian*, III, 348–49.

This belief in eventual western predominance also affected the attitudes of some easterners towards western institutions; believing, too, that the West would some day overwhelm the East in numbers and in political power, easterners like Edward Everett called for eastern aid to western cultural institutions so that when the day came and the East fell under the political domination of the West, the victor would at least possess a population of well-educated men and women—educated in the New England tradition—who would therefore be able to find common bonds with the East. See Everett, "Education in the Western States," *Orations and Speeches* (Boston, 1895), I, 344–53.

10. Constance Rourke, *Audubon* (New York, 1936), pp. 50–64; John Francis McDermott, *The Lost Panoramas of the Mississippi* (Chicago, 1958), *passim;* Perry T. Rathbone, "The Art of the Mississippi," *Mississippi Panorama* (City Art Museum of St. Louis, 1950), pp. 27–48; John Francis McDermott, *Seth Eastman, Pictorial Historian of the Indian* (Norman, Okla., 1961), *passim.* For a bibliographical listing of the artists who portrayed the Trans-Mississippi West during the period 1819–65, I am indebted to a list compiled by John C. Ewers of the Smithsonian Bureau of Ethnology.

11. Price, *The Old Masters of the Blue Grass*, pp. 3–5; George W. Rank, *History of Lexington, Kentucky* (Cincinnati, 1872), pp. 39, 40. Bush, Grimes, Dodge, Beard, and Ver Bryck also painted in Lexington.

12. Price, *The Old Masters of the Blue Grass*, pp. 20, 76–77; Samuel Page to John Durand, Louisville, January, 1857, Durand Collection.

13. Price, *The Old Masters of the Blue Grass*, pp. 133–36.

14. Kendall, *History of New Orleans*, II, 651–56. Kendall asserts that Jarves made $60,000 a season at times, taking half away with him when he

left. Undoubtedly, Jarves was more successful than most artists who visited New Orleans; but even if this sum is exaggerated, all did quite well there.

15. J. Thomas Scharf, *History of St. Louis City and County* (Philadelphia, 1883), II, 1622–26; Thomas S. Noble to Bradish, St. Louis, June 7, 1860, Alvah Bradish Papers, Detroit Public Library, Burton Historical Collection. Charles van Raavensway of the Missouri Historical Society in St. Louis has compiled a file of artists who worked in or out of the city.

16. McKelvey, *Rochester*, pp. 125, 310–11; G. S. Gilbert to Alvah Bradish, Rochester, June 23 and July 13, n.d., Bradish Papers. For Buffalo Fine Arts Academy, see Circular of the Buffalo Fine Arts Academy, January, 1863; Thomas LeClear to Bradish, n.d. [1863], Bradish Papers.

17. *Pittsburgh Gazette and Manufacturing & Mercantile Advertiser*, April 18, 1823.

18. Oliver Larkin, *Art and Life in America* (New York, 1949), p. 216; "Art Rises Amidst Flames of Industry's Mighty Furnaces," *Pittsburgh Post-Gazette*, September 26, 1936; *Hesperus*, I, No. 13 (August 2, 1828), 101; "Art Topics: Artists before 1875," Carnegie Public Library Files, Pittsburgh; "Art in Pittsburgh, Some Pioneer Painters and the Adverse conditions their Enthusiasm overcame," by Martin B. Leisser, *Pittsburgh Gazette-Times*, May 2, 1910; Erasmus Wilson (ed.), *History of Pittsburgh* (Pittsburgh, 1898), chap. 30. Sully exhibited his *Queen Victoria* in Pittsburgh in 1839 (*Daily Advocate and Advertiser* [Pittsburgh], July 25, 1839).

19. "Cincinnati and Art a Century Ago," in *Cincinnati Enquirer*, August 7, 1921; Edna Maria Clark, *Ohio Art and Artists* (Richmond, Va., 1932); Francis P. Weisenburger, *The Passing of the Frontier, 1825–1850* (History of the State of Ohio, Vol. III [Columbus: Ohio State Archaeological and Historical Society, 1941]), 196; Harriet Martineau, *Retrospect of Western Travel* (London, 1838), II, 236; *Cincinnati Mirror and Chronicle Devoted to Literature and Science*, IV, No. 26 (April 25, 1839), 208–9; "A Review of Cincinnati's Part in the Field of Art," *Enquirer* (Cincinnati), May 9, 1915; Circular, "To Admirers of the Fine Arts, September 27, 1839, Edward Brackett, Sculptor" (Chicago Hist. Soc. MSS); John Cranch to Charles Lanman, Cincinnati, July 25, 1840; October 19, 1840; September 10, 1840; Cranch to Lanman, Washington, n.d., Lanman Letters, LC; a list in the Cincinnati Art Museum Library indicates that eight artists worked in Cincinnati between 1792–1820, forty-seven between 1820–50.

20. Rose, *Cleveland, the Making of a City*, pp. 212, 228; S. P. Orth, *History of Cleveland* (Cleveland, 1910), Vol. I, chap. 49; manuscript notes in Ohio Archaeological and Historical Society Library, compiled

by Miss Clara M. Eagle, concerning portraits in Ohio painted before 1860.

21. Pierce, *Chicago*, I, 313, 314–15; II, 427; letters in Durand Collection and in Kensett Papers. Quoted are letters from Mark Skinner to Asher B. Durand, Chicago, November 1, 1854; June 10, 1859.

22. Bradish Papers, esp. Rev. Dr. Andrew Yates to Bradish, September 4, 1833; A. I. Wynkoop to Bradish, December 9, 1838; Invitation to Bradish to deliver a course of lectures in Detroit, January 20, 1861; also see biographical article on Bradish in *Detroit News-Tribune*, January 17, 1897. For painters and artists in Detroit, see Clarence M. Burton, *The City of Detroit, Michigan, 1701–1922* (Detroit–Chicago, 1922), II, 1194; Friend Palmer, *Early Days in Detroit* (Detroit, 1906), pp. 380, 400, 416, 451, for information about Detroit residences and museums; *Detroit City Directory, 1852–1853* (Detroit, 1853); "Artists in Detroit," 3 vols. MS notebooks and biographical folders compiled by Miss Ellis, in Burton Historical Collection, Detroit Public Library. Of the artists who were in Detroit before 1870 or who did a good deal of work in the city before that year, Miss Ellis found almost one hundred names, testifying to the wide diffusion of interest in art in that city during these years.

23. E. D. Mansfield, *Memoir of the Life and Services of Dr. Daniel Drake* (Cincinnati, 1855), pp. 134–35, 142–43, 369; Letters from Probasco to his attorney, William I. Lowry, 1867–69, Hist. and Phil. Soc. of Ohio MS; *Act of Incorporation of the Cincinnati Academy of Fine Arts, with an address by John P. Foote, President of the Board of Trustees* (Cincinnati, 1828); *Western Journal* (St. Louis), VI (1851–52), 66–67; *Pittsburgh Daily Gazette*, February 23, 1850; Charles Cist, *Cincinnati in 1841, Its Early Annals and Future Prospects* (Cincinnati, 1841), p. 135.

24. Larkin, *Art and Life in America*, pp. 112, 115, 151; "A Review of Cincinnati's Part in the Field of Art," *Enquirer*, May 9, 1915; Mansfield, *Memoir of the Life and Services of Dr. Daniel Drake*, pp. 134–35; R. C. Buley, *The Old Northwest* (Indianapolis, 1950), II, 578; Clara Longworth de Chambrun, *Cincinnati, Story of the Queen City* (New York, 1939), p. 173. Many articles describing the museum's activities may be found in the *Cincinnati Literary Gazette* for 1824–25.

25. "A Review of Cincinnati's Part in the Field of Art," *op. cit.*; for a presentation of Brackett's statue to the museum, see Circular, "To Admirers of the Fine Arts, September 27, 1839" (Chicago Hist. Soc. MS). The collections of the Western Museum eventually were deposited in Cincinnati's Museum of Natural History (C. L. de Chambrun, *Cincinnati*, p. 320).

26. *Act of Incorporation of the Cincinnati Academy of Fine Arts* . . . , pp. 10–11; Cist, *Cincinnati in 1841*, pp. 129, 131, 132; C. L.

de Chambrun, *Cincinnati*, pp. 142–43; "A Review of Cincinnati's Part in the Field of Art," *op. cit.; Report of the First Annual Fair of the Ohio Mechanics Institute* (Cincinnati, 1838). Pictures, engravings, and statues were exhibited in 1838, 1839, and 1840; but no works of art appeared in the 1841 Fair of the Ohio Mechanics Institute and none in 1850 or 1852 or thereafter. See reports of the various annual fairs published annually, on file in the Hist. & Phil. Soc. of Ohio.

27. Cist, *Cincinnati in 1841*, p. 142; quote is H. A. Ratterman's, in "A Review of Cincinnati's Part in the Field of Art."

28. Cist, *Cincinnati in 1841*, pp. 133–36.

29. *Ibid.*, p. 142; John Cranch to Charles Lanman, Cincinnati, September 10, 1840, Lanman Letters.

30. Newspaper clipping with no name in American Art-Union scrapbooks, January 14 and 16 [1846]; *Transactions of the Western Art Union for the Year 1847*, (Cincinnati, 1847), pp. 23–25; William Adams to Thomas Cole, August 6, 1842, Cole Papers.

31. *Transactions of the Western Art Union . . . 1847*, pp. 20–23.

32. *Ibid.*, pp. 5–7, 18, 19, 22.

33. T. W. Whitley, *Reflections on the Government of the Western Art Union and a Review of the Works of Art on its Walls* (Cincinnati, 1848), *passim.*

34. "A Review of Cincinnati's Part in the Field of Art," *op. cit.;* Rufus King Letters, Vol. II, 1854–59, letters concerning Ladies Gallery, October 6, 1854, January 14, 1855, September 28, 1856 (MS in Hist. and Phil. Soc. of Ohio). The problem of the nude statues was apparently solved when the ladies hired the sculptor Fazzi to make fig leaves for them (Larkin, *Art and Life in America*, p. 178).

35. C. L. de Chambrun, *Cincinnati*, pp. 108, 267; Rufus King to his mother, January 14, 1855; November 19, 1854; May 15, 1857; June 20, 1858; August 28, 1859, King Papers.

36. In 1868, another Cincinnati Academy of Fine Arts was incorporated, with thirty-eight subscribers purchasing shares of $100 each. Rufus King, Joseph Longworth, and other gentlemen associated with earlier efforts "to effect regular exhibitions of paintings in Cincinnati and to increase the knowledge and enjoyment of art" worked with great energy to make this new effort a success, but in vain. "Appreciation of art" existed among Cincinnatians, but it was "incrusted with a very parsimonious spirit." The organization could not meet its expenses and was abandoned after its second exhibition in 1869. In 1876, Joseph Longworth added $370,000 to the endowment of the School of Design on condition that the city contribute to its yearly support; and when in 1880 Charles West projected the idea of an art museum for the city, the School of

Design and its collections were transferred to the newly-formed museum association. In 1884 the two groups were merged with the formation of the Cincinnati Museum of Fine Arts. See Cincinnati Academy of Fine Arts, 1868–69, Reports; Treasurer's notebook and Committee Reports at the Hist. & Phil. Soc. of Ohio; C. L. de Chambrun, *Cincinnati*, pp. 108, 267; Rufus King letters to his mother, January 14, 1855; November 19, 1854; May 15, 1857; June 20, 1858; August 28, 1859; Circular in the Cincinnati Museum of Fine Arts files entitled "Catalog of the Ladies Picture Gallery, 1855"; Cincinnati Museum Association, *Seventh Annual Report*, pp. 33–34; Dr. Daniel Drake, *Anniversary Discourse on the State and Prospects of the Western Museum Society*, p. 24.

37. L. Hastings, "Emerson in Cincinnati," *New England Quarterly*, XI (September, 1938), 455; Scharf, *History of St. Louis City and County*, I, 313; II, 1617; *St. Louis Directory and Register of 1821* (St. Louis, 1821); Falconer to Durand, Toledo, Ohio, February 24, 1855, Durand Collection.

38. Numerous newspaper clippings on art in St. Louis in the files of Charles van Raavensway, Missouri Historical Society, detail these shows, sales, and exhibitions. Quotations are from Thomas S. Noble to Alvah Bradish, St. Louis, June 7, 1860, Bradish Papers; *Western Journal*, VI, 66–67, VII, 218; *Missouri Republican*, October 14, 1859; also see McDermott, *Lost Panoramas*, p. 22 and *passim*.

39. *Edwards' Programme and History of the St. Louis Agricultural and Mechanical Association* (1859), p. 23; *Missouri Republican*, September 28, 1860; *Catalogue of the First Annual Exhibition of the Western Academy* (St. Louis, 1860); Scharf, *History of St. Louis City and County*, II, 1618, 1621; *Constitution and By-Laws of the Western Academy of Art, 1859* (St. Louis, 1851). The "Act to Incorporate the Western Academy of Art" was approved on March 14, 1859, and certified by the Secretary of State on March 29, 1859 (*ibid.*)

40. Scharf, *History of St. Louis City and County*, p. 622.

41. Kendall, *History of New Orleans*, I, 125–26, 296; II, 649, 645, 674.

42. *Ibid.*, II, 649, 651; George Cooke to Thomas Cole, New Orleans, April 10, 1846, Cole Papers.

43. Kendall, *History of New Orleans*, II, 657–60; I, 202–4. In 1885 the Southern Artists' League was organized, and other art associations followed in the 1880's and 1890's, leading to the founding of the Delgado Museum of Art in 1910–11, the gift of Isaac Delgado, "a public-spirited figure" (*ibid.*, II, 660).

44. Lambdin presumably brought his museum to Pittsburgh in 1828, but in 1833 Lambdin's Louisville Museum was visited by Miner Kellogg,

Cincinnati artist, who recorded his favorable impressions in his Journal, May, 1833, I, 3–4 (on microfilm at the Hist. and Phil. Soc. of Ohio in Cincinnati). The Pittsburgh *Bulletin Index,* however, reported that in 1828 the museum contained twenty quadrupeds, two hundred birds, five hundred minerals, four hundred fossils, one hundred "reptiles in spirits," and life-size wax figures of "Louis XVI taking leave of his family before Execution." The museum was also reported as owning fifty paintings ("Pittsburgh Primitives," *Bulletin Index,* November 10, 1938). Also see the *Hesperus* (Pittsburgh), August 2, 1828, I, No. 13, 101, for report of Lambdin's project and recommendation for its encouragement.

For development of art in Pittsburgh also see Joseph Adams to Durand, Pittsburgh, April 11, 1855, Durand Collection; *Pittsburgh Daily Gazette,* February 23, 1850; *Greater Pittsburgh,* April, 1932; J. J. Gillespie Company, *One Hundred Years in Pittsburgh* (1932); *Catalogue of the First Annual Exhibition of the Pittsburgh Art Association, 1859* (Pittsburgh, 1859); *Catalogue of the Second Annual Exhibition of the Pittsburgh Art Association, 1860* (Pittsburgh, 1860); *Pittsburgh Post Gazette,* September 26, 1936. Undoubtedly the records of the Gillespie Company, which is still in existence, would throw a great deal of light on art in Pittsburgh, but the company would not permit its record books to be examined.

45. Pierce, *Chicago,* I, 289; II, 427; Mark Skinner to Asher B. Durand, Chicago, June 10, 1859, Durand Collection; "Resolutions of the Meeting of the Contributors to the Fine Arts Exhibition . . . June 20, 1859," George F. Rumsey Papers, CHS; William Berry to the editor of the *Crayon,* Chicago, January 30, 1860; Leonard W. Volk to John Durand, Chicago, March 11, 1861, Durand Collection; *Reports of the Exhibition Committee of the Kentucky Mechanics Institute of Louisville, 1856, with circular of the Fourth Exhibition,* pp. 41–44.

46. Whitley, *Reflections on the Government of the Western Art Union,* p. 5.

47. *Western Journal and Civilian,* VII (January, 1852), 289; John M. Falconer to John Durand, Toledo, February 24, 1855, Durand Collection.

48. Mansfield, *Memoir of the Life and Services of Dr. Daniel Drake,* pp. 240, 242; Thomas Smith Grimke, *Oration on . . . Grecian and American Eloquence* (Cincinnati, 1834).

49. See *Missouri Republican,* July 22, 1835, and *Daily Pennant* (St. Louis), July 23, 1840, for sale of Old Masters.

50. Manning F. Force to Charles Eliot Norton, Cincinnati, September 24, 1854, Norton Letters, Harvard College Library; *Catalogue of the First Annual Exhibition of the Pittsburgh Art Association, 1859.*

51. See letters in Durand Collection.

52. Erasmus Wilson (ed.), *History of Pittsburgh* (Pittsburgh, 1898), chap. 30; Mark Skinner to A. B. Durand, Chicago, June 10, 1859, Durand Collection; William Berry to John Durand, Chicago, January 30, 1860, Durand Collection.

53. B. M. McConkey to Asher B. Durand, Cincinnati, June 14, 1847, Durand Collection; *Catalogue of the First Annual Exhibition of the Pittsburgh Art Association, 1859.* For Blythe, see *East Liverpool Mercury*, August 22, 1861; *Carnegie Magazine*, XVI (January, 1943), 8, 228–29; Larkin, *Art and Life in America*, p. 116.

54. John Cranch to Charles Lanman, Cincinnati, July 25, 1840, Lanman Letters; *Missouri Republican*, January 10, 1849, comments on Miss Sarah Peale's lifelike portraits; Lillian B. Miller, "Patriotism, Patronage and Taste . . . ," *Mag. of Art*, VII (November, 1952), 322–28.

55. Cf. the English experience, in John Steegman, *Consort of Taste, 1830–1870* (London, 1950), chap. 3.

CHAPTER 16 ART AND NATIONALITY

1. Miss Ludlow, *A General View of the Fine Arts, Critical and Historical*, introd. Daniel Huntington (New York, 1851), pp. 11–12.

2. Walter Jackson Bate, *From Classic to Romantic* (New York, 1946), p. 2; Henry James, *Roderick Hudson* (New York, 1960), p. 40. See also W. Channing in the *North Amer. Rev.* (July, 1816), p. 196, for an early statement concerning Turner's landscapes, one of the very few to appear in an American publication during these years and indicative of the change taking place in Americans' attitude toward nature. For a statement about the effect of climate and scenery upon the creation of a national music, see H. R. Cleveland's "Review of *The Life of Haydn . . . and Mozart . . . ,*" *North Amer. Rev.*, L (January, 1840), 13–15. For Oliver Wendell Holmes's dissent from the generally held idea that artistic inspiration would be found "in the grandeur of nature in our Western World, and the influences to be exerted by our free institutions," see *North Amer. Rev.*, L (April, 1840), 358–59. Holmes believed that American nature impressed upon her citizens "a tendency to the useful rather than the beautiful" and that the character of the American mind would depend more on "the influence of the material and social peculiarities of existence in the new world, than upon the terms of our constitution or the magnificence of our landscapes."

3. *History of the North-Western Soldiers Fair, Held in Chicago. . . . 1863* (Chicago, 1864), p. 35; *Record of the Metropolitan Fair . . . New York, April, 1864* (New York, 1867), p. 99; *Memorial of the Great*

Central Fair . . . held at Philadelphia, June, 1864 (Philadelphia, 1864), pp. 116–17; also see *History of the Brooklyn and Long Island Fair, February 22, 1864* (Brooklyn, 1864), pp. 56 ff.; *Our Acre and Its Harvest. Historical Sketch of the Soldiers' Aid Society of Northern Ohio . . .* (Cleveland, 1869), pp. 190–92; J. G. Forman, *The Western Sanitary Commission. A Sketch* (St. Louis, 1864).

4. Thomas Colley Grattan, *Civilized America* (London, 1859), II, 105–6.

5. *Newark* (N.J.) *Advertiser*, April 16, 1843; *Record of the Metropolitan Fair in Aid of the United States Sanitary Commission . . . April, 1864* (New York, 1867), p. 99.

6. Richard Hofstadter, *Anti-Intellectualism in American Life* (New York, 1963); Bigelow's speech is reported in *Transactions of the American Art-Union . . . 1846* (New York, 1847).

7. Myron P. Gilmore, *The World of Humanism, 1453–1517* (New York, 1952), p. 231, and chap. 9 *passim.*

8. C. E. Lester, *The Artist, the Merchant and the Statesman . . .* (New York, 1845), I, viii; Charles Boynton, *Address Delivered Before The Young Men's Mercantile Association . . .*, *"Our Country, the Herald of a New Era"* (Cincinnati, 1847), p. 24; "The Fine Arts in America," *Southern Quarterly Review*, II (July, 1849), 6, 23, 24; *Literary World*, April 3, 1847, pp. 208–9. A typical reference to the Italian and American experience may be seen in W. Minot, Jr., "Art in America," *North Amer. Rev.*, LII (April, 1841), 307; here Minot expresses the hope that the different states and cities of the United States would experience "a generous rivalry" as did the Italian states of an earlier period. Cf. Jacques Barzun, *Berlioz and the Romantic Century* (Boston, 1950), I, 380, for similar conclusions with respect to the relation of the European nineteenth century to the sixteenth.

9. Francis Henry Taylor, *The Taste of Angels* (Boston, 1948), p. 476, and chap. 6 *passim;* Arno Schönberger, *The Rococo Age* (New York, 1960), p. 16.

10. C. C. Perkins, "American Art Museums," *North Amer. Rev.*, CXI (July, 1870), 1–29.

11. "Remarks on the Progress and Present State of the Fine Arts in America," *Analectic*, VI (November, 1815), 371; Boynton, *Address Delivered Before the Young Men's Mercantile Association, "Our Country, the Herald of a New Era,"* pp. 16–17, and *passim;* George W. Greene to Governor William H. Seward, February 24, 1839, Seward Papers, University of Rochester Library.

12. F. O. Matthiessen, *American Renaissance* (New York, 1941), pp. 24–25; *Analectic*, VI (July, 1815), 225; Franklin B. Dexter, "Remarks

upon the Athenaeum Gallery of Paintings for 1831," *North Amer. Rev.*
XXXIII (October, 1831), 511, 512. See also clipping in American Art-
Union collection of newspaper articles "Albany Gallery of Fine Arts"
(1847): ". . . he who learns to look with admiration upon a work of art
as a natural consequence must admire and learn to imitate a virtuous
action. The painter thus becomes a moral teacher, and under the impulses
of his inspired calling may inculcate a lesson which the printed page often
fails to convey."

13. Mount Papers, NYHS Misc. (italics his); Emerson, "The American
Scholar," *The Works,* ed. J. E. Cabot (Boston and New York, 1883), I,
111; Bliss Perry, *The Heart of Emerson's Journal* (Cambridge, Mass.,
1926), p. 104, entry of September 28, 1836. Cf. John Steegmann, *The
Rule of Taste from George I to George IV* (London, 1936), chap. 10, for
a similar evaluation of English art after the Reform Bill of 1832, when a
new middle class demanded an art that was "easy to read. Those painters,
therefore, who produced the most readily comprehensible narratives, or
could satisfy the most widely experienced of the simple emotions, were
naturally held in the highest estimation" (pp. 181–82).

14. *Literary World,* April 3, 1847, p. 209; S. Osgood, "The Real and
Ideal in New England," *North Amer. Rev.,* LXXXIV (April, 1857), 557.
Also see Horace Binney Wallace, *Scenery and Philosophy in Europe*
(Philadelphia, 1855), and S. G. Fisher's review of the book in *North
Amer. Rev.,* LXXXI (July, 1855), 212 ff., for typical expressions of the
mid-century's attempt to reconcile realism in technique with idealism in
conception in art.

15. Orville Dewey, "Powers' Statues," *Union Magazine of Literature
and Art,* October, 1847 (italics his); Remarks of W. T. Headley,
Proceedings of the American Art-Union . . . 1845 (New York, 1846),
p. 13.

16. *Providence* (R.I.) *Journal,* November 13, 1849, letter signed "S," in
American Art-Union clippings.

17. Lillian B. Miller, "Patriotism, Patronage and Taste in Mid-Nine-
teenth Century America," *Mag. of Art,* VII (November, 1952), 322–28.
Cf. Steegmann, *The Rule of Taste,* pp. 186, 188, for English middle-class
insistence upon a literary and moralistic art; Barzun, *Berlioz and the
Romantic Century,* I, 255, for French middle-class moralism in the 1830's
and "its twin, literalism."

18. Quote is from *Record of the Metropolitan Fair . . . ,* p. 103.

19. "Travel Diary of Divie Bethune Duffield, 1855," Detroit Public
Library, Burton Historical Collections; John M. Falconer to John
Kensett, New York, July 7, 1861, Kensett Papers, E. D. Morgan
Collection, NYSL.

20. Information concerning the Barbizon School's reception in New York may be obtained from the unpublished MS by Samuel Swift in Jaccacci Collection, Metropolitan Museum of Art. The manuscript reports that the 1864 New York buyer was able to sell six of the Corots to an enterprising dealer at two hundred dollars apiece; and at the sale of the Cutting Collection, early in the twentieth century, one of these Corots brought $3,450. Many of Belmont's pictures were sold at auction in 1872 and made their way to other New York collections. Belmont's gallery was often opened to the public for charitable purposes; in 1864, for instance, the United States Sanitary Commission profited greatly from it, and in 1876, the National Academy and the Metropolitan Museum. Belmont was born in 1816 and died in 1890; as the representative of the Rothschild banking firm in the United States during the Panic of 1837, he accumulated his fortune; and as a Democratic politician, he was favored by appointment to foreign service—as Consul General to Austria from 1844–50, and as Minister to the Netherlands from 1853–57.

21. J. R. Lambdin to George S. Pepper, 1858, in PAFA files. See also letters concerning Jarves Collection in the Boston Athenaeum files; James Jackson Jarves, *The Art-Idea* (New York & Boston, 1864); Francis Steegmuller, *The Two Lives of James Jackson Jarves* (New Haven, 1951), chap. 13.

22. "On Picture Buying," *Crayon* (July, 1856), p. 217; *Southern Quarterly Review*, VI (July, 1849), 27.

23. Kenneth Stampp, *And the War Came* (Baton Rouge, La., 1950), chap. 8; *North Amer. Rev.*, LXXXIV (January, 1857), 271–72; LXXXIV (April, 1857), 535 ff. Hawthorne admitted in 1854 "that we have so much country that for the heart everything falls away except one's native state." (Quoted in Benjamin Spencer, *The Quest for Nationality* [Syracuse, 1957], p. 272.)

24. "A Review of the Allston Exhibition," *North Amer. Rev.*, L (April, 1840), 358–59.

25. D. D. Barnard, *A Plea for Special and Popular Repose. Being an Address delivered before the Philomathean and Euclerian Societies of the University of the City of New York, July 1, 1845* (New York, 1845), p. 18; W. T. Headley in *Transactions of the American Art-Union . . . 1845* (New York, 1845), pp. 13–17.

26. "The American Art-Union," *Southern Literary Gazette*, October 21, 1848. For Southern nationalism in literature, see Spencer, *The Quest for Nationality*, pp. 268–75.

27. "Nationality in Art," *Cosmopolitan Art Journal*, I, No. 3 (March, 1857), 75.

ACKNOWLEDGMENTS

Samuel Eliot Morison has generously granted permission to quote at length from *The Life and Letters of Harrison Gray Otis, Federalist. 1765–1848.* The following libraries have kindly granted permission to use and quote from the manuscript materials in their collections:

Boston Athenaeum
Boston Public Library
Chicago Historical Society
Connecticut Historical Society, Hartford
Detroit Public Library, Burton Historical Collections
Filson Club, Louisville
Harvard College Library
Historical Society of Pennsylvania
Maryland Historical Society
Massachusetts Historical Society
New-York Historical Society
New York Public Library
New York State Library
Ohio Archaeological and Historical Society, Cincinnati
Pennsylvania Academy of Fine Arts Library
University of Rochester Library
Wadsworth Athenaeum, Hartford, Connecticut

BIBLIOGRAPHY

MANUSCRIPT MATERIALS

Academy of Fine Arts of Philadelphia, 1794–1830: MS Papers Relating to the Early History. 3 vols. *Historical Society of Pennsylvania.*

Washington Allston Letters. Dana Collection, *Massachusetts Historical Society.*

American Academy of Fine Arts: Letter Books, papers. *New-York Historical Society.*

American Art-Union Collection: Correspondence, Catalogues, Transactions, Reports, Proceedings, Minutes of the Committee of Management, Minutes of the Purchasing Committee, Price Lists, etc. *New-York Historical Society.*

Anthology Club: Records. *Massachusetts Historical Society.*

"Art in Cincinnati": notes and clippings. *Cincinnati Art Museum Library.*

"Art in Missouri": clippings and files of Charles van Raavensway. *Missouri Historical Society.*

"Art in Pittsburgh": notes and clippings. *Carnegie Public Library* (Pittsburgh).

Artists' Fund Society: Minutes, Papers, 1835–1858. 3 vols. *Historical Society of Pennsylvania.*

"Artists in Detroit": MS by Miss Ellis. *Detroit Public Library, Burton Historical Collections.*

Barnard Papers. *Wadsworth Athenaeum* (Hartford, Connecticut).

Journals of Gamaliel Bradford V. *Harvard College Library.*

Alvah Bradish Papers. *Detroit Public Library, Burton Historical Collections.*

Luther Bradish Papers. *New-York Historical Society.*

Mellen Chamberlain, A.L.S. *Boston Public Library.*

Cincinnati Academy of Fine Arts MSS. *Ohio Archaeological and Historical Society* (Cincinnati).

Thomas Cole Papers. *New York State Library.*

Dreer Collection, A.L.S., Painters and Engravers. 5 vols. *Historical Society of Pennsylvania.*

Asher B. and John Durand Collection. *New York Public Library.*

Clara M. Eagle Notes. *Ohio Archaeological and Historical Society* (Cincinnati).

Etting Collection, A.L.S., 1767–1889. *Historical Society of Pennsylvania.*

Edward Everett Papers. *Massachusetts Historical Society.*

Dr. John W. Francis Papers. *New York Public Library.*

Robert Gilmor, Jr., Sketchbook. *Boston Public Library.*

Gratz Collection, A.L.S., 1711–1910. *Historical Society of Pennsylvania.*

Joel T. Hart Papers. The Pindell Collection, *Filson Club* (Louisville).

Herring Miscellaneous. *New York Public Library.*

Philip Hone MS Diaries. *New-York Historical Society.*

Jaccacci Collection. *Metropolitan Museum of Art.*

Miner Kellogg Journal and Letters (microfilm). *Ohio Archaeological and Historical Society* (Cincinnati).

Kensett Papers. E. D. Morgan Collection, *New York State Library.*

Rufus King Letters. *Ohio Archaeological and Historical Society* (Cincinnati).

Rufus King Papers. *New-York Historical Society.*

Charles Lanman Letters. *Library of Congress.*

Livingston Family Papers. *New-York Historical Society.*

Maryland Historical Society: Circular. *Wisconsin Historical Society.*

Mayer, Miscellaneous MSS. *Maryland Historical Society.*

Miscellaneous Manuscripts. *Chicago Historical Society.*

Samuel F. B. Morse Letters. *Library of Congress.*

William S. Mount Papers. *New-York Historical Society.*

John R. Murray, Jr. Diary, "Travels Through Europe, 1799–1800." *Library of Congress.*

Charles Eliot Norton Letters. *Harvard College Library.*

Pennsylvania Academy of the Fine Arts: 1817–1828, Minute Book. *Historical Society of Pennsylvania.*

Pennsylvania Academy of the Fine Arts: March 31, 1830–October, 1831, Minute Book. *Historical Society of Pennsylvania.*

Pennsylvania Academy of the Fine Arts: Rough Minute Book, 1841–1845. *Historical Society of Pennsylvania.*

Pennsylvania Academy Miscellaneous Letter Collection. *Pennsylvania Academy of Fine Arts Library.*

J. and T. H. Perkins, *et al*, Extracts from Letter Books. *Boston Athenaeum.*
Thomas Handasyd Perkins, Diaries. *Massachusetts Historical Society.*
Probasco Letters. *Ohio Archaeological and Historical Society* (Cincinnati).
Rodewald, Miscellaneous MSS. *Maryland Historical Society.*
George F. Rumsey Papers. *Chicago Historical Society.*
Schuyler Miscellaneous MSS. *New-York Historical Society.*
Seward Papers. *University of Rochester Library.*
Thomas Sully's Journal. *New-York Historical Society.*
Charles Sumner Letters. *Harvard College Library.*
John Trumbull Miscellaneous MSS. *New-York Historical Society.*
Trumbull–Silliman Correspondence. *Connecticut Historical Society* (Hartford).
John Vanderlyn Papers. *New-York Historical Society.*
Gulian C. Verplanck Papers. *New-York Historical Society.*
Winthrop Papers. *Massachusetts Historical Society.*

GOVERNMENT PUBLICATIONS

American State Papers: Documents, Legislative and Executive. 38 vols. Washington, D.C., 1832–61.
Compilation of the Messages and Papers of the Presidents, 1789–1897. Edited by J. D. Richardson. 10 vols. Washington, D.C., 1896.
Congressional Globe, Containing the Debates and Proceedings, 1833–1873. 100 vols. Washington, D.C., 1834–73.
Debates and Proceedings in the Congress of the United States, 1789–1824. 42 vols. Washington, D.C., 1834–56.
Documentary History of the Capitol. Washington, D.C., 1904.
Executive Documents. 1830–47.
House Documents. 1873–1900.
House Executive Documents. 1847–95.
House Reports. 1819–60.
Journal of the House of Representatives of the United States. Annual volumes. Philadelphia and Washington, D.C.
Journal of the Senate of the United States. Annual volumes. Philadelphia and Washington, D.C.
Journals of the Continental Congress, 1774–1789. 34 vols. Washington, D.C., 1904–37.
Register of Debates in Congress, 1825–1837. 29 vols. Washington, D.C., 1825–37.
Senate Documents, 1817–49.

Statutes-at-Large of the United States of America, 1789–1873. 17 vols.
Boston, 1850–73.

MAGAZINES AND NEWSPAPERS

American Monthly Magazine and Critical Review, 1817.
American Museum, 1790–92.
American Museum, or Universal Magazine (Philadelphia), 1787–92.
Analectic Magazine, 1813–18.
Atlantic Monthly, 1858–61.
Baltimore Sun, 1838.
Carnegie Magazine, 1943.
Catskill (N.Y.) *Recorder,* 1840.
Cincinnati Mirror and Chronicle Devoted to Literature and Science, Vols.
 I–IV.
Cincinnati Mirror and Western Gazette of Literature and Science, Vols.
 I–III.
Cosmopolitan Art Journal, 1857–58.
Crayon, 1855–60.
Detroit News-Tribune, 1897.
Edinburgh Review, Vol. XXXIII.
Enquirer (Cincinnati), 1915.
Family Magazine, 1838.
Greater Pittsburgh, April, 1932.
Hesperus (Pittsburgh), 1828.
Hudson (N.Y.) *Whig,* 1817.
*Literary Gazette, or Journal of Criticism, Science and the Arts, being a
 Third Series of the Analectic Magazine,* 1821.
Literary Magazine and American Register, 1803–7.
Monument (Baltimore), 1838.
Morning Post (St. Louis), 1849.
Newark (N.J.) *Advertiser,* 1843.
New York Commercial Advertiser, 1817, 1838.
New York Courier & Enquirer, 1838.
New York Journal of Commerce, 1846.
New York Mirror, 1838.
New York Spectator, 1828.
New York Tribune, 1848, 1858.
North American Review, 1815–80.
Oneida (N.Y.) *Observer,* 1825.
Pittsburgh Daily Gazette, 1850.
Pittsburgh Gazette and Manufacturing and Mercantile Advertiser, 1823.
Pittsburgh Post-Gazette, 1936.

Portfolio, 1811, 1817.
Western Journal and Civilian (St. Louis), Vols. I–VI.

CONTEMPORARY SOURCES

Adams, Charles Francis (ed.). *Familiar Letters of John Adams and his Wife, Abigail Adams.* New York, 1876.

———. *The Memoirs of John Quincy Adams.* 12 vols. Philadelphia, 1874–77.

Adams, Henry (ed.). *The Writings of Albert Gallatin.* Philadelphia, 1879.

Alison, Archibald. *Essays on the Nature and Principles of Taste.* New York, 1830.

American Antiquarian Society. *A List of Portraits Painted by Ethan Allen Greenwood.* (Proceedings of the American Antiquarian Society, 1946).

Ames, Mary Clemmer. *Ten Years in Washington, Life and Scenes in the National Capitol as a Woman Sees Them.* Hartford, 1876.

Baltimore Museum of Art. *A Century of Baltimore Collecting, 1840–1940.* Baltimore, 1941.

Barnard, D. D. *A Plea for Special and Popular Repose. Being an Address delivered before the Philomathean and Eucleian Societies of the University of the City of New York, July 1, 1845.* New York, 1845.

Barnard, Henry. *Special Report of the Commissioner of Education on the Condition of Public Schools in the District of Columbia.* Washington, 1871.

Beach, Moses Yale. *Wealth and Biography of the Wealthy Citizens of New York City.* New York, 1842.

Boynton, Charles B. *Address Delivered before the Young Men's Mercantile Association, January 19, 1847, "Our Country, the Herald of a New Era."* Cincinnati, 1847.

Bulfinch, Ellen Susan (ed.). *The Life and Letters of Charles Bulfinch, Architect.* New York, 1896.

Cary, T. G. *Memoir of Thomas H. Perkins.* Boston, 1856.

Catalogue of Books . . . of the Late Mr. Justice Story . . . Sold . . . April 3, 4, 1846. Boston, 1846.

Catalogue of Books to be Sold . . . by Howe and Spaulding, 2 September, 1824. New Haven, 1824.

Catalogue of the Enterprise Library. New York, 1834.

Catalogue of the First Annual Exhibition of the Pittsburgh Art Association, 1859. Pittsburgh, 1859.

Catalogue of the First Annual Exhibition of the Society of Artists of the United States. Philadelphia, 1811.

Catalogue of the First Annual Exhibition of the Western Academy. St. Louis, 1860.

Catalogue of the Library of Major D. B. Douglass . . . sold . . . March 15, 1839. New York, 1839.

Catalogue of the . . . Library of the Late Hon. John Pickering to be Sold . . . September 15, 16, 17, 18 and September 22, 23, 24, 25. Boston, 1846.

Catalogue of Pictures at the Shakespeare Gallery.

Catalogue of the Second Annual Exhibition of the Pittsburgh Art Association, 1860. Pittsburgh, 1860.

Catalogue of Valuable Books . . . sold 19 November by Mills, Minton & Company, 1819. 1819.

Catalogue of a Valuable Private Library Sold . . . by Royal Gurley & Company, October 9 and 10, 1846. 1846.

Catalogues of Paintings, Engravings, &c at the Picture Gallery of the Maryland Historical Society, 1848–1858. Baltimore, 1848–58.

Chastellux, Marquis de. *Travels in North America in the Years 1800–1801–1802.* Translated from the French by an English gentleman who resided in America at that period. New York, 1828.

Cist, Charles. *Cincinnati in 1841; Its Early Annals and Future Prospects.* Cincinnati, 1841.

Constitution and By-Laws of the Western Academy of Art, 1859. St. Louis, 1859.

Cooper, James Fenimore. *The Deerslayer.* New York, 1925.

(Copley-Pelham Letters). *Letters and Papers of John Singleton Copley and Henry Pelham, 1739–1776.* Edited by Guernsey Jones. (Massachusetts Historical Society Collections, Vol. 71.) Boston, 1914.

Crèvecoeur, Hector St. John de. *Letters from an American Farmer.* London, 1940.

Deas, Mrs. Anne Izard. *Correspondence of Mr. Ralph Izard of South Carolina, from the Year 1774 to 1804, with a short memoir.* New York, 1844.

Detroit City Directory, 1852–1853. Detroit, 1853.

Dewey, Orville. "Powers' Statues," *Union Magazine of Literature and Art,* October, 1847.

Dickens, Charles. *American Notes for General Circulation.* 2 vols. New York, 1842.

Didier, Eugene L. *The Life and Letters of Mme. Bonaparte.* New York, 1879.

Drake, Daniel. *Anniversary Discourse on the State and Prospects of the Western Museum Society . . . June 10, 1820.* Cincinnati, 1820.

———. *Remarks on the Importance of Promoting Literary and Social*

Concert in the Valley of the Mississippi . . . Remarks delivered at Transylvania University to the Literary Convention of Kentucky, November 8, 1833. Louisville, 1833.

Edwards' Programme and History of the St. Louis Agricultural and Mechanical Association, 1859. St. Louis, 1859.

Emerson, Ralph Waldo. *The Conduct of Life.* Boston & New York, 1860.

———. *The Journals of Ralph Waldo Emerson.* Edited by Edward Emerson. 10 vols. Boston, 1909–14.

———. *The Works of Ralph Waldo Emerson.* Edited by J. E. Cabot. 12 vols. Boston & New York, 1883.

Everett, Alexander. *An Address to the Phi Beta Kappa Society of Bowdoin College.* Boston, 1834.

Everett, Edward. *Orations and Speeches on Various Occasions.* 2 vols. Boston, 1895.

Fearon, Henry B. *Sketches of America.* London, 1819.

"The Fine Arts in America," *Southern Quarterly Review*, XXX (July, 1849), 338 ff.

Flagg, Jared B. *Life and Letters of Washington Allston.* New York, 1892.

Foote, John P. *Act of Incorporation of the Cincinnati Academy of Fine Arts with an Address to the Members of the Institute by John P. Foote, President of the Board of Trustees.* Cincinnati, 1828.

Forman, J. G. *The Western Sanitary Commission. A Sketch.* St. Louis, 1864.

Fraser, Charles R. *Reminiscences.* Charleston, 1854.

Gilmor, Robert, Jr. "Diary of Robert Gilmor, Jr.," *Maryland Historical Magazine*, XVII, Nos. 2 and 3.

[Goode]. *A Memorial of George Brown Goode, together with a Selection of his Papers.* Washington, 1901.

Grattan, Thomas Colley. *Civilized America.* 2 vols. London, 1859.

Greenough, Frances B. (ed.). *Letters of Horatio Greenough to his Brother Henry Greenough.* Boston, 1887.

Guide to the Lions of Philadelphia, comprising a description of the Places of Amusement, Exhibitions &c. Philadelphia, 1837.

Hall, Captain Basil. *Travels in North America in the Years 1827 and 1828.* 3 vols. Edinburgh, 1829.

Hall, Francis. *Travels in Canada and the United States in 1816 and 1817.* Boston, 1818.

Hamilton, Thomas. *Men and Manners in America.* 2 vols. Philadelphia and London, 1833.

Helper, Hinton Rowan. *The Impending Crisis of the South: How to Meet It.* New York, 1860

Hilliard, G. S. (ed.). *George Ticknor, Life, Letters, and Journals*. Boston, 1876.

History of the Brooklyn and Long Island Fair, February 22, 1864. Brooklyn, 1864.

History of the North-western Soldiers Fair, Held in Chicago . . . 1863. Chicago, 1864.

Hosack, David. *Memoir of DeWitt Clinton*. New York, 1829.

Ingersoll, Charles Jared. *A Discourse Concerning the Influence of America on the Mind*. Philadelphia, 1823.

Irving, Washington, and Paulding, James K. *Salmagundi; or the Whim-whams and Opinions of Launcelot Langstaff, Esq., and Others*. 2 vols. New York, 1835.

Jarves, James Jackson. *The Art-Idea*. New York and Boston, 1864.

Kames, Lord (Henry Home). *Elements of Criticism*. New York, 1883.

King, Charles R. (ed.). *Life and Letters of Rufus King*. 6 vols. New York, 1894–1900.

Kirkland, Dr. John. *Discourse in Commemoration of John Adams and Thomas Jefferson*. (American Academy of Arts and Sciences *Memoirs*, New Series, Vol. I.) Cambridge, Mass., 1883.

Lester, C. E. *The Artist, the Merchant and the Statesman of the Age of the Medici and of our Own Times*. 2 vols. New York, 1845.

Ludlow, Miss. *A General View of the Fine Arts, Critical and Historical*. Introduction by Daniel Huntington. New York, 1851.

Marryat, Captain Frederick. *Diary in America, with Remarks on its Institutions*. 2 vols. Philadelphia, 1839.

Martineau, Harriet. *Retrospect of Western Travel*. London & New York, 1838.

———. *Society in America*. New York, 1837; London, 1839.

Mason, G. C. *Reminiscences of Newport*. Boston, 1884.

Mayer, Brantz. *Commerce, Literature and Art: A Discourse Delivered at the Dedication of the Baltimore Athenaeum, October 23, 1848*. Baltimore, 1848.

Memorial of the Great Central Fair . . . Held at Philadelphia, June, 1864. Philadelphia, 1864.

Morse, Edward L. *Samuel F. B. Morse, Letters and Journals*. Boston, 1914.

Murray, Charles A. *Travels in North America During the Years 1834, 1835, and 1836*. 2 vols. New York, 1839.

Nevins, Allen (ed.). *The Diary of Philip Hone*. 2 vols. New York, 1927.

Nevins, Allen, and Thomas Milton H. (eds.). *The Diary of George Templeton Strong*. 3 vols. New York, 1952.

New York Directory of 1802–1803. New York, 1803.

Noble, Louis L. *The Life and Works of Thomas Cole.* New York, 1856.

Norton, Charles E. *Letters.* Boston, 1913.

Our Acre and its Harvest. Historical Sketch of the Soldiers' Aid Society of Northern Ohio. . . . Cleveland, 1869.

Perry, Bliss. *The Heart of Emerson's Journals.* Cambridge, Mass., 1926.

Philadelphia Guide, 1817. Philadelphia, 1817.

Philadelphia in 1824, or a Brief Account of the Various Institutions and Public Objects in this Metropolis. Philadelphia, 1824.

[John Pintard]. *Letters of John Pintard to his Daughter . . . 1816–1833.* New York, 1940.

Poore, Ben: Perley, *Reminiscences of Sixty Years in the National Metropolis.* 2 vols. Philadelphia, 1886.

Price, Sir Uvedale. *On the Picturesque.* London, 1842.

Record of the Metropolitan Fair . . . New York, April, 1864. New York, 1867.

Reports of the Annual Fairs of the Ohio Mechanics Institute. Cincinnati, 1838–60.

Reports of the Exhibition Committee of the Kentucky Mechanics Institute of Louisville, 1856, with circular of the Fourth Exhibition. Louisville, 1856.

Reynolds, Sir Joshua. *The Discourses of Sir Joshua Reynolds.* London, 1924.

Rowland, Dunbar (ed.). *Jefferson Davis, Constitutionalist. His Letters, Papers, and Speeches.* 2 vols. Jackson, Miss., 1923.

Rusk, Ralph L. *The Letters of Ralph Waldo Emerson.* New York, 1939.

Ruskin, John. *Modern Painters.* 2d ed. London, 1848.

———. *The Seven Lamps of Architecture.* London, 1849.

———. *The Stones of Venice.* London, 1851–53.

St. Louis Directory and Register of 1821. St. Louis, 1821.

Semmes, Raphael. *Baltimore as Seen by Visitors, 1783–1860.* (Studies in Maryland History, No. 2.) Baltimore, 1953.

Shaftesbury, Lord. *Second Characters.* Cambridge, 1914.

Stokes, I. W. P. *Iconography of Manhattan Island, 1498–1809.* New York, 1915–28.

Tocqueville, Alexis de. *Democracy in America.* Edited by Phillips Bradley. 2 vols. New York, 1945.

Transactions of the Western Art Union for the Year 1847. Cincinnati, 1847.

Trollope, Frances. *Domestic Manners of Americans.* Edited by Donald Smalley. New York, 1949.

Trumbull, John. *Address Read before the Directors of the American Academy of the Fine Arts . . . by the President.* New York, 1833.

———. *Autobiography of John Trumbull, Patriot-Artist, 1756–1843.* Edited by Theodore Sizer. New Haven, 1953.

———. *Letters Proposing a Plan for the Permanent Encouragement of the Fine Arts by the National Government addressed to the President of the United States by John Trumbull, President of the American Academy of Fine Arts.* New York, 1827.

Tudor, William. *Letters on the Eastern States.* Boston, 1817.

———. *Miscellanies.* Boston, 1821.

Washington, George. *The Writings of George Washington.* Edited by J. C. Fitzpatrick. Vol. XXX. Washington, 1931–44.

Whitley, T. W. *Reflections on the Government of the Western Art Union, and a Review of the Works of Art on its Walls.* Cincinnati, 1848.

SECONDARY WORKS

Adams, Brooks. *The Degradation of the Democratic Dogma.* New York, 1919.

Adams, Henry. *History of the United States during the First Administration of Thomas Jefferson.* 2 vols. New York, 1889.

Albion, Robert G. *The Rise of New York Port, 1815–1860.* New York, 1939.

American Association of Museums. *Proceedings,* Vol. IX. 1915.

American Philosophical Society. *Early Proceedings: Old Minutes of the Society from 1743–1838.* Philadelphia, 1884.

Barker, Virgil. *American Painting.* New York, 1950.

Barzun, Jacques. *Berlioz and the Romantic Century.* Boston, 1950.

Bate, Walter Jackson. *From Classic to Romantic.* New York, 1946.

Bayley, Frank A. *Life of John Singleton Copley.* Boston, 1915.

Beach, Leonard (ed.). "Travel Journals of Peter Irving of New York, 1807," *Bulletin of the New York Public Library,* XLIV, No. 8 (August, 1940), 587 ff.

Becker, Carl L. *The Heavenly City of the Eighteenth Century Philosophers.* New Haven, 1932.

Berman, Eleanor D. *Jefferson Among the Arts.* New York, 1947.

Bobbe, Dorothy. *DeWitt Clinton.* New York, 1933.

Bolton, C. K. *The Founders, Portraits of Persons Born Abroad Who Came to the Colonies in North America before the Year 1701.* Boston, 1919.

Boorstin, Daniel J. *America and the Image of Europe.* New York, 1960.

———. *The Americans: The Colonial Experience.* New York, 1958.

Bridenbaugh, Carl. *Cities in Revolt, Urban Life in America, 1743–1776.* New York, 1955.

———. *The Colonial Craftsman.* New York, 1950.

Bridenbaugh, Carl and Jessica. *Rebels and Gentlemen.* New York, 1942.

Brooks, Van Wyck. *The Flowering of New England.* New York, 1936.

Brown, Robert E. *Middleclass Democracy and the Revolution in Massachusetts, 1691–1790.* Ithaca. N. Y., 1955.

Buley, R. Carlyle. *The Old Northwest.* 2 vols. Indianapolis, 1950.

Burton, Clarence M. *The City of Detroit, Michigan, 1701–1922.* Detroit–Chicago, 1922.

Casseday, Ben. *The History of Louisville from Its Earliest Settlements till the Year 1852.* Louisville, 1852.

Catlin, George B. *The Story of Detroit.* Detroit, 1923.

A Century of American Landscape Painting, 1800–1900. Exhibition Catalogue of the Whitney Museum and Springfield (Massachusetts) Museum of Fine Arts. Introduction by Lloyd Goodrich. 1948.

Chambrun, Clara Longworth de. *Cincinnati, Story of the Queen City.* New York, 1939.

Charvat, William. *The Origins of American Critical Thought, 1810–1835.* Philadelphia, 1936.

Clark, Edna Maria. *Ohio Art and Artists.* Richmond, Va., 1932.

Clark, Eliot H. *The History of the National Academy of Design, 1825–1953.* New York, 1954.

Corner, Thomas C. "Private Art Collections of Baltimore," *Art and Archaeology,* XIX (May–June, 1925).

Cowdrey, Mary Bartlett (ed.). *The American Academy of Fine Arts and the American Art-Union.* 2 vols. New York, 1953.

———. *The National Academy of Design, Exhibition Records.* 2 vols. New York, 1943.

Crawford, M. C. *Romantic Days in the Early Republic.* Boston, 1912.

Cummings, Thomas. *Historic Annals of the National Academy of Design.* Philadelphia, 1865.

Curti, Merle. *The Growth of American Thought.* New York, 1943.

Dangerfield, George. *The Era of Good Feelings.* New York, 1952.

Davis, Joseph S. *Essays in Earlier History of American Corporations.* 2 vols. Cambridge, Mass., 1917.

Dickason, David H. *The Daring Young Men. The Story of the American Pre-Raphaelites.* Bloomington, Ind., 1953.

Dickson, Harold E. *John Wesley Jarvis, 1780–1846.* New York, 1949.

Dictionary of American Biography. Edited by Allen Johnson and Dumas Malone. 22 vols. New York, 1928–44.

Dolk, Lester C. "The Art Teaching of John Ruskin in Relation to the

Aesthetics of the Romantic Era." Unpublished Ph. D. thesis, Department of English, University of Illinois, 1941.

Dorfman, Joseph. *The Economic Mind in American Civilization, 1606–1865.* 2 vols. New York, 1946.

———. *Thorstein Veblen.* New York, 1934.

Dow, G. P. *The Arts and Crafts in New England.* Topsfield, Mass., 1927.

Dunlap, William. *History of the American Theatre.* New York, 1832.

———. *History of the Arts of Design in the United States.* 3 vols. Boston, 1918.

Durand, John B. *The Life and Times of A. B. Durand.* New York, 1894.

Eaton, Clement. *Freedom of Thought in the Old South.* Durham, N.C., 1940.

Evans, Joan. *John Ruskin.* New York, 1954.

Fairman, Charles E. *Art and Artists of the Capitol.* Washington, 1927.

Flexner, James T. *First Flowers of the American Wilderness. An Examination of Art and Society in Colonial America.* Boston, 1947.

French, Henry W. *Art and Artists in Connecticut.* Boston, 1879.

Frothingham, Paul R. *Edward Everett, Orator and Statesman.* Boston, 1925.

Gillespie, J. J. (Company). *One Hundred Years in Pittsburgh.* Pittsburgh, 1932.

Gilmore, Myron P. *The World of Humanism, 1453–1517.* New York, 1952.

Glicksberg, Charles I. "Bryant on Emerson the Lecturer," *New England Quarterly,* XII, No. 3 (September, 1939), 530–34.

Gottesman, Rita S. *The Arts and Crafts in New York, 1726–1776.* New York, 1938.

Govan, Thomas Payne. *Nicholas Biddle. Nationalist and Public Banker, 1786–1844.* Chicago, 1959.

Greenslet, Ferris. *The Lowells and Their Seven Worlds.* Boston, 1946.

Hamlin, Talbot. *Benjamin Henry Latrobe.* New York, 1955.

Handlin, Oscar. *This Was America.* Cambridge, Mass., 1949.

Hastings, Louise. "Emerson in Cincinnati," *New England Quarterly,* XI, No. 3 (September, 1938), 443–69.

Hazelton, George C., Jr. *The National Capitol, Its Architecture and History.* New York, 1908.

Herring, James, and Longacre, J. B. *The National Portrait Gallery of Distinguished Americans.* 4 vols. New York & Philadelphia, 1834–39.

Hofstadter, Richard. *Anti-Intellectualism in American Life.* New York, 1963.

Howe, Winifred E. *A History of the Metropolitan Museum of Art with a Chapter on the Early Institutions of Art in New York.* New York, 1913.

Hudson, William P. "Archibald Alison and William Cullen Bryant," *American Literature*, XII (March, 1940), 59–68.

Hunter, Wilbur H. "Tribulations of a Museum Director in the 1820's," *Maryland Historical Magazine*, XLIX, No. 3 (September, 1954), 214–22.

Isham, Samuel. *A History of American Painting.* New York, 1927.

James, Marquis. *The Raven; a Biography of Sam Houston.* Indianapolis, 1929.

Jensen, Merrill. *The New Nation.* New York, 1950.

Jones, Howard Mumford. "The Influence of European Ideas in 19th Century America," *American Literature*, VII (November, 1935), 241–73.

Kelby, William. *Notes on American Artists, 1754–1820.* New York, 1922.

Kendall, John Smith. *History of New Orleans.* 2 vols. Chicago & New York, 1922.

Kohn, Hans. *American Nationalism.* New York, 1957.

Ladd, Henry. *The Victorian Morality of Art.* New York, 1932.

Larkin, Oliver. *Art and Life in America.* New York, 1949.

Latrobe, John H. B. "Reminiscences of Baltimore in 1824," *Maryland Historical Magazine*, I (March, 1906), 1–121.

Lee, Eliza B. *The Lives of the Buckminsters.* Boston, 1851.

Lipman, Jean. *American Folk Art in Wood, Metal and Stone.* New York, 1948.

———. *American Primitive Paintings.* New York, 1942.

McDermott, John Francis. *George Caleb Bingham, River Portraitist.* Norman, Okla., 1959.

———. *The Lost Panoramas of the Mississippi.* Chicago, 1958.

———. *Seth Eastman, Pictorial Historian of the Indian.* Norman, Okla., 1961.

McKelvey, Blake. *Rochester, the Water Power City, 1812–1854.* Cambridge, Mass., 1945.

McMurtrie, H. *Sketches of Louisville and its Environs.* Louisville, 1819.

Mansfield, E. D. *Memoir of the Life and Services of Dr. Daniel Drake, M.D., Physician, Professor and Author.* Cincinnati, 1855.

Matthiessen, F. O. *The American Renaissance.* New York, 1941.

Miller, Lillian B. "John Vanderlyn and the Business of Art," *New York History*, XXXVI, No. 1 (January, 1951), 33–44.

———. "Patriotism, Patronage, and Taste in Mid-Nineteenth Century America," *Magazine of Art*, XLV, No. 7 (November, 1952), 322–28.

Miller, Nathan. *The Enterprise of a Free People*. Ithaca, N.Y., 1962.

Miller, Perry (ed.). *The Transcendentalists*. Boston, 1953.

Morison, Samuel E. *Harvard College in the 17th Century*. Vol. I. Cambridge, Mass., 1936.

——. *Maritime History of Massachusetts, 1783-1860*. Boston & New York, 1921.

——. *The Life and Letters of Harrison Gray Otis, Federalist. 1765-1848*. Boston and New York, 1913.

Murdock, Myrtle Cheney. *Constantino Brumidi, Michelangelo of the United States Capitol*. Washington, 1950.

Nevins, Allen. *Ordeal of the Union*. 2 vols. New York, 1947.

Nye, Russell B. *The Cultural Life of the New Nation, 1776-1830*. New York, 1960.

Oberholtzer, N. *Philadelphia: A History of the City and its People*. Philadelphia, 1912.

O'Neall, John Belton. *Biographical Sketches of the Bench and Bar of South Carolina*. Vol. II. Charleston, 1859.

Orth, S. P. *History of Cleveland*. Cleveland, 1910.

Palmer, Friend. *Early Days in Detroit*. Detroit, 1906.

Pasko, W. W. (ed.). *Old New York*. New York, 1889-90.

Pelletreau, W. S. *History of Putnam County, New York*. Philadelphia, 1886.

Pierce, Bessie L. *A History of Chicago*. 2 vols. New York, 1937.

Pleasants, Dr. J. Hall. *Four Late 18th Century Anglo-American Landscape Painters*. Worcester, Mass., 1943.

Pomerantz, Sidney I. *New York, An American City, 1789-1803. A Study of Urban Life*. New York, 1938.

Price, Samuel W. *The Old Masters of the Blue Grass*. (Filson Club Publications, No. 17.) Louisville, 1902.

Prime, A. C. *The Arts and Crafts in Philadelphia, Maryland, and South Carolina*. Topsfield, Mass., 1929.

Quincy, Josiah. *A Municipal History of the Town and City of Boston During Two Centuries from September 17, 1630 to September 18, 1838*. Boston, 1852.

Rank, George W. *The History of Lexington, Kentucky, Its Early Annals, and Recent Progress*. Cincinnati, 1872.

Rathbone, Perry T. *Mississippi Panorama*. St. Louis, 1950.

Ravenel, H. H. *Charleston, The Place and the People*. New York, 1906.

Rendezvous for Taste, 1814-1830. An Exhibition Celebrating the 25th Anniversary of the Peale Museum. The Municipal Museum of the City of Baltimore, 1831-1956. Baltimore, 1956.

Richardson, E. P. *Painting in America*. New York, 1956.

———. *Washington Allston; A Study of the Romantic Artist in America.* Chicago, 1948.

Rippy, J. Fred. *Joel R. Poinsett: Versatile American.* Durham, N.C., 1935.

Rose, William G. *Cleveland, the Making of a City.* Cleveland & New York, 1950.

Rourke, Constance. *Audubon.* New York, 1936.

———. *The Roots of American Culture and Other Essays.* New York, 1942.

Rusk, Ralph L. *The Life of Ralph Waldo Emerson.* New York, 1949.

Rutledge, Anna Wells. *Artists in the Life of Charleston, Through Colony and State from Restoration to Reconstruction.* Philadelphia, 1949.

———. *Cumulative Record of the Exhibition Catalogues of the Pennsylvania Academy of Fine Arts, 1807–1870.* Philadelphia, 1955.

———. "Early Art Exhibitions of the Maryland Historical Society," *Maryland Historical Magazine,* XLII, No. 2 (June, 1947), 124–36.

———. "One Early American's Precocious Taste," *Art News,* March, 1949.

——— (ed.). "Four Letters of the Early 19th Century," *South Carolina Historical & Geneological Magazine,* XLII (January, 1942), 54.

Sanderson, John. *Biography of the Signers of the Declaration of Independence.* Philadelphia, 1823.

Savelle, Max. *Seeds of Liberty.* New York, 1948.

Scharf, J. Thomas. *History of Baltimore City and County from the Earliest Period to the Present Day.* 2 vols. Philadelphia, 1881.

———. *History of Maryland.* 2 vols. Baltimore, 1879.

———. *History of St. Louis City and County.* 2 vols. Philadelphia, 1883.

Scharf, J. Thomas, and Westcott, Thompson. *History of Philadelphia, 1609–1884.* Philadelphia, 1884.

Schlesinger, Arthur, Jr. *The Age of Jackson.* Boston, 1945.

Schönberger, Arno. *The Rococo Age.* New York, 1960.

Scoville, Joseph A. (Walter Barrett, pseud.). *Old Merchants of New York City.* 4 vols. New York, 1853–66.

Semmes, John E. *John H. B. Latrobe and his Times, 1803–1891.* Baltimore, 1917.

Shinn, Earl. *The Art Treasures of America.* 3 vols. New York, 1879.

Simkins, Francis B. *The South, Old and New.* New York, 1947.

Simpson, Lewis. *The Federalist Literary Mind; Selections from the Monthly Anthology and Boston Review, 1803–1811.* Baton Rouge, La., 1962.

Smith, Henry Nash. *Virgin Land. The American West as Symbol and Myth.* Cambridge, Mass., 1950.

Smith, Walter B., and Cole, Arthur. *Fluctuations in American Business, 1790–1860.* Cambridge, Mass., 1935.

Sparks, Jared B. *The Life of Gouverneur Morris.* Boston, 1832.

Spencer, Benjamin. *The Quest for Nationality.* Syracuse, N.Y., 1957.

Stampp, Kenneth. *And the War Came.* Baton Rouge, La., 1950.

Stanard, Mary Newton. *Colonial Virginia; Its People and Customs.* Philadelphia, 1917.

Steegman, John. *Consort of Taste, 1830–1870.* London, 1950.

———. *The Rule of Taste from George I to George IV.* London, 1936.

Steegmuller, Francis. *The Two Lives of James Jackson Jarves.* New Haven, 1951.

Streeter, Robert. "Association Psychology and Literary Nationalism in the *North American Review,* 1815–1825," *American Literature,* XVII (November, 1945), 243–54.

Swan, Mabel M. *The Athenaeum Gallery, 1827–1873.* Boston, 1940.

Taylor, Francis Henry. *The Taste of Angels.* Boston, 1948.

Taylor, George R. *The Transportation Revolution, 1815–1860.* New York, 1951.

Tuckerman, Bayard (ed.). *The Diary of Philip Hone, 1828–1851.* 2 vols. New York, 1889.

Tuckerman, Henry T. *Book of the Artists. American Artist Life.* New York, 1867.

Vanderbilt, Kermit. *Charles Eliot Norton, Apostle of Culture in a Democracy.* Cambridge, Mass., 1959.

Wade, Richard C. *The Urban Frontier; the Rise of Western Cities, 1790–1830.* Cambridge, Mass., 1959.

Walters Art Gallery. *The West of Alfred J. Miller.* Norman, Okla., 1951.

Wecter, Dixon. *The Saga of American Society.* New York, 1937.

Weidner, Paul R. (ed.). "The Journal of John Blake White," *South Carolina Historical & Geneological Magazine.* Vol. XLII, Nos. 2–4, 55–71, 99–117, 169–86; Vol. XLIII, Nos. 1–2, 35–46, 103–17.

Weigley, Russell F. *Quartermaster General of the Union Army.* New York, 1959.

Weisenburger, Francis P. *The Passing of the Frontier, 1825–1850.* Columbus, 1941.

Wertenbaker, T. J. *The Old South; The Founding of American Civilization.* New York, 1942.

Weston, Latrobe. "Art and Artists in Baltimore," *Maryland Historical Magazine,* XXXIII, No. 3 (September, 1938), 213–27.

Whitehead, Alfred North. *Science and the Modern World.* New York, 1925.

Whitley, W. T. *Gilbert Stuart*. Cambridge, Mass., 1932.
Willey, Basil. *The Eighteenth Century Background*. London, 1949.
Wilson, Erasmus (ed.). *History of Pittsburgh*. Pittsburgh, 1898.
Wiltse, Charles M. *John C. Calhoun, Nationalist, 1782–1828*. New York, 1944.
Winsor, Justin. *Memorial History of Boston, 1630–1880*. 4 vols. Boston, 1881.
Wright, Louis B. *Culture on the Moving Frontier*. Bloomington, Ind., 1955.
Wyeth, S. D. *The Federal City*. Washington, 1865.
Wynne, James. *Private Libraries of New York*. New York, 1860.
Yale University Art Gallery. *Connecticut Portraits by Ralph Earl*. New Haven, 1935.

INDEX

317